On Art And
ARTISTS

Copyright © 1989 by The Chronicle Publishing Company

Printed in the United States.

Library of Congress Cataloging-in-Publication Data

Albright, Thomas.
 On art and artists/Thomas Albright; edited by Beverly
 Hennessey; foreword by Wayne Thiebaud; afterword by
 Lawrence Ferlinghetti.
 p. cm.
 ISBN 0-87701-589-9
 1. Arts — Themes, motives. 2. Artists — Psychology.
 I. Hennessey, Beverly. II. Title.
NX60.A37 1989
700—dc19 89-956
 CIP

Text design by Robin Weiss.

Distributed in Canada by Raincoast Books
112 East Third Avenue
Vancouver, B.C. V5T 1C8

10 9 8 7 6 5 4 3 2 1

Chronicle Books
275 Fifth Street
San Francisco, California 94103

On Art And ARTISTS

ESSAYS BY THOMAS ALBRIGHT

Edited and with an Introduction by
BEVERLY HENNESSEY

Foreword by
WAYNE THIEBAUD

Afterword by
LAWRENCE FERLINGHETTI

Chronicle Books · San Francisco

Acknowledgments

BEVERLY HENNESSEY

I'd like to thank Phelps Dewey for his confidence in my ability to carry out this endeavor; Jay Schaefer and Rachel Zimmerman of Chronicle Books for their superb expertise on many levels; Judith Dunham for her discerning eye in copyediting the manuscript; Michael Hennessey, Susan Lohwasser, Ruth Albright, Jeannette Redensek, Margo Cowan and Ray Towbis for their invaluable advice; and Samantha Rose, my two-year-old daughter, for being so patient and good while I worked on this publication.

Great art remains a pointing finger, a material object, tracing the outlines of a constellation, an illusion, in a night sky. Too often, like animals, we look only at the finger.

THOMAS ALBRIGHT
April 10, 1980

Table of Contents

On Criticism

Satire

On Music

Foreword

WAYNE THIEBAUD

Exaltation of the artist requires a concomitant exhaltation of the critic . . . and if art is to have a special train the critic must keep some seats reserved on it.

—*Oscar Wilde*

It is difficult for anyone writing about art to match the kind of self-criticism that artists can make of their own work. Serious painters who love painting cannot help but recognize how difficult it is to measure up to painting's grand achievements. Those artists who fancied themselves to be above this kind of critical confrontation were likely to elicit stinging reminders from Thomas Albright. It was therefore more comforting to read his reviews of other artists' works and try to avoid those written about one's own work. I can still recall when he wrote the following:

Thiebaud remains a curious artist. He sometimes brings to mind Morandi, sometimes the facile formula and brand-name identifiability of Walter Keane.

For over twenty-five years I witnessed Thomas Albright participate in panel discussions, art openings, interviews, and parties. His strategy depended upon a determined outsider's view of the established art scene: incorruptibility depends on an indifference to power politics, established reputations, money, and fame. (He once told me that he, for one, did not want to be famous even for fifteen minutes.) This role as an outsider allowed him the option to drop in on the art world, have a good look, and drop out in order to sustain a personal veracity that was of primary importance to him.

Since art is a field where one can become an expert and be wrong, Albright was aware of the myth of objectivity. This gave him the ease of subjectivity and let him respond to works as he genuinely felt about them, with directness and clarity. He was personally discomforted by the effete, the highbrow and artful affectations of any kind. He confessed his own prejudices were in favor of egalitarianism, tireless workers, risk-takers, and street fighters. He recognized that art comes from art, but believed that no art should be protected by entrenched academic environments; art must finally be tested in the streets.

The creative search for alternatives to what we already know is a supreme challenge and continues to drive one to desperate actions. It can and often does turn artists into absurd types: eccentric dressers, cranky xenophobics, shy people, neurotics, liars, and crooks. But to see the art and not the artist is the role of critical interrogation. Tom was very good at approaching art with love, allowing us to see a work of art naked and unmasked.

Introduction

BEVERLY HENNESSEY

On Art and Artists is a tribute to Thomas Albright, whose impassioned writings on art appeared on the pages of the *San Francisco Chronicle* for more than twenty years. The pieces selected here reflect Albright's impressive critical range and cover one of the most exciting and turbulent periods in the history of art. From the psychedelic flowering of the late 1960s through the emergence of performance art in the 1970s and the "new realism" of the early 1980s, Albright's critique was always provocative, rich, and highly opinionated. His writings on jazz display an unparalleled sensitivity to the form. In fact jazz music, even more than art, was Albright's lifelong passion.

Albright was born in Oakland, California, in 1935. His mother, an avid reader, taught him to appreciate literature at an early age—by eight he was writing entertaining essays on his family life. As an undergraduate at the University of California at Berkeley, Albright met Alfred Frankenstein, art history professor and art critic for the *San Francisco Chronicle*. Frankenstein urged Albright to to join the staff of the paper, and in 1957 Albright began writing reviews for the *Chronicle*.

Albright's early adult life was spent in the North Beach section of San Francisco hanging out with the beatniks of the 1950s and playing jazz piano. Like many other artists drawn to the romanticism of the beat lifestyle and aesthetic, Albright frequented cheap hotels and bars, and when he wasn't writing, he was drinking. One Christmas his parents drove to the city from their home in Calistoga and found him passed out in a telephone booth. They promptly took him to a Carmelite priest in Napa Valley who assured them their son had not veered permanently from his Catholic upbringing and faith. But this early exposure to avant-garde poetry, painting, and music gave Albright an invaluable art education—one which the U.C. Berkeley academics could not have alone provided.

Although Albright had come a long way from his quiet childhood in northern California, he still saw himself first and foremost as a compassionate human being and not just a writer and intellect. Frequently, artists would drop by the *Chronicle* office unannounced to get a handout from him, and he would always be happy to oblige. Money seemed secondary to Albright, whose favorite places to shop were St. Vincent de Paul and Goodwill, where he acquired a motley collection of brightly colored shirts, flamboyant wide ties, and porkpie hats.

But Albright's individualism was most apparent in his brashly honest and often abrasive reviews. Refusing to be silenced by the powerful art establishment, Albright would speak his mind when he felt galleries were showing mediocre work, and he never kowtowed to the art world's flighty tendencies of taste. Albright believed in the political and aesthetic power of art. And for the artists he respected—Clyfford Still, Richard Diebenkorn, Frank Lobdell—Albright was willing to get out on a limb and inform the public of his views on "great art" and artists with a committed and passionate display.

In 1980, Albright discovered he had lung cancer in an advanced stage. He was at the height of his career. His fluid and acerbic writing style had matured and his columns in the *Chronicle* were in top form. He continued to fight the disease with great courage and raced the clock to achieve some of his finest accomplishments as his physical strength waned.

I was Albright's friend and literary agent. Together we spent his last months determined to finish his art history, *Art in the San Francisco Bay Area, 1945–1980,* which was completed just days before his death on May 14, 1984. He was 49 years old.

Albright was first and foremost a newspaper journalist. He thrived under pressure and loved the feel of newspaper print on his hands. He was eager and willing to be outspoken in print but very shy and humble in person. He was both brilliant and uncompromising, with the intellectual scope of an outstanding critic and the insight and passion of an exceptional man.

etely.
s Mon-
ructiv-
tion of
re into
strain
ved the
Expres-
all art,
e most
ary."

ems to
right
tions it
two of
vell as
ery ex-
ure of
lis, 109
ainting
Berrg-

ped a
oundly
past by
to the
ions of
rbarian
ssels —
ial and
tempo-
his art
e gives
ng the
rich in
nd that
d other
ment in
st both
geology
nd the
d decay

t forms
ematic

similar in some respects to the monumental pieces he exhibited a couple of years ago — towering columns of irregular ceramic slabs placed one on top the other, with three of their sides cut sheer; the fourth, the "front," combines mangled human forms — fragments, bones — with gnarls and folds that more nearly resemble congealed lava.

But the structures have become less pyramidal or wedge-like, more slender and upright, generally towering nine feet or more high. And they are more abstract.

The tendency for a breast, a foot or a knee-cap obtrusively to "pop out" from the more firmly imbedded forms has been curbed: the new sculpture projects more the frangments of the figure, or of bones turning into rock. With a few exceptions, the color with which deStaebler impregnates his material is also more subdued, and controlled.

But while the new pieces are more harmonious on the surface, they also seem more arbitrary in structure and concept, in the way that a lava formation is more arbitrary than the construction of the human figure. The great dilemma of deStaebler's expression is arriving at a precarious, delicately callibrated balance between figuration and abstraction, between form and dissolution; its attainment, when it occurs, gives his strongest work its sense of deep internal tension.

It is achieved here, it seems to me, in the relatively small "Right Sided Woman Standing," and ap-

tures. But for the most pa
opting for a more abstra
proach, deStaebler seems
have resolved the dilemma so
as to have evaded it.

The pieces are all quite
ful, as natural outcroppings
can be quite beautiful, but
them seem rather too easy
the skin.

Although the range of a
in deStaebler's sculpture is
he uses his references expre
and absorbs them into a co
form of his own. The proble
Oliveira's new paintings is
gratuitous eclecticism.

All belong to a series
"Swiss Site." Two or thre
almost straight caricatu
Turner, with hazy, light-pe
atmospheres, intimations of
mering reflections and dus
houettes. Most are more like
between Turner and Dieber
"Ocean Park" paintings, wit
vocal interior "edges" that
luminous atmospheres from
emerges the halo-like imag
distant tower. A few conta
and traces of imagery that
William Wiley — a checke
flag, a funky pyramid, a wl
arabesque with candy stripin

Oliveira is masterful a
dling the effects of atmosphe
painterly surfaces, and the ju
where they coincide; on t
face, many of these new pa
look spectacular. But, for
wildly casting about for sigr
imagery, or "content," in t
these paintings seem to be r
but seductively vaporous
effects. They are like a new

The Unique Quality That Is Art

APRIL 16, 1981

Probably because we grow up believing in "democracy," and also in the idea that art is "universal," most people seem to harbor the notion that art has something to do with such traditional ideals as "equality" and "fair play."

To be sure, the exceptionality of a few historic "geniuses" is almost universally acknowledged. Yet, for the rest, the assumption seems to be that in everyone there flickers a "creative spark" that requires only the proper encouragement to flame into another Michelangelo or Picasso. We who publicly record our impressions of art are frequently beset by wrathful accusations that we are nipping budding Leonardos.

Or we are told it is dirty pool to look for "masterpieces." Creation is as unique as people, and one should be content with singling out and praising those humble merits to be found in even the most trivial of things.

Such arguments betray, it seems to me, an erroneous concept of what art really is. Art is not (usually, for art *can* be anything) mere isolated objects, with good points and flaws. As Benedetto Croce put it, "We hear of *merits* in relation to works of art that are more or less failures, that is to say, of *those parts of them that are beautiful*.... It is, in fact, impossible to enumerate the merits...[of successful works] because, being a complete fusion, they have but one value. Life circulates in the whole organism; it is not withdrawn into the several parts."

Art is itself an organism, a body of work that evolves from a unique vision which, in turn, deepens through the continued effort to give it form. It is an organic outgrowth of those who pursue a commitment to make themselves artists. Talent, sincerity, training, hard work, dedication—all are important and, probably, crucial to it, yet none in itself, nor even all together, necessarily guarantees art.

It is precisely uniqueness that is lacking in most of the work one sees. It tends to share "concerns" and styles that are momentarily popular in the art schools and art journals—or else the clichés of kitsch. No two such works may be exactly alike, but their differences are superficial, like those among fingerprints, and have nothing to do with vision.

On the other hand, where an artist does successfully give form to this uniqueness of vision, it is a qualitative, rather than a quantitative, achievement. It does not admit of comparisons. As Henry James wrote, "It is idle to pause to call [experience] much or little so long as it contributes to swell the volume of consciousness." Nor does art admit of competition. The concept of "fairness," as well as the envy and backbiting so rampant in the art world, is to do not with art but with art politics.

An artist who believes strongly enough in his own vision will not be hurt by misplaced critical damns; probably more artists have been damaged by inflated praise. To aggrandize mediocrity is not

only to inflate its worth, but to demean real artistic achievement. Mediocrity is given its due when it is called mediocre— which, after all, signifies the mean, the average, the norm.

This is not to say that all the other things we lump together as "artistic activity" are not of value. They can be therapeutic, entertaining, fulfilling, fun. The sandlots have their place in art, as in baseball. They can help give those who take part a better understanding of the game.

There is, indeed, an art to being an aware and responsive *audience*. In recent years, we have fallen into a simple-minded equation of "participation" with overt activity. But one participates more meaningfully in really seeing one great work than in turning out a hundred mediocrities.

Art brings into being something that had never existed before. It is, by its very nature, isolating and, thus, "elitist." This "elitism," however, has nothing in common with the so-called elites of the economic and social structures; it is more like a priesthood—not something one can inherit, buy or fake a way into, yet open without discrimination to anyone with the vocation and commitment to devote a lifetime to its service.

It is for the rest of us to be the artists' responsive and engaged audience, to look to them, not for sweet nothings, but for the inspiration that we need to carry out some of the other work that needs to be done in the world.

Another Kind of Pollution

SEPTEMBER 15, 1977

In this conservation-minded era, it is curious that one of the most rapidly spreading blights has so far been virtually unrecognized—and can be expected to expand.

I refer, not entirely in jest, to art pollution.

We all know some of the more conspicuous symptoms: the jazz solo that drags on twenty minutes too long; the LP with one good three-minute cut (or no good cut); painters and sculptors who knock out an exhibition every twelve or eighteen months; galleries and "alternatives" thereto that multiply as quickly as the schools turn out accredited "artists" to fill them.

Another routine show, another routine review.

In addition to such traditional ancillary roles as those of art writer, art dealer, art curator, collector, historian and teacher, the "support system" has multiplied to encompass entire new lines of professional art groupies and parasites twice and more removed: art funders and proposal drawers, program coordinators and policy planners, lawyers for the arts, lobbyists for the arts and coalitions for the arts.

Those with vested interests will cite the bitter and enduring struggle between art and Philistinism, but it's a different ball game now. The words art and artist, far from provoking suspicion or contempt, today command an almost magical respect, as the proliferation of their usage makes quite clear. Bad enough a tradition that confers on anyone who works in a visual medium the privilege of using the word *art* to describe the paltriest daubings or excrescences in pigment or clay

(or dabblings in performances or video). Now we have also recording artists (any musician to set foot in a studio), culinary and gastronomic artists, information artists, systems artists and artists who merely think about art.

We have art employed as an arm of education, as a tool of personal and social therapy, as a weapon of political propaganda, as a euphemism for every conceivable kind of commercial entertainment, as a palliative to alleviate unemployment. Perhaps never before have so many people been engaged at blithely combining so many materials and covering so many surfaces of various sizes and kinds in the name of "art," with so little reflection on what "art" is and whether it may not have a saturation point.

As employment in traditionally "productive" sectors of the economy—agriculture, manufacturing—continues to diminish, and more people are diverted to service and "leisure" occupations, the trend can only escalate. "Art," with its practically unlimited "growth potential," is promoted as an activity everyone should—and can—take part in.

And "art" becomes the hottest new commodity in our omnivorous consumer society.

I used to enjoy thinking of the "straight, advancing line," as Clement Greenberg and other evolutionists tend to envision the accumulated fund of discoveries made by artists, as more accurately being a mere section of an ever-enlarging circle—not the thin end of a limb, but a continually expanding area of choice and possibility from which any artist could

draw for his or her own use. But now I tend to see the circle as the surface of a vast, swirling vortex, with a yawning maw at its center that sucks down and consumes indifferently everything—"avant-garde" or traditional, masterpiece or schlock, original or copy— that comes its way.

Overall, this proliferation probably has been a Good Thing—it's kept a lot of us gainfully employed and away from more harmful activities. But art is a rare phenomenon that, like most things, tends to become devalued by flooding the market.

Those involved with the arts might begin to take a few cues from the conservationists. Public lands and building surfaces should not be turned over with impunity to "artists," any more than to other developers. We could start gilding other professions—public accountant, statistician— with the aura of glamour and "creativity" that has attracted so many people to the arts. Perhaps the government could pay artists to leave things alone, to take time out from production, as they've done with farmers for years. And recognition should be granted to editing as a basic creative activity—the credit given for the art of not doing, of rejecting possibilities.

During World War II, when gas was rationed, there were windshield stickers that read "Is this trip really necessary?" There is something very appealing about a plain surface, an empty space; silence is a rarity these days. People proposing to alter these states should first consider if their activity constitutes an improvement.

Great Art Lives in the Present

APRIL 2, 1981

Art is troublesome because it is so much like man.

Man embraces the fundamental contradiction that he is an animal, but not *just* an animal. A similar contradiction lies at the foundation of art. It is an object, a material fact, self-contained and self-sufficient, a created organism.

At the same time, it is an experience. It *functions* as an act of communication conveying a "message" that is something other than the mere physical components of its construction, and thus takes its life in the proverbial eye of the beholder.

The artist relates, first and foremost, to art in its former capacity; it is the relationship of maker to object. He begins with a vision or idea, perhaps at the merest threshold of definition, and with the materials necessary to give it form. His task is to sustain the dialogue among these elements necessary to bring his work to fruition, the fullest possible realization of his intention—by the very nature of the task, something only the artist himself can judge.

The relationship of the viewer—including the "critic"—to the finished work is, necessarily, quite different. Lying outside the work as object, he can participate in it only as experience, as one of innumerable stimuli in the environment that take on meaning only as they elicit a response. Except for the most rudimentary of these—a stoplight, say—such responses are infinitely complex, with as

many variations as there are individuals. In another word, "subjective."

The artist tries, of course, to exercise some control over the communicative function of his work. He struggles to give his intent an organically appropriate visual form. He can, and should, attempt to control the *presentation* of his work after it has passed from his hands, to ensure that its essential "meaning" is not destroyed, or utterly contradicted, by the context in which it is displayed.

The power of context may have its lamentable aspects, such as the way museum-goers so often look at a label first to help them decide what to think about a work. Still, the saw holds true that in a dark room, all colors are black.

At the same time, for the artist to become preoccupied with the communicative function of his art *within the work itself*—to "slant" it for an audience, to take the hypothetical "viewer" by the hand to guide his thoughts and feelings—is to dilute one's art to illustration. Or, if an artist goes so far as to do practically all of the viewer's thinking and feeling for him, to reduce his work to kitsch.

The viewer, for his part, can make an effort to understand the dialogue between vision and material, the creative process that eventuates in the object that meets his eye. He can make use of the voluminous store of verbal "information" that generally exists for his assistance. And, of course, assimilate as much as possible of the evi-

dence of his own raw perceptions.

Still, no matter how intricately, or even deeply, a viewer may penetrate the context of a work of art, or contemplate the purely visual components of the work itself, he is left simply with an object, and a framework, that he can only really *know* as an aggregation of more or less unrelated visual and autobiographical or historical data, like the words in a dictionary. The one thing—the only thing—of which he can be sure is the impact that these things have upon him personally.

The complaint is sometimes made that critics permit personal experience to "stand in the way" of an "objective" appraisal. But, unless one is content with a mere report, a verbal inventory of visual data, subjective experience is the only authentic subject of criticism, the one thing a critic can know.

If art is much like man, it is also much like history: The only valid way to see an era is the way it saw itself; the only possible way, from the point of view of what it means to us today. There are times when we feel that an event from centuries past has come alive to us more or less intact. The same is true of great works of art, which manage somehow always to live in the present—although it is equally impossible to determine whether because of an inherent transcendence, the skill of some teacher in making it vital to us, or a surpassing movement of our own imagination.

The Languages beyond Literature

APRIL 10, 1980

Some time ago, a reader introduced me to a compelling book of essays, *Language and Silence,* by George Steiner.

Steiner is principally a critic of literature. But he is a profound analyst of the twentieth-century sensibility in general, and his observations can extend to the visual arts as well.

Steiner's premise is that literature has largely lost its value as a form by which our deepest insights and feelings are given voice. Prose has become primarily a neutralized vehicle of simple reportage or trashy fiction; much of our most serious communication now gravitates to other languages—the mathematical language of science (and pseudosciences like sociology), the absolute language of music (and the allied language of poetry).

James Joyce, Steiner writes, represents, with Proust, a culmination of the heroic nineteenth-century novel; their ambition was to give voice to every area of human experience. The twentieth-century sensibility begins, not with *Ulysses,* but with such writers as Kafka, in whose work language approaches "the shore of silence."

A central work is Wittgenstein's early *Tractatus Logico-Philosophicus,* with its message that "language can only deal meaningfully with a special, restricted segment of reality. The rest, presumably the much larger part, is silence."

This insight is expressed in art that points to "silence" but does not trespass on it. Such silence stands at the core of the labyrinthean spirals of Jorge Luis Borges, and all around Samuel Beckett's dark interior monologues. It lies just out of reach of Robert Musil's unfinished monument, *The Man Without Qualities,* as it does of Kafka's unfinished longer works. It is the pivot around which revolve the twilight parables of Hawthorne, Melville, Henry James and later writers, on the contradictions between reason and moral judgment, and action and faith— J. Alfred Prufrock versus Doctor Faustus.

In the visual arts, it defines one of the critical differences between early Modern movements like Cubism and Expressionism, with their lingering confidence in a coherent world contained within a frame, and the sensibility, expressed most strongly in Abstract Expressionism, that the picture is a focal point for forces that lie primarily beyond its edges. The former tried to explain itself in written manifestos; the latter favored silence.

The silence pierces the otherwise solid sculptural forms of Henry Moore, and is the very substance of Alberto Giacometti's expression, which suggests a process that remains unfinished, although as complete as man can make it.

The problem is, can one distinguish

between such transcendant "silence" and mere mindless dumbness? "The silence, which at every point surrounds the naked discourse, seems, by virtue of Wittgenstein's force of insight, less a wall than a window," Steiner writes. Yet many contemporary artists have taken Wittgenstein's distinction between what can and cannot be said as the cue for not trying to say anything, an art of surfaces and "data." Their work remains a wall.

In the end, the judgment of whether the work of a Warhol reveals to us something about contemporary society, about life itself, or simply about soup cans, is as subjective as most other questions about art. It is as impossible to distinguish a mystical silence from mere muteness as it is to pass judgment on the morality of Captain Ahab. The contemporary artist and his audience are, like the modern tragic hero, Hamlets and Agamemnons without the benefit of ghosts or oracles (false or otherwise) to speak in judgment with what seems the voice of a higher authority.

The Rothko that speaks to one person is silent to another; the Ad Reinhardt whose spirit just yesterday resounded like an oratorio today stands mute. Great art remains a pointing finger, a material object, tracing the outlines of a constellation, an illusion, in a night sky. Too often, like animals, we look only at the finger.

The Content Is the Message Now

AUGUST 9, 1979

The pendulum theory of history gains support from the current flurry of interest in the function of art as language.

In the 1960s, one spoke, exclusively and solemnly, about *form,* citing Clement Greenberg or Michael Fried. The buzz-words were *picture plane, support, field, ground.* The medium was the message.

Now, almost as though the possibility had never dawned on them before, the kinds of art thinkers who formerly busied themselves with dissecting painting and sculpture into their most rudimentary formal components have suddenly discovered that art *says something*—and, of course, they rush to vitiate this newfound possibility of meaning as speedily as possible: by parsing it away.

The new emphasis on *content* includes a residue of Freud and Jung left over from an emphasis on content that dominated criticism before the last swing of the pendulum. But for the most part, it is couched in different verbiage—semiotics, structuralism—and has a new set of heroes: Noam Chomsky, Roland Barthes, Marvin Minsky.

Much of it centers around the medium of photography—for similar reasons, one suspects, that the current "Creativity" show at the California Academy of Sciences confines itself to such artists as Jasper Johns and John Cage: because their work consists primarily in reshuffling recognizable elements from the "real world," and it

therefore seems easier (or even possible) to tell where "life" leaves off and "creativity" (or at least contrivance) begins. The most frequent point of departure is a remark written by Walter Benjamin in the 1930s: "The illiterate of the future will be he who cannot read a photograph."

The literary metaphor seems to provide the cue for attempting to translate to the analysis of photography—and, presumably, the other visual arts as well, for how can they be separated?—the kinds of investigations that have clustered in recent years around the written and spoken word. These revolve around two separate, if related, areas: semiotics and "transformational grammar." Loosely speaking, these correspond to the distinction between vocabulary and syntax.

The problem is that although analyses of the greatest refinement have been devoted to both these subjects in recent years, they have failed to shed any light on even the simplest declarative sentence: The ball is round. One suspects that much linguistic study is simply a restatement of an age-old philosophical conundrum.

One now investigates "signs" instead of "sensations"; "linguistic structure" becomes the new name for logic, or the way the world of sensation is held together. But how do any of these things—sensation, logic, meaning—relate to anything outside of themselves, or how did they come into being in the first place? For all

their abstract beauty, systematic philosophies leave us only more or less perfectly drawn closed circles.

Art has the power, at least, of reaching beyond these circles, of helping us achieve comprehensions that reason alone cannot encompass (as Socrates, when he had reached the boundaries of logic, turned to myth and poetry). But art acts in its own way; it is not a mere dialect to be translated more or less verbatim to another, more familiar tongue. When artists speak of visual "illiteracy," they mean that while many people are educated to speak knowledgeably about art, to know something of its history, forms and iconography, there are few who really learn to see.

Neither formal analysis nor semiotics and structural investigation are apt to tell us what it is that makes a great work of art more than mere marks, or "signs," on a sheet of canvas or paper (although a great deal of work that has been influenced by these disciplines is, indeed, nothing but mere marks and signs, mirroring themselves in endless auto-orgies of reflexivity).

The visual idiocy behind both approaches remains the same. As Unamuno once wrote of the Spanish Jesuits, "They amuse themselves in counting the hairs in the tail of the Sphinx in order to avoid looking into its eyes."

A Lament for the Lost Fan

MAY 22, 1980

The backbone of baseball has always been the fan in the bleachers—the passionately dedicated follower of the game who will come out to the park through good years and lean.

He is happy when the home team wins, but he is there basically in hopes of the rare, unexpected thrill: the grand-slam home run, the no-hitter, by either side. And because he can sense a metaphorical connection to his own life in the game's peculiar balance of plan and accident, skill and luck—above all, the day in, day out need to endure.

Such "fans" were once an important aspect of the art world. They were not themselves artists, as the fan in the bleachers is not himself an active ball player. They were not self-interested dealers—scouts—nor were they necessarily collectors or pedigreed art historians—fans who have memorized the record book.

What they were, were real connoisseurs, informed and knowledgeable enough to follow the action, to perceive the significant nuance, to tell the great from the good, the good from the competent, the competent from the bum.

Most importantly, they *cared*. They were not Philistines, although they were rude enough to holler when they felt catcalls were deserved. They discussed and argued about art in bars and coffeehouses. They were usually opinionated, and often wrongheaded. They were the best audience that one could have.

This audience, it often seems, has all but disappeared from the art world. More and more often, people report that, although they used to go to galleries and museums with some regularity, they rarely bother anymore. These are not the scene-maker types who were attracted to the visual arts in such numbers during the Gilded Sixties, who still desultorily browse the galleries but have largely transferred their attention to more fashionable forms: principally performance, including dance and theater.

On the contrary, they are most often those who once looked to the visual arts for real sustenance. They are frequently so turned off they don't even go to see the good shows.

Part of this is no doubt a result of the national obsession in recent years with the most superficial notion of "creativity"—the idea that it is more "creative" to be endlessly *producing* mediocre works of art than to *experience* a great one. So everyone speaks at once, and no one has time anymore to listen.

But mostly it seems a logical outgrowth of the preoccupation with *reflexivity* that has dominated the visual arts in recent years—the progressive abstraction, or withdrawal, of art from living experience to an absorption in its own ideas, materials and processes. Piet Mondrian, Kasimir Malevich, Wassily Kandinsky, Jackson Pollock, Mark Rothko, Clyfford Still—all gradually developed forms of ab-

stract expression that remained living organisms, with organic roots in the ideas and experiences from which they sprang.

In the past two decades, however, art has become increasingly an abstraction from itself. Abstract paintings abstract from other abstract paintings, figurative paintings from photographs. Young artists emulate the forms that Joseph Beuys evolved from *his* experiences, rather than developing forms from their own.

The emphasis of art upon its own artifice—the picture plane, raw materials and processes—has resulted in an art of surface and technique, mired in its own conventions and increasingly remote from sources outside of it—like Robert's Rules of Order as distinct from the law of gravity, or the Ten Commandments.

Art should never be show business, nor can it retreat to the academic "realism" of an earlier era; life today is lived on a level of abstraction and symbol undreamed of in earlier ages. But the burden is on the artist to create work that has some authentic roots in his own experience, and therefore can connect on some level with the experiences of others.

Otherwise, art becomes mere ritual, like a Japanese tea ceremony, and artists will continue to be pretty much their own audience—like Kafka's Hunger Artist, who at last achieved the independence he had always sought, to do whatever he wished, blissfully starving to death in his pile of straw, with no one to notice.

Go East, Young Artist? That Is the Question

JUNE 19, 1980

A perennial question for younger artists on the West Coast, and particularly in San Francisco, has been whether to try their luck in the Big City—New York—or to stay home.

The dilemma is as old as the history of art itself in the Bay Area and the rest of California. Artists of the generation of Robert, Charles and John Langley Howard, deeply impressed by what they saw of early Modern art at the Panama-Pacific Exposition in 1915—San Francisco's version of the Armory Show—formed a steady procession from the West Coast to Paris during the pre-Depression years.

Robert Motherwell, a student at the California School of Fine Arts in the mid-1930s, was among the most prominent of a younger generation of West Coast artists to move east in search of fame and fortune. The exodus gained momentum in the early 1950s, when many of Clyfford Still's San Francisco students followed him east to settle in New York in the years when Abstract Expressionism was beginning to gain acceptance. It perhaps reached a zenith in the 1960s, when West Coast art schools began turning out more students than ever before, and the inflationary New York art scene seemed a Land of Opportunity.

The growth of an art scene, of sorts, on the West Coast over the past decade, coupled with advances in communications, has made it somewhat more attractive for artists to stay. But the issue is far from dead, and younger artists continue to ask if they may have to go east if they are ever going to make it.

The first question this raises is, of course, to make what? Obviously, one does not have to go to New York, or anywhere else, to make art. The East Coast – West Coast question is, in perhaps most respects, relevant to the making not of significant art but of careers. The exodus to New York by so many Bay Area artists through most of the fifties and sixties made few, if any of them, better artists, merely more successful careerists—like Motherwell, perhaps the most overestimated postwar American painter.

Yet, it also seems true that artists need some kind of direct and continuing relationship both with the tradition of their art and with the general currency of ideas, if only to react against. For every great artist such as Titian or Tintoretto, Michelangelo or Raphael, who came out of a *milieu,* there has been a Velázquez or El Greco, Cézanne, Van Gogh or Gauguin, Ryder or Still, who developed his mature expression in relative physical or social isolation; yet each, at one time, had more or less intimate links to the principal center of contemporary cultural activity—Italy, Paris, New York.

In the end, it is no doubt basically a matter of temperament whether one functions better *as an artist* in a melting pot or on the frontier. The former has the advantage of contact, intensive social stimulation, of *energy;* more intangibly,

the East Coast also has the great museum collections (and if our local art institutions wanted to do something of real value, instead of engaging in the summer tour business or sponsoring art lifts for socialites, they might consider arranging charter flights for artists to see major New York shows).

The frontier has the advantages of a greater distance from tradition and received ideas; it encourages the "coonskinner" virtues of independence, inwardness, reflection. In addition, the orientation of the West Coast is less emphatically European, more open to the contributions of other cultures. It seems no accident that the most powerful and original "New York" artists of the 1940s and 1950s—Still, Pollock, Rothko—all had roots in the West Coast—or that postwar New York was, in a sense and for a brief period, melting pot and frontier at the same time.

We on the West Coast often seem to lack appreciation of our advantages. Artists still look east for guidelines and recognition—as the nation itself, when it was young, for so long looked to Europe. Or they purvey a superficial "frontier" imagery.

Provincialism is always the great bugaboo of frontier living. But if it can be overcome, and the real advantages exploited, there is hope for a truly vigorous period in the cultural life of the West Coast, in the perhaps few years that are left before the frontier here comes to an end, as it did in New York in the early sixties.

How Subjective Is 'Timelessness'?

NOVEMBER 27, 1980

Timelessness is one of those words that floats around blissfully unexamined in discussions about art.

It is a quality that we generally assume "great art" to have, while lesser works of art do not. At the other extreme, we tend to dismiss the "one-shot," the work with the quick initial impact that as rapidly diminishes, and does not occur again.

In actuality, of course, timelessness refers not to eternity, which is unknowable, but to certain works of art whose values have endured for long periods of time. The question, then, is, How long is timeless?

Do we take into account the judgments of previous generations, or only our own? In my personal experience, for example, Thelonious Monk, Billie Holiday and Lester Young have proven as durable as Mozart, Bach and Beethoven—and much more so than Buxtehude.

Granting the primacy of subjective experience, must we be able to respond to a painting or sculpture for fifty or seventy-five years before we grant it an "enduring" quality, or are five or ten years—or even less—enough? And what of the frequency and duration of one's encounters with it?

How many rereadings must a poem be able to withstand before it can qualify as timeless—or, indeed, before it yields diminishing returns? Anyone who has visited repeatedly a favorite work of art over a period of time knows that there are occasions when the experience one has come to expect of it simply does not happen. On the next visit, the work may *appear* once more—or, perhaps, reveal itself in a new light. Or one may never really *experience* it again.

Indeed, one of the most disconcerting of experiences is returning to a work of art that one once found deeply affecting—or, worse, introducing someone else to it—only to discover there is no longer anything there. How many times have you taken a friend to a favorite movie, only to find yourselves sitting side by side in mutual embarrassment?

Henry Miller, writing of his experiences with literature, recalled that he once considered "Death in Venice" the model short story. Challenged by a skeptical friend who had not read it, Miller began to read the story aloud to him, and found the words turning to sawdust in his mouth. Later, he reread the longer novels of Thomas Mann's he had admired and found that they, too, now seemed "meretricious."

The reverse, of course, also occurs. Walt Whitman, for example, was the target of a scathing review by Henry James when the latter was a smart-ass young critic; in later years, James would sometimes recite impassionately from *Leaves of Grass*. But, in general, it seems more common for impact to diminish, rather than grow richer, with time, or at least with repetition.

But does this change in perspective—or in the nature of one's experience—really diminish, as Miller suggests

it does, the value of a work of art, even its purely personal value? There are, of course, countless encounters in the realm of "the arts," as outside of them, that leave us wholly unmoved—if not always unentertained; and entertainment, too, has a place—and not an unimportant one—in the fabric of our lives.

But is a rare moment of great comic art less great because it is not as funny a second time? Because as adults we can no longer relate to a fairytale that enchanted us as children, does its charm evaporate? Has *Steppenwolf,* a novel that affected me profoundly when I was twenty, become "meretricious" because it no longer seems relevant in a second reading at forty-five?

A novel like, say, *Don Quixote* is probably a *greater* work of art; its levels are so numerous that one can read it repeatedly, at various times of life, and be repeatedly rewarded. But to be affected at all by a work of art is an occurrence as rare as it is fragile.

However remote the work may eventually come to seem, it must retain, I think, at least potentially, some of the virtues we once found in it, if only in fond memory. Like a former lover, or simply a good companion, however much we may later grow apart, it has been a source of grace at one time in our lives. Such grace is a rare gift, a thing one can neither make happen nor make last. It merits enduring gratitude.

Creativity and Artistic Freedom

NOVEMBER 8, 1979

If one were to take at face value the public verbalizings by which artists, filmmakers, dramatists and musicians are represented so ubiquitously these days, one would have to believe that (a) no one compromises with the customary obstacles to artistic freedom anymore, ever; (b) artists are no longer subject to such atavistic hang-ups as money or prestige; (c) everyone is thoroughly committed to "creativity," and is involved one hundred percent in total self-expression, doing his own thing.

It would seem to follow that we are in an era of unprecedented adventure, innovation, individuality and growth in the arts—if not necessarily greatness, for none of these qualities guarantees the existence of great artists. But this is by no means the case.

On the contrary, exceptional individuals or even strong personalities seem more rare than ever. Most contemporary expression is derivative, eclectic, mannered, academic, timorous and ingrown or with an emphasis on slickness and style over substance.

By the time they have reached graduate school, most art students have mastered the rhetoric of artistic freedom (it is another story, of course, in Marxist countries, which still hold to the old-fashioned notion of art as an instrument of social utility). This makes for inspiring interviews. But their work is no stronger, more original—genuinely free—than that of students half a century ago.

Why is this? The obvious answer is the habitual gulf between what people say and what they do. Yet it seems too much to brand all these people as hypocrites; they usually appear to be sincere—if not, necessarily, honest.

I recently had a discussion with an artist who has spent much of his life working under totalitarian regimes. He noted that among artists and intellectuals "underground," a fierce sense of individualism and independence flourished. People with intense convictions, they expressed themselves outspokenly, at least among one another. They knew their enemies, and their friends. On the other hand, his first impression on arriving in the United States was of a pervasive conformity of which most people seemed completely unaware.

This is not to sing the praises of dictatorships, but to question whether we have not, perhaps, inadvertently arrived at a totalitarianism beyond the wildest dreams of dictators, in which controls are no longer imposed from without, but internalized, and even reinterpreted as "freedom." Real individuality gives way to the values that keep the wheels of a consumer society turning—standardization, stylization, special effects and slick packaging, a lack of discrimination in which everything is toler-

ated and nothing much matters.

People increasingly seem to anticipate criticism, rather than act and then wait for criticism—if any—to come. Rebellion has itself become stylized, co-opted; rock music and the life-style that has developed around it have become billion-dollar industries.

Most "alternative spaces" show no real alternative art, and in any event are financed by the federal government. We no longer have a Nixon, McCarthy or even LBJ to kick around—but it's also become more difficult to tell who our friends are.

Artistic freedom is always limited, of course, by talent and vision, and it is only a beginning—free to do what? But it may be that such freedom does not flourish in an atmosphere where everything is made too easy—that it is not something that can be given, but must be won. In an elusive, shadowy, Kafkaesque world where nothing any longer seems black and white, the enemy, more than ever, may lie within.

In any case, it would be refreshing for a change to read an interview with some serious young painter or director who would say: "Don't be fooled by all these serious, unpretentious, sincere, creative little things I do. They sell all right. They get good reviews. And I usually score with the models."

What Has Happened to Authority?

JANUARY 8, 1981

As a Roman Catholic long fallen away from the flock, I was strangely disconcerted when I went on Christmas Eve to a midnight Solemn High Mass in the traditional Latin rite.

I am not enamored of the vernacularization of the liturgy as I have witnessed it in rare attendances at Mass in recent years. The Christmas Mass was everything I could have expected, meaning the way I remembered it from childhood: the chanting, resplendent vestments, incense. But when the priest turned briefly to English to welcome the congregation, it suddenly became clear that this antiquated Mass was not transpiring under some special papal dispensation, but was rather the service of a renegade sect without the Vatican's blessing.

And from that moment, the proceedings became, for me, a form of theater—impeccably performed, but without *authority*. It was not the same as visiting a Roman Catholic church where, even in the disinfected new liturgy, I *recognize* the presence of authority although I may not personally *acknowledge* its force. The authority here simply did not exist. Without it, the actions on the altar were mere spectacle.

I was impressed by this experience because it seemed like most contemporary art: deficient in nothing one can put a finger on, and yet lacking in everything because it is all surface effects, missing something essential underneath.

The relationship of art to authority is a complicated matter. The earliest art probably had the authority of magic behind it. Religion continued to provide a foundation for art in Western civilization until relatively recent times. As the making of art objects evolved into a specialized activity, involving highly developed techniques, artisanship came to enjoy an authority of its own—especially as art became linked to "realism," and authority fell to those who mastered the conventions of replication.

Artists also rebelled against established authority, of course—increasingly in the nineteenth century—but not without the help of new forms of authority that arose to take their place. The "tradition of the new" coincided with the development of art criticism and a proliferation of manifestos—forms that fell back on the authority of the word, and its cargo of rationalism, to "explain" what the new was about.

Increasingly refined theories gradually evolved, culminating in the notions of purism and "linear evolution" elaborated by Clement Greenberg. Between them, the "tradition of the new" and the idea of evolution defined the authoritative foundation—the "concerns" and "issues"—of Modernism: It must be innovative, and its innovations should progress toward increasing purity of form and clarity of intent.

The fatal weakness of this authority was that although it provided standards against which new work could be measured, they had no meaning beyond the realm of art itself—and so this realm became smaller, more self-enclosed, invert-

ed and academic, and its audience like-wise. And eventually the "tradition of the new" decreed that this authority, too, must be overthrown, even though there no longer seemed anyplace for "evolu-tion" to go, except into the ultimate purity of sheer concept—or back to objects that anthologize history.

The most significant feature of this "Post-Modern" era is that it is a time when authority has virtually ceased to exist, ex-cept in the form of fashion (and even its force is diminishing) and a nodding ac-quaintance with art history. This may be good. Prevailing authority has inspired more revolt than allegiance among most of the best modern artists.

It may be possible to make authority reside solely within the work of art itself, as painters like Still, Rothko, Pollock and Barnett Newman sought to do—in the specific and concrete, as it does in nature. Yet when authority exists within, rather than more or less independently and a pri-ori, it becomes perilously akin to charis-ma, a flimsy cult of personality, and totally dependent on the vagaries of the behold-er's eye, in which Walter Keane can be equal to Picasso.

In the absence of authority, art now has more freedom than ever. But a conse-quence is that it is apt to function on a more and more subjective level, or to exist primarily as surfaces, as spectacle, as an orthodoxy paraphrasing its past.

Some Consequences of the Open Mind

FEBRUARY 5, 1981

"Openness" is a quality that has been much touted in recent years, particularly in circles where art is a center of interest.

As is usually the case when ideas become fashionable, a half-truth, or a principle that is true perhaps half of the time, is made into a way of life. In fact, "openness," like many another attribute of our ambiguous existences, has about as much to discommend as to recommend it.

It scarcely seems necessary, in 1981, to argue the virtues of confronting as much of experience as one can without the straitjacket of rigid stereotype and prejudice (not to be confused with judiciousness, or making judgments *after* the fact). Henry James's "The Beast in the Jungle" is probably the definitive testament to the tragic futility of holding such stratospheric expectations that one fails to see what one was looking for when it is directly alongside.

Still, to turn oneself into a more or less total, or continual, tabula rasa—even if such a state were possible—would seem an equally empty and crippling alternative.

Surprise, for one thing, exists only in relation to the expected—one reason that "free," or aleatory, music so quickly acquires a perversely monotonous predictability.

It is pleasant to passively window-shop sensations. But it is something much more when the rare experience occurs that exceeds all expectations, devastates every preconception, levels a superstructure of ideas that one may have laboriously built up and surrounded oneself with for years. Not something *pleasant,* necessarily—but as thrilling, elating and liberating as it may be traumatic. Such an event is not a mere sensual message, but a thing that can change one's life.

It is one of the paradoxes of human nature that we always try to make things *easier* for ourselves and our offspring. For artists in recent years, life has become easier in scores of ways—scholarships, grants, teaching jobs, opportunities to show. And more and more people have become "open"—or at least no longer hostile—to any form of expression.

But as fewer demands, or even expectations, are made of artists, fewer artists seem willing or able to make demands of themselves. And they produce less and less demanding art—the eclectic pastiches, the uncentered virtuosity and erudition, the uncommitted superficiality which have become the hallmarks of Post-Modern art. Their work gives as little as it gets, or asks, making less and less difference to the lives of their audiences—and, one often suspects, perhaps even to the artist's own.

It is, of course, as impossible as it is undesirable to live either completely "open" or "closed." Impressions require a permissive receptivity, action, limitation and form.

At a time when permissiveness seems much more widely accepted than limitation, however, one must question the desirability of continually attempting

further to smooth the road—or broaden the line of least resistance. To move in defiance of gravity requires traction. Jackson Pollock used to say he learned more from Thomas Hart Benton than from any other teacher, because Benton gave him so much to react against. He would have difficulty finding such a hard-nosed, resistant teacher now.

Artists, understandably enough, frequently appeal for greater "openness" on the part of their viewers. Communication, however, if it has meaning at all, is not simply a matter of injecting something into an empty, passive receptacle, but is an exchange between discrete individuals, who bring to it the sum of past experiences and convictions as well as their sensitivities, and who, although perhaps profoundly altered by the experience, retain a basic integrity. When art communicates under these circumstances, it is not just more chit-chat to pass the time of day, but can be an act of revelation and conversion.

"Openness"—and even "balance"—have their limitations. There are certain commitments—perhaps any real commitment—that one must enter into without reservation. And there are experiences—dedication, loyalty, self-sacrifice—that are forever denied those who would remain so "open" to experience, or who, in single-minded pursuit of "self-fulfillment," conduct their lives as though they were ledger sheets, coolly balancing profit and loss.

On the Nature of Contradiction

FEBRUARY 21, 1980

A common complaint against critics—at least by those who put up with us for any time—is that we contradict ourselves.

One year, we gripe that not enough new artists are getting shown; the next, we say there are too many. We say one artist's work is amateurish, and another's, too "professional."

It is easiest to kiss off this carping with Ralph Waldo Emerson's aphorism, "Consistency is the bugaboo of little minds." But it doesn't say much.

One problem, of course, is that critics have the onus of trying to be precise in areas where imprecision and paradox reign. This imprecision comes into relief when a reader will take your put-down of a Photo Realist, for example, as a denunciation of figurative painting in general, breathlessly enclosing a snapshot of his terrible geometric abstraction. Trash a conceptualist and all the traditionalists applaud; praise "vision" and corny pictures of dreams come in the mail.

It is only one of the paradoxes that the finest works of "art" are often "artless"; a "primitive" trades naiveté and instinct for sophistication at the horrendous risk of never becoming more than a mere stylist. And yet there is the example of the greatest artists who fell from innocence ultimately to rise to the highest pinnacles of human achievement.

But the main problem revolves around the very nature of contradiction itself. Art and history have consisted of a series of pendulum swings because it is human nature to seek refuge in extremes—ultimates—and then to find these extremities insufferable—dead-ends that leave no place else to go.

Authoritarian societies, for example, produce a static art and culture, because they choke deviation and variety. But a society that is excessively "tolerant" breeds stasis, too; where everything is equal, nothing really matters. In the past, when one of these polar extremes was reached, factions—"conservatives" in one cycle, "liberals" in the next—reacted, until the pendulum began to swing the other way. It mattered little, really, whether it swung "right" or "left"; things *happen,* not when the pendulum rests, but when it moves.

These reactions in the past usually took place against an extreme that had been reached by another generation; if our forefathers were authoritarian, we became libertarian. In recent times, the pendulum has moved so rapidly that we react, if at all, almost against ourselves.

Most of us can still vividly remember conditions that we ourselves once fought against: Is anyone so sickened with the current atmosphere of anything goes, and its attendant indifference, that he would plead for a return to the oppressiveness of the McCarthy era? Or, on the other hand, the naive, futile rebelliousness of the 1960s? One wearies almost of the very

idea of pushing the pendulum once more toward such clearly visible ends. And it threatens to lag to a permanent standstill.

Yet it is contradiction that keeps us moving, and it is the motion itself that counts. Henry Miller once said that even in a perfectly realized, Utopian society, he would have to remain a rebel, just to keep everyone on their toes. The fundamental, inescapable contradiction—that we are all animals, but not *just* animals—is the basis of art, as it is of life.

Such contradiction is tiresome, and so artists, like the rest of us, perpetually try to escape from it. They opt out into the security of categories; settle for too much chaos, or take refuge in too much control; content themselves with an art that has no ambition at all, or labor over a chill "perfection" that is as alien to art as it is to life. So there is almost always room for criticism.

Somewhere between prefabricated certitudes—between the static extremes of materialism (capitalist or communist) and spiritualist cult, between the hot tub and satori—there exists a vast, if terrifyingly equivocal and ever-changing, area of real freedom. Here the artist can take a transitory, relative state, a contradiction, and transmute it into something indivisible and absolute.

But that's another contradiction.

Getting Lost in the Shuffle

OCTOBER 15, 1981

At least right now, "pluralism" seems to be a fact of cultural life in the 1980s that we will have to learn to live with.

There is a certain irony in this. Artists have long complained about the monopolization of recognition held in the past by particular movements and styles. Now, almost anything goes, and no one knows quite what to do about it.

In theory, this pluralism would seem to encourage greater innovation, originality and real individuality of expression. In actuality, there has been little perceptible increase in any of these things. There are more *styles,* all getting certain recognition. There is more eclecticism; the pastiche has become perhaps the dominant style of the so-called Post-Modern era.

There is more surface novelty, and more contrived—and fundamentally similar—eccentricity. But the uniqueness and depth of vision that are really all that distinguishes art from craft (without them, a painting may as well be a chair or a table) seem in as short supply as ever. It sometimes seems there was more real individuality in the arts in the days when things were more difficult, for it is easier now for artists of every kind to display their work someplace. And easier for all of them to get lost in the shuffle.

The institutional art world has, for the most part, responded to pluralism by following the line of least resistance—foregoing the risk of making specific commitments to individual artists, and encouraging mere increase, or "energy." Criticism, by and large, has devolved into local boosterism, with a little good to say about almost anything. One is likely to find more forthright criticism now in the world of show business than in the arts.

At a time when discrimination between novelty and originality, style and vision, is more important than ever, museums—the institutions with the most authority to attempt the task—have largely retreated into an essentially reportorial role. Group shows, and even many solo exhibitions, are selected primarily to be *representative* of certain trends, including pluralism itself, rather than to present a coherent view of an individual artist's expression, and the way it has developed.

Museums exhibit more and more of everything, and proportionately less that has authentic impact. Such a noncommittal attitude has resulted mostly in a vast increase of mediocrity.

How, given the current situation, can such discriminations be made? The matter is really not that different than in the past. Styles and movements always have grown up around individual artists whose own work transcended them. They are the artists whose expressions continue to live; the others survive, not so much as art, but as footnotes to the history of taste.

Art is nothing if not a vehicle for experience—a kind of experience that pro-

foundly alters the way one feels, thinks, sees. The sources of these experiences are not the same for everyone, and so pluralism is not only healthy, but necessary. Indeed, the art that counts, because it is unique, is always pluralistic. But when pluralism simply means a proliferation of *categories* rather than of real individuality, it becomes only a euphemism to justify the relentless multiplication of Art School Art.

Having the kind of experience that sharing the vision of an authentically individual artist can convey is going to make one feel strongly about that artist, and so one is going to be committed to the artist's work. Strong commitments, among other things, cause fights among people with opposing views. It is easier to try to be all things to all people, to seem committed to everything in general and nothing in particular.

But if people in the art world don't feel strongly about the work they deal with, how can they expect it to matter to anyone else?

Robert Motherwell once said there were perhaps one hundred individuals in any area who "represent a young generation's artistic chances," and perhaps "not more than five...able to develop to the end." Giving these individuals the support they need is far more important than pouring more water into the sea of mediocrity.

The Universal Nature of Art

JULY 24, 1980

Painters generally speak of the relationship of "figure" to "ground" as though this were purely a painting problem, and perhaps to most of them it is.

However, in the most profound painting—and there are counterparts in other forms and media as well—this question and its resolution become an echo of all the fundamental dualities that plague, provoke and give purpose to human thought and, it may be, to existence itself.

Art in general is built on the effort to balance basic polarities: content and form, idea and material. Perhaps its most potent metaphor is the polarity between—in their most broadly constructed terms —portraiture and landscape.

Traditional art recognized three or four basic distinctions: portrait, landscape, still life and a category which, depending on its theme, was either genre or history (or mythological or biblical) painting. But the distinction between portrait and landscape underlies the rest, and also the abstract art that for a time supplanted them. The one is man looking into himself; the other, looking out at the world and his own creations.

The "portrait" is dominated by "positive" form, the "landscape" by "negative" space. The portrait is self, the landscape is other. The one is Platonic, the world as a projection of idea; the other, Aristotelian, idea as an empirical outgrowth of the world. The portrait is vertical, the landscape, horizontal—or, if one wishes, male and female, yin and yang. The former is existentialist, imposing its will on the raw material of reality; the latter, Zen, accepting things as they are.

The portrait is Expressionism and Surrealism; the landscape is the objectivist abstraction of space and structure of Malevich and Mondrian. Portraiture is ethics, magic, myth, religious art; landscape, epistemology, scientific perspective and color theory. Ultimately, the portrait is the individual, and man; landscape, the community and the cosmos. And the changing relationships and shifting balances between portraiture and landscape, vertical and horizontal, figure and ground, are art's metaphor for the relationship of man to society, to nature and to the universe.

When the relationship between figure and ground in art changes, it reflects a change in man's definition of himself. With the Renaissance, for example, the figure was detached from the flat, anonymous surface it had dominated in the era of the religious icon, and placed in an illusionistic, landscape space where it became, with the rest of the physical world, an object of objective examination. Impressionism, on the other hand, reflected the insight that the world, the landscape, existed only in terms of one's perceptions of it. Cézanne intuited, and the Cubists later developed, a reconstructed landscape based upon our concepts of it.

Abstract Expressionism divided

around the poles of Clyfford Still and Jackson Pollock, in whose works the figure, shattered and vastly enlarged, seems to expand to absorb the universe; and the painting of Rothko and Reinhardt, where man seems on the verge of vanishing into the "void," but thereby filling it.

The mental landscape has become the frontier into which developers are now moving most rapidly. The emphasis of much art has shifted to examining the "landscape" of its own language, its own materials and processes. And it may be that the artist becomes alienated from his own tools when they themselves become the principal *objects* of analysis and study, precluding the kind of involvement in their *use* that can give vision and form to the artist's interior world, or his conception of the exterior one.

It is perhaps the unique capacity of art that its most monumental achievements manage to embrace and resolve polarities which, in other areas of life—including philosophy—seem hopelessly unbridgeable: positive and void, the boundary between subjective and objective worlds. Where such resolution fails, or is not even attempted, art degenerates into decoration, on one hand, or illustration—the vast gap between object and idea that plagues so much contemporary art. Where it succeeds, we approach perhaps as near as we can come to grasping the way of things.

The Mysteries of Contemporary Art

DECEMBER 6, 1979

A few weeks ago, when renovation of the interior of the Emporium department store was in full swing, various people suggested that the huge plastic curtain surrounding the store's central rotunda should be "reviewed" as a kind of grass-roots Christo sculpture.

What was interesting about this was not the resemblance itself, but the fact that it was suggested by people who three or four years earlier would have seen nothing more than a construction project. People not particularly initiated into the mysteries of contemporary art had been led to look at a portion of their experience of the world around them in terms of the work of a contemporary artist.

"Our age is not an age of revolution, but of advertising and publicity," Kierkegaard wrote a century and a half ago. The familiarity of so many people with the basic premises of Christo's work is, no doubt, partly an illustration of how aptly this observation applies today.

But it is also an illustration of art's magical power to transform the experience of those who come in contact with it. If it is true that "life imitates art," it is because of the immeasurably profound and far-reaching ways in which art becomes absorbed into our deepest levels of experience, literally shaping the way we perceive "reality."

Art is inevitably, at least in part, a re- flection of the cultural and spiritual climate in which it grows. But the most significant art not only mirrors, but *intensifies,* reorders experience into new shapes—new *facts*—as substantial in their way as a continent or ocean that has just been discovered. It works, dramatically or more subtly, to enrich and alter the landscape of the spirit.

The stained glass windows and exterior sculpture of the cathedral at Chartres were designed not only to reflect the Augustinian concept of the City of God, but to project the unverbalized essentials of what this concept implied to the illiterate masses. The view of mankind projected in the art of the Renaissance has become the lens through which we continue to see ourselves in many respects today. Concepts borrowed from art—Impressionism, Surrealism, Dada—have entered our way of both speaking and understanding.

The dawn of Modern art in the nineteenth century reflected the new democratic order, when the common language that had knit society together—and had served as a bridge between artist and viewer—degenerated into a babel of small talk. The artist no longer spoke for the deepest feelings of his common culture, but tried to speak *to* it, in a voice that became increasingly personal, and private.

At a time when money, fashion and academic cliché constitute what lingua

franca there is left in the art world, the artist who speaks to large numbers of people—the Paul Jenkinses no less than the LeRoy Neimans—has to be suspect. The rare, exceptional artist remains capable of transforming the experience—changing the life—of those who encounter his work, as great artists always have, but his audience is now limited and fragmented.

There are people for whom an abstraction by Pollock, Still or Rothko will never represent more than a wallpaper design. But there are those of us for whom such concepts as energy, freedom and transcendence have been practically defined by encounters with their work.

Not every work of art that has a transformative effect is an enduring monument to the human spirit. Warhol helped to focus our consciousness on the new consumer culture of the 1960s, but his work was primarily a reflection of topical taste, like the paintings of Adolphe-William Bouguereau. The transformations that art brings about are not always immediate or obvious. And there are other experiences that have a similar profound power to change.

But this transformative force certainly is one of the primary answers to that much asked question, "Well, just what is it you critics look for, anyway?" When art is capable of demonstrating such potency, why expect less of it?

The Age of Surfaces and Special Effects

OCTOBER 30, 1980

If most art—meaning mediocre art—reflects its time, we live in an age of surfaces.

Movies, for example—including the recent efforts of once-great filmmakers such as Michelangelo Antonioni and Frederico Fellini—bog down increasingly in their own High Tech: an almost routine use of seductive color, glossy special effects.

We have what might be called the Post-Modernist novel, which relies on stylistic pastiche, parody and self-parody, and the objectivist novel, or the novel of surfaces. We have philosophers who concentrate exclusively on the study of language, rather than what it is that language exists to attempt to communicate—indeed, who assert that the latter is a mere function of the former. A philosophy of surfaces.

Avant-garde jazz, or "improvised music," no less than the contemporary academic music of the conservatory, is largely a collection of fragments, clusters, tone colors—that is, of surfaces, of tics, twitches and spasms of "energy"—without central nervous system, or heart. And in the visual arts, whatever the rubric, the overriding concern, the "content" as well as the vehicle, has most often become the surface.

This has nothing to do with the traditional representation of space of "realistic" painting. The paintings of Clyfford Still, or Robert Rauschenberg's early "combine painting" at the San Francisco Museum of Modern Art, for example, are perfectly "modern" in their rejection of illusionistic space and emphatic picture plane; yet they are not flat in the way that the paintings of Carlos Villa and Michael Henderson in the adjoining gallery are flat.

In these, everything seems to have simply been spread across the surface, like frosting a cake; they resemble rubber stamp impressions. The forms in the Stills and the Rauschenberg, on the other hand, seem to have been dragged to the surface, often forcibly and against great resistance, from beneath, or within, the canvas—which is to say, within the artist, for all authentic art is a kind of self-portraiture, a self-projection and, when it reaches greatness, a self-transcendence as well. What takes place on the canvas is a metaphor for what has occurred in the artist.

Superficiality is as characteristic of most Photo Realism as it is of "decoration," or of much Conceptualism, with its medium-is-the-message "reflexivity"—a manner of saying that form follows function, when art has lost consciousness of having any function, and turns in on itself —less substance, more style.

I suspect the "surfaceness" of so much contemporary expression reflects the progressive dwindling of *experience* in contemporary life, and its replacement by *information*. Experience is information which, because it mysteriously corresponds to some equally mysterious inner need, becomes organically absorbed into the fabric of one's life, and often changes it. Information is the undifferentiated *data* that bombard us everywhere—some of it of interest and even of utility, but remaining outside the central framework of our lives.

Such information is the stock-in-trade of institutionalized education and of the communications media. The eclecticism, the knowing pastiches, the crippling hyper-self-consciousness of means and ends, all the neo-this and neo-that, seem the product of people who have spent too much time looking at slides and other color reproductions—at surfaces—immersing themselves in lore *about* art. And too little time directly encountering art itself—meaning not only painting and sculpture but great music, poetry, dance, literature, all among the most potent sources of real experience—or the raw experience of the street and the countryside.

The nature of experience changes. The physical world was more immediate in eras more dependent on weather and topography; this was reflected in "realistic" painting and literature. As "inwardness" grew, the external world became a matter of interpretation.

The "surfaceness," the prevalence of raw information, in current art may reflect some irreversible tendency to increasing abstraction, a withdrawal from external reality and introspection alike, through which the human organism will become an information processor in the same impartial, mechanical way as a computer. I desperately like to think not.

Real art is a great rarity in any age; we are always in need of more. Now, perhaps more than ever, we need more real artlessness as well.

Art Trend of the 1970s: Nostalgia

DECEMBER 13, 1979

Given the quantity and quality of art that already exists from past times and distant cultures, we've no urgent need for new art, Harold Rosenberg said.

Most of the more conspicuous happenings in the art world during the 1970s seemed to support that opinion, developments in contemporary art no less than the accelerating number of international superspectacles that probably added up to the decade's most significant "trend."

In their way, this conformed to the nostalgia that seemed to be the 1970s most prominent mood. We had ancient Egypt ("Treasures of Tutankhamun"), "Archaeological Finds of the People's Republic of China," "5,000 Years of Korean Art" and—the capper in antiquity—"Ice Age Art." The big "Splendor of Dresden" show, which filled the California Palace of the Legion of Honor for six months this year, by comparison, seemed almost contemporary. It exemplified another growing trend in all the arts during the 1970s: the precedence of packaging over content.

Revivalism was a major current in much contemporary expression as well. The decade opened with a broad phalanx of movements left over from the successive waves of vanguard assaults that swept the 1960s: Conceptualism, Photo Realism, Process art and materials-oriented abstraction. By the end of the decade, such tidy formations had largely been put to rout.

Among the few younger artists to achieve a measure of recognition in the 1970s, many made a specialty of an eclectic mopping-up operation. They scurried through the scattered bits and pieces of the past and assembled what they could use into patchwork Frankenstein monsters: New York painter Jennifer Bartlett, for example, in whose work a variety of styles becomes the principal content. New York sculptor Alice Aycock combined Neo-Classicism with Dada in a way that paralleled a tendency one could also find expressed more or less successfully in jazz (the Art Ensemble of Chicago) and architecture—the organization into a conceptual superstructure of what might otherwise be a chaotic pastiche of borrowings from just about everywhere.

Many painters revived the mussed-up, painterly look, and sometimes even a bit of the ethos, of the Abstract Expressionist painting of the 1940s and 1950s—part of a general 1950s revival. There was a concurrent eruption of retrospectives of the principal artists of the period: Rothko, Still, Pollock, de Kooning, and such lesser-known figures as Wallace Berman and George Herms.

At best, the renewed interest in Abstract Expressionism seemed to reflect a touching urge to scrape away the veneer of shallow slickness that has spread over so much painting since the early 1960s; but much of the new painting simply replaced one set of mannerisms with another.

The past two or three years saw checkered attempts to raise new banners to the sound of such rallying cries as "New Imagism," "Narrative Art," "Abstract Illusionism" or, even, "Personalism," but they turned out to be no more than trial balloons that popped about as soon as they were launched and gave way to the hot air that inflated them.

Meanwhile, artists like Christo—the one figure of the 1970s to achieve the celebrity status that artists like Warhol, Rauschenberg and Jasper Johns had in the 1960s—worked on a scale almost as big as life itself. Contrariwise, there was much work that was miniaturesque, diffident, intimate almost to the point of privacy; it tended to disappear into life through its very lack of assertiveness. There were ideas without objects, and objects without ideas. What conflicts occurred were mostly political: efforts by this or that group—defined more by social or cultural factors than by esthetic ones—to get a bigger slice of the pie.

In general, by the end of the decade, the militant era of Modern art—the great epic battles between abstract and figurative art, rationalism and primitivism, artist and Philistine—seemed to have passed, leaving the battlefield in the state of anarchy that opponents to ideologies and movements always have hoped to achieve. And no one knew what to do about it.

In the meantime, the main fact of life in the world of contemporary art continued to be sheer proliferation—in the numbers of working artists, schools, galleries, museums, styles and directions. Government became increasingly involved in financial support (as well as legislation), through such agencies as the National Endowment for the Arts, and a substantial portion of its patronage went toward "alternative" spaces specializing in conceptualist, performance and installation pieces—a significant measure of the degree to which such forms had ceased to have any real "revolutionary" impact.

By the end of the decade, the "avant-garde" had ceased to exist in any sense other than as a promotional blurb (remember *Avant-Garde* magazine?).

Avant-gardism lingered primarily in the realm of photography. Always a little behind the times, it managed to telescope much of the development that painting and sculpture had undergone during the 1960s: a vast growth of practitioners, dealers and collectors; a growing self-consciousness, preoccupation with its own processes and forms.

Perhaps paradoxically, the growth in diversity—in "pluralism"—did not seem to encourage a corresponding increase of strongly individual artists; there was, rather, a multiplication of marginal idiosyncracies and of broad general trends and marginal variations within them.

Contemporary museums especially have continued to see their role as an essentially journalistic one of reporting on trends and developments rather than making sharp qualitative discriminations and firm commitments. At a time when trends have reached an apogee of ephemerality and lack of definition, and it has become more important than ever to attempt to single out work of outstanding individuality, museums organize more meaningless group shows than ever.

The museum thus becomes a part of the general tendency for quantity of activity to take precedence over quality. Art in general during the past decade tended to become simply another element of consumer culture. Galleries lost most of what aura they once had of the sacrosanct.

Perhaps paradoxically, too, the general

increase that characterized the contemporary art world of the 1970s seemed often to be accompanied by a growing basic indifference. People seemed willing to accept just about any form of expression—but to take less and less of it seriously. Contemporary art was seen as a desirable frill—an "amenity," as the developers put it, along with swimming pools and tennis courts—but scarcely as a necessity.

Art is, of course, an aspect of cultural history. The expression of the past ten years has reflected the general traumas that have wracked the decade (in the midst of which the bicentennial came almost as an embarrassment): the double-edged humiliation of the Vietnam War, Watergate, Jonestown, the various aspects of the so-called sexual revolution—the general crises of confidence, identity, purpose and belief, the challenge of learning to yield and share power and live in a world of relative values without loss of faith in the absolute value of one's own convictions.

But the most significant art also always stands somewhat aside from the cultural history of its time. We don't, after all, think very much about the 1650s anymore; we think of the Age of Velázquez or the Age of Rembrandt. In art, as distinct from history, it is always the unique and concrete, rather than the collective and general, that ultimately count. The past decade has had no lack of commentators to tell us all the things that it was "post"; perhaps in the years to come, we will find what, or who, the 1970s have been "pre."

Decade of the Searching 'Post-Avant-Garde'

JANUARY 7, 1979

Now we have only one more year to come up with a definitive assessment of exactly what constituted the "spirit of the seventies."

Perhaps the decade's sheer elusiveness of definition will prove to have been its most distinctive characteristic. To be sure, certain broad tendencies have seemed conspicuous enough.

The nostalgia and revivalism nurtured in the sixties by the folk music movement, by Pop art and Photo Realism and the "camp" sensibility, have accelerated. The political and social activism that typified the previous ten years have peaked out—one reason, perhaps, that the "apathetic" fifties have become such a prime target for the nostalgia mills. In popular music, it has been an era of "fusion"; in jazz, of consolidation and reissues; in movies, of "special effects."

In the visual arts, the 1970s is being described as the decade of the "post-avant-garde." Certainly, the succession of dramatic novelties to which the 1960s made us accustomed (if not jaded) has not been visible in recent years. Conceptual art is taught in schools and appears at the San Francisco Art Festival. Video, performance, "installations" continue, but they are no longer in the "vanguard" of anything, simply among the multitude of clichés open to the contemporary art student as potential points of departure.

The one development that seems peculiar to the 1970s has involved a subtle shift in the artist's conception of his own role, which has come to be equated (in many cases) with that of the anthropologist; thus, the importance recently assumed by photography, the most effective instrument of pictorial documentation, and by the so-called narrative approach—the pictorial record or journal. Perhaps it is the contemporary artist's principal defense against the spate of current exhibitions dedicated to anthropological antiquities: "Treasures of Tutankhamun," "Ice Age Art."

In general, people no longer seem to look to contemporary art for entertainment, as they did in the 1960s. Nor do they seem to look to it as often for inspiration, spiritual communication or much of anything else of great meaning, as they frequently did in the previous decades. A few years back, Robert Irwin broke off his career as a sculptor to launch what has since become an active second career as a lecturer and panelist, recycling Edmund Husserl and raising such "root questions" as "Why art?" It is a question that seems to have been anticipated by Saul Steinberg's 1964 *New Yorker* drawing.

Most artists have continued to search out their answers in the studio, but, overall, it has been a decade of troublesome questioning: If the artist is no longer the self-creating, romantic hero—the role which the artist perforce assumed when his relationship to society became unclear—what, then, is his function? How does one create an art that is different in kind, rather than merely in degree, from the work of the academies, the commercial art galleries and the schlock shops?

Recent exhibitions and publications have redirected attention to the work and lives of Mark Rothko, Barnett Newman and the other pioneers of postwar American painting. The renewed interest seems to reflect, in addition to the doldrums of

visible activity, a new attraction toward the kind of individuality that the work of the so-called Abstract Expressionists projected. The ego is respectable again.

Artists in the 1960s tended to react against the intuitive, antirationalistic emphasis of painting in the late 1940s and 1950s by giving priority to carefully calculated stratagems—Formalism or "antiart," as the case happened to be. Those who in the postwar years had been attracted to art as an instrument of self-discovery—a vehicle of faith—in the 1960s tended to gravitate to other activities— political and social movements and the basically satellite forms of expression that grew out of them: rock music, psychedelic or "visionary" painting, the mural movement.

In either case, the emphasis was on the artist's relationship to movements, or groups. The "avant-garde" Formalist approached his work almost with the detachment of a research and development specialist in the sciences or technology (although, ironically, the cult of personality that grew up around such earlier artists as Pollock and de Kooning lingered to confer a kind of superstardom on such "objectivists" as Frank Stella that most of his more individualistic predecessors of the forties and fifties did not attain until their work was no longer fashionable). "Visionary" artists sought connections with the collective unconscious rather than the private one; muralists sought to reflect the concerns of various social and ethnic groups.

With the 1970s, the road of arid, professional calculation has dead-ended in incestuous reflexivity, parody and gamesmanship. On the other hand, the mindless group emotionalism—or, often, mere sensationalism—that sustained the so-called revolutionary mood of the 1960s has too often culminated in mobism or cultism, Altamont or Jonestown—or, as with the pop music industry, which has made a billion-dollar business out of institutionalizing the props and rhetoric of "revolt," it has been fully co-opted into the system.

The return to individuality that one sees among certain artists now differs dramatically from the postwar years, however. Artists then spoke a great deal about freedom, but their commitment to artistic freedom was coupled with a fatefully incompatible absolutism—a perhaps inevitable by-product of their beliefs that their every gesture was an act of heroism and salvation. They tended to see only their own freedom. Jean Cocteau, in his journal, *Opium,* prophesized exactly the personal destinies of painters like Rothko and Newman, Ad Reinhardt and Clyfford Still: "We are in a period of such individualism that one no longer speaks of disciples; one speaks of thieves.... The only outcome of an increasingly pronounced individualism is solitude. Now it is no longer artists from the other bank of the river who detest each other, but artists from the same bank.... It is that which makes our worst enemy the only one who will be capable of understanding us completely, and vice versa."

Today, a real cultural relativism seems to exist, affording the conditions for an artistic freedom such as the Abstract Expressionists only romanticized about or, at best, seized strictly for themselves. As yet, it takes form largely in more qualified expressions—relatively modest or intimate in scale, frequently linking up with elements from a larger frame of reference,

but without being strictly bound by them, i.e., the recent rash of personal talismans and fetishes.

The live-and-let-live openness produces problems of its own. The fetishistic obsession with "originality" that prevailed among the postwar generation of American painters is replaced by a disturbing tendency to make eclecticism respectable once more. If contemporary art is no longer regarded as a religion in which the artist is the sole communicant, as Harold Rosenberg once wrote of the isolationism described by Jean Cocteau, the other extreme is indifference, handiwork without any inner necessity or compulsion, mere Making Things. The opposite of elitism is commonness.

The challenge posed by this new kind of "personalism," or "pluralism," is how, if everything is more or less equal to everything else, anything can assume singular importance, become a particularly significant experience in one's life. If Abstract Expressionism was destroyed in part through the tyranny brought about by its practitioners' sense of mission, the problem today is how to make anyone's art seem urgently to matter. The museums and the art media, especially, have been sidestepping this issue, devoting their attention in recent years almost exclusively to individuals who came to prominence when artists were still heroes (or superstars), and introducing newcomers through big theme (or themeless) shows that represent a throwback to the group syndrome of the 1960s.

It is one of the principal paradoxes that all of us will have to confront more responsibly and imaginatively in the years ahead.

Reestablishing Contact with the 'Beat' Esthetic

SEPTEMBER 30, 1979

The Wallace Berman retrospective at the University Art Museum in Berkeley and the George Herms retrospective at the Oakland Museum help us to reestablish contact with a magical moment in West Coast art. It all but ended in the 1960s, when most California artists were seduced by the siren song of success that drifted west with the New York mainstream, and the close-knit Beat underground gave way to the publicity-conscious mass movements of the Hippie era.

After almost two decades dominated by Pop art, Formalism, Conceptualism and neo-Dada, the work of Berman and Herms, and the artists, poets, filmmakers and others who were loosely associated with them, has become all too easy to misread. It relates, on a certain level, to many of the movements and issues that have dominated the spotlight in recent years. But its center lies in a different realm which, once recognized, throws into relief the hollowness just beneath the special effects that constitute so much contemporary expression—and not just in the movies.

The assemblages of artists like Berman, Herms and Bruce Connor, together with their tendency to "jump around" from painting to collage and film to poetry, drew scorn when they first appeared from those who identified "art" exclusively with a specific *form,* like painting or sculpture; it was derided as "junk" or excessively "literary." However, as Clyfford Still once said, art has to be more than "*just* painting." This does not mean that strong art cannot be done in traditional media, as Still himself showed; one of the great fallacies of the 1970s has been to underestimate the potential of painting. It does mean that art is not the exclusive property of any one form, and will not be hemmed in by arbitrary rules.

In many respects, it was the "funky" Beat poets-assemblagists-painters-filmmakers who carried forward the spirit of postwar American painting most powerfully, after a second generation of painters had converted Abstract Expressionism into a style—"good painting," a respectable gallery art.

For the pioneer Abstract Expressionists—as commentators like Irving Sandler are now at last beginning to remind us—art grew not only or even primarily from a consciousness of its own history and traditions, but from *experience*—an absorption and transfiguration of myth and archetype into a profound form of self-portraiture. Form was a function of content.

In the 1950s, a new generation of rebellious artists sought to reestablish connections with experience that second-wave Abstract Expressionist gallery painting seemed to be losing. They turned to exploring what Robert Rauschenberg called the "gap between art and life." Artists like Rauschenberg and Jasper Johns on the East Coast, and Berman, Robert Alexander, Edward Kienholz and others in the west, revived the forms of assemblage and collage that Kurt Schwitters, Max Ernst and other Dada artists had developed after World War I, and adapted them to the urgencies of the new, postwar era.

Early on, however, there was a subtle parting of the ways between East and West coasts that seems more and more decisive in retrospect. It is symbolized most graphically by one of Rauschenberg's earliest neo-Dada gestures—the *Erased de Kooning Drawing* that he "created" in 1953. Such a self-conscious

gesture would have been virtually unthinkable outside of the glare of publicity that was beginning to center on the New York art world. (Who would a West Coast artist in the mid-1950s have erased? Richard Diebenkorn, perhaps, or Rico Lebrun? But who would have paid attention if he had?)

Abetted by an increasingly sophisticated apparatus of theory, exegesis and promotion—the idea of revolution was itself made fashionable, and every novelty was made a "revolution"—the work of people like Rauschenberg, Allan Kaprow and (especially) Johns became largely a series of *strategies* for converting different elements of "reality" into Art. Paradox, parody, paraphrase, an emphasis on "process," or self-announcing artifice—all became devices by which East Coast assemblagists and happeners not only put a frame of "Art" around reality, in the manner of Marcel Duchamp, but engaged it in a loud dialogue with art history at every possible point.

And with a certain inevitability, their frame of reference became narrower and narrower, and their work became a kind of para-art—an art of facts, of surfaces, techniques or "information" devoid of underlying significance or spirit and, therefore, of genuine life. For all its variety of ingredients, the work of Johns, and Rauschenberg since the 1960s, has been as blandly "objective" as the most minimal painting or sculpture by Frank Stella or Donald Judd.

The most common denominator of most avant-garde art of the past two decades has been an increasing *reflexivity*—art whose basic subject is art, that evolves primarily from art, criticizes and parodies art, a parasite feeding on its own body, and reflecting itself endlessly, as in a hall of mirrors. This reflexivity—the medium is the message—is the link between conceptualists and phenomenologists, and between avant-garde artists and specialists in the philosophy of language—like cryptographers cracking codes only to arrive at others that cannot be decoded, onions that are all skin and no center. As if poetry could be written by studying grammar, they preoccupy themselves with analyzing the tools, rather than contemplating the work to be done.

Less concerned with the stature of their work as "Art," West Coast assemblagists and others instead concentrated on the experience, the life, they sought to reflect or project; the medium was not a particular technique or material, but the artist himself, who transformed fact into metaphor and isolated data into correspondences. A target or a flag in a Jasper Johns—as commentators never tired of telling us—remained a target or a flag only ironically, but was essentially a neutralized field of surfaces, textures and forms from which the fangs of reality had been removed—an oblique comment on life, but mostly a commentary on art.

In a Berman or Herms or Conner, target or flag or mushroom retained its full potency of associations, and ramified out to form all kinds of others as well; the aim was not to neutralize, but to multiply connections and meanings.

While the art world on the East Coast became more and more self-enclosed and more academic, West Coast artists reached out. Since the dawn of the Modern era, artists have responded to the gathering crisis of values in the Western world by drawing upon sources outside of the system of scientific, analytical ratio-

nalism: Japanese prints, the sculpture of Africa, Oceania and pre-Hispanic America. The chaos of the postwar years was reflected in the existential gesture painting of de Kooning and Franz Kline, and in the assertion of new values—at once individual and transcendent—of the painting of Still, Rothko and Barnett Newman. The Beat artists picked up and carried on what Jung called modern man's "search of a soul," and Hermann Hesse, "the journey to the East."

Many journeyed elsewhere as well. With Antonin Artaud, they sought illumination in madness and darkness or, with Jean Cocteau, in opium and other drugs. They went back to the roots of Western science in magic and alchemy. They sought, with Jean-Paul Sartre, to find the raw center of primitive, unnamed existence—symbolized by jazz.

Mexican culture had an especially deep attraction for the Beat artists of the 1950s, as it had for Artaud, Luis Buñuel and Malcolm Lowry, with its tenuous balance of violent extremes and complex texture in which the everyday shades into the surreal, the natural landscape into the occult. And, of course, peyote, with its insight that all existence is sacred but not too solemn.

Existentialism overlapped with Zen, which in turn found an echo in Robert Musil's suggestion that the rejection of "dreams, legends and sophistries" and "discovery about the natural world" might lead to a new relationship, based on experience to God. And in Ludwig Wittgenstein's near whisper, "If only you do not try to utter the unutterable, then *nothing* gets lost. But the unutterable will be—unutterably—*contained* in what has been uttered."

The existence of all these allusions and implications gives Beat art its intricate texture and density, even when, as much of Berman's work, it is physically most spare. It *is*, in many ways, a "literary" art, designed to be "read" rather than simply scanned. But it is poetry rather than prose, neither raw unprocessed "data" with a frame around it nor the simple illustration of expository narrative, but an organism held together by its own internal relationships, tensions and contradictions.

The Conceptualist mound of dirt depends entirely on text for its very existence as "Art"; behind it stands the self-conscious, theoretical art-world art of Duchamp. Beat art is more akin to Watts Towers (although its "innocence" is thoroughly informed), an "outsider" art, a secretion of the artist's evolving life and experience that builds and expands organically to become an encompassing system, like the shell of a nautilus.

At its most powerful it is—as poet Jack Spicer once described the ideal poem—a "collage of the real" in which all the artist's *resources* are *focused* on dragging

the real into the poem. [Words] are what we hold on with, nothing else. They are as valuable in themselves as rope with nothing to be tied to.... I yell "Shit" down a cliff at the ocean. Even in my lifetime the immediacy of that word will fade. It will be dead as "Alas." But if I put the real cliff and the real ocean into the poem, the word "Shit" will ride along with them, travel the time-machine until cliffs and oceans disappear.

The vitality that characterized the art of the West Coast underground during

the 1950s went into eclipse in the 1960s, as artists in San Francisco and Los Angeles looked more and more toward New York, adopting provincial versions of Formalism (the L.A. "finish fetish") or neo-Dada and Pop art (Bay Region Funk). The Kierkegaardian irony of the funky art of the fifties—"concealed enthusiasm in a negative age"—gave way to Johnsian parody with a country-western drawl: a kind of hedging device by which an artist could allude to high ambition, and at the same time spoof it, masking his own impoverishment in the stance of just kidding around. Real irony is a cutting, subversive force; parody reflects exhaustion, of a culture and of the spirit.

In his book *The Northern Romantic Tradition: From Friedrich to Rothko,* Robert Rosenblum suggests that the history of forms is paralleled by a subcurrent of spiritual content. The former can be observed with a certain "objective" accuracy, made to conform to a linear, "evolutionary" framework; it therefore forms the core of the conventional approach to art history, upon which all too many of our notions of art itself are based.

What Wassily Kandinsky called "the spiritual in art" is, by contrast, more a recurring constant which surfaces from time to time in various historic forms— sometimes stretching traditional forms, sometimes creating new ones. It is a quality that a few artists of vision, great talent and intense commitment may eventually achieve, rather than a concrete foundation or stepping-stone which can be taught, or learned, in school, and upon which the journeyman professional can build to a high level of mediocrity. It is an inevitably questionable, subjective, virtually rhetorical attribute—and yet an unmistakable one when it is encountered in a work of art; without it, art can attain no higher than a certain standard of professional excellence.

One of the few exhibitions ever to cope with this issue was the fascinating "Perceptions of the Spirit" show at the University Art Museum a couple of years ago. Artists like Conner and Jay DeFeo were included, along with most of the first-generation Abstract Expressionists; artists like Rauschenberg and Johns were not. Berman and Rothko hung side by side, and their work seemed to belong together.

Not everyone, of course, associated with the Beat underground of the 1950s became good artists, or remained artists at all. At its outer extreme, the Beat esthetic degenerates into the life-is-art stance of the cracked environmentalist or hobbyist whose work disappears into the landscape, as the Duchamp-inspired museum art of the 1960s is vanishing into the history of taste.

Nonetheless, in the work of Berman, Herms, Conner and certain other artists of the era—Jay DeFeo, Keith Sanzenbach, Jordan Belson, among them—the underground of the 1950s produced more art of the spirit than the law of averages might account for.

There is much to be learned from it that lies well beyond the closed-circuit worlds of *Artforum,* the conventional art history texts and the objectivist, structuralist and phenomenologist bibles.

Video Games—An American Art Form

OCTOBER 9, 1982

Although America has contributed a handful of great painters and a sculptor or two to the world's artistic treasures, traditional art forms have not been a strong suit.

Our most characteristic and influential achievements, in keeping with the country's democratic ideals, have been the great collective art forms that shade into invention on one hand (skyscrapers, the automobile) and on the other into popular entertainment (movies, jazz, rock).

Not, God knows, that we haven't *aspired* to the so-called higher things, one of the reasons it has so often been left to Europeans to point out the value of the art forms that have grown up largely unrecognized in our own backyard—and perhaps part of the reason why, in every area but jazz, Europe has eventually managed to produce achievements (the Bugatti and Rolls-Royce; Le Corbusier and Mies van der Rohe; the Beatles and Rolling Stones) that have superseded our own.

Except for jazz, which black musicians developed from a folk expression into an art form that they have continued to perfect, America's most memorable artistic contributions have taken place while they were still in the *artless* stage. No one has ever beat the wonderful artlessness of early Laurel and Hardy movies, or the hard-boiled detective novel (and film) of the 1940s; Dashiell Hammett is as original and important a writer as Samuel Beckett (and probably more important than William Faulkner).

But American expression tends to freeze when it becomes too self-conscious (this has also been so of not a few individual American painters and sculptors); and few, if any, American films in recent decades have equalled the *artfulness* of Michelangelo Antonioni or François Truffaut.

A new visual expression with all the unmistakable Made-in-the-USA hallmarks has now arisen in the form of video games. Like the pre-Hispanic peoples of Mexico, who knew about the wheel but used it only for toys, we have taken television and, having largely failed to find more purposeful uses, made of it a sheer spectacle of color and movement—wed to old-fashioned American utilitarian aims, of course. These games are played to win, and designed to take your money.

They range from the Mondrianesque geometries of "Pac Man" (and "Ms. Pac Man"), a kind of *Broadway Boogie-Woogie* brought to life, to games with unpredictable, gestural traceries of light and energy that are closer to a Jackson Pollock, and through every shade of Surrealism—and, of course, Pop art, or Surrealism American style—in between.

An unreadably erudite dissertation by some learned French critic will probably appear in *Artforum* any day now, but meanwhile, video games, like such innovations in the past, have become an art form through the back door. Even film reviewers, accustomed as they are to negotiating the tightwire between "art" and "entertainment," have had trouble figuring what to do with the Walt Disney production *Tron,* the first Hollywood movie to exploit fully the visual effects of video games and computer-generated graphics. Judged by the conventional standards of film as a branch of literature—plot, characterization, acting—*Tron* does not get raves, but neither do James Bond movies or the Arthurian legends.

Mythology does not customarily involve originality or even depth of characterization or complexity of action, but, on the contrary, relies on a simplicity of both that approaches stereotype—the differences between one myth and another are largely those of setting, historical and geographical. I found *Tron*—in which the hero gets lost within the innards of a megacomputer and has to outperform it in a Trial-by-Video-Game to escape—a fascinating movie fairy tale in the lineage of *The Wizard of Oz, Yellow Submarine* and *Goldfinger* (with certain undertones of *Lord of the Rings* and *Ten Commandments*). Sometimes clumsily, *artlessly* obvious, as fairy tales often are, it is the first myth set in the new visual—and psychological—landscape of the computer.

Afterward, we spent an hour in a North Beach arcade playing video games. I was struck by what a different world this was from the pinball machines, shooting galleries and other near-obsolete prevideo games I had grown up with.

In those archaic games, there was also a premium on quick reflexes and mental cool. But the less predictable, non-programmed movement of a pinball down an incline involved relatively more improvisation, less calculation.

On the other hand, in the old games it was strictly player against target, enemy, the force of gravity or the score—a simple matter of subject versus object. You sat firmly in the driver's seat. In the new games, inimical forces, generally of cosmic dimensions, are also firing away at you, attempting to blast (or gulp) you into instant annihilation.

Above all, there is an electronic-age freneticism to the new games that is light-years away from the relatively unhurried pace of pinball, let alone old-fashioned coin machine baseball or hockey. These games take your money much faster, and generally give you far less time in return. Compared with the frantic pace of most video games, a leisurely, high-stakes poker game is the epitome of relaxation. Not to mention the kind of Monopoly games that sometimes used to go on for days at a time, abetted by unsecured loans and other primitive forms of "creative financing."

Together with the speed is a peculiar sense of insubstantiality, the difference between a flickering image and the concrete materiality of a steel ball and flippers. It contributes to a curious blurring of the distinction between image and reality. You find yourself driving too fast afterward, as you do just after getting off an airplane. A motorcyclist pulled out in front of us, moving too slowly. The first thought was "Let's take that guy out."

Individual artists attain greatness primarily through the capacity of their work to transcend the historic circumstances under which it was made. Collective expressions, although they have the transcendent aspects—the heavenward reach of a high rise, the sheer sleekness and speed of a fine automobile—achieve their significance primarily through the sensitivity with which they reflect their times and places. Video games are dazzling to watch, challenging to play. But their popularity also calls to mind what Goethe had to say about the perils of "activity without insight."

A Striking but Overlooked Art Form

APRIL 4, 1980

Most people go out to the ballpark to watch the home team win.

I go to see a unique spectacle of avant-garde art: performance, Conceptualism, Surrealist ritual, psychodrama, dance. Where else can you find a more perfect union of all these forms than in a game of baseball? And with a clear reason for being?

To see all this, you have to get to the ballpark well before the game. The performance art begins with the grounds keeper who rolls the little contraption that sprinkles fresh chalk dust along the foul lines. Stark, measured and solemn, the ritual moves relentlessly forward with a classic inevitability until the powerful, archetypal geometric figure—with the smaller, symmetrical rectangles of the batter's boxes—is newly emblazoned against the tawny surface of the base paths.

There are comparable rituals to observe if you arrive late, such as the more lyrical raking of the infield before the sixth inning, when the ground crew drags fine mesh grids across the churned-up base paths, soothing the lesions and abrasions in gradually broadening swaths, like putting a fine finish to a stucco surface with a trowel.

But it can't quite match the austere chalking performance, with its overtones of magic circles, ancient pagan ritual and such.

Shortly after this ends, the dance, or body art, begins—calisthenics, yoga, jogging on the outfield grass. And, of course, hitting and fielding practice, and the pitchers' warm-ups—sometimes the best balletic, or pitching, form you will see all afternoon (games played under artificial light just cannot even be considered as works of art).

And, in some ways the most compelling work of all, the sprinkling of the infield dirt—a languid, contemplative process piece in which the dry, dust tones gradually give way to a color field of rich mocha, like a giant brown paper towel slowly absorbing a coffee stain.

On rainy days, this is replaced by the more dramatic—if sometimes agonizingly prolonged—rite in which the infield is covered by gigantic tarpaulins; they billow in the wind like great heaving waves as they are later folded and finally gathered up on huge rollers—a kind of low-budget version of Christo's Running Fence.

Finally, of course, comes the game itself. The conceptualists in the stands watch only the action they have to in order to fill in their scorecards—a given ball game, they say, is a mere dot in a sea of statistics.

But, on the other hand, you can forget all about the score and observe the play as pure dance—or as stark drama, a confrontation between man and man, batter

and pitcher, as elemental as the final scenes of *High Noon,* or between both and the whims of Fate. You can find evidence in what transpires for brilliant strategic masterminding, blind chance or a Superior Intelligence, all depending on your point of view.

With luck, you might see an inspired demonstration of cunning and skill by a great pitching artist like Luis Tiant; a thrilling defensive play; a masterpiece of direction or choreography by a brilliant tactician like Earl Weaver, Billy Martin or Dick Williams; a rookie player of untested capabilities hit his first home run, or a veteran like Willie McCovey blast out one more grand slam.

On the other hand, compared with the unfailing beauty—or at least consistency—of the pregame ritual, the game itself can be anticlimactic. You can get distracted by such irrelevancies as the matter of who is winning, and performers who are playing like actors who have suddenly forgotten their lines.

But if you can put these little side issues out of your mind, concentrate on the ritual and the unpredictable flashes of artfulness, and respond with proper humor to the comedy, your time is likely to be rewarded.

Even watching a ball club like the Giants.

The Worker's Theory of Relativity

AUGUST 21, 1980

Construction work may seem a peculiar way to spend most of a two-week vacation. But there are ways in which it offers a greater change of pace than lying around the seashore.

There are the obvious benefits of working out-of-doors instead of in, of laboring principally with the hands rather than the mind. Above all, one is absorbed in a more or less orderly sequence of finite tasks, the end of which is the completion of a finite, concrete job: a level foundation, a structure that stands. You know when you are done.

There are times when writing seems the most perverse of all possible activities. When one finally finishes the endless ritualizing that most of us go through—like the ball player who interminably fiddles with his cap before taking position in the batter's box—and sits down to write, a prison door slams shut. The next minutes, or hours, are spent enclosed almost wholly within one's own, or someone else's, head. One works within a realm of symbols that produce nothing as tangible as a painting or sculpture—or, in their ways, even a piece of music or mathematical equation.

Still, even writers—or, at least, we journalists—share with people in most other occupations the fact that external, more or less objective forces exist to tell us when we are finished. However involved we may become in a given piece—and however much we may later wish we had written something other than what finally appears—the point comes when the deadline intervenes.

It is one of the unique characteristics of art that, although it may involve making a concrete physical object, there are no such outside factors to determine when a work is "completed." Most of us are employed in performing tasks that end in specific things whose value can be judged by utilitarian standards, or in filling allotted segments of time in occupations that continue with or without our services, like newspapering or banking.

But the artist is the only individual in all of creation who is capable of bringing his art into being. And he has only himself to determine when a work is done. Neither level nor square nor plumb line can help him, for the end of a work of art is to contain—indeed, to *be*—that which cannot be measured.

A recurring theme throughout art history has been the flaunting by certain artists—Tintoretto, Goya, Edouard Manet—of standards that their eras imposed of what constituted a "finished" painting. On the other hand, Albert Pinkham Ryder reworked the canvases in his studio over and over; one could argue that he never truly "finished" anything. Willem de Kooning, one of the many contemporary artists who have agonized verbally over the question, said, "I don't finish, I just stop."

The artist's larger task is, of course,

never completed. Work on a given piece comes to an end, and work begins on something else—another stage in what is really one continuing work of self-discovery.

The endlessness of the artist's labor has sometimes been likened to the myth of Sisyphus. But, as Albert Camus pointed out, each time Sisyphus had pushed his burden to the top of the hill, he could take it easy as he followed it back down; his task was clear-cut, and he always knew how far it was back to the summit. Sisyphus was the prototype of the nine-to-fiver.

Another instructive vacation experience was a mysterious back ailment—the kind that enables one to carry ninety-pound sacks of cement mix with no more difficulty than usual, but makes bending over to put on a sock an excruciating pain. One realizes how so many of our normal assessments of things imply a foundation of sound physical health.

For example, people frequently speak of art as though it were nearly synonymous with "energy." Yet one can conceive of physical ailments that demand as much energy from their victims simply to cross a street as a sculptor might put into producing his most masterful creation. Energy helps, but art clearly involves much, much more.

Performance Art: When Audiences Count

SEPTEMBER 24, 1981

Performance art has undergone an interesting metamorphosis in recent years.

It originated in the 1960s as a branch of Conceptual art and, in most cases, an extension of sculpture. Artists in the 1960s were seized with the urge to make a greater impact in the "real," physical world. Painting grew bigger or turned into sculpture; sculpture became earthworks, environments, happenings. With performance, the artist became inseparable from his work.

Yet it remained ritualistic and hermetic, basically indifferent to the presence of an audience and to dramatic or entertainment value. Like sculpture itself, it was simply *there*. The viewer was permitted to "overhear," but the event would have proceeded even without him.

Performance art usually worked in "real time" as well as real space, as distinct from the highly compressed and telescoped time of traditional theater. This approach sometimes resulted in compellingly powerful pieces like one that Terry Fox presented some years ago at the University Art Museum in Berkeley, where he spent several days coming and going at odd hours, creating a sculpture of flour and water through a painstakingly slow, hypnotically repetitive process in which he seemed to have transformed himself into some kind of natural, geological force. But real time also made much early performance art boring.

Performance art has become an umbrella term encompassing events that are, perhaps more often than not, basically a branch of theater. It is increasingly directed toward an audience—and audiences have grown.

A striking example occurred last week, when Laurie Anderson headlined a bill that sold out two evenings at the twelve-hundred-seat Market Street Cinema. Equally impressive has been attendance for George Coates's new piece, *The Way of How,* at the New Performance Gallery on Seventeenth Street.

The basic forms of these performances are a far remove from the performance art of old. As more people with theatrical backgrounds have been drawn to performance art—and as more visual artists have become conscious of the problems of working in time as well as in space—real time has largely given way to a pacing and development rooted in more traditional ideas of theater. Anderson's performance, although it included elements of ritual and preserved the equation of artist with artwork, was a series of short, discrete skits rooted in Dada cabaret theater, a parody of vaudeville.

The Way of How is even further removed from the original precepts of performance art. Coates, the writer-director, remains entirely behind the scenes, while the performance is enacted by others. Its roots are in such early-century multimedia creations as the 1913 Futurist opera *Victory Over the Sun,* in mime, in the comic choreography of Laurel and Hardy.

One could argue that this audience-

directed performance art has become less "pure," compromising itself with entertainment and show-business values. But the test, as always, is whether it works, on an expressive, artistic level, whatever else it may also incorporate.

Anderson's performance, though "purer" than Coates's, I found pretentious, flat and essentially pointless. Coates's piece, on the other hand, maintains a ritualistic tempo, but constantly develops and builds with astonishing fluidity. It includes stunning abstract visual effects, but also adds up to a profoundly expressive statement—as I read it, about contending styles of art, which periodically join forces to try to impose themselves on an Everyman figure. He spends much of his time in a wheelchair, blindly resisting, but sometimes joins with them, and at others goes his own way, for he also embraces an innocence and life force that art, for all its power, can never wholly capture.

By exploiting the stylization of theater, such a performance work, paradoxically, is likely to have more impact in the "real world." It attracts more people and appeals on many levels. But there is room for the hermetic performance art of a Terry Fox as well. Like monks, some artists perform best in society, some in the cloisters. Who can say which matters more?

Movements Conceived in Terms of Revolution

JANUARY 13, 1983

Post-Modernism is a term heard more and more frequently now, usually with the implication that there is something bewilderingly new about the cultural state it tries to define: a preoccupation with historicism, revivalism and nostalgia; a retrograde esthetic of paraphrase, parody and pastiche.

In fact, Post-Modernism, as so described, is almost as old as Modernism itself. Picasso and Georges Braque painted the first Cubist abstractions around 1910, but by 1917 Picasso had begun to revive the classical art of ancient Rome. Igor Stravinsky, about the same time—coinciding, probably not incidentally, with the end of World War I—embarked on the Neo-Classical phase of his career.

Indeed, Modernism, as a movement, was meteorically short-lived. First erupting in Paris (and among the early Expressionists in Dresden), then surfacing with startling rapidity in Munich (*Der Blaue Reiter*) and Rome (Futurism), the action shifted to Moscow (Suprematism, Constructivism) and Zurich (Dada) during the First World War, and then burned itself out in the Bauhaus when it was closed by the Nazis in 1933.

What was special about these movements was not just the radicalism of the artistic forms that they produced, but the fact that, for all the diversity and occasional infighting among them, they were all conceived in terms of revolution. Earlier artists such as Van Gogh or Gauguin were dedicated primarily to individual "self-expression," Cézanne to the solitary, monastic pursuit of structure and form. But the Modernists were more collectivist in spirit and goals.

Picasso and Braque let critics like Guillaume Apollinaire do most of the talking, but they were not reluctant, during the pioneering era of Analytical Cubism, to experiment in such close collaboration that it remains difficult to tell their work apart.

The early Expressionists lived and painted together communally, and sought to draw art into an intimate union with everyday life in an organic wholeness based on the Augustinian ideal of the Middle Ages—and on "primitive" cultures, for primitivism was as powerful an inspiration among most Modernists as were the new revelations of science and technology.

Their Utopian idealism served as a model in many ways for the increasingly aggressive Modern movements that followed. The rhetoric was militant. The notion of an "avant-garde" was borrowed from the military. The aim was not just radical artistic innovation, but revolutionary social and cultural change.

This is why they became so closely allied to radical political causes. And why the avant-gardes in the Soviet Union and Germany were crushed when the political winds changed.

The revolutionary ideals of early Modernism persisted in the more political strain of Surrealism that remained anchored to the ideas of Marx and Freud. But, for the most part, by the 1930s, the last vestiges of Modernism, as an alliance of artistic and social revolt, had run their course.

Radical politics, right and left, attached itself to the reactionary esthetic of Social Realism. The School of Paris re-

treated into *l'art pour l'art*. Disciples of Mondrian continued to paint exercises in plane geometry, but their work became increasingly detached from the social idealism that had given Mondrian's its reason for being.

Abstract Expressionism, for all its idealistic fervor, was born at a time when it was no longer possible to share the naive faith of a more innocent age than it was possible for art directly to revolutionize society. It did not abandon the hope that art had *purpose*, that it could change lives, but it adapted the stance of the subversive, the guerrilla fighter, rather than the uniformed armed rebel. It sought to reach people one at a time.

Implicit was the Jungian notion that the best way to reach others was to probe into oneself.

It confined "revolution" to the work itself and let others do the talking—as Picasso, Braque and earlier Post-Modernists mostly had been doing all along.

The bourgeoisie, in truth, delights in being *epaté*'ed, and so the revolutionary rhetoric, at least for a time, lived on. In some ways, it has been Modernism's most influential legacy. But in the past decade, its lack of relevance has become self-evident. It, too—the grand statements of purpose, the manifestos—has run its course.

What is "new" about Post-Modernism is the growing willingness to acknowledge that art is art, by no means negligible, but with definite limits to its scope and goals. What is new, as the fin de siècle number twenty draws near, is this sense of cultural exhaustion.

And Finally, in Conclusion

MARCH 27, 1980

It seems as characteristic of people always to seek conclusive definitions for "art," as it is of art persistently to elude them.

Students almost invariably seem to believe that general laws of some kind exist—and teachers are supposed to have the key to them. Critics, and artists, too, are sometimes equally easy prey to the seduction of The Answer.

Such formulas are invoked, at least in part, because they seem to reduce the awkwardness, or ridiculousness, that generally surrounds verbal discourse about art: the "critiques," for example, to which art students periodically submit works.

These are often occasions for tongue-tied teachers to go about mumbling inarticulate nothings; with a formula to help, they can articulate academic irrelevancies.

The critic Robert Goldwater once complained that when the Abstract Expressionists discussed each other's paintings, they voiced subjective responses without ever checking them against specific works.

"The assumption was that everyone knew what everyone else meant, but it was never put to the test.... For artists, whose first...concern is with the visible and tangible, this custom assumed the proportions of an enormous hole at the center," he said.

Partly in reaction to such distress, a school of painting arose in the early 1960s wherein virtually everything that could be talked about was there where one could see it. "What you see is what you get," as Frank Stella said. But one saw, and got, virtually nothing.

Philosophers have debated the question of subjectivity and objectivity for centuries. It is not likely to find a solution—one of the reasons philosophy continues to exist. It seems certain enough that somehow, through one of the most inexplicable of processes, people do sometimes *communicate*—though almost always not all or precisely what we would have wished.

But it also seems true that those qualities in art that distinguish masterpiece from mediocrity, success from failure, have little if anything to do with "objective," "verifiable" laws—except that where such "laws" are held to exist, great art usually violates them.

If valid formulas existed, they would have to account equally for Piero della Francesca and Tintoretto, El Greco and Velázquez, for an encompassing modern master like Picasso and also for Mondrian, Rothko or Still, who devoted themselves strictly to a single basic vocabulary. And, of course, such a recipe must yield a masterpiece to whomever used it.

The truth is that art is a frightfully uncertain, terrifyingly lonely enterprise. The one best resource an artist can take to it is probably a healthy dose of "paranoia." That is, he has to cherish the illusion—or

delusion—that the vision he seeks to achieve is more important than anything else he could be attempting, regardless of criticism—or praise—other than his own. Such monomania makes most artists bad critics.

Without this blind, unreasoning faith, no conceivable formula can give an artist a "direction," or "reason" for going on. With it, come the seizures of anxiety that are its other half, the sort of self-doubt and suspicion that drove Cézanne in tears from a testimonial where he was praised by the greatest painters of his day; he thought they were all putting him on.

Still, fantasies of persecution, no less than of grandeur, have their uses. They provide protection against the awful uncertainty of never knowing if what one is doing is of the slightest interest to another individual. They seem preferable to the utter indifference that is closer to the cold reality of the artist's lot—unless he attains "success," with its attendant appreciation for the wrong reasons.

If an artist can hold onto this illusion of his own greatness, he may ultimately, as Cézanne did, achieve it.

He may never be more than a Gully Jimson. Still, Gully went out believing in the power and "truth" of his own vision. A person—artist or otherwise—can do worse.

ely.

s Mon-
ructiv-
ion of
e into
strain
ed the
xpres-
ll art,
e most
ry.”

ms to
right
ions it
two of
ell as
ry ex-
re of
s, 109
inting
Berrg-

ed a
undly
ist by
to the
ons of
barian
els —
al and
empo-
his art
gives
ig the
rich in
d that
other
ent in
t both
eology
d the
decay

forms
matic

similar in some respects to the monumental pieces he exhibited a couple of years ago — towering columns of irregular ceramic slabs placed one on top the other, with three of their sides cut sheer; the fourth, the “front,” combines mangled human forms — fragments, bones — with gnarls and folds that more nearly resemble congealed lava.

But the structures have become less pyramidal or wedge-like, more slender and upright, generally towering nine feet or more high. And they are more abstract.

The tendency for a breast, a foot or a knee-cap obtrusively to “pop out” from the more firmly imbedded forms has been curbed: the new sculpture projects more the frangments of the figure, or of bones turning into rock. With a few exceptions, the color with which deStaebler impregnates his material is also more subdued, and controlled.

But while the new pieces are more harmonious on the surface, they also seem more arbitrary in structure and concept, in the way that a lava formation is more arbitrary than the construction of the human figure. The great dilemma of deStaebler’s expression is arriving at a precarious, delicately callibrated balance between figuration and abstraction, between form and dissolution; its attainment, when it occurs, gives his strongest work its sense of deep internal tension.

It is achieved here, it seems to me, in the relatively small “Right Sided Woman Standing,” and ap-

tures. But for the most pa opting for a more abstrac proach, deStaebler seems r have resolved the dilemma so as to have evaded it.

The pieces are all quite h ful, as natural outcroppings o can be quite beautiful, but m them seem rather too easy the skin.

Although the range of al in deStaebler’s sculpture is he uses his references expres and absorbs them into a col form of his own. The problen Oliveira’s new paintings is gratuitous eclecticism.

All belong to a series “Swiss Site.” Two or thre almost straight caricatur Turner, with hazy, light-per atmospheres, intimations of mering reflections and dusl houettes. Most are more like between Turner and Dieben “Ocean Park” paintings, with vocal interior “edges” that luminous atmospheres from emerges the halo-like image distant tower. A few contai and traces of imagery that s William Wiley — a checker flag, a funky pyramid, a wh arabesque with candy stripin

Oliveira is masterful at dling the effects of atmosphe painterly surfaces, and the ju where they coincide; on th face, many of these new pai look spectacular. But, for wildly casting about for sign imagery, or “content,” in th these paintings seem to be n but seductively vaporous effects. They are like a new

Acquisitions from an American Abstract Giant

MAY 18, 1975

Henry Hopkins, director of the San Francisco Museum of Modern Art, has just negotiated one of the most important acquisitions in Bay Region history: the gift of twenty-eight paintings that span forty years of work by Clyfford Still.

These paintings, with three additional ones, will form the first exhibition in the museum's ambitious schedule of bicentennial activities, after which they will be permanently installed in the so-called Arch Gallery. I saw most of these works as they were ranged around the gallery to be photographed for a full-dress color catalogue. Never have I been so excited, so profoundly moved, by a collection of canvases covered with paint.

A press release announcing the acquisition refers to Still as "one of the giants of American abstract painting," but he is really THE giant. Jackson Pollock, Franz Kline, Willem de Kooning, Mark Rothko, Barnett Newman—the work of all these pioneers of postwar abstract painting (with the exception of Ad Reinhardt), which once seemed so devastating, seems somehow to have mellowed with the years; their vast expanses of canvas seem to have grown smaller, accommodating themselves to the comfortable scale of the art history texts. The impact of Still's painting, however, remains as volcanic, awesome, exhilarating and mysterious as ever.

Each painting confronts one anew with a fresh shock of revelation, a surge of elated energy and release—and a certain anger and resentment, too, toward the lofty absoluteness with which they tower above the world of relative values and

judgments within which criticism normally functions, a perverse urge to cut them down to mortal size. But the paintings remain impervious to challenge, and one leaves these works with the same feeling that Still imparted to his strongest during those explosive years when Abstract Expressionism swept through the California School of Fine Arts here in the late 1940s—with the conviction that art can be one of the mightiest of forces and that, given the unswerving commitment and discipline that Still's work reflects, anything is possible.

In securing this gift from Still, Hopkins and the museum have met the exacting standards of the century's most uncompromising artist, and one of its most complex and enigmatic personalities. An outspoken critic of the art establishment throughout his career, Still has steadfastly refused to show, sell or give away his work except under his own stringent conditions.

Living in the countryside of Maryland, in determined isolation from the New York art world, for the past fourteen years, Still has not exhibited in a private gallery since 1969 (he has shown in private galleries only five times in his entire career); his last one-man museum show was at the Institute of Contemporary Art in Philadelphia in 1963.

Still has been known to refuse sales to collectors who fell short of his standards, and his only other gift to a museum—a collection of thirty-one paintings which he donated to the Albright-Knox Art Gallery in Buffalo, New York, in 1964—carried the same conditions that his gift to San Francisco does: The paintings must be

permanently kept together, and a catalogue published to document and reproduce each work.

Taking into account the relatively small space the San Francisco Museum of Modern Art has to allocate toward a permanent one-man installation, Still has agreed to an arrangement whereby approximately one-third of the paintings will be publicly displayed at any one time; they will occupy walls that are being constructed in front of the existing ones, which will hold the paintings not on view and be accessible to viewing by students and scholars by special arrangement. The paintings will be rotated every three or four months, Hopkins said.

Still has clearly selected these twenty-eight works with meticulous concern for illuminating the main lines of his development, and they emphasize a number of significant points. By far the most important one is that Still, now seventy-one years of age, is still painting, and—as Hopkins points out—not at all in the manner of an artist who has passed the peak of his career. Indeed, a monumental work that dates from 1974 is one of the most sweeping, powerful paintings that he has ever done, with a richness of color and texture that link it to the work that Still was doing in the early 1950s, although the collection also belies the impression Still's painting has progressively "thinned out" during the past two decades; in fact, it shows that he has alternated between rich, thickly troweled textures and more thinly applied pigments, surrounded by large areas of bare canvas, through much of his career.

The earliest of these twenty-eight paintings was done in 1934. Its subject is a striding male figure, painted in austere, earthen colors and a broad, expressionistic style that has remote resemblances to the paintings of Chaim Soutine, but which looks ahead (somewhat uncannily) to the Bay Region Figurative style that grew up as a reaction against Still's influence in the early 1950s, much more than it looks back. In this painting, Still states the theme that he has continued to develop more and more metaphorically and abstractly in his art, and pursued with unyielding single-mindedness in the conduct of his life: the lone individual moving with towering self-confidence through a neutral environment which becomes whatever one chooses to make it.

Distinct lines of continuity link this painting to the more abstract works of the late 1930s that follow, but the human form gives way to massive, bonelike shapes in dramatically contrasting colors. One can detect certain analogies in these paintings, too—to Marsden Hartley, to José Clemente Orozco and Pablo Picasso—but, as Hopkins observes, the history of Still's "influences" is almost entirely a story of successive rejections of influences. If anything, the forms in these paintings, and in those that follow, resemble gigantic enlargements and intensifications of details from earlier works.

By 1942, only a geometric shape recalling the stylized motifs of Northwest Indian art remains as a figurative reference point, combined with a jagged line that slices through an austere color ground like a raw nerve; Hopkins said that Still refers to this

linear force, which assumes increasing importance in his later paintings, as a "lifeline," but he emphasizes that this is the only symbolic reference that Still will volunteer about his work.

Certain tenuous allusions to figure or landscape lingered in Still's painting up until the work he did when he came here to teach in 1946, but for all practical purposes, his paintings of the early 1940s are overwhelmingly abstract. Working in almost total isolation—at Washington State University; in Saratoga Springs, New York; and in Oakland, where he lived while with the aircraft industry during the early years of World War II—Still had arrived, by 1943, at a style that was more radical in its abstraction and more sweeping in scale than any New York School artist at that time, and more revolutionary in its expression than the work of any other American painter.

The niceties of drawing, the sensuousness of metier, the decorative qualities of color, the dynamics of composition and of forms interwoven with space—all rapidly vanished from Still's paintings of the 1940s. They are supplanted by a new esthetic wherein traditional concepts of "beauty" and "ugliness" are replaced by the grandeur of a raw and elemental Thereness which, at the same time, is transcendent in its implications. It is a presence of jagged, shredded, opaque forms and scabrous or sodden colors and textures which are, paradoxically, agitated and convulsive in their internal movements and awesomely still in their totality.

There is little point in going into further detail here about a collection of paintings that will not be displayed publicly for another seven months and which, at any rate, are totally impregnable to the assaults of the written word. Suffice to say that it includes several major works that Still completed during his years in San Francisco, and as rich a cross section of his later paintings as is practicable in the case of an artist for whom each work is clearly a unique way-point along a trail that leads deeper and deeper into the recesses of his own being.

For, ultimately, the basic subject of Still's paintings is art—not art history, which is the subject of much of the art one sees today—but, in the words of Harold Rosenberg, the process of "engagement" by which, through constant gnawing and hacking, "a mind is created." People have generally found almost anything easier to deal with than the stark confrontation of a work of art on the terms which governed its creation, and so they are eager to surround art with "interpretation," "analyses," and a host of other crutches which have mushroomed into a gigantic superstructure of devices designed to make art more comfortable—and more profitable.

Within the framework of this superstructure, Still's painting has been generally misunderstood and his attitude has been considered arrogant and prima donna-ish. When he was teaching here in the late 1940s, the surface appearance of his work was widely imitated; after he moved to New York in 1950, his work was a major influence on Barnett Newman and others who developed the "color-field" school of abstract painting.

Nothing, however, could be further from the spirit of Still's art than imitation, unless it is the concept of a "school" or an

historic "movement." Still has said of the latter group of artists that they are "preoccupied with the search for more esthetic devices and means," whereas his concern is "with the origins of ideas"; one sees in his work a frequent return to earlier concepts, coupled with a constant development from them—the artist as his own tradition and historic reference point.

Similarly, most of the mystery that has come to surround Still's personality resolves into perfect logic if one draws a proper distinction between the "art world," with its commercialism, politicking and rat-race competition for prestige and glory, and the organic process of growth and development that is fundamental to art itself. Still has always been highly conscious of the fact that what passes for "success" in the art world is more dangerous than "failure"; aware of the stature of his work, he can afford to call his shots, and has; aware that the only place where success or failure has any real meaning is in the studio, he can be indifferent if others refuse to accept his terms.

Still's notorious "demands," his legendary aloofness, resistance to interviews and attacks on critical exegeses of his work—even the most favorable—are really nothing more or less than an attempt to assert that the art world must revolve around art and the artist, rather than the other way around, and to reaffirm the primacy of the visual experience over the verbal.

"Still is an educator and a moralist," says Hopkins. "I can't think of any other artist who has more carefully controlled his work, his life and his own destiny."

The Critical Year for Rothko

MARCH 13, 1983

A heavy concentration of history is on hand right now at the San Francisco Museum of Modern Art. Its center of gravity is, of course, the gallery that houses the collection of paintings by Clyfford Still. During the past decade it has become a kind of shrine consecrated to preserving the quality of experience—the perpetually fresh thrill of a revelation that is at the same time a shock of recognition—which is art at its level of highest achievement.

Just installed in one of the two long galleries opening off the Still room is a museum-organized survey of two decades of work by the New York artist Frank Stella. His art of surface effects, with its motto, "What you see is what you get," helped power a movement that Formalist critics once supposed to have written *finis* to the chapter of art history of which Still's work is one of the transcendent examples. The gallery extending to the other side continues to accommodate the fifteen-year survey of paintings by Frank Lobdell which demonstrates so vividly how much more a strong and dedicated artist with roots in Abstract Expressionism has been able to draw out of it.

Meanwhile, the small gallery just around the corner from the Still room is being made into an appropriately secluded sanctuary for a group of nine paintings by Mark Rothko. Arranged by SFMMA director Henry Hopkins, the show marks the beginning of public activity by the Mark Rothko Foundation, which warehouses one thousand or so of his works, now that a period has finally been put to the sordid litigation that followed Rothko's

suicide in 1970.

A more fitting long-term loan would be hard to imagine. Nineteen forty-nine, the year when all but two of these paintings were done, was one of the most crucial pivot points in Rothko's career—we can almost literally see the labor pains as his "mature style" is born. It was also one of two years that he spent his summers here as a guest instructor at what is now the San Francisco Art Institute, where his work exerted a profound influence on such local artists as Richard Diebenkorn.

At a time when younger artists are all turning again to painting, albeit often of the most superficial kind, the Still-Rothko galleries now provide the SFMMA with an extraordinary one-two combination punch by the two great visionaries of twentieth-century American art who devoted their lives to the attempt to seize the absolute in the medium of paint on canvas.

The relationship of Rothko and Still, like that of van Gogh and Gauguin, is one of the great odd-couple stories of modern art. They first met at a mutual friend's in Berkeley in 1943, while Still was living in the East Bay during the war; Rothko was passing through on a visit to Portland, Oregon, where he had spent his teens before going off to Yale and settling in New York. They resumed their acquaintance when Still landed in Manhattan in 1945, after two years of seclusion in Richmond, Virginia, where he had pushed his painting through a far-reaching metamorphosis to arrive at the most radical new form of abstraction since Mondrian.

By the time of Rothko's death, they

had not been speaking for more than a decade. But in the last half of the 1940s—critical years in the development of each of them—they maintained a friendship that was important to them both.

Bowled over by Still's shockingly unprecedented new work, Rothko interested Peggy Guggenheim in showing it in her gallery, and wrote an introduction to the catalog for Still's first one-man show. Still, after he began teaching at the California School of Fine Arts here in the fall of 1946, was instrumental in having Rothko brought there to teach in the summers of 1947 and 1949. They exchanged paintings. Still sent his new canvases back to Rothko in New York, who stored them and helped prepare them for Still's one-man shows at Betty Parson's gallery.

"We were complete opposites," said Still, himself stiff-backed and Calvinist, uncompromising in his art, a canny guerrilla fighter in the world of art politics. "He was a big man. He would sit like a Buddha, chain-smoking. We came from different sides of the world. He was thoroughly immersed in Jewish culture. But we had grown up only a few hundred miles apart. We had read many of the same things. And we could walk through the park together and talk about anything."

"They complemented each other," recalled Clay Spohn, who taught here with both of them in the late 1940s. "Rothko loved people and suffered much emotionally...he desired respect and recognition of the fact that he was a lovable guy. Still had a contempt for the general run of people, since he felt most of them were stupid

fools. He didn't give a damn about anything other than his vision of some kind of ultimate. But they both loved art and those principles of art they believed in."

Rothko had moved from early figure paintings, resembling Max Weber and Milton Avery with nods to Edouard Vuillard and André Derain, to a form of abstraction closer to Joan Miró, with ideographic shapes and automatist calligraphy that floated in soft gray washes as though they were suspended underwater. It fit in with a then-current preoccupation with Jungian symbolism, and had already made an impact on such Bay Area painters as Elmer Bischoff and David Park through a one-man show of Rothko's work at the San Francisco Museum of Art in the summer of 1946. But by the time Rothko came here to teach the following summer, his style was undergoing a dramatic change.

The "Year in Transition" is framed by paintings from two other years like a pair of bookends, one from 1947, the other from eight years later. The 1947 is a fascinating, glowing, if still groping and tentative little painting: modestly scaled, washed with radiant, thinly stained patches of muted color that move gently across its surface like clouds breaking up after a rain. The drawing, the line, that played so prominent a part in Rothko's previous paintings has disappeared, and with it, any suggestion of figurative images. On the other hand, a burst of white light in the vicinity of the lower left corner appears to be toying with the idea of becoming a square. It foreshadows the gentle

order that would spread to contain the fluid and amorphous qualities of his shapes and colors in the years ahead.

What one sees in the work that follows is the dramatic process by which Rothko finally arrives at the appropriate rhythms, and tempo, for the majestic vision he is seeking to convey. The rhythms are as yet too staccato, too broken, in *Number 11*, with its relatively thin horizontal bands of strongly contrasting colors. They are even too complicated, too diffuse, in *Number 8*, its large red field interrupted by gratuitous white streaks.

But before the year is out, Rothko has found a movement that is as majestic, as serene, as seemingly timeless as an ancient Chinese bronze, while embracing an internal energy as vibrant and intense as radiation: in the big painting with the yellow field, and even more in the taller, narrower canvas flooded with magenta, where the forms bleed and blur at their edges, where the colors blend into an encompassing radiance of light, where everything seems to expand and breathe and pulsate and at the same time to have become immobilized. Their forms are at once immaterial and monumental.

There seems little doubt that Still led the way in this "transition," or transformation. There are, at least in the earliest of Rothko's abstractions, Still's ragged edges, spiky shapes, the urgency of the impulse itself to draw further and further away from clear-cut connections with the visible world.

But of course these paintings are significant, not for what there is in them of Still's, but for what Rothko made uniquely his own: the radiance, the serenity, the self-effacement. They become, indeed, in many ways, the exact opposite, or complement, of Still's expression: abstract landscapes rather than distillations of the figure, abstract self-portraits; not so much presences as strangely energized, irresistibly compelling voids. As Still once put it, to Rothko meaning existed in the eye of the beholder; to himself, in the eye of the creator.

Perhaps Still's most important influence on Rothko was to encourage his commitment to the similar pursuit of an absolute vision. For a time, they worked together in an area that is still imperfectly understood, on the very frontiers of language—purer than words, yet more complex than mere visual sensation. Literature has dominated our consciousness up until very recent times—the TV era—and it naturally became one of the principal targets of their revolt: hence their progressive renunciation of imagery, myth, titles, anything that might smack of the abhorred bugaboo of "illustration." Yet the fundamental language of literature continued to permeate their sensibilities and pervade their work: metaphor, dramatic conflict, the mythic view itself of the artist perpetually struggling to liberate himself and fulfill his destiny. Rothko once said he saw his pictures as dramas: "I became a painter because I wanted to raise painting to the level of poignancy of music and poetry." Still wanted his paintings to have "the vastness and depth of a Beethoven sonata or Sophocles drama." And by the

time they died both artists were decrying—generally in grandiloquent, Melvillean prose—the inclination to regard their work in strict visual terms on the part of a new generation of artists and critics who were taking their "antiliterary" rhetoric at face value—one of the most tragic misunderstandings of modern art.

Rothko's art underwent one more dramatic change after this "Year in Transition" when he drew the shutter down on the window to the world in favor of a purely interior landscape of the psyche. This occurred in the acrylics Rothko painted in his last two years—bleak and desolate wastelands in black or brown and gray from which the light seems to have gone out altogether.

In his parable of the camel, the lion and the child, Nietzsche saw freedom as the end of a simple sequence of revolt and rebirth. But it seems more likely that there are two degrees of freedom, one which comes after oppression has been cast off, the other as a result of a commitment, freely chosen but unreservedly pursued, that the first freedom makes possible. Oppression being the widespread thing it is, the first kind of freedom is generally conceived as an end rather than a beginning, and so those who arrive there rarely move beyond it. Those who do—commitment involving the hardship and sacrifice that it does—generally revert back.

Certain artists have achieved some memorable results within this more primitive area of freedom; it has also provided the pretext for the furious floundering and flailing of so much action painting, which seemed so liberating at the time and appears so aimless now, and the wishy-washy, go-with-the-flow Post-Modernist eclecticism that currently prevails.

Rothko and Still, almost uniquely among artists of their generation, made use, like Mondrian, of the freedom Modernism had opened up to commit themselves to pilgrimages of discovery that only each of them, individually, could carry out.

Still rarely if ever wavered, remaining in total control of his art and life to the very end. He was among those rare artists in all of history who have fought and labored through the most rigorous of self-imposed disciplines to reach the transcendent release that lies on the other side—where, indeed, a distinction between "discipline" and "freedom" no longer exists.

Rothko, like Orpheus or Lot, sometimes looked back—to decorative, "French" niceties of finesse and elegance, no less than to the conventional signposts of "success" in the art world. He eventually lost nerve, hope, life, control over his legacy. Still's art is a consummate expression of exaltation; Rothko's gives us tantalizing and fugitive glimpses of it.

Lobdell's Monastic Commitment

JANUARY 30, 1983

Almost twelve years ago, Hilton Kramer wrote a memorable review (it introduced the term "Dude Ranch Dada") in the *New York Times* in which he contrasted William T. Wiley to Frank Lobdell.

Lobdell's art, he wrote, "speaks with a kind of parental certainty...and the moment is not exactly propitious for parental certainties of any sort, least of all those about art." With Wiley, said Kramer, "art has ceased to be a moral problem and has become instead a beguiling game of appearance and reality." Wiley, he added, was "the man of the hour."

How times change.

After a decade and a half of art dominated by "beguiling games," a new generation has come of age that seems starved for expression—and specifically for *painting*—of the substance, probity and high moral purpose for which Lobdell, like his most influential teacher, Clyfford Still, has always stood almost as a synonym. The present survey thus comes at a time when younger artists are again likely to be especially receptive to the serious, knuckled-in, almost monastic commitment embodied in his work.

Of all the painters who studied under Still at the California School of Fine Arts in the late 1940s, none has remained so close in spirit and, in form, broken so far away. Lobdell's sensibility has always been as emphatically graphic as painterly. One of his most distinctive contributions was to reintroduce drawing to the area, or "field," abstraction of Still and Rothko. If their art was basically one of paring away to arrive at certain fundamental absolutes, Lobdell seems to have set himself the task of seeing how much, without compromising this sense of elemental power, he could restore.

This objective alone, without regard to Jungian interpretation in terms of psychic fragmentation and synthesis, guaranteed that Lobdell's painting would be a battleground—indeed, a kind of re-creation of the struggle between figure and landscape, man and environment, that Still had eventually resolved in his own work by exploding and expanding the human to become coextensive with the universe.

There is a desperate, elemental drama in such early paintings of Lobdell's as *March, 1954,* its tortured, jagged black lines twisting into a schematic, perverted, barely humanoid shape that suggests the abortive scribblings of an early species of primitive man. It seems to grope futilely for release from an amorphous, protoplasmic white mass to which it remains bound.

Odd that Kramer should have chosen the word "certainties" in connection with Lobdell's painting. These early paintings are indeed saturnine, almost puritanical, in their tough, thick-skinned surfaces and aversion to color, but no artist, not even Willem de Kooning, has made hesitation, revision—a sometimes ponderous

existentialist *uncertainty*—so fully a part of his style.

So, however, is a brazen audacity. And the glory of this show is its revelation of how tenacity, daring and even a certain recklessness have led Lobdell to a wholly new expression of confident, triumphant liberation. As W. H. Auden might have said, we see him turn from Hamlet into Don Quixote.

Perhaps his most audacious move was to embrace the most hated, feared—and envied—of the bogeymen among the Abstract Expressionists of Lobdell's generation: Picasso. There is a new freedom of movement among the broken and twisted figures, clearly derived from Picasso's "bone" paintings of the early 1930s, that culminates in Lobdell's *Dance* series of the early 1970s. And, in their bone-rattling *danse macabre,* there is also something wholly unexpected from Lobdell: flashes of distinct, if blackly grotesque, comedy.

Indeed, if Still brought the dualities of his art under check in an exalted expression of the sublime, Lobdell's art seems to have reached its epiphany in, of all things, humor, absurdist and in extremis though it may sometimes feel. In the most recent paintings, the heavy, Stone Age forms of his personal symbolic language shift almost playfully between pure abstraction and suggestions of imagery, with a sharp-edged whimsicality that recalls Saul Steinberg. They float in a free, gravityless space from which the figure has at last physically withdrawn, although maintaining an intimate involvement with it, as a dreamer with his dream.

There is no joking here, of course, about the nature and purpose and deadly serious urgency of art itself. The feeling of a Sisyphus condemned to labor endlessly beneath a burden almost too much to bear (could that be the source of the round "balls" that now roll weightlessly along the inclines in Lobdell's new paintings?) has vanished, or been radically transmuted. But the spiky, jagged forms, the thick, frayed lines, the naggingly insinuating "ghost images" slice and seethe through the hallucinatory space of these paintings like the raw endings of a terminal hangover.

They are the hard-won, and still hard-fought, revels of an artist who has served Bay Area painting somewhat as Camille Pissarro in the late nineteenth century served the French—as its soft-spoken but stubbornly uncompromising conscience. Through an unrelenting labor of learning what he could from others and building on what he found to be specifically his own, Lobdell has ultimately become his own principal historical source of forms and their meanings. It is a life-long commitment not many artists are willing to undertake. But whoever said that all there was to freedom is sex and drugs and rock 'n' roll?

Just One Single Rose—A Glorious Anachronism

APRIL 11, 1969

In a day when many artists work a production-line schedule against a deadline of annual or biennial one-man shows, the one-painting exhibition of Jay DeFeo's *The Rose* at the San Francisco Museum of Art is a glorious anachronism.

The Rose is almost eleven feet high, eight feet wide and eight inches thick; it weighs twenty-three hundred pounds and took six years in the creation, from 1958 to 1964.

Nowadays, an artist who spent six years on the same idea would turn out two or three versions of it, each with its own pricetag. It is not hard to imagine two or three hundred versions of *The Rose* buried inside the layer-upon-layer, lava-flow crust of the finished painting, but if they are they have been lost, changed, reworked and transformed into a single—as the press release says—"ultimate statement," a "landmark of the Abstract Expressionist movement in the Bay Area." And ultimate statement, however temporary, tentative or inconsistent, was what Abstract Expressionism was all about.

The Rose is a product of that heroic, swan-song period in the early 1960s when Abstract Expressionism was moving in a direction of more specific imagery, when painting and sculpture were moving closer together and when conflict and drama in black and white were moving toward a more colorful, lyrical expression. It is a masterpiece of that transitional age.

The "rose" itself is a gigantic white mandala which recalls somewhat the great, tragic mandala-on-burlap paintings that Keith Sanzenbach evolved out of Abstract Expressionism at a somewhat earlier period. It radiates from the center of the painting in sculptural, fanlike folds and furrows; then the rays diffuse, break up, disperse through and permeate the rugged crust of gray and black gnarls and fissures that surrounds it.

There is a vague feeling of landscape in the structure of the painting's surface, its lower portion full of boulderesque bulges and dark crevasses, the upper portion of fluffier radiance of light pushing against the boundaries of darker, shadowy recesses. But the entire painting has a fascinating ambivalence between materiality and immateriality, depending largely on where one stands in relation to it, and on the play of overhead lighting in the otherwise darkened gallery. Sometimes the rose seems to emerge out of a geological mass as solid and unyielding as the earth itself; at other times it seems to hover amid billowy clouds. *The Rose* is not the consummated union between painting and sculpture which everyone was after in

those days, but it exists in a mysterious, ambiguous gray area in between.

The Rose was originally entitled *The Death Rose,* which was very much in the Abstract Expressionist tradition. But somewhere in those six years and multiple layers of paint, the sense of death seems to have evolved into a quite different thing. The white rose is an image that seems to be constantly emerging from the chaos around it, persisting over and illumining it, rather than fading or dying away. And the general feeling resembles nothing so much as an Abstract Expressionist version of Botticelli's *Birth of Venus.*

The exhibition, organized by the Pasadena Art Museum, includes showings of a film made by Bruce Conner depicting the ordeals of movers in getting the massive painting out of DeFeo's studio, a process which Conner interprets as a tragicomic funeral ritual. I happened by the museum on moving-in day, and can only report that Conner's movie is perfectly true to life. If DeFeo really wanted to be With It, she might have left the painting on exhibition inside that gigantic, solemn packing crate marked "This Side Up" and "One Big Rose." But any work as masterful as *The Rose* is always going to be with it, whatever it happens to be.

Strong Works by Powerful Artist

FEBRUARY 7, 1980

Jay DeFeo was one of the most powerful Bay Area artists to emerge from the rich ferment of the 1950s, when Bay Area Figurative painting vied for dominance with Abstract Expressionism and both were targets of rebellion by the funky "mixed-mediaists" and assemblagists of North Beach.

DeFeo turned out to be a visionary in Abstract Expressionist clothing. At least at first, her work was abstract, bold and gestural, concentrated in simple black shapes with titles that hinted at mythic themes. Later, she turned on occasion to strange, figurative things like her weirdly haunting *Eyes*—actually a big drawing on paper, although with DeFeo the line between drawing and painting has always been dim. And she did immense creations that mixed house paint, stones, string and God knows what else, making great, lava-like slags that carried Abstract Expressionist textures into a dimension of funky, hybrid painting-sculpture.

All this culminated in *The Rose,* the extraordinary, twenty-three-hundred-pound painting that DeFeo completed in 1964, after six years of work. The evolving images and ideas that most artists would extend into one or more series—exhibiting a new batch every eighteen months—DeFeo obsessively developed and covered up, one layer over another. After an Ultimate Statement like *The Rose,* an artist could only start all over.

There is now a rare chance to see something of a cross section of DeFeo's work. Her massive encrustation, *Incision,* from the early 1960s, is on display in an exhibition of Bay Area works from its collection at the San Francisco Museum of Modern Art. A show of DeFeo's more recent work is at the Paule Anglim Gallery.

Incision was a direct antecedent to *The Rose.* Its bleak sludges of marbled black, white and gray that seem to struggle against their own mass and weight; the regular, machinelike gash that slashes through them; the hapless strings that hang from the rocklike masses at its bottom—these epitomize the funky sensibility of the late 1950s. The image of a mushroom cloud lay in a shadowy corner of the psyche, while the machinery of consumerism was rising to convert whatever it could into glossy, instant clichés. It seemed that if beauty and truth were still to be found, they were most likely to exist—not without irony—in the ash can and the gutter; permanence was the core, if one there was, hidden at the center of the cast off and transitory.

The *materiality* of materials was emphasized by many of the second-wave Abstract Expressionist painters who came up when DeFeo did—generally, then as now, to highly cosmetic, or "confectionistic," effect. *Incision* really is raw and volcanic, and

yet somehow also evocative and vulnerable, a rare monument to an "ugly" beauty.

The earliest works at Anglim are two big diptych paintings from the early 1970s *Loop Series*. They are like battlegrounds on which the sensibilities of two eras seem to be locked in desperate combat: the aggressive, awkward forms and rugged surfaces of 1950s Funk versus the hard, crisp shapes and flat, buttoned-down grounds—the clean (or slick) look—of the 1960s. In these paintings, the conflict ends in an irresolute clinch, between the mannerisms of a raw, funky power that DeFeo seemed reluctant to give up, and of a new impulse toward concentration and simplicity in which she seemed not yet to be convinced.

The newer pieces are mostly smaller works on paper—combinations of faintly penciled lines and fragmentary patches of paint, basically—like almost all of DeFeo's work—in a muted but unexpectedly rich spectrum of blacks, whites and grays. Most belong to a series called *One O'Clock Jump*.

Their common link is a central disk, surrounded by lightly traced concentric circles and, generally, by a broader, ragged fragment of a circle—vaguely like a broken record (the classic Basie version, perhaps?). Except that, in the best works, the interiors where the label would be seems to contain the cosmos: faint gray areas that suggest the continents as seen from a space rocket; more often, simply the white of the paper itself which, in contrast to the fragile pencil lines and smears and daubs, becomes a fullness rather than a blank spot, a serene dazzle of illumination. Occasionally, DeFeo fills in more of her surface with "color," but her pieces are far more powerful when they are most concentrated, reduced almost to a breath.

In these—and in a strange black painting on which a shape of translucent, hoarfrost white seems to float like a disembodied specter—the mannerisms of Abstract Expressionism have retreated to a few ragged spots, erasures, smudges; but its spirit has been absorbed and distilled into the very essence of the images, the disks, whose geometric regularity was, of course, the antithesis of all that the funky sensibility of the fifties stood for. They stand like Platonic visions of order and tranquility fleetingly glimpsed in the midst of an organic flux and indeterminacy, the refusal to crystallize, that were the hallmarks of the Abstract Expressionist mystique.

These works are not Ultimate Statements but very strong ones. In the end, an artist's ultimate statement is the entire body of his or her life's work. DeFeo seems to have found a way to press on with making that statement once more.

Diebenkorn's 'Ocean Park'—A New World

NOVEMBER 2, 1977

Few visitors could have approached with greater skepticism than I the big Richard Diebenkorn retrospective at the Oakland Museum.

At most, Diebenkorn had always impressed me as one of the "little masters" of postwar American painting—solid enough, but plodding, a bit academic and basically unexciting; if Robert Motherwell could be called the Pissarro of Abstract Expressionism, Diebenkorn seemed to be its Sisley.

To be sure, the New York critical establishment had lavished praise upon the retrospective during its eastern showings, but that, I figured, was probably a case of overcompensation, the ironic payoff for Diebenkorn's having held his ground on the West Coast and thereby avoided being touched by the same brush that spread so much now very tarnished gilt over East Coast painting in the 1960s.

There is no absence of confirmation for these judgments in the exhibition, particularly in the area that contains the earlier work, where the installation is cluttered and could have benefited from judicious editing. There are the abstract paintings from the late 1940s, when Diebenkorn was a very junior colleague of Clyfford Still on the faculty of the California School of Fine Arts, that one remembers seeing, oh so many times, under dozens of different names, in scores of local exhibitions well into the late 1950s. There are the familiar figurative paintings to which Diebenkorn turned in the middle 1950s, followed, it sometimes seemed, by almost every Bay Region painter who wasn't still imitating the abstractions.

And then—well, suddenly everything changes. This happened for me when I glanced across the Great Hall and spied a painting from 1970 called *Ocean Park No. 30,* but it could just as easily occur with almost any of the two dozen big abstract paintings from the last five or ten years that the exhibition includes. With that field of pulsating light—subdivided into bands of sensuous, loosely brushed colors, but essentially an unbroken expanse of atmospheric radiance—and its almost Gothic architecture of vertical and diagonal lines, one leaves behind labels like Abstract Expressionism and Bay Area Figurative and enters a breathtaking new world that is as unique to Diebenkorn as Mondrian's or Still's or Rothko's is to their creators.

In fact, these late works suggest that Diebenkorn may be Still's greatest student, one of the very few who got the message and therefore moved beneath the surface appearances to find and follow his own way. Between them, these two painters have the four elements pretty well covered: Still, the master of fire and earth; Diebenkorn, of water and air.

As Alfred Frankenstein pointed out in his review shortly after the retrospective opened, the revelations afforded by Diebenkorn's recent paintings color and, in effect, alter altogether the earlier works, a transformation not always to their advantage. In most of the early abstractions, one can now see, perhaps a lit-

tle too clearly, the geometric scaffolding that became more prominent in the figurative paintings and came to the foreground in the late abstractions. They contribute toward an ungainly, neither-fish-nor-fowl effect in which the conventions of vigorous, gestural spontaneity are retained, but are belied and neutralized by compositional devices that often seem both arbitrary and calculated.

In retrospect, however, these paintings are also fascinating arenas in which various confrontations and struggles were taking place: conspicuously, between the "field" abstraction of Still and Rothko and the gestural draftsmanship of Willem de Kooning and Conrad Marca-Relli (with resolutions that frequently resemble those of Hassel Smith and Philip Guston); more fundamentally, between Europe and the postwar United States. Abstract Expressionism was largely a revolt on behalf of power against taste, and one of its prime targets—especially on the West Coast—was the prettified, sensuous colors and surfaces that had become practically synonymous with French painting.

For an artist whose sensibility would soon attract him so strongly to Matisse, this battle was clearly an agonizing one; not surprisingly, Diebenkorn, as Motherwell and de Kooning, eventually resolved it somewhat more in favor of Europe than did most of their postwar American colleagues. Yet, this did not come about until Diebenkorn had achieved a substance and viscosity—even an "ugly" rawness to those oil-slick greens and salmon pinks—that provided him with a sturdy and quite personal foundation to bring to his investigations of Matisse. He could therefore absorb Matisse without being seduced by him, and a residue of stringy, knuckled-down "toughness" remains in Diebenkorn's late work to contribute a taste of bitters to the otherwise rich, sweet color.

Diebenkorn has said that he has always been "temperamentally" a "landscape painter." The "abstract" paintings that date from his residence in New Mexico in the early 1950s introduce the first in the triumvirate of natural themes around which his work has since revolved: light, in these instances a blanching, chalky light irradiating compositions that suggest the desert as seen straight down from the air. Returning to Berkeley in the middle 1950s, Diebenkorn began work on the extended series, inspired by overlooking the Bay from his hillside studio, that led by slow degrees to recognizable imagery, and these paintings frequently introduce the second of his motifs: water.

The figurative paintings that followed for the next decade or more were, as Alfred Frankenstein pointed out, about the articulation of space—as well as about Matisse and David Park and Edward Corbett and, as Maurice Tuchman observes in the exhibition's catalogue, about a subtle psychological tension between inside and outside, confinement and freedom that seems to underscore those many figures in front of windows, or looking off from porches. But many of these paint-

ings, too, tend to suffer somewhat from retrospective vision; the eye inclines to emphasize their tensely interlocking geometric architectures—place your thumb over a chair or figure or window in one of the catalogue reproductions and, presto, you almost have an *Ocean Park.*

Three large paintings from 1965-67, beginning with *Recollections of a Visit to Leningrad,* are probably the most overt homages to Matisse in which Diebenkorn ever indulged, but they also graphically delineate a process by which he seems to have recognized, as if for the first time, exactly what it was he had been painting all those years. As only an artist of great originality and maturity is able to do, Diebenkorn found that he could now isolate what was his own from what was Matisse's or someone else's. Working with these elements—a peculiar quality of color, a unique "handwriting" in his brushwork, an unmistakably personal architecture—he began to construct a world of forms and colors in his own image.

In a sense, the *Ocean Park* paintings all address the same "problems," but with solutions that seem virtually limitless. They are "field" paintings but, in contrast with the characteristic color-field abstraction of the 1960s, with its simpleminded allegiance to the flat surface, they are fields that coexist with, and incorporate, lines and planes which mark out subtle layers of space, or depth. In short, they come to grips with, and triumph over magnificently, that other great bugaboo of the Abstract Expressionists, Cubism. They take the measure of infinity.

Diebenkorn articulates these fields with measured reserve, guiding the eye along a more or less precise path, upward on a vertical axis, back along a receding diagonal, then forward again as a "horizon line" interlocks with another vertical. Some of the paintings have "borders" suggesting the window frames of the earlier, figurative work. The lines sometimes enclose and define more and less opaque areas of color. Sometimes they hang, float or sink slowly in color pools of wondrous translucence. In places Diebenkorn leaves exposed evidence of erasures and revisions, somewhat in the manner of de Kooning; but it would be a mistake, I think, to regard these in a similarly existential light, as symbols of agonized and crucial decisions and rejections, for there is little sense of struggle, of *angst*, in these paintings.

On the contrary, they seem to reflect a confident, if reserved, authority, a willing yielding to the forces of flux and change—and the undercurrent of the eternal—represented by the elements, the sea and the sky, that lie outside the window of Diebenkorn's Southern California studio.

Even the distribution of light across these canvases, in soft dapplings and flowing nuances, seems considered and measured; but, although there is nothing precipitate about these works, they are nonetheless direct. And however circumscribed in certain areas, one or more elements in these paintings—planes, colors,

light—is always fluid, shifting, expanding or overlapping to draw the discrete parts into a spacious, unified whole. The erasures and revisions point to the existence of alternatives, equally valid "might-have-beens," affirming the open-ended, organic sense of temporality and change that co-exists with the ordering and control.

The *Ocean Park* series has been criticized by some viewers as Johnny-One-Note formula paintings. Certainly, Diebenkorn has made no flashy demonstration of stylistic or thematic versatility, and the new abstractions are founded on elements that have persisted throughout his work. But greatness in art is measured, not necessarily by how much ground is covered, but by how deeply, how fully and movingly it is explored. There is some of Still in these paintings—in the function of edges, and the general sense of soaring verticality—and there is some of Lyonel Feininger in the crystalline purity of the loosely flowing geometry. But perhaps the closest precedent is the late paintings of Claude Monet, with their similar foundation in the endless quest of investigating the nature of water and air. Like Monet, or Still or Rothko—indeed, like most other great contemporary artists—Diebenkorn demonstrates that it is possible to construct a universe by exploring a single idea to its frontiers.

The Shaky Position of a 'New Realist'

DECEMBER 18, 1977

After many years in eclipse, the Bay Area Figurative painters—the "New Realists" of the 1950s—are returning to the spotlight.

The Oakland Museum started things off two years ago when it organized modest surveys of Elmer Bischoff and Nathan Oliveira. The monumental Richard Diebenkorn retrospective, organized by the Albright-Knox Art Gallery in Buffalo, attracted record attendance to the Oakland Museum last month, and next summer it is scheduled to bring here a full-dress James Weeks retrospective from Brandeis University. Meanwhile, a major retrospective of David Park, organized by the Newport Harbor Art Museum in Southern California, is on display in the museum's Great Hall.

Park's position in the pantheon of Bay Area Figurative painters, inasmuch as a pantheon exists, has become shaky in recent years. His historical priority as the first of these painters dramatically to defect from Abstract Expressionism has not been challenged (although Weeks had resisted abstraction all along); in fact the very painting that boldly heralded Park's return to nature, a 1950 work called *Kids on Bikes,* occupies a prominent place in the display.

What has been called into question, by the few who have had anything to say at all about Park recently, is the entire quality of his achievement. His painting has been described as mediocre, and worse.

There is no absence of reasons for such assessments in the retrospective. Park's death, in 1960, at the age of forty-nine, after cancer had so weakened him that the work of his final year was confined to small drawings and gouaches, makes impossible the kind of exhibition that builds dramatically to a soaring climax of artistic self-realization, as the Diebenkorn show did; the deft little figure sketches that hang beside the big, ambitious oils at the far end of the hall form poignant punctuation marks to a development one senses was cut off in mid-course.

Moreover, these are not paintings over which one can uncategorically effuse. A few, I think—the 1957 *Nude-Green* from the Hirshhorn, and the nearby *Ethiopia*—are masterful; many seem trifling, or worse. Most often, a single painting is a battleground of triumphs and problems, of bold invention and hesitation. But the attempt to forge a new, figurative art out of components of Abstract Expressionism that Park helped launch (about the same time de Kooning was doing so in New York) opened up enough new challenges to preoccupy a number of artists in the Bay Area and elsewhere for years to come. It is not surprising that Park, in the decade he had left, was not able to resolve them all.

The 159 works go all the way back to drawings and watercolors Park did as a six-year-old growing up in Boston, Massachusetts. There are the familiar oils and temperas of the late 1930s, with their gen-

teel cocktail parties, rhythmic dancers and self-absorbed musicians; the exuberant exercises in Picassoid, silly-putty distortion of the late 1930s; and a group of small, subdued, less frequently seen paintings from the middle 1940s in which Park reduces silhouettes to simple, pictographic shapes and turns them into amusing jigsaw puzzles of "positive" and "negative." Three canvases that survive from the Abstract Expressionist period show how Park acquired, with a vengeance, the shrill, acrid palette and blistered, slablike surfaces of AE, California School of Fine Arts style.

Paul Mills, in an illuminating catalogue article, suggests that many of the early new figurative paintings that follow were designed as iconoclastic parodies of the prevailing Abstract Expressionist style. I had never thought of them that way, but there is certainly an exaggerated play with bits of images that sneak, Still-like, along the canvas edges, as well as a concerted assault upon the "picture plane." The caricature becomes unmistakable in such out-and-out satires as *Woman With Black Glove,* which is reminiscent of the caustic figure paintings Hassel Smith did before he plunged into Abstract Expressionism.

One wonders if this "iconoclasm" may be the source of some of the problems that haunt these early figure paintings—and not a few later ones. Time and again, whether deliberately or because of a more

fundamental contradiction in the enterprise of reconciling abstract and figurative elements, Park goes just over the edge in articulating features of a face, pinstripe patterns on a shirt or dress, sometimes a mere eyebrow or crew cut. This is often coupled with an irresolution in his treatment of space, so that a tapestry of otherwise tensely interlocking, flat color patches will suddenly falter into mushy areas of semivolumetric forms. It is like seeing an Alex Katz figure stepping out from an early Diebenkorn abstraction.

By the middle 1950s, Park had knuckled down to coming to grips seriously with the problems his earlier paintings opened. His first move was to free color and light from the earlier claustrophobic, impacted forms; in paintings like *City Street* and *Interior,* they become shimmering, palpable atmospheres through which the figures move and breathe. Finally, not unlike the way de Kooning had a few years earlier, Park liberated gesture, using light, color and huge brush loads of paint itself virtually to sculpt the massive, chunky, ruggedly chiseled forms of his last paintings, or to blow them apart. Implicit in these works, as Mills observes, is "a strong blast of illumination" that gives Park license virtually to explode forms into shrapnel of dazzling white highlights, jet black shadows and violent color, without sacrificing the sense that these are, somehow, "true to life" figures.

In certain cases, one still wishes he

had omitted this or that detail, but most often Park overrides these objections through sheer vigor and energy, and the bold power of his composition and scale.

Park showed no signs of "settling down." If *Nude-Green* is haunting in its somber simplicity (and sets the stage for Oliveira's figures that were soon to come), *Ethiopia, Daphne* and *Cellist* erupt with fire and vitality, while in *Rowboat* and *Four Men* Park approaches a classic monumentality and calm through an articulation of deep space that one associates more commonly with Weeks.

"Art ought to be a troublesome thing," Park once said, and these paintings remain that, if perhaps not always in ways that Park intended. He had a horror of decoration, and it is no small part of Park's achievement that the raw, harsh spontaneity he so admired in Still's early painting, he maintained in his own work until the end. The horror of fencing himself in assured a restless, unresolved character in Park's art.

But his most forceful paintings retain, I feel, a power and urgency that one no longer finds in the more fully "realized" figurative works we saw in the Diebenkorn retrospective, and Park's audacious "failures" are more interesting than so many less ambitious "successes."

Question of 'Contemporary' Art

NOVEMBER 26, 1979

While modernists such as Piet Mondrian and the Russian Constructivists were dedicated to the notion of art as a continuing adventure into the future, an equally strong strain of twentieth-century art has followed the example of Pablo Picasso and the Expressionists in affirming that all art, from the most antique to the most exotic, is always "contemporary."

The latter approach seems to have particular currency right now, and some of the questions it raises stand at the center of two of the most interesting, as well as problematic, of current gallery exhibitions: the new sculpture of Stephen De Staebler at James Willis Gallery, and the new painting of Nathan Oliveira at John Berggruen Gallery.

De Staebler has developed a compelling, sometimes profoundly poetic expression in the past by investing forms that allude to the art of antiquity—suggestions of Egyptian tomb sculpture, barbarian thrones, Chinese bronze vessels—with an emphasis on material and process that is highly contemporary. It has further enriched his art that the material to which he gives such emphasis is clay, among the oldest mediums of creation, rich in all manner of associations, and that the cracking, congealing and other processes that are so prominent in his ceramic sculpture suggest both the formative workings of geology on the natural landscape, and the ruinous workings of time and decay on the man-made.

The allusions to ancient forms amount to a kind of schematic shorthand—it can really be no more than that—triggering whatever historic, romantic and other associations we may have with Egyptian sculpture, barbarian thrones and so on.

These gather as a kind of patina of myth and nostalgia around the materials and forms that communicate to our perceptions more "abstractly" and directly—that is, in the real sense of the word, concretely.

De Staebler's new sculpture is similar in some respects to the monumental pieces he exhibited a couple of years ago—towering columns of irregular ceramic slabs placed one on top the other, with three of their sides cut sheer; the fourth, the "front," combines mangled human forms—fragments, bones—with gnarls and folds that more nearly resemble congealed lava.

But the structures have become less pyramidal or wedgelike, more slender and upright, generally towering nine feet or more high. And they are more abstract.

The tendency for a breast, a foot or a kneecap obtrusively to "pop out" from the more firmly embedded forms has been curbed: the new sculpture projects more the fragments of the figure, or of bones turning into rock. With a few exceptions, the color with which De Staebler impregnates his material is also more subdued, and controlled.

But while the new pieces are more harmonious on the surface, they also seem more arbitrary in structure and concept, in the way that a lava formation is more arbitrary than the construction of the human figure. The great dilemma of De Staebler's expression is arriving at a precarious, delicately calibrated balance between figuration and abstraction, between form and dissolution; its attainment, when it occurs, gives his strongest work its sense of deep internal tension.

It is achieved here, it seems to me, in the relatively small *Right Sided Woman*

Standing, and approached in two or three sculptures. But for the most part, by opting for a more abstract approach, De Staebler seems not to have resolved the dilemma so much as to have evaded it.

The pieces are all quite beautiful, as natural outcroppings of rock can be quite beautiful, but most of them seem rather too easy under the skin.

Although the range of allusion in De Staebler's sculpture is great, he uses his references expressively and absorbs them into a coherent form of his own. The problem with Oliveira's new paintings is their gratuitous eclecticism.

All belong to a series called *Swiss Site.* Two or three are almost straight caricatures of J. M. W. Turner, with hazy, light-pervaded atmospheres, intimations of shimmering reflections and dusky silhouettes. Most are more like a cross between Turner and Diebenkorn's *Ocean Park* paintings, with equivocal interior "edges" that frame luminous atmospheres from which emerges the halolike image of a distant tower. A few contain bits and traces of imagery that suggest William Wiley—a checkerboard flag, a funky pyramid, a whiplike arabesque with candy striping.

Oliveira is masterful at handling the effects of atmosphere and painterly surfaces, and the junction where they coincide; on the surface, many of these new paintings look spectacular. But, for all his wildly casting about for significant imagery, or "content," in the end these paintings seem to be nothing but seductively vaporous special effects. They are like a new suit of clothes that contains no emperor.

Bronzes Fighting Mortality

OCTOBER 18, 1983

Bay Area artists have rarely paid much attention to the strictures of purists against combining, or switching, media. From the Funk art of the 1950s to the contemporary ceramics movement and the painted sculpture of Manuel Neri, Stephen De Staebler or Robert Hudson, the local specialty has been the mixed drink rather than the straight shot.

Although it comes as a surprise to see Nathan Oliveira exhibiting sculpture for the first time in his current show at the John Berggruen Gallery, his move (or at least his respite) from painting to making three-dimensional pieces in cast bronze is thus in keeping with one of the area's more distinctive artistic traditions. The big surprise is how effective and understatedly powerful these new bronze pieces are.

Painting seemed to have been coming too easy for Oliveira; at least his recent work had often struck me as facile exhibitions of seductive effects. These new sculptures, or whatever they are, amount to a veritable rejuvenation of his art.

Part of the local tradition just referred to is that when artists change media, it is usually to pursue their usual themes in a fresh disguise; the idea is what counts, and anything goes that will help to put it over. So lines of continuity are everywhere in this new work: from Oliveira's paintings, monoprints and even—or perhaps especially—his earliest specialty in lithography.

Of course, the new work includes a few human figures—spectral and attenuated, like those that have dominated so much of his painting over the years, standing two or three feet above bases from which they sweep a bit like genies, in the manner of the Art Nouveau figurines.

Featureless or nearly so, their useless hands extending from withered arms, ravaged by mortality, yet lifting upward and moving at least tentatively forward, the most successful of these pieces—*One, Two* and *Three*—are compelling studies in vulnerability and endurance, charged with tensely balanced formal energies and restrained pathos.

Oliveira has also experimented with a few heads, but most of his new pieces (the show fills both of Berggruen's two floors), and the most distinctive of them, derive from the "landscapes," furnished with images of enigmatic objects suggesting fetishes and ritual, that have occupied his recent monotypes.

These translate here into horizontal bronze slabs, most of them the size of large desktops, the surfaces molded and scored, and bonded to forms that stand out above them, so that they suggest relief maps. They are relief maps, however, that are shrouded in mystery, and in magic.

These "landscapes" are littered with suggestions of rubble and debris—little blobs and globs and dabs that hint at having once taken more decisive shapes, but seem now to be melting back into the earth. But there are also evidences of construction or planning—lengths of cast cord that stretch taut across the surface of the land between the forms of tiny pulleys.

Above all, there are remnants of structures and artifacts—skeletal, boatlike objects, although they are more ambiguous than that; forms resembling spears; and others that suggest oars, the teardrop shapes of their paddles sometimes

"falling" over the landscape's edge: ruins of things that either have been partially destroyed or suddenly abandoned before they were ever completed.

Oliveira has given these bronzes a patination—actually, a variety of patinas, ranging from a kind of flesh color to an aqueous gray-green—that has some of the sensuous, Turneresque quality of the atmospheres that envelop the forms in his recent paintings; it is enhanced by the complexity of texture—loose linear hatchings and scrawls, sometimes combined with a fine, netlike grid—that used to characterize Oliveira's lithographs.

Here, color and texture have the effect not only of unifying his surfaces, and the variety of things attached to them, but also of making everything appear as though it were seen from a certain distance, not just in space but also in time.

The generally smaller "landscapes" belonging to a series called *Site* convey the impression of being relatively close, as though one has stumbled upon an archaeological dig from which the archaeologists themselves have vanished as mysteriously as the peoples that preceded them.

The *Yucatan* landscapes, on the other hand, seem to be viewed from a great height, their forms more difficult to discern and more ambiguous, like the markings on the great plateau in Peru that are sometimes attributed to visitors from space.

In any event, they speak eloquently, as Oliveira's figures do, of time and decay, destruction and perishability, and of a will to endure and to create that persists in spite of those things.

Bischoff Returns to the Abstract

APRIL 25, 1979

Artists, like other more or less public figures, tend to become typecast. If they appear to make a dramatic, 180-degree change, the act of change itself often becomes a center of controversy: praised as a courageous refusal to rest on past performance, or damned as a trendy sellout or failure of nerve.

The fact is, most of the so-called issues of art—figurative versus abstract, "thick" versus "thin," geometric versus organic—have more to do with politics than with esthetics, and most of us (artists, sometimes, most of all) find it hard to see past the politics to the object or experience itself.

Ideally, perhaps, we would approach the work of every artist, however "established," as though he were a total unknown showing for the first time at the San Francisco Art Festival. And yet, if art is worth any more than the material that goes into it, it is also a reflection of all that the artist is and has been, and so change, when we are aware of its occurrence, and the complex of forces that appear to motivate it, cannot be omitted from the picture.

All of which brings us to the current show of recent paintings by Elmer Bischoff at the John Berggruen Gallery. Bischoff was, of course, one of the best known of the Bay Region Figurative painters throughout most of the 1950s and all of the 1960s; but in the early 1970s he switched (actually, returned) dramatically to abstract painting (and from oil to acrylic).

When these abstractions were first exhibited at the San Francisco Art Institute four years ago, they seemed to be rushing exuberantly down half a dozen newly uncovered avenues at once. Since then, Bischoff appears to have settled in, and these new works give a somewhat clearer idea of what his new abstraction is about.

The paintings are quite big. The action takes place among a variety of relatively small, eccentric, allusive, seemingly fragmentary shapes that are somewhat closer to geometry than to biology, and between these shapes and sensuously brushed, stained, marbled and layered films of soft off-white and whitened pastels. The small shapes are often painted in vivid, full-throttle colors; sometimes they are "ghosts," mere outlines barely visible beneath a translucent white veil. They glide, hurtle, careen, cascade and occasionally seem to lose themselves in the matrices of milky white and pastel, somewhat like particles in a solution that has just been given a vigorous shake.

It is not impossible to find connections to Bischoff's figurative paintings in the pearlescent light and sensuous surface touch of these new abstractions—nor, for that matter, to the meaty abstractions that Bischoff did at the California School of Fine Arts back in the late 1940s, when sneaking little forms along an edge (as most of these paintings do) was one of the ubiquitous clichés of Bay Region Abstract Expressionism.

Where Bischoff's figurative paintings tended to revolve around light and color, however, the emphasis here is graphic and diagrammatic, almost cartoonish; in contrast to the brooding introspection and haunting poetry, the mood is bright, out-

going, sometimes even playful.

Are these new paintings as good as the figurative paintings? I certainly don't think so. Gathered all together in one space, they present an impression of repetition, if not of formula, the distinctions between them having a more or less arbitrary, or "problem-solving," look. The clunkiness often seems contrived; the vigorous movement seems all on the surface, carefully—and, often, somewhat obviously—counterbalanced, brought under control.

In feel, if not appearance, the paintings are reminiscent of the calculated, academic vein of Abstract Expressionism that flourished here under the influence of Diebenkorn's early abstract paintings those many years ago. All the ingredients are there, but they fail to do the one thing that art has to accomplish: to become a moving experience.

Yet, the surface energies and tensions are real enough, and the impulse behind these paintings seems, in its way, authentic. Bischoff has said that he returned to abstraction because he found that, for whatever reason, he had lost faith in the figure, and his figurative work was beginning to seem to him "melodramatic and trumped up." These recent paintings seem to be the kind of work an artist does when he has to mark time—when the choice is between continuing to paint— anything—or going fishing.

It is, therefore, very much a part of the mainstream of American painting in the 1970s.

A Schizophrenic Picture of Wayne Thiebaud

JANUARY 17, 1980

Wayne Thiebaud has been one of art's more interesting cases of mistaken identity.

His roots are in the Bay Area Figurative tradition that developed here in the 1950s around David Park, Elmer Bischoff and Richard Diebenkorn, as Thiebaud's big retrospective at the Oakland Museum a couple of years ago showed. The work of these painters was a curious blend of old ingredients and new ones. They went back to traditional "realists" like Titian and Rembrandt, as well as Munch and Degas; they revived forgotten painters like Giorgio Morandi.

From the modern tradition, they took the impulse to *caricature*—that is, to abstract, in the strict sense of the word, as Manet's *Olympia* had abstracted or caricatured Titian, and Picasso's Neo-Classicism, Classical Greek art. And they coupled this with Abstract Expressionism's abstraction of material—paint—and of color and texture, as expressive forces in themselves.

Thiebaud happened to apply this approach to the traditional still-life subject of edibles—untraditional edibles, to be sure, like gumballs and creampuffs— about the same time Warhol painted soup cans and Claes Oldenburg made hamburgers. He thereby, almost by coincidence, attained recognition as a Pop Artist. Much of his work since the middle 1960s—landscapes, views of dizzily careening streets zigzagging down the precipitous slopes of San Francisco hills—has thus bewildered viewers who were unaware that Thiebaud

was a straight-arrow realist all along. Or sort of.

Two current local gallery shows— Thiebaud's first in years here—could scarcely be more schizophrenically dissimilar. A show at John Berggruen Gallery is a big, overstuffed collection, principally of new and older graphic work. It contains a few fine things, but on the whole looks disgustingly like a supermarket full of the kind of multiple-edition images that so many "name" artists have been grinding out in recent years for the lower-cost, higher-volume trade. Some look less like Pop art than like the old-fashioned commercial art one sees on Union Street.

The show at Charles Campbell Gallery is a more compact, and generally more select survey of paintings and drawings that span almost twenty years.

As Thiebaud's work so often seems to do, it runs a spectrum from the poetic to the academic. At the poetic end are such paintings—mostly from the 1960s—as *Yellow Dress* (by inference, almost a figure painting), *Ice Cream Cone, Scattered Lipsticks* and the tiny *Cherry Treats*. This last, especially, seems to epitomize all the things that Thiebaud does best—distilling an image into two or three simple, compelling, tensely related shapes that cast hallucinatory, orange-rimmed blue shadows across creamy, whipped white grounds. Things seem both more—great architectural mounds in eerie, empty spaces—and less—mere patches of color

and paint—than they appear.

At the academic end are most of the new figure drawings, and the recent cityscapes, in which Thiebaud seems to have sacrificed his powers of concentration to an urge to complicate and "solve" compositional "problems." At some point between are paintings like *Neckties,* which seem to represent Thiebaud making a formula of himself.

Then there are other paintings that seem to change position on the spectrum just as soon as you have assigned them one—the strange, nostalgic, dreamlike landscape, for example. Thiebaud's work sometimes brings about a delayed reaction—a painting one almost passes over as trivial, like the tiny *Alameda Waterfront,* or that arouses a certain suspicion because of its very immediacy, like *Outbox,* will somehow insinuatingly, or insidiously, draw one back.

Thiebaud remains a curious artist. He sometimes brings to mind Morandi, sometimes the facile formula and brand-name identifiability of Walter Keane. At their very best, his paintings, almost in spite of the reasons they "shouldn't work," create a sneakily compelling illusion in which everything seems equivocal: the distinction between "real" and "abstract," probity and canny stratagem, cool impersonality and a subterranean intensity. They recall, as Morandi sometimes does, Pablo Picasso's definition of art as a lie that helps us to see truth. By which, of course, he meant that what we commonly see as "truth" is itself a fiction.

The Magnificence of Manuel Neri

SEPTEMBER 30, 1976

In certain "primitive" cultures, the making of art is confined to a special, out-of-the-way place where creative energies are joined to the forces of magic and ritual.

If one were to visit one of these sites—or, perhaps more aptly, to unearth one while exploring the ruins of some long-lost civilization—it might bring the discoverer much the same feeling as the magnificent Manuel Neri retrospective that fills the art division gallery at the Oakland Museum.

It has long been my impression that Neri is one of the most powerful sculptors alive; yet the force, the drama, the brooding, compelling mystery that one feels when seeing his work all together in the former Benicia church which he uses as a studio, has surfaced only sporadically or dimly in his various gallery and museum shows over the past two decades.

Isolating a Neri sculpture in a corner, or setting it on a slickly painted pedestal, somehow takes something important, if not absolutely essential, away from it, as witness the red cast-fiberglass figure that resides at the gallery's entrance. Strong as it is, it has become an object, fixed and immutable.

However, as one surveys the rest of Neri's sculptures in this superbly installed display—the gnarled, notched and crumbling plaster figures, standing, seated, reclining; the heads perched on funky wooden tripods; the torsos and other fragments —one senses that Neri has probably never really "finished" anything. Some pieces he appears to have abandoned—perhaps temporarily, perhaps for good. Others he seems to have set out gradually to destroy—hacking off a leg or arm, chiseling, sanding, reducing.

Like the paintings of de Kooning, Neri's sculptures seem to exist primarily as embodiments of energies and processes—an impulsive, spontaneous gesture here, a more considered refinement or re-complication there—locked in a tense, seemingly temporary, equilibrium. They are "works in progress," or perhaps in decay, but arrested together and gathered here in a collective expression of great power, pathos and grandeur.

As a "retrospective," the exhibition seems somewhat unbalanced, with certain periods represented extra heavily, others—the early ceramics, the monumental "stelae" of the late 1950s, the fiberglass "skins" that Neri cast from earlier plaster figures five or six years ago—sparsely or not at all. There is, however, a fascinating collection of tiny, spindly "figures" constructed of rags, wire, sticks and whatnot, and dating from Neri's earliest student days. These parallel somewhat the then-popular Surrealism of sculptors such as Kenneth Armitage, but their crude, makeshift and ephemeral quality gives them an altogether different feeling, like the talismans or fetish objects of some private kind of magic.

The bulk of the exhibition represents Neri's obsessive preoccupation with the human form. His earliest figures—the 1959 *Seated Girl* and the nearby *Standing Man*—could almost have stepped out of a mid-1950s canvas by the "cofounder" of Bay Region Figurative painting, David Park: the ruggedly chiseled plaster surface planes are smeared with vivid pigments that sometimes accentuate, sometimes obliterate the sculpted bulges and hollows, and the stances loosely suggest an ambiguous narrative situation.

The use of electric, violent surface color reaches a peak in the standing female figure of 1960–61, which is more like a sculptural Joan Brown, but the magnificently somber, white *Shrouded Figure* across the room—all but one limb withdrawn into its torso like a latter-day unfinished Pietà—dates from the same year. And, in general, the works that follow suggest that Neri, for most of the past fifteen years, has constituted his own principal influence, his own history.

His recent pieces tend to be more attenuated and fragile-looking, their textures more gnarled and globby than rounded and chiseled, their surfaces a spectral white. Yet they seem fundamentally to represent the same figure that Neri has been working on for twenty years, or at least the same set of endlessly unresolvable contradictions and paradoxes: between surface and mass, mound and hollow, smooth and rough (one's hand keeps itching to explore)— above all, between plaster and flesh, and plaster and marble.

For perhaps the most enduring paradox of Neri's art is the contradiction between the antique ideal, to which his sculpture so often alludes, and the awkward, sagging, slouching reality of the contemporary mortals whom his sculpture represents.

In an antiheroic age, Neri's sculpture—with its sketchlike immediacy, its sense of imminent change, its "flaws" and subtle ironies, as well as its solemnity and fragile durability—seems, like the work of Francis Bacon and Alberto Giacometti, to approach a grandly epic statement perhaps as closely as contemporary figurative art can afford to do.

A Curious Repertoire of the Guston Imagery

MAY 25, 1980

A retrospective is usually a celebration of an artist's growth. It traces the evolution of his vision from its origins in the conventions and clichés of his youth to its realization in the mature individual expression for which the artist has become best known—the reason he is being given a retrospective in the first place.

In the case of the big Philip Guston survey at the San Francisco Museum of Modern Art, it is the most recent work—the big paintings of the past fifteen years—that is "on trial," the unknown that remains to be "proven." Guston achieved his reputation in the early 1950s as one of the later blooming, second wave New York Abstract Expressionists. Since the mid-1960s, however, he has concentrated on painting a curious repertoire of idiosyncratic, generally quite recognizable imagery. According to the exhibition catalogue—a handsome, book-length production published by George Braziller, Inc.—Guston wanted the show to contain only this more recent work. Museum director Henry Hopkins, who helped select the exhibition, wanted to include a sizable contingent of paintings from the more familiar abstract period—few of which have been seen in this part of the country.

The result is a compromise in Guston's favor: ninety-eight works, all but a few of them paintings, among which both the abstract and the earlier, preabstract phases of Guston's work are represented, but with a heavy emphasis—well over half the show—on the "figurative" paintings (and drawings) since 1968. It is the first time that a substantial number of these paintings have been gathered together in a museum exhibition—indeed, it is Guston's first major museum show since 1966, when his recent work was displayed at the Jewish Museum in New York. The current retrospective—which will travel widely —represents a substantial coup for the San Francisco Museum of Modern Art, which organized the show with support from the SCM Corporation and the National Endowment for the Arts.

Guston was not only a latecomer to Abstract Expressionism, but was one of the few American painters to maintain at least a remote attachment to Social Realism through most of the 1940s. His earliest things here—a somber drawing of hooded Klansmen looming before a lynching and a crucifixion; a heroically earthy *Mother and Child,* both from 1930—are bluntly sincere allegories. They strongly reflect the influence of David Alfaro Siqueiros, as well as topical events of Guston's youth as an embattled teenaged radical in Los Angeles, where antiunionism was intense, and was occasionally linked with a highly active chapter of the Ku Klux Klan.

At the same time, their Piero della Francesca architectural backdrops also nod in the direction of Surrealism. And, in general, the Social Realist inclination to retain more or less solid links to the world of substantial objects and historical events mingles with a contradictory urge to *transform*—itself ambivalent, sometimes governed primarily by consciousness of the tradition and formal principles of art, sometimes by a more unreasoning impulse, dream or nightmare, that may link to historical events in a more subtle manner than objects and images in themselves do.

By the time he did his two *Porch* paintings seventeen years later—the last figurative works of Guston's pre-Abstract Expressionist phase—the influence of Piero

had been fused with that of Picasso to arrive at a flattened, highly stylized Byzantine Cubism not unlike that then practiced on the West Coast by such painters as Jean Varda. Yet these and other paintings of the 1940s also maintain their connection, albeit more oblique, to a sense of the historic moment. *Martial Memory,* a mock battle performed by Piero-like children in a bleak, bricked urban setting that recalls both Ben Shahn and Giorgio de Chirico, was painted on the eve of American entry into the Second World War. The huddled, compacted forms of the harlequinesque figures in the two *Porch* paintings convey a claustrophobic oppressiveness which Guston relates to early photographs that he saw of survivors from the Nazi death camps.

In some ways, then, it is Guston's complete break with recognizable imagery and plunge into total abstraction—his familiar, most celebrated paintings from the early 1950s—that seem his most uncharacteristic expression. Its formal evolution is clear enough—from the play of abstract shapes and rhythms at the bottom portion of *Porch No. 2* to the angular planes and curiously meandering lines (with their hints of stitched fabric) of *The Tormentors.* The fragile, spidery little ink drawing, *Ischia,* done in 1949 while Guston was traveling in Italy—with its suggestions of the massed cubes and arches of arid Mediterranean hill towns—looks forward to the shimmering, fragmented abstractions of the following years, with their dry grainy surfaces and frequently hot roses and pinks.

Guston, whose imagery both before and after this period seems so intensely concrete, in these abstractions of quivering energies that seem to dance and swirl around an implicit central core in a perfect balance of centrifugal and centripetal forces, achieved a unique lyric poetry of the tentative and the transient, the evanescent and the ephemeral. There are scarcely half a dozen of these classic abstractions in the show, but the most masterful of them—such paintings as *Attar, To B. W. T.* (Bradley Walker Tomlin) and, especially, the 1964 untitled *Painting*—are among the most genuinely *beautiful* works to emerge from the triumphant years of postwar American painting: warm, radiant, evocative and magical as a pulsating mirage, yet achieving their effects without any of the cosmetic seductiveness that began to enter the work of so many other painters who took up Abstract Expressionism at about the same time Guston did. They suggest the early plus-minus abstractions of Mondrian refracted through one of Monet's lily ponds.

In retrospect, at least, it now comes as no surprise to see shapes begin to coalesce amid the undefined energies of Guston's abstractions around the mid-1950s. What is surprising is the mood of almost psychotic morbidity (connecting again to history?) that accompanies their appearance. In the earliest of these transitional paintings, lumpish chunks of color take on greater intensity and bolder contrast. But as time goes on, the shapes that coagulate toward the centers of these paintings become black and shadowy; the surrounding color is gradually submerged in oppressive sludges of dark, dirtied grays.

In such paintings as *The Light* (1964) and *Inhabiter* (1965), the black central shapes gradually become recognizable as shaggy, vaguely defined human heads; Guston's drawings, meanwhile, turn from abstract, convoluted thickets of troping,

organic line to such boldly simplified, cartoonlike fragments as *Loaded Brush* and *Off Center.* Finally, in the last years of the 1960s, the imagery of Guston's recent painting bursts forth—comically spooky, or spookily comic, hooded figures resurrected from the old KKK paintings of the 1930s; clocks; gallon jugs; bare light bulbs suspended from overhead cords; sometimes the trappings of a painter's studio. They are painted in the schematic style of a pictograph or cartoon, and most often outlined with a deliberate clumsiness in the heavy black contours of a coloring book diagram.

At first these paintings are busy and cluttered, the images scattered across anonymous grounds that suggest littered urban wastes *(Flatlands)* or strewn through schematic interiors; their fiery, Martian reds and spots of gangrenous blues and electric greens stand against livid white grounds. But by the early 1970s, Guston's forms are reduced to one or two simple images, or more intricate bunchings of motifs that are massed toward the centers of the canvases. Scale becomes monumental, and simple horizon lines underline the looming, aggressive presences of the images that tower above them. The surfaces regain some of the painterly richness of Guston's earlier abstractions, and color returns—although now with a lurid intensity of blood reds and oil-sludge blacks, excremental browns against corrosive blues and greens—that has more in common with the grotesque world of the underground cartoon than to Pierre Bonnard or Monet.

A great deal of controversy has raged over this change in Guston's work, as is likely to happen when an artist who is well known for a certain thing makes an abrupt about-face—and, while lines of continuity to Guston's past can certainly be found, these new paintings unquestionably are different not simply in degree but in kind from anything Guston had done before.

The "pro" argument generally takes the line of the curious amalgam of pedantic compositional analyses and Tom Wolfish pop by Ross Feld that comprises the exhibition catalogue's principal essay, an effusive paean to change as a process synonymous with growth; it makes much—too much, at times reading almost as an apologia—of Guston's "courage" at breaking from abstraction to embark on "these cheesy provocations" (at another point, he refers to the new paintings as kabobs) in the face of adverse criticism that greeted their first appearance in New York.

These, however, are side issues. After all, Willem de Kooning had long since shocked most of his admirers by reintroducing imagery to abstraction in the same year—1950—that Guston was first moving from figurative to abstract painting; there is plenty of precedent for Guston's recent paintings in the work of Alan Davie, of Leon Golub and other Chicago Imagists, and of the numerous painters in this area who have built their reputations on quirky, cartoonish representations of cryptic and obsessive autobiographical imagery.

Certainly, Guston's new paintings are eminently *dislikable* works. Deliberately crude, ungracious, they exude a sense of regressive infantilism—even a fecal quality in the forms and colors of works like *Moon* and *Ravine,* with its lumpish mounds upon which giant insects crawl. They remind me of drawings by autistic children, who compensate for the dehu-

manized world that they inhabit by personifying inanimate objects—isolated or with the most obscure of connections between them—so that they take on a larger-than-life, and menacing, reality.

In this respect, these paintings may well reflect, in a profound, perhaps quite unconscious way, the times, with their self-preoccupation, disengagement and isolation, the emphasis on date and *technic*, materiality and surface. They seem related to the emphasis on schema and diagrams—maps of systems whose internal relations are logical but whose premises are absurd—that are common in visual expression associated with the "punk" scene. They have links to the world of cartoon reality projected in so much recent American literature—*Catch 22, One Flew Over the Cuckoo's Nest, V,* the serio-absurd caricatures of Kurt Vonnegut and Walker Percy, and the fabulous nonfiction of Tom Wolfe: reflections of a time when most satire is easily outdistanced by events, and comic exaggeration seems the only appropriate means of projecting the monstrous disparity between high tech and "software," the veneer of inflationary "positive thinking" and the terrifying emptiness and nihilism that seem to yawn just beneath.

Yet, ultimately these paintings are disturbing not in terms of their expression or "content"—art is quite often so disturbing—but as works of art. "It's a strange thing to be immersed in the culture of painting, and to wish to be like the first painter," Guston has said. "I should like to paint like a man who has never seen a painting." But, for all their striving to disagreeableness, it is finally a sense of "the culture of painting" that Guston's recent work conveys—the work of an artist who is more interested in painting as such than in what is being painted. And in explaining his move away from Abstract Expressionism, Guston quoted Picasso: "We were more interested in painting than in Cubism. The others were more interested in Cubism than in painting."

There is little, if any, sense of real change—of *growth*—in most of Guston's painting of the past ten years—the big canvases that fill the long north gallery. There are new motifs—an overcoat; shoes and dismembered feet and rag-doll legs; disgusting bugs; the head of a woman (Musa, Guston's wife), usually buried up to her eyelids beneath a comforter or a body of water; a grizzled, severed head with a baleful staring eye. There is no absence of "meaning," or possible inferences, sometimes helped along by titles—*Bad Habits, Source, Head and Bottle* may be the most vivid portrayal of a hang-over since Malcolm Lowry.

But cryptic or more seemingly clear-cut, these paintings draw principally upon the devices of illustration and of anecdote. They combine these with an often quite inventive use of plastic, or formal, resources—construction, color, surface—but without adding up to more than the sums of their parts. They are, to hark back to a distinction that Guston himself once made (although it goes back at least to Croce), pictures as distinct from living organisms. At a very early stage in these new paintings, impulse, as Ovid put it, seems to have become method. And for all their apparent variety of imagery, they therefore have an underlying sense of sameness; like a cartoon, they disclose themselves immediately. By contrast, the abstractions of the early 1950s, for all the apparent sameness of their forms, seem

each to possess a unique, independent life and, as all things that live, continually to change, to take on new resonance and implication.

"I do not see why loss of faith in the known image and symbol in our time should be celebrated as a freedom," Guston was quoted more than twenty years ago. "It is a loss from which we suffer, and this pathos motivates modern painting and poetry at its heart."

The question, however, is not one of figurative versus abstract painting—almost always a specious "distinction," as this survey of Guston's work shows. Indeed, the irony of Guston's recent paintings is that they "plug in" again to the "known" world only to reflect loss and pathos of another kind—the oppressive, masturbatory self-absorption, the autism, of what we like to refer to as the decade just past, although it shows no signs as yet of changing.

Sensitive art reflects its times (and the very stuntedness of Guston's new work may be a part of this); so do the newspapers, and many other things. Great art also transcends them, provides a sense of liberation from the oppressiveness of the commonplace fact, the topical event. Guston's paintings of the early 1950s possessed this sense of freedom and release. Whether his new work will outlast the moment, or will eventually seem as hopelessly tied to it—as "dated"—as the Social Realist painting of the 1930s, remains very much to be seen.

On Andrew Wyeth

JULY 15, 1973

Andrew Wyeth is the grand patriarch of American schlock art.

This is not to say that Wyeth is himself an ordinary, run-of-the-mill schlock painter, for fathers are not entirely responsible for the excesses of their offspring.

The big Wyeth show at the M. H. de Young Memorial Museum demonstrates that he has consistently held to a standard of craftsmanship which is at once much more accomplished and less ostentatious in flaunting its slickness than that of most of his followers.

Yet, underneath all those thousands of minutely rendered blades of grass in *Christina's World,* the miraculously transparent old curtains that drift in the breeze, the painstakingly recorded features of his portraits, one senses—well, primarily labor, and infinite patience.

Wyeth's paintings all seem calculated to be viewed from about two feet away; at least, they are most satisfying seen close-up, where one can inspect and admire their wizardry of texture and detail, the sheer, cold imperfection with which Wyeth handles pencil, watercolor, dry brush or tempera.

Give them the distance they require to be viewed as artistic expressions rather than dazzling, craftsmanly exercises, however, and nothing more happens. People often speak of the feeling of emptiness projected by Wyeth's work, but—as the Hatter might say—feelings of emptiness are not the same as emptiness of feelings. That, to my eye, is the end in which all this craft and labor ultimately results.

To be sure, Wyeth makes use of every possible contrivance that might work to project feeling, or at least to simulate it. His one persistent, insistent theme is *vanitas,* removed from its traditional symbology of death's heads, mirrors, jewels, hourglasses, and transported to the familiar, everyday world of— well, just exactly where are all those scaly decaying walls, the tattered scarecrows, the deserted golden fields and bleak winterscapes supposed to be?

In one startling, relatively early (1944) painting called *Christmas Morning,* the sense of emptiness and loss is presented quite explicitly in a surreal dreamscape, a figure swathed in death sheets merging imperceptibly into the contours of bare, dunelike hills that recede into the distance.

Despite its overstatement, its basic corniness, its Art Decolike stylization and Wyeth's as yet imperfect tempera technique, this painting comes off as the most sincere attempt at real emotional expression of the exhibition.

There is a tentative quality to this work that is at once immensely appealing and, in retrospect, poignant, because Wyeth's future painting was to follow a very different path.

In her catalogue essay, Wanda Corn, organizer of the exhibition, describes this "Wyeth transcendental ideal: to evoke a sensation of the infinite within the context of the commonplace."

The commonplaces of Wyeth's painting, however, are not really the commonplaces of life, but of myth, or at least that chapter of the great American fairy tale that has to do with mother, apple pie and the old-fashioned virtues of simplicity, endurance and the so-called natural life.

Again, one cannot dismiss this aspect of Wyeth's painting as schlock pure and simple, for he does live in this insular, inbred New England Yankee world that he paints, and he has been portraying it over and over again for most of his career.

Yet the essential appeal of his work, whatever its motivation, is to a kind of counterfeit nostalgia for a never-never land of places, people and things that are by no means "commonplace," familiar and universal, but that red-blooded Middle Americans are indoctrinated to believe ought to be familiar and universal, from their earliest picture books to the most recent TV episode of the Waltons; they appeal to simpleminded fiction dressed as obdurate fact, to sentimentality masquerading as emotion.

How many of us really lived in one of those simple, white-frame houses out in the hills, or went over the river and through the woods to grandmother's house for Thanksgiving? And how many of us merely read about these saccharine fantasies in the *Saturday Evening Post?*

To be sure, there are ants and flies in Wyeth's sugar-coated world, as there are villains in Walt Disney movies, but the "Gothic," "haunted" quality that supposedly resides in these paintings seems as chimerical as a four-year-old in a Halloween costume; one can always sense mother waiting just off there in the wings, ready to rush in and tell you it's all right.

Wyeth's paintings are essentially illustrations of popular, moralistic, Americana fables rather than expressions of interior or exterior reality; they spell out in precise detail exactly what one is supposed to feel; and they remain comfortable rather than disquieting, idealized rather than human, strangely but strongly nationalistic rather than "infinite" or personal.

Within the context, the Wyeth show ranges from predictable to disappointing. His least successful efforts, by far, are the portraits, wherein each wrinkle, whisker, wart and mole is reproduced with meticulous care, but add up to as superficial and bloodless a record as the portraits in display windows of photographic studios, never mind the insistent homeliness, presumably designed to pass as earthiness, of Wyeth's subjects.

The nudes that Wyeth has been painting on the quiet for the past few years are both fleshless and bloodless, Doris Days on location in Maine. It scarcely seems accidental that the most gossamer of all is entitled *The Virgin,* and one would like to see it hung alongside a Mel Ramos, for a few more laughs.

Since 1968 or so, Wyeth has also been experimenting periodically with more vivid color contrasts, but the results on hand seem gratuitous, jarring and unassimilated into the subdued and low-keyed context of Wyeth's art.

What remains are many remarkable passages of brushwork, subtle textures and lighting in Wyeth's peculiar, exceedingly narrow range of sepias and grays and pewters and light greens.

Occasionally, such qualities will dominate an entire composition, such as a modest gem of a landscape called *River Cove* from 1958. More often, it is merely a corner where brilliant white snow patches melt, or a portion of old plaster wall or an empty space of snow between the contrivances of subject and form.

And so Andrew Wyeth, America's most popular figurative painter, paradoxically comes off most effectively as an abstractionist. As a draftsman, as an illustrator, he falls a little short of pure perfection.

But as an artist involved in conveying ideas and feelings, Wyeth is, if not a pure, unmitigated schlockster, a painter who behaves very much like one a depressing amount of the time.

The Virility of Bellows

OCTOBER 31, 1982

This year marks the one hundreth anniversary of the birth of George Bellows, and the San Jose Museum of Art has had the wit (and, thanks to Atari, the corporate sponsorship) to observe the fact with the first Bellows show to appear in this part of the world in recent memory.

Coincidence has brought us something of a crash course in recent weeks of that gray area in American art between the Armory Show in 1913 and the eruption of Abstract Expressionism in the mid-1940s: shows of Max Weber, the Precisionists, Milton Avery.

The history of twentieth-century art has almost always been presented in terms of the epic adventure of Modernism, and individual artists, American no less than European, were assigned their niches in relation to the roles they played in that adventure. Yet such painters as Weber, Avery and the Precisionists were simply doing what American artists, with few exceptions, had done all along: adapting the latest stylistic ideas from Europe to native subject matter.

Bellows was one of the pioneers of an expression out of which an authentic American art would finally emerge in the 1940s with the earliest Abstract Expressionist paintings of Jackson Pollock and Clyfford Still. Art historians, obsessed with links, are forever reminding us of the influence on the first-generation Abstract Expressionists of Surrealism and other imports from abroad, but Pollock, although he idolized Picasso, owes at least as much to his love for Albert Pinkham Ryder and his early studies under Thomas Hart Benton; Still loathed Modernism in general and Cubism in particular—"the combined and sterile conclu-sions of Western European decadence," he said of the Armory Show—and emerged out of a blunt approach to American Scene painting: the "buck-eye" tradition with obscure roots (like Ryder) in poorly reproduced and overvarnished Rembrandts.

In any event, the thing that distinguishes Pollock from Joan Miró or André Masson, or Still from Roberto Matta, is the thing that made American painting the American expression thing that it is. (It might be likened to the way John L. Sullivan once won an exhibition match with a devotee of *la boxe française;* after the Frenchman had tried to outfinesse him with a few delicately balletic foot kicks, John L. hauled off and punched him across the room.) And there is a whole lot of this thing in George Bellows.

Organized by the Metropolitan Museum of Art, the San Jose show is long on prints—sixty-one lithographs and drawings—and short on paintings (six, only a couple of prime quality), but lithography formed an important branch of Bellows's work and the exhibition manages to represent most of his principal themes: boxing, of course; polo and tennis; naked men massed inside *The Shower Bath* and boys skinny-dipping at *Splinter Beach;* art classes and art juries; and, as a kind of change of pace, tranquil portraits of his wife and two young daughters.

In an era of feminist politics, it is easy to forget the weird matriarchy—paradoxically designed, by putting them on a pedestal, to keep women "in their place"—that prevailed in Anglo-Saxon American society in those aptly named Victorian years before women won the vote (and which burst out of all control

with the passage of Prohibition). There were segregated havens of masculinity (saloons were one), just as there were delicate areas where males were not allowed to tread. But in "mixed company" (the term itself is indicative) a "ladylike" standard of behavior prevailed, and one of the activities that took place in "mixed company" was art.

Men, and women, of spirit began to rebel against the genteel, well-mannered salon art that this standard fostered, flaunting a defiant emphasis on forms of expression that we would today call "macho": raw, iconoclastic, sometimes shocking in violence or lustiness, away from the standards of the parlor to those of the streets. "Don't try to please the ladies, Rollo! Line her out!" Charles Ives scribbled in the margins of his music. "Be willing to paint a picture that does not look like a picture," Robert Henri told his students, among whom (together with the Ash Can painters) was Bellows, a twenty-two-year-old fresh from Ohio who supported himself with weekend earnings from playing pro basketball and baseball.

Bellows had already become an overnight success by the date of the show's earliest piece, 1913, when he was elected a full National Academician. The tiny conté drawing, *In the Park,* its Gibson-girl figures generalized to silhouettes of splotchy white space, suggests a familiarity with Maurice Prendergast's tapestrylike Impressionism. But the images of women and children dressed in their Sunday best could not hold Bellows's attention for long, and in his two 1916 lithographs of Central Park, the static, porcelain-doll figures have clearly become secondary to the elemental drama of the light and shadow contending for the background.

This—the dramatic interaction of light and dark—remained in many ways the basic content of Bellows's art. Hanging around Tom Sharkey's boxing club, he had discovered the perfect figurative complement for this conception of elemental conflict in the sweating, massed forms of near-naked male figures grappling in the ring, their muscular frames glistening in the stark overhead light that flickers more randomly across the faces and heads of the ringside crowd as it gradually shades into darkness.

As in the work of the Ash Can painters, the virility of the subject matter was coupled to a largely conventional, pictorial form (as Bellows's earthiness contended with a lingering Victorian modesty, the genitals of his nude male figures discreetly hidden from view). But in Bellows's best things, such as his sketchlike 1921 *Polo,* the contradiction between gestural linear energy and the almost classical pyramiding of forms becomes so extreme, and reaches such a brilliant fusion, that it reinforces the elemental conflict of his themes.

And the somewhat crude, bluntly powerful Rembrandtian fabric of light and shadow (the influence is clear in *The Murder of Edith Cavell)* spreads over everything (perhaps obscuring some of Bellows's shortcomings as a draftsman—he had trouble doing a convincing hand) from scenes of life drawing and anatomy classes to Billy Sunday preaching—in Bellows's view, almost a kind of athletic contest between the revivalist and his congregation. In the cloudy sky that glowers over his intense 1919 painting *Tennis at Newport,* the dramatic lighting transforms the painterly

conventions that Henri passed on to Bellows from the Munich academy into a hallucinatory vision that approaches the skies of El Greco's *Toledo*.

Bellows has generally been seen, by art historians as he was by his more admiring contemporaries, as the epitome of red-blooded American vitality, ebullience and optimism, a more accomplished (and more fortunate) version of George Luks. But was he?

Here and there is a puzzlingly out-of-character subject, like his *Dance in an Insane Asylum*. And there is an edge of satire—that is, of contempt—inherited, through Henri, from Honoré Daumier, in his treatment of spectators at the ring no less than of out-of-shape bathers, *Artists Judging Works of Art* and *Parlor Critics*. Among the few people to escape it—aside from his boxers, heroic even in defeat— are many of the women Bellows portrayed: frequently inward-turning and withdrawn, but almost always (even in the portraits of his daughters) with a cool, direct, relentlessly appraising gaze very much resembling his own in a self-portrait. They are fighters, too, in a less physical realm.

There is much in Bellows that brings to mind Jack London, including a darkish side that resembles London's Nietzschean streak, with its notion of Darwinian struggle and survival-of-the-fittest. (Bellows once admitted he knew nothing of boxing: "I'm just painting two guys trying to kill each other.") Both men died early—London was forty, Bellows forty-three—retirement time for most athletes, but an age when many artists are just beginning.

A Sense of Doom and Baudelaireian Beauty

FEBRUARY 9, 1969

The big show of Edvard Munch's graphics at the Los Angeles County Museum of Art comes while the caprices of taste have produced a curious psychological distance to Munch's work.

"He sure was sick," students remarked repeatedly as they browsed through the gallery, while an obviously well-adjusted young lady in Los Angeles–length miniskirt shared with members of a tour the familiar Freudian clichés about Munch's life and work: "He was rather a different person who came onto the scene."

Bootstrap conservatism and helping-hand liberalism we have always had with us, but it is a peculiar fact of the times that even the dissidents, the hippies and militants, believe implicitly in the power of positive thinking or positive action. Anything can be accomplished through greater self-knowledge or proper social planning, Hell and the Devil have been banished from present-day theology, and the femme fatale who reigned over the arts of the fin de siècle is simply a neurotic, uptight bitch with whom any man in his right senses would have nothing whatsoever to do. Our post-Freudian age is, in other words, curiously close in attitude to the pre-Freudian age of Enlightenment, Optimism and Universal Progress. And it is all a long way from the art of Edvard Munch, whose message was black psychological determinism and a sense of unremitting doom, cultivated to a hellish, Baudelaireian beauty.

The exhibition, organized by Ebria Feinblatt, curator of prints and drawings at the Los Angeles County Museum of Art, and William S. Lieberman of the Museum of Modern Art in New York, contains seventy-four lithographs, etchings and woodcuts, most of them from a single, anonymous collection.

In a catalogue essay, Lieberman states that Munch's chief significance was as a printmaker rather than a painter, which sounds like one way of saying that this is not the big, comprehensive Munch show that is long overdue; one might also wish for a more liberal selection of Munch's work between the 1920s and his death in 1944, which would offer an altogether mellower, better-balanced view of Munch's career. But these are trifling matters. Munch was, without question, one of the first artists of his time to regard printmaking as a major creative outlet, of an importance equal to painting, and the prints that he created have all the richness, resonance and depth of oils.

It often comes as a surprise to those familiar with only the standard texts that Munch lived into his eighties and died of perfectly natural causes on an estate near Oslo where he had lived for twenty-seven years. But following an emotional breakdown in 1908 Munch devoted himself increasingly to paintings of harmonious landscape scenes and only occasionally did he rework some of his earlier psychodramas. The obsessive, horrific images which everyone identifies with Munch were the product of his earliest years, and it is this period that makes up the bulk of the exhibition.

Two opposing currents created a counterpoint which runs throughout Munch's entire output, and they are stated at their purest in the show's earliest works. *Death and the Maiden* and *The Vampire,* both drypoints of 1894, are macabre Gothic fantasies in the most conventional sense of nineteenth-century allegorical illustration, populated with skeletons and necrophiliac nudes with wings.

On the other hand, a series of prints that dates from the same and the following year are slices of Bohemian life done in a spirit of genre realism—filled with romantic melancholy in *Conversation Hour* and *Moonlight,* which is bathed in pregnant, Rembrandtian shadows; with the dyspeptic bite of Toulouse-Lautrec in *The Day After.*

These two currents alternate throughout the exhibition; there are portraits of penetrating naturalism, of August Strindberg and Knut Hamsun, of Munch himself sitting over a wine bottle in a grim mood which points toward his later proletarian realism; there are periodic excesses of Symbolism, theatricality and decorative rhetoric. It was when these two currents fused in visions that inseparably united symbol to reality that Munch created his most compelling images, his "visual crystallizations" which joined Expressionism to *Jugendstil,* black, self-confined figures to haunted atmospheres of muted, glowing color, and which created the twentieth-century archetypes of shrieking desperation and empty malaise.

In a second version of *The Vampire,* a color woodcut and lithograph which Munch worked on between 1895 and 1902, the male victim is no longer a skeleton but a man in ordinary clothing, his head cradled against the bosom of a woman who grasps him almost in a manner of condolence; the grisly reality behind the almost saccharine scene is conveyed almost entirely through the strictly visual elements from which Munch fashioned his symbolic vocabulary. The woman's body is an eerie glow of light against which the man's body is cast in darkness; the contours are trembling, reverberating lines and the scene is surrounded by a flat halo of gaping darkness.

Thus did Munch reach back into the darkest recesses of myth to create a new mythology of his own time. His favorite myth, of course, was fallen woman and her relationship to the fall of man; his femme fatale is anonymous Woman, interchangeably Eve, Delilah, Salome and Cleopatra, infused with the intense Scandinavian variety of angst that reaches from Strindberg to Ingmar Bergman, and with all the fin de siècle sexual neurosis that produced Freudian psychology.

Munch's favorite schematic symbol was a moon and its abstract reflection, female and male. One of his clearest statements, if not one of Munch's most accomplished works, is an 1896 lithograph entitled *Withdrawal.* The dark figure of a man moves vacantly toward a dark forest, rigidly framed by the trunk and limb of a tree; his hand clutches the tips of flowing strands of hair from the head of a woman in

white who stands in the open air looking in the opposite direction, off to sea.

The show includes versions of most of Munch's major, recurring themes: *Anxiety, Desperation, Jealousy, Melancholy, The Shriek,* titles which read like horsemen of the apocalypse, except that instead of pestilence and famine they personify mankind's strictly internal plagues and agonies.

The anxieties and melancholies are written on masklike faces of figures who seem to be sleepwalking through vast, flat expanses of empty countryside; they stare vacantly from the canvas directly into the viewer's eyes, and they see nothing. Utter desperation contorts the features of skeletal figures who seem just to have awakened, who shriek and cover their ears against reverberations that shatter through the universe.

Whether static or charged with agitation, Munch's backdrops are almost always either abstract color atmospheres or suggestive of a pastoral, almost bucolic countryside of forests, villages and quiet inlets harboring tiny fishing boats.

In the hands of later Expressionists, anxiety and alienation quite often became identified with the anonymity peculiar to the big urban cities; Ernst Ludwig Kirchner, for example, created his faceless pedestrians against the hellish backdrop of metropolitan streets, but nature became a source of primitive regeneration when his figures took to the countryside; this undertone of social comment was further developed in the work of still later Expressionists such as George Grosz.

For Munch, however, alienation and despair were not simply among the ill side effects of city living; they were the very fabric of life itself. Nature offered no solace, for it existed only in relation to the states of feeling that it reflected.

In *The Kiss,* an uncharacteristic, lyrical theme in which Munch's male and female embrace with a rare, tender fulfillment, the silhouetted figures are cut from a single block over which an uncut section of coarse-grained wood creates a torrent of falling lines like a scrim screen, or a cleansing rain.

The polarity of Symbolism and realism which merged in Munch's most celebrated works draws apart again in many of the later graphics. *Three Girls on a Bridge,* from 1918–20, is in the flamboyantly decorative, Symbolist style, but increasingly Munch sought to channel his Expressionism into more realistic figures. He was frequently quite successful: the *Actor* of 1908–09, with half his face in light and the other in shadow, literally and symbolically; the gloomy portrayal of a Wiesbaden health resort; and a perfectly masterful lithograph entitled *Insane,* in which the simple, huddled figure of a woman stares blankly at her own shadow.

This is not the Munch we all know and love, but it was Munch of more maturity, with a more complex view of good, evil and mankind. It was also, of course, a Munch who would continue living for another thirty years.

An Artist Who Thought of Everything

JULY 31, 1980

The Picasso retrospective, which fills the Museum of Modern Art in New York, elicits a pair of first impressions.

It recalls Lee Krasner's account of an exasperated Jackson Pollock hurling a book on Picasso across a room, and muttering, "The son of a bitch thought of everything."

And one wonders if Picasso ever threw anything away.

The idea that everything an artist touches has value derives from a nineteenth-century notion of "genius." It is this Portrait of the Artist as Genius that emerges here most vividly. It is a rocky, erratic genius. Most of the twentieth century is in it, prefigured in a few paintings, sculptures or an odd, prophetic assemblage whose implications others explored—or exploited—for entire careers.

But where, one wonders, is Picasso?

Picasso, the prodigy, is evident in the very first paintings, with their mastery of academic realism and, almost as early, Picasso the omnivorous absorber, drawing on Degas, Toulouse-Lautrec, van Gogh, El Greco, Cézanne.

By 1907, in the many works that revolve around the landmark painting *Les Demoiselles d'Avignon,* Picasso, the "primitive," emerges: the maker of icons—and, one suspects, self-projections—of raw formal and psychological power. And, hard behind, Picasso, the Analytical Cubist, suddenly subjecting the overpowering presence that the figure had previously assumed to the detached, disciplined fragmentation that Cézanne had derived from landscape—absorbing the figure into its ground.

The list goes on, for nearly sixty years more: Picasso, the Synthetic Cubist; the maker of witty collages that question the relationship of art to reality; the Neo-Classical revivalist of ancient Greece and Rome; the inspired cartoonist of such works as *Guernica.*

For all this change, however, one finds few signs of real growth. Each period, of course, has individual milestones. And, when viewing more than one thousand pieces, it can be difficult to tell if the viewer, or the artist, has grown tired.

But in many ways, Analytical Cubism seems to represent the end of Picasso's real development. It was an esthetic with which he appears to have been somewhat uncomfortable—thus, the tension in these paintings—and which was, perhaps, even uncharacteristic.

Cubism conferred life upon the canvas itself, made it an organism independent of history or autobiography—of its maker. But, if there was a "fundamental Picasso," one senses it was the early painter of icons—or self-portraits.

The dissolution of the icon in the field—of man in the landscape—seems to have kindled in him an atavistic impulse to reclaim it: to forestall the disappear-

ance of the human form—or, perhaps, his sense of his own identity, of the "genius." It is as though, standing at the edge of an abyss within which he must risk losing what he had found of himself in order to penetrate perhaps deeper layers concealed within it, Picasso, rather than go over, had retreated.

But he could rarely connect again to the raw energy of the earlier paintings. The human figure regains more or less of its integrity. But it is basically a decorative integrity, the result of combination and recombination—of *invention* more than *discovery*. Or, in the Neo-Classical and "boneyard" paintings, Picasso reverts to traditional forms of pictorial illustration.

Picasso's mastery of both decorative and illustrative resources made him the century's most popular artist. But only rarely—primarily in the bronze sculpture—does Picasso recapture the totemic power and intensity of his iconic paintings of 1907–08.

It can be argued, of course, that "genius" has no need to "grow"; certainly, the visual experience of an entire century has grown because of Picasso's inventions, as well as his discoveries. Yet, one wonders what he may have achieved if, instead of foraging over so broad an area, he had narrowed in and dug more deeply. To reach a certain point and cease to grow beyond it makes "genius" distressingly similar to the way of too many of the rest of us.

Bufano's Lively Split Personality

FEBRUARY 25, 1982

Beniamino Bufano holds a curious niche in the history of Bay Area art: widely beloved by people who, as they say, know what they like, somewhat less than highly respected by the cognoscenti of the art establishment.

The public affection always extended as much to Bufano's personality as to his art—his humanitarianism and populism, his elfin clownishness and cantankerousness (as a member of the San Francisco Art Commission in the 1940s, he tried to set up a rival orchestra to the San Francisco Symphony, and lured Leopold Stokowski and Igor Stravinsky here to conduct pop concerts), as well as to a somewhat more dubious persona that he cultivated with such stories as having posed for the Indian's profile on the old buffalo nickel, or chopping off his trigger finger and sending it to President Wilson as a pacifist gesture in World War I.

Such high-profile behavior—together with Bufano's very popularity at a time when it was considered almost a hallmark of "serious" art that it be widely disliked or misunderstood—did not sit too well with the official art world while Bufano was alive. Alfred Frankenstein wrote in the *Chronicle,* shortly after Bufano died in 1970, that he "could never decide if he wanted to be a sculptor or a town character, [and] his performance in the second of these assignments often interfered with his performance in the first."

Something of a Bufano resurrection is now happening, with a sizable show in the lobby of the Ordway building in Oakland's Kaiser Center, and another collection of his work scheduled to open to the public shortly in the new Embarcadero West building on Fourth Street. The latter includes the Bufano mosaics that used to struggle against the gloom of the old Moar's cafeteria on Powell Street, which have returned here for a permanent home after repining for the past six years in a Modesto warehouse.

The Oakland show, sponsored by the Bufano Sculpture Park, a nonprofit group trying to enlist support for a Bufano museum, contains thirty-nine pieces that form a fairly good cross section of Bufano's work. There are monumental sculptures and miniature ones, in stone, wood and stainless steel, with and without inlays of mosaic. There are St. Francises and animals.

The earliest sculpture, a 1938 *Penguin With Nursing Chick* in wood combined with mosaic and stainless steel, is already almost the prototypical Bufano, in theme and in its streamlined, stripped-down forms. On the other hand, a 1946 piece represents a rare venture into total abstraction, a simple V-shape in gleaming stainless steel—although the title makes clear that Bufano thought of these upreaching, winglike shapes as a representation of *The Crucifixion.*

Even at this late date, when pluralism has weakened the temptation to assess virtually everything in terms of its impact on what we think of as art history, and without Bufano himself in the way, his art elicits mixed feelings. In his forms, as in his social philosophy, Bufano was very much an artist of his times—basically, the 1930s. His themes were those of the anti-war and labor movements: peace, unity, brotherhood. His style was Art Deco—a melting pot of derivations from ancient Chinese, Egyptian, Assyrian and pre-Columbian art, together with borrowings from Byzantine, Romanesque and Gothic,

recast into the powerfully simplified forms passed on from Cubism by way of artists like Amádée Ozenfant and Fernand Léger.

Art Deco often has been seen as simply a debased, popularized dilution of avant-garde forms, Modernism with its cutting edge rounded off. But while the wild range of its borrowings frequently amounted to little more than a desperate escape into exoticism, there also was a sense in which its rampant eclecticism reflected a serious search for an international artistic language, a visual Esperanto. In this, it carried forward one of the central missions of the most rigorous apostles of Modern art, from Kasimir Malevich and Piet Mondrian to the Bauhaus, which was to create models for a new social order based on reason and right relations.

The line is sometimes awfully thin between such idealism and simple sentimentality, and sentimentality was Bufano's most frequent pitfall. By the 1930s, it had become apparent that, if art were to have the broad social impact that the earlier Modernists had sought, its message would have to be spelled out more explicitly than abstract arrangements of squares and rectangles.

Bufano often spelled out his ideas all too clearly—especially when he added little mosaic insets to his sculptures. On the other hand, once in a while Bufano was able to make his mosaic inlays really work, as they do in the elaborately neo-Byzantine tree-of-life that adorns the skirt of a monumental bronze of St. Francis from 1960, which is totally absorbed into the primitively powerful form, awesome scale—and an almost medieval feeling of unfeigned religiosity—of the figure itself.

He was most consistent by far in his animals. Beyond all else, Bufano's art was a search for innocence, and, not unlike Franz Marc in his paintings before the First World War, he found in the simplicity and self-containment of the world of animals his most appropriate subjects and forms.

Bufano's animals, to be sure, are not icons symbolizing a pantheistic identification with the elemental energies of nature; even his bears and walruses are gentle, civil creatures whose natural habitat is the urbane setting of city parks and the entryways to civic buildings.

But there is a wonderful purity and composure to the best of these pieces. Their forms, stripped down to the barest essentials, mirror perfectly the innocence and serenity that Bufano sought to express. No one can fail to respond to a piece like *Porcupine,* a mere sphere of stone with a tapering head peering from beneath the ridge of a polished carapace, on a level of sheer, childlike wonder and delight.

This uncomplicated kind of response is not as highly valued by the art world as it is by the public. But it is certainly a legitimate one, honestly achieved.

If Bufano has been too indiscriminately praised by the populace, he also has been much underestimated by art officialdom. But he may well have preferred to remain widely loved than more narrowly respected, and perhaps his reputation will be better safeguarded that way. As the changing fashions of official art in recent years have made clear, the art establishment can be far more fickle in its tastes than the public.

Outspoken Man with a Brush

MAY 18, 1978

If you have ever met Hassel Smith, you will know him as a person whose intellectual brilliance is equaled only by his impulsiveness.

Over the past thirty years, his painting has swung—sometimes abruptly and dramatically—between these two poles, with a continuing undercurrent of biting, lampooning wit. They are brought into striking contrast in a show of Smith's recent and older work at Gallery Paule Anglim.

The older work comprises some of the explosive, often quite masterful Abstract Expressionist improvisations that Smith painted in the late 1950s and early 1960s. Smith was among the San Francisco painters who changed their styles virtually overnight under the impact of Clyfford Still during the postwar years.

Smith absorbed a great deal from Still's jagged, ax-cut edges, shredded shapes and nude, uningratiating color, but his abstractions are basically action paintings, at an opposite extreme from the absolutism of Still's transcendent and visionary art. The untitled oil of 1960 that looks like a vandalized Still summarizes the similarities and contrasts.

Smith's racing, whiplash calligraphy and its frequent paraphrases and sly allusions to anatomical parts and totemic symbols align his action paintings with those of Arshile Gorky and Willem de Kooning, but carry no hint of their ambiguity, equivocation and "struggle." There might be crises, indecision and violent change (and the variety of Smith's work suggests that there often were), but most frequently they appear to have been resolved outside of the canvas itself. When it came time to paint, the statement was immediate, expansive and outspokenly there, for better or worse—and better more often than not.

These paintings come quite late in the history of Abstract Expressionism as a movement capable of sustaining every graduate student to wield a brush; by the early 1960s, most were switching to straight edges and masking tape. In the early 1970s, Smith also made this move. He has said that he was influenced by Mondrian's decision "to stop inventing shapes" and also by a conflict between the painting he did and the painting he taught. He decided "to resolve this contradiction in favor of the painting taught."

This is a fairly secure way to assure academic painting, and while one must respect Smith's decision to throw new challenges in his way, I find myself unmoved by his more recent work—although not quite so totally unmoved as by his last show a year ago. That was dominated by geometric abstractions divided into areas of flat, generally pastel acrylic color, decorative in a hot, acrid way, and laid on in muggy densities, with fussy little textural variations and stenciled numbers that underlined a resemblance to game boards.

The current show contains a wallful of these paintings, and they still look like claustrophobic, compacted and constipated demonstrations of scholastic "problem-solving." But there is also a *Cosmic Funk* in which a sense of atmosphere and space begins to open around the movement of rounded forms that resemble beer can tabs; a construction in which rods and dowels (and shadows) project Smith's color geometry into a relief that slyly suggests Giorgio de Chirico goings-on in front of a Bauhaus facade; and a remarkable *Homage to Varda* which, if not in the same league with the most forceful of his early works, is at least a good contemporary painting, 1970s style.

Joan Brown's Artistic Pilgrimage

OCTOBER 13, 1983

Joan Brown, an artist who always has moved to the sound of a different drummer, became prominent when she was just out of school in the late 1950s, on the coattails of the Bay Area Figurative movement.

There was always something in her expression that made it quite distinct from the more reticent and formal painting of Diebenkorn, Elmer Bischoff and David Park: an inclination to images that were commonplace enough—dogs, old shoes—but exuded a fey, quirky eccentricity, and to a bald directness in the way these images commanded their territory on the canvas that gave her paintings, with their thick, Abstract Expressionist impastos, the transfixing, larger-than-life intensity sometimes found in folk art.

These features of her style became more pronounced in Brown's paintings of the 1960s and early 1970s, their forms growing increasingly distilled and simplified in a manner inspired by Henri Matisse, while their imagery drew on elements of Brown's everyday life—her family, her pets, her art historical interests, her pastimes, above all her own image—and moved them into a dimension of fantasy and myth.

Gallery shows have made clear she has been moving in another direction in recent years, but—except for the obvious fact that it is more rarefied (or thinner)—the nature of this direction has so far proven somewhat baffling. A big survey of her work over the past half-dozen years, at the Mills College Art Gallery, gives a clearer picture of what she has been up to.

The show gathers some forty works, all from the artist's studio, into an installation that looks a bit like a scaled-down Rosicrucian Museum, complete with brightly painted, freestanding columns, pillars and obelisks. It outlines a personal pilgrimage which, at least in terms of art, seems to end back in 1967, or perhaps it was 1968—the period when half the artists in San Francisco, it often seemed, were painting visions of gurus and signs of the zodiac and journeys to the East in the flat, vibrant colors of psychedelic poster art.

Brown was doing some of her strongest paintings around that time—a *Dance* series peopled by skeletons and spectral silhouettes and ghosts of old memories. A few years later she began to travel extensively—to Europe, Egypt, South America—and, around the same time, became engrossed in the writings attributed to Seth, with their themes of astral travel and reincarnation.

By 1979, when she painted *The Departure by Plane* and *The Departure by Ship,* their tiny images engulfed in abstract dapples and vortices of loosely brushed colors, the travel theme already had become clearly more metaphorical than autobiographical.

Brown seems to have undertaken this "journey" somewhat humorously at first: *The Cosmic Nurse* (1978) sounds like the title of a comic strip; *The Misunderstanding* (1978) is invaded by images that resemble Mickey Mouse. The cartoonlike quality remains in her more recent pieces—indeed, the forms become flatter and flatter, like cutouts or decals—but Brown seems to have taken her subject matter more and more seriously.

The soft, luminous, Impressionistic backgrounds of her earlier paintings give way to fields of flat, unmodulated color. Cats become prominent, reeking with hermetic inscrutability.

The images and symbols of ancient

Eygptian art frequently appear, although these paintings are nothing if not eclectic, and so there are also symbols that seem closer to Sanskrit, and figures borrowed from the religious art of India and Tibet. The self-images that always have been so obsessive a leitmotif in Brown's paintings remain, but they are now often wrapped in cloaks or saris, novices (or sometimes high priestesses) participating in exotic initiation rites and other rituals.

Half sections of columns stand on either side of some of these big canvases, and occasionally they come off the wall altogether, as in-the-round pillars. There are also obelisks, a trellis and a four-sided *Cat Temple* with a walk-in door.

With the help of raga background music, there are moments when all this *almost* begins to work. Brown's self-portraiture always has had a disarming, stranger-in-a-strange-land feeling, and that combination of anxiety and wonder is preserved in some of the paintings here. There is certainly an undeniable sincerity and even a kind of authenticity to these works. But they function more as elements of an environment—almost as a form of theater—than as paintings.

Mysticism and art are distinct, if sometimes overlapping spheres of activity, as the poetry of Kahlil Gibran so ripely demonstrates. Mysticism is a spiritual enterprise toward the end of resolving contradictions and the cessation of striving; art is a highly physical one, all contradiction and perpetual striving, in probably its noblest form.

I think Joan Brown was a better artist when she was painting dogs that looked like wolves, rather than cats that look like sphinxes. And I hope she will get off the astral plane and come back to Earth.

A Psychedelic Flowering

JULY 16, 1967

For the past year or two, the tendrils, rosettes, mandalas and photomontages of "psychedelic art" have blossomed out all over, from window posters to miniskirts, from record jackets to direct mail advertising. Yet the artists themselves have been notoriously shy of personal publicity, wary of art galleries, hostile to the establishment—and the feeling has largely been mutual.

The times, however, are a-changin'. In April, Wes Wilson, the best-known local poster-maker, went so far as to permit feature coverage in *Time* magazine; a complete set of his posters is in the collection of the Oakland Museum, and one is included in an exhibition of "The American Poster," from the nineteenth century to the present, circulated by the American Federation of Arts and scheduled to open at the Mayfield Mall shopping center in Mountain View.

Glide Memorial Methodist Church, which this spring organized a show of art works by rock musicians, today is opening an exhibition called "The Flower Children's Art Bag" comprising mainly the Haight-Ashbury's more grass-roots talent. A show of fifty posters for the Fillmore Auditorium and Avalon Ballroom is scheduled at the San Francisco Art Institute.

Meanwhile, what promises to be the most important local show so far of psychedelic art opens tomorrow at the Moore Gallery. Appropriately entitled "Joint Show," the exhibition gathers together for the first time work in original graphic art, collage and oils by five major local poster-makers: Wilson, Victor Moscoso, Rick Griffin, Stanley Mouse and (Alton) Kelly.

So far as I know, a comprehensive, even semischolarly account of the rise and evolution of the psychedelic look in mid-1960s art has not yet been written. There are probably all kinds of theses and dissertations now underway in the academies, but meanwhile, psychedelic art may be the first revolutionary art movement to find its earliest acceptance and receive its most comprehensive coverage in the entertainment and society pages. Indeed, the times they are a-changin'.

The art institute's press release refers to psychedelic posters as an "example of fashion influencing art in a constructive manner," and Frances Moffat, the *Chronicle*'s society editor, tells me that the return of paisleys to fashion began about five years ago, which predates the psychedelic poster by two or three years. Phenomena like this rarely happen in isolation, however, and their common roots would seem to lie in the same kind of factors which created the historical styles from which both psychedelic art and mod fashion have so obviously drawn: the fin de siècle Art Nouveau.

Psychedelic art comes in a variety of colors, shapes and sizes, but if one feature is readily apparent, it is its inspiration in "something old"; its three B's are Blake, Beardsley and Bosch. For all the God's eyes, Islamic calligraphy, Buddhist mandalas and Indian swastikas, its closest counterpart would seem to be happenings in Europe and England (and New England) that formed an undercurrent through much of the nineteenth century, from William Blake and the Pre-Raphaelite Brotherhood through the Transcendentalists, the Gothic Revival, William Morris and Art Nouveau. These movements combined varying degrees of mysticism, Utopianism and irrational romanticism in reaction against the Age of Reason, the

Industrial Revolution, the rise of the assembly line. It was the age which first sharply questioned the idea of progress as it had developed in Western civilization since the so-called Renaissance.

Blake and the Pre-Raphaelites sought to reestablish roots in the vitalizing currents of the past—in medieval simplicity, purity, the mystical union of thought with feeling which existed before alchemy and astrology divided into science on one hand, magic on the other. The Transcendentalists—and even the scientific-minded Impressionists—began Western civilization's first major journey to the East, importing Brahmanistic thought and Japanese prints. Morris and his contemporaries fought the assembly line with the kind of design only the hand could make, the printing press with a revival of calligraphy. In Toulouse-Lautrec, the age created the commercial art poster.

Most of these movements—reactionary in terms of their day—rather rapidly became footnotes to the mainstream of Western history, although a return to primitive centers of energy was part of the later appeal of African sculpture and the medieval craftsman's guild idea was strong among the early German Expressionists. Cubism, however, marked the beginning of a long flirtation of art with urbanization and industry, and Expressionism responded with Freud.

The gap between celebration of the machine and the revolt of the individual continued and widened down through the years of Abstract Expressionism, as did the breach between artist and public. Progress, meanwhile, led to the development of plastic and a Second World War, to cybernetics and Vietnam.

It led also to Pop, Op and camp, television and LSD, Marshall McLuhan and a revival of Carl Jung. Psychedelic art, wildly eclectic, may be inspired by everyone from Blake, Aubrey Beardsley and Alphons Mucha to John Anthony Thwaites and Gustave Doré. But it would be hard to imagine one of Wes Wilson's blatantly stark-naked, heavily modeled, Medusa-haired nudes in the days before Pop art and Mel Ramos, impossible to conceive of his blinding color juxtapositions before Op.

Camp, the doctrine that says if something's bad enough it's funny, shows itself all through psychedelic art, especially in its photography department. No one ten years ago would have thought of reviving Beardsley with a straight face, let alone employing the mannered, looking-straight-at-the-camera poses in the over-sized poster photos of the Jefferson Airplane and the Grateful Dead. In a sense, much of psychedelic art could be called camp that backfired.

Mouse, who began his career in Los Angeles painting monsters on sweatshirts, says he has been influenced by "all art—especially television." There is a montage-collage element in much psychedelic art that seems best explained by Marshall McLuhan's notion of an overall, mosaiclike structure, similar to the flashing images of a TV screen, replacing our traditional straight-line, printed-page way of seeing things.

Like TV, psychedelic art is a "cool" medium, demanding participation by the viewer, if only to decipher what the lettering says. In this respect, as in its commercial function, it parallels the tendency of current mainstream art toward breaking down the lines between artist and viewer, artwork and environment, art and life.

Mouse also says he found out "where it's really at when I got stoned." Griffin said experience with psychedelic drugs "intensified" his vision, formerly inspired for the most part by "engravings in old books."

The five artists come from highly diverse backgrounds and, contrary to the notion that psychedelic art exhibits a primitive kind of anonymous sameness, their work is highly individual and distinct.

Wilson, whose work most nearly resembles Beardsley's, is, like Beardsley, largely self-taught. Twenty-nine years old, he is a philosophy drop-out of San Francisco State College and was working as a printer when he started doing dance posters some two years ago.

Moscoso, the most highly trained artist of the group, studied at Yale with Josef Albers and Rico Lebrun—"at the same time"—and at the San Francisco Art Institute with Diebenkorn, Bischoff and Oliveira. He says he has retained all his early training, but considers his new style—which he terms "contemporary eclectic"—to have entirely supplanted his early work.

Griffin, at twenty-four, is active in surfing circles and is artist-writer of a comic strip called "Narcoman." One of his drawings appears on the cover of "This World."

Mouse is founder of the Pacific Ocean Trading Company on Haight Street, and was one of the first to do rock posters in a camp style that later developed into the psychedelic look. Kelly, one of the early members of the Family Dog—promoters of rock-dance concerts—attended art school at Yale, and has been drawing dance posters for two and one-half years.

Solitaire with Soup Cans

MAY 31, 1970

Roy Lichtenstein and Claes Oldenburg have both been honored with major retrospectives during the past year, and the triumvirate is now complete with a big Andy Warhol exhibition at the new Pasadena Art Museum. Of the three major flag-bearers of the Pop art movement of the 1960s, Warhol proves to wear the thinnest.

No name in contemporary art is more familiar than that of Andy Warhol, and no image is more elusive. There is Warhol, the fifty-thousand-dollar-a-year advertising artist turned Master of the Campbell's Soup can, the S & H Green Stamp, the Brillo box and other images appropriated from the world of consumables and the mass media.

There is Warhol, the maker of films featuring campy capers and naturalist tedium extended to insistent lengths sufferable only by a masochist on Methedrine. There is Warhol the public figure, the put-on, the poseur, founder of the Factory and the Velvet Underground, architect of superstars like Taylor Mead and Viva, victim of a bizarre Svengali-Trilby-style assassination attempt.

The Pasadena show, which was organized by the museum's outgoing curator, John Coplans, but selected in accord with Warhol's request, concentrates on the serial aspects of his art. That is, it contains big paintings that repeat the identical image of Marilyn Monroe twenty-five times, and dozens of small paintings that depict Marilyn only once, but still identically except for color, gathered from collections throughout the country and all

hung together like a layout of solitaire. One can presume that this serial aspect is supposed to represent the most serious side of Warhol's art (though any presumption in regard to Warhol must be made with caution), but the result is an exhibition that is even more boring than it needed to be.

When Pop art first burst on the scene a decade ago, it represented a vigorous kick in the pants to the atrophying esthetic of Abstract Expressionism, but even more significantly, to an entire intellectual stance which had been associated with it. That stance was both alienated and exclusive, reveling in the esoteric progressions of cool jazz, the revival of arcane Baroque music, the intellectual subtleties of a Jean-Paul Sartre or Samuel Beckett. Noncommercial FM stations and the *New York Times* were In, "Gordo" was the only comic strip worth following, Kenneth Rexroth inveighed in stentorian tones against Brooks Brothers suits, Allen Ginsberg howled about Moloch, and no one was more Out than Elvis Presley.

Along came Pop with an art that was neither intellectual nor anti-intellectual, but simply a dumb reproduction of trivial images from the despised worlds of advertising, merchandising, journalism and the nineteen-cent hamburger stand. Anyone could understand the art if not the motivation. Best of all, Pop was non–art historical, and a whole new audience, comprised largely of the young and of dilettantes from the world of high society, could learn all about it from the ground up simply by

reading the newsmagazines and keeping abreast of the latest movies, advertisements and styles—not to mention developments within Pop art itself—from which Pop artists drew their inspiration. Enter pop culture, and its alliance of art, fashion and money.

The very impersonality of Pop art laid it open to a variety of interpretations. It represented a kind of Zen acceptance, or celebration, of the trivialities of American life, or a revival of the American vernacular tradition, or a Dada satire, or a subtle indictment of American conformity and materialism.

In a book published by the New York Graphic Society to accompany the show, Coplans manages to touch on most of these contrasting ideas, sometimes two to a paragraph. He refers to the Pop artists' "strictly neutral" detachment from "emotional attitudes about their subject matter," and then to Oldenburg's tragic humor, Lichtenstein's pathos and the "particularly savage and uncompromising" character of Warhol's images. Warhol, writes Coplans, "almost by choice of imagery alone it seems, forces us to squarely face the existential edge of our existence."

An infinitely more revealing catalogue essay appears in the form of a personal reminiscence by Calvin Tomkins. Among other things, Tomkins records for posterity that "Andy," while "still making more than almost any other illustrator in the business," began doing paintings of comic strips and huge Coca-Cola bottles some time in 1960. But shortly thereafter, he learned that Roy Lichtenstein had got his comic strip paintings to the galleries first, and James Rosenquist had cornered the market on oversized bottles.

Warhol was so "desperate for ideas" he paid fifty dollars for the suggestion of a dealer named Muriel Latow that he paint money, and it was Latow who also dreamed up the idea, gratis, of the Campbell's Soup cans. The later "death" series—the car wrecks, suicides and electric chairs—was, according to Tomkins, originally suggested by Henry Geldzahler, curator at the Metropolitan Museum of Art. Exit Warhol, the original idea man, from that elusive Warhol image.

Warhol's original contribution to Pop art was an imagery even more banal than that of Lichtenstein (people do, after all, read comics), and subjected to less transformation than the hamburgers and pies of Oldenburg. While Lichtenstein has developed the formal and coloristic implications of his early painting, and Oldenburg the Expressionist and Surrealist aspects of his early work, Warhol has remained the Pop purist, playing the same tired games, developing, if anything, a tendency toward the shallowly decorative. One has to give or take a little, considering that by the mid-1960s Warhol had shifted his primary interest to filmmaking, but the Pasadena exhibition indicates that Warhol's painting career can basically be reduced to two, perhaps three, good, if erratic, years.

The show's earliest works are the thirty-two Campbell's Soup cans, with which

Warhol erupted on the scene in his first one-man show in 1962 at Irving Blum's old Ferrus Gallery in Los Angeles. Painted in a crisp, wiry line against a stark white ground, realistic in every detail except for the central emblem and arranged in a continuum from Chicken Gumbo to Tomato Rice, they still carry an impact, obdurate in their trivial "thereness" and stupefying in the monotonous repetition with which they proclaim their monotonous products.

On the opposite wall hangs a series of Campbell's Soup cans done in 1965 by the acrylic and silkscreen process which Warhol has since perfected, but in various combinations of boldly harmonized, decorator colors which vitiate their parodistic effect, at least as far as soup goes. They are, perhaps, parodies of the earlier paintings.

For all of Warhol's notorious verbal cons, he remains in many ways his own best spokesman. Hanging above one gallery is a large sign bearing the quotation: "If you want to know all about Andy Warhol just look at the surface of my paintings and films and me. There I am, there's nothing behind it."

When Warhol abandoned oil painting for acrylic and silkscreen, his interest in the surface appearances of objects and images began to compete with a new interest in the surfaces of his paintings. The hard-edge crispness of the original Pop style gives way to a use of color slippages and textural effects that combine the impersonality of mechanical reproduction with a surface richness and complexity that al-most hark back to Abstract Expressionism.

The "disasters" of 1963 and 1964 achieve much of their effect through a contrast between their detached, journalistic, "charged images"—to borrow a Coplansism—of grisly accidents and violent riots, and the erosions of black, of spectral whites and halftones to which they are variously subjected. They also achieve a sometimes mesmerizing impact through a repetition of identical or similar images, adjacent or overlapping in a way that suggests a cinematic sequence, but a sequence in which, paradoxically, nothing changes except for those sinister black erosions.

Similarly, the portraits of Marilyn and Liz employ repetition to stupefying lengths, but even more telling are the color variations among identical faces: a swath of green mascara here, of pink mascara there, of magenta somewhere else, all over the same pinkish flesh, with the same flat yellow hair and big, off-register red lips, and all adding up to the same blank, unreal anonymity, no matter how varied or bright the package. Actually, this description does them too much credit, but the Marilyns and Lizes at least remain the most brilliant works that Warhol has done in color, while the Disasters are Warhol's —or Warhol-Geldzahler's—most expressive and memorable images.

As time goes on, Warhol's interest in surface effects and colors becomes more and more paramount and his work becomes—well, more and more superficial.

Color enters into a few of the early Disasters and most of the later ones, used as a pervasive, permeating form of artificial light, in a manner that parallels the use of white to form halftones. Occasionally, the color imparts a symbolic undertone to the imagery, but Warhol seems to have grown increasingly interested in its strictly decorative possibilities. In the electric chairs of 1967 and a series of self-portraits dating from about the same year, he plays around with liquid color solarization effects. These later works have a great deal of authority, but they seem to lack the old conviction.

The most disastrous segment of the exhibition is a large gallery devoted entirely to the flower paintings done at various times between 1964 and the present year—thirty-five of them all told, although some paintings contain more than one image. Coplans professes to see these as some kind of flowers of evil, gravitating "toward the surrounding blackness... haunted by death." But they appear to this writer, at any rate, as so many rolls of decorator fabric; choose your colors to match your living room. The exhibition comes to an end in an adjacent gallery stacked with one hundred silkscreen-on-wood Brillo boxes dated 1970 and labeled "Pasadena Art Museum, gift of the artist." But in contrast to the old soup cans, this seems strictly to be Warhol parodying Warhol.

The show, to be sure, does not do Warhol justice; a full-fledged retrospective would have to include a representation of the films, the pillows, the conceptual pieces, all of which this totally passes over. Such a mammoth display might or might not alter the Warhol image that emerges from Pasadena. This image is of a basically minor league talent, which a stroke of luck and timing elevated to fame and fortune, of a daring colorist who has made a major contribution to the commercial silkscreen process, of an erratic artist whose work is neither consistently good nor consistently bad, and, primarily, of a bizarre cultural phenomenon. It is often the fate of the satirist whose satire does not threaten the basic fabric of things but merely apes the isolated absurdities, that he is eventually outdistanced by his audience. Mort Sahl educated part of a generation to the fact that the funniest part of the daily paper is the main news section, but once everybody knew that, they no longer needed Sahl to point it out. Nor has anything much changed.

Warhol-style Campbell's Soup designs now appear on wastebaskets and water tumblers at the five-and-dime, and his original paintings command record prices at the auctions. Like most satire that is scarcely distinguishable from the object satirized, Warhol's work has itself turned into an assembly-line-style commodity, a spoof to the second power that retains only the humor of a private joke, all the way to the bank. The repetitious serial images that once seemed such a mordant commentary on the monotonous surfeit of American conformity now produce only a monotonous surfeit of Andy Warhol.

A Moving Experience

DECEMBER 13, 1979

Art clichés usually have origins in an art that is profound and original, and the current vogue of tattered and torn materiality, or sugar-coated Minimalism, is no exception.

Among the most profound originators of this esthetic was the late German-born New York artist Eva Hesse. The University Art Museum in Berkeley is displaying a large memorial exhibition of her work, and I hope that everyone will take the time to go and see it.

For Hesse's followers, the show should provide an object lesson that firstest is almost always mostest, and that in art the sincerest form of flattery is not the imitation of a style but emulation of the process of self-discovery by which a real artist creates his or her own.

For the rest of us, the work of Eva Hesse constitutes, to my taste, at least, one of the most beautiful and moving experiences since the first generation of Abstract Expressionism.

Hesse had a tragic life, culminating in her death of a brain tumor in 1970, at the age of thirty-six. For better or worse, these tragic circumstances have produced a romantic mythology which is impossible to ignore in viewing Hesse's work, like van Gogh's ear, Jackson Pollock's alcoholism, Diane Arbus's suicide and the battle against cancer of Terry Fox, whose expression most nearly approaches Hesse's own.

These circumstances, however, were also an intimate part of the forces that went into the creation of Hesse's work. Robert Pincus-Witten's essay in the exhibition catalogue makes passing reference to her origins in Expressionism and Surrealism. The current exhibition contains none of these early works, concentrating instead on the constructions and drawings that Hesse produced during her brief period of celebrity, from 1965 until her death.

These show, however, that she remained essentially an Expressionist all her life, with one eye on developments in the art world around her, but the other always fixed deep inside.

The exhibition's earliest works are neo-Dadaist, painted constructions in a wild mixture of media—wire, bolts, concrete, wooden screw pegs—that suggest Hesse began by looking at artists like Claes Oldenburg, Lucas Samaras and Jasper Johns.

Her own distinctive contributions were a feeling for raw materiality that is more forthright than that of Johns or Samaras, and a sense of sexuality that is both more visceral and more abstract than Oldenburg's.

These early pieces are objects—coils of electrical wire, dangling cords, spheres and hemispheres; they are also unmistakable metaphors for human sex organs, all the more forceful for their obliqueness and sense of mystery.

Within a short time, Hesse began adding latex, rubberized cheesecloth and fiberglass to her repertoire of funky, flimsy and flawed raw materials, and she started casting an eye in the direction of Minimalism.

No doubt she was intrigued by the absurd juxtaposition of the wayward and perishable with the rigor and durability of Euclidean geometric forms. One suspects, however, that Hesse was attracted to Minimalism for the same reason that Arnold Schönberg invented the twelve-tone row: to discipline, channel and intensify the seething Expressionism of her artistic vision.

At any rate, the "mockingly funny" quality to which a statement on the wall alludes has largely dissipated from Hesse's work, a product of the artistic climate that prevailed when it was created.

What remains is a quietly awesome statement on frailty and transcendence, expressed in forms that are not Minimalism with frosting but Expressionism distilled and purified.

In the great works of her last three years, Hesse was able to take the simplest sheet of rubberized wire mesh, as in the work called *Area,* and transform it into a metaphor of the human form, of life, decay and endurance.

Four serial "paintings" called *Aught* set the style that is followed today by practically every artist working with rubberized latex, but it is better than any of them because it is not pretentious, but a statement on pretension.

Hesse's great wall of empty, translucent latex boxes called *Sans* and her huge screen of fiberglass and rubberized cheesecloth resembling a row of hospital stretchers are like containers from which a life has just departed; they have the cloudy transparency of surgical fluids and lingering death.

Pincus-Witten says the motifs of Hesse's work "are not interesting because they may lend themselves to elaborate extrapolations of meaning but simply because their forms are interesting apart from any thematic obliquity."

It is true that forms are always what survive in art, long after their meaning has changed or dissipated. It is, however, this meaning, or vision, that invests forms with their potency, and while forms can be imitated or copied, visions can never be.

The "decorative is the only art sin," Hesse once said, and while her style has, like Pollock's, spawned an entire generation of decorators in cheesecloth and rubber, her work itself retains as much force and mystery as ever.

Krasner: Energy Rather than Power

FEBRUARY 26, 1984

By now, the story of Lee Krasner's rise to recognition as one of America's major artists since the Second World War has become fairly well known.

There were her eleven years of marriage to Jackson Pollock, during which her own career was largely overshadowed ("Pollock struggled with Picasso but he didn't have to share a home with him," William Rubin, director of the New York Museum of Modern Art's department of sculpture, wryly observes in a foreword to the exhibition catalogue); another decade or more of continued struggle to achieve her own identity as an artist during which she was still more widely thought of as a widow than a painter; finally, spurred by a younger generation of curators and critics, acknowledgment during the past five or six years as—to quote a blurb on the exhibition catalogue—"a seminal first-generation Abstract Expressionist."

The question that now inevitably shadows the present exhibition—the first sizable show of Krasner's art ever to appear in these parts—is, of course, whether this belated and hard-won reputation is wholly justified by the work itself, or whether it is more a product of feminist advocacy and/or the insatiable craving of art historians for disinterring new "masters" from the potter's fields of the past.

The question is not made easier to answer by Barbara Rose's extended essay in the exhibition catalogue, which is written in the relentlessly uncritical, Horatio Alger style that has become the norm for this generally lamentable literary genre. It is long on historical perspective (albeit with some strange lapses; she has de

Kooning, for example, arriving at "an abstract style" in 1950, the year of his first "Woman" paintings), but is short on insights into the intimate motives and meanings—the substance and content—of Krasner's art.

Most curious of all, in seeking to establish Krasner's credentials as a "charter member of the group...to create the first major innovations in modern painting since Cubism," Rose sets up a criterion which most of the pioneering Abstract Expressionist painters would surely have disdained: "Krasner was certainly among the first to emerge as a full-fledged abstract artist with an early understanding of Matisse, Picasso and Miró as well as Mondrian." Other than a few art historians, who cares?

The importance of the first-generation Abstract Expressionists lay, not in their "understanding" of Matisse, Picasso, et al.—or, as Rubin puts it, of "painting culture"—but in the urgency and tenacity of the compulsion they felt to escape from their shadows and create something new.

Certainly, there is nothing in the earlier section of the exhibition—a considerably pared-down version of the show that opened last year at the Museum of Modern Art in New York—to indicate that Krasner was, in terms of originality and authority, not to say influence, an artist of major importance during the 1940s. She was, on the contrary, as Rubin points out, like Arshile Gorky, a "late bloomer," and although Gorky's painting achieved its fullest flowering in the mid-1940s, Krasner's did not comparably blossom until around 1960—a little late for a "seminal

first-generation Abstract Expressionist." A "seminal late bloomer," maybe.

These early paintings do establish Krasner as an artist of unusual individuality, knowledgeability and range, reflecting a background that already included a thorough academic training (Cooper Union, the National Academy of Design), experience working with the WPA mural project, and wide exposure to avant-garde ideas via studies with Hans Hofmann and participation in the American Abstract Artists group.

There is a small abstraction from the early 1940s of fractured Cubist forms enclosed by heavy black outlines that reflects the influence of Picasso as translated by Gorky, and a remarkable *Blue and Black* from 1951–53 whose flat, decorative patterns of Moorish arabesques reflect the influence of Matisse (with a touch of Barnett Newman and Clyfford Still). There is a very distinctive group of "little image" paintings in which hieroglyphic black-and-white "writing" is tightly compressed in compartmentalized grids—Mondrian as translated by Joaquin Torres-Garcia, as Rose observes. And, of course, there are the inevitable "little Pollocks."

Significantly, only one of these small, dense, allover mosaics and webbings of paint uses Pollock's "drip" technique; such paintings as *Noon* derive rather from the "Shimmering Image" style of Pollock's immediate, "predrip" period, when he painted some of his happiest and most lyrical works, with a robust energy that had not yet lost contact with the earth (or canvas). Indeed, Krasner seems to have had a knack for seizing and developing ideas that were perhaps too-quickly-passing phases in the paintings of her teachers: the looping, whiplash black line that charges a painting such as Hofmann's 1947 *Ecstasy,* for example (perhaps representing his own synthesis of Picasso, Matisse, Miró and Kandinsky—and of Pollock and de Kooning) echoes across a great many of Krasner's abstractions, early and late.

There is, as Rose points out, a distinctive visual rhythm that unites Krasner's otherwise quite disparate early paintings. Generally, it is turbulent (if controlled), Baroque and aggressive, although at times it grows quieter and more legato, as in the flowing vertical bands of pastel colors that fill an untitled abstraction from 1951, and reappear in a later group of paintings that also incorporate strips of raw canvas and torn paper. The latter are painted an inky black to create dark, looming silhouettes that recall those in the *Spanish Elegies* of Robert Motherwell, which were so influential in the early 1950s.

The other quality that brings these diverse paintings together, apart from the breadth and the depth of their immersion in "painting culture," is Krasner's tendency to work—more or less self-consciously, it would often seem—in terms of a dialectic: action, reaction, synthesis. Thus, there are paintings that emphasize the dramatic action of line and others that stress the sensuous qualities of color; Cubist order and Expressionist freedom—or, sometimes, a more decorative, School of Paris approach to design and pattern.

A series of joyously exuberant paint-

ings from the early 1950s that suggest the vitality and growth of natural forms—grasses, plants, foliage—is followed by a group of violently expressionistic canvases strewn with dislocated and ravaged shards of the human figure in the manner of Picasso as violated by de Kooning—Krasner's emotional reaction, perhaps, to Pollock's violent death in an auto accident in 1956.

Still, for all the outbursts of power and occasions of syntheses achieved in these paintings of the 1950s—perhaps Krasner's most novel (or, in such works as *Bald Eagle,* disparate) device for arriving at the latter was using scraps of cast-off paintings of her own or Pollock's as collage elements in new works—there is little that really sets them apart from the creations of many another talented contemporary caught up in the sweeping orbit of Pollock, Hofmann and de Kooning. The seams of her many influences too often show.

If the exhibition makes an inconclusive case for Krasner's preeminence among American artists of the 1940s and 1950s, however, it strongly suggests that she was one of the very best painters at work in the United States in the early 1960s. This period, when Abstract Expressionism was abruptly eclipsed by the glitter of Pop art, neo-Dada, postpainterly abstraction, etc., is, of course, a territory that remains ripe for further exploration. We on the West Coast know all too little about what such painters as Jack Tworkov, James Brooks, Grace Hartigan, Ernest Briggs, Jon Schueler, Philip Roeber and Sonia Gechtoff were doing then; people in the East know even less about the work of San Francisco artists.

In any event, in such paintings as *Uncaged* (1960), with its feverishly churning swirls of interlacing black and white line, and the immense, volcanic *Charred Landscape,* Krasner finally breaks loose in an authentic frenzy of explosive, if tightly harnessed and thereby intensified, energy. The huge, mural-sized painting *Cobalt Night* is one of the rare works in this show that really makes one's hair stand on end, all of its elements—line, color, form—pulled together in a web of dense, opaque, black, white, gray and blue shatter marks that explode from various epicenters like showers of meteors. In *Gaea* (1966), the terms of the dialectic set forth in earlier paintings such as *Celebration* and *The Seasons*—line here, color there—return, but they are resolved through sheer force of scale and the violence of the colors and the rhythmic counterpoint.

This was not, unfortunately, a period that lasted very long. By the beginning of the 1970s, Krasner was painting designy hard-edge abstractions that hark back to the Art Deco abstractions of artists like Lorser Feitelson. Later, she turned to the rather reckless expedient of carving up some of her dense charcoal drawings from the late 1930s and using these to create hard-edge design patterns against areas of unpainted canvas. And by the beginning of the 1980s, Krasner appears to have returned to square three or four, if not exactly square one, with muscular, gestural abstractions that resemble very much her paintings from the 1950s.

Krasner has never stood still, Rose en-

thuses in her unremittingly admiring manner, but such paintings as *Twelve Hour Crossing, March Twenty-First* (1961) simply suggest the old saying about what happens the more things seem to change.

Ultimately, the real problem that has dogged Krasner through most of her career appears to have been not the prolonged subordination of her identity to that of Jackson Pollock in particular, but to its submersion in the whole business of so-called painting culture generally. Somewhat like de Kooning, she has only rarely managed to transcend it, as Still and Rothko did, nor has she succeeded in wholly reconciling herself to it, in the manner of Motherwell or Diebenkorn or, in another way, Ad Reinhardt.

The result is a highly inconsistent body of work, uneven enough to include an occasionally masterful effort, but generally more prone to the display of energy than to real power. And it is this predominance of painting culture in her work, one suspects, that delayed Krasner's recognition during those brave, revolutionary years when such culture was suspect, and that makes her work seem so attractive now, when eclecticism and pastiche are eagerly embraced by so many artists, curators and most (but not all) critics.

The Era of Conceptualized Schlock

JULY 5, 1979

They stood for as long as four hours to visit Judy Chicago's *Dinner Party* during its final days at the San Francisco Museum of Modern Art.

Museum officials estimate that the show drew more than ninety thousand viewers—twice the turnout for either of the recent retrospectives of Robert Rauschenberg or Jasper Johns. One expects crowds like that for the "Splendor of Dresden" or "Treasures of Tutankhamun," but as far as contemporary figures in the visual arts are concerned, no single personality has drawn that much attention since Andy Warhol. And indeed, in some respects, Judy Chicago is the Andy Warhol of the 1970s.

As Warhol did, Chicago produces "art" in a factory setting—although it is characteristic of the differences between the edgy cynicism of the early 1960s and the serendipitous Positive Thinking of the present that she does not call it that. Rather, the *Dinner Party* was a "project" with "teams" and a "support community"—all under the umbrella (or tax shelter), of course, of a "nonprofit organization."

It is characteristic of the differences between the eras, too, that while Warhol's sphinxlike public image was part of his appeal, our knowledge of Chicago extends unto the details of her earliest orgasms.

Chicago's work, as Warhol's, appeals to a broad segment of the public partly because it gives status (if not necessarily dignity) to commonplaces: soup cans and other items of commerce in Warhol's case; in Chicago's, the styles and techniques of traditional "women's" crafts (another index of the differences between the times).

Both specialize in forms of conceptualized schlock, totally dependent on the aura that the art world provides to distinguish it from objects at a supermarket or crafts bazaar. At the same time, both—paradoxically—represent an attack against "high art." Warhol came from the flank, by insinuation; Chicago's assault is more frontal, couched in current buzz phrases about "elitism" and "relevance." In both cases, the message is basically the same: Any number can play the game, and everyone should be famous for fifteen minutes. And the museum world has rushed—more reluctantly, it is true, with Chicago—to gather their work into the fold.

This is, in great part, because the work of both has brought into contemporary museums large numbers of people who had not previously been conspicuous by their presence. Warhol appealed to a newly affluent leisure class of cultural consumers who wanted to partake of the glamour that seemed to surround "high art" without troubling overmuch with its substance. His work provided a way of satisfying avant-garde pretensions and, at the same time, indulging a taste that was totally banal—of appearing hip while remaining totally square.

Chicago's ceramics and needlework appeal to a different sense of style—anti-style, for Telegraph Avenue Scruffy seemed to be de rigueur among most of the crowds I saw. Their mood, in contrast to the self-conscious decadence and parody of Warhol's heyday, is a kind of laid-back and stultifying earnestness. The casual audience for "art" in the 1970s is indifferent or antipathetic to the image of "avant-gardism."

The new crowds are made up of people who identify largely with "the counterculture"—with a do-it-yourself, crafts-oriented, life-is-art, everyone-an-artist attitude. Yet, like Chicago, they are not content to remain without recognition from the "established" art world. And they seem as indifferent as Warhol's trendy followers to the rigorous, lonely and quite unpublic process by which an artist digs deeper and deeper to create him (or her) self, and out of which a real work of art eventually may grow.

But the Beautiful People brought the art world money from the "private sector"; Chicago's less-beautiful followers, being more numerous, swell the head counts that bring grants from the National Endowment for the Arts and from foundations (the NEA chipped in thirty-six thousand dollars to the *Dinner Party*). Warhol epitomized an era when art became hopelessly enmeshed with Business; Chicago, a time when it has become thoroughly entangled in Politics.

Tàpies's Testament to Human Presence

OCTOBER 8, 1981

Catalan painter Antoni Tàpies occupies a curious niche in twentieth-century art.

He was among the artists coming of age in Europe after the Second World War—Jean Dubuffet, Pol Bury, Karel Appel—who burst forth with radically original styles that more or less paralleled the development of Abstract Expressionism here. Except for Dubuffet, their achievements tended to be overshadowed as the spotlight shifted from Paris to New York.

Yet Tàpies also was one of the earliest artists to explore an area of expression that has become almost a cliché of much abstract painting in the past decade: the use of raw materials—paint, sand, plastics, resins—no longer as *media*, or a means of expressing something else, but as the fundamental *content* of the work itself.

Or almost, for it is one of the dramatic revelations of an exhibition of Tàpies's work at the Stephen Wirtz Gallery that the dense, opaque slabs and doors and walls that have become the hallmark of his painting are charged with an undercurrent of profound and somber poetry. It is a world away from the contemporary fetish for splashy surface effects, where the medium is the only message.

This is, oddly enough, the first time a significant quantity of Tàpies's work has ever been exhibited here. It includes only work from the past decade, and so it will require some later exhibition to trace the rather interesting early phases of Tàpies's development: the paintings of the mid-1940s, which combine the emphatic surfaces of his mature work with crudely scrawled images that resemble the primitivism of Dubuffet's *art brut;* his more thinly painted canvases from the turn-of-the-1950s in which spidery organic shapes float through mysterious interiors in a way that recalls Joan Miró and Roberto Matta.

The show, nonetheless, reveals an artist of broader range than the standard reproductions of Tàpies's work in the art history texts suggest. There are small pieces that transform sheets of X-ray paper into strangely ominous wall reliefs, and there are relatively conventional drawings in which schematic images appear in a wiry calligraphy that recalls Paul Klee.

The centerpieces of the show, however, are the works that show Tàpies at his most characteristic: big paintings covered with thick, sooty slags of oil mixed with crushed stone, into which graffiti and phantom images—a cross, the suggestion of a face—have been carved, or to which handles have been attached to complete the image of a double door. They engage in a dialogue with ragged cracks and fissures that seem more the work of nature than of man.

What is it that makes these apparently inert walls of paint—or, sometimes, mere surfaces on which a few marks are scattered—seem to speak, while so much other painting that superficially resembles it stands dumb? Part of the reason, as

Tàpies points out in the show's catalogue, is autobiographical. To an artist born in Barcelona, and living there through the Spanish Civil War, old walls, with their clandestine graffiti, signified not only time and decay, but became "witnesses to the trials and inhuman setbacks inflicted on my people."

Also, Tàpies notes, his walls evolved from a period of "frenetic movement, gesticulation, incapable dynamism" that made every canvas a "battlefield in which the wounds were multiplying each time till infinity. Then the surprise occurred.... Everything joined together in a uniform mass.... And one day I tried to arrive directly at silence with more resignation.... The millions of furious stabs were transformed into millions of grains of dust, of sand...."

Whatever the case, Tàpies's strongest paintings are not just walls, but portraits. Like all portraits, they are about mortality—of inanimate things no less than of the man-made marks upon them. And also immortality.

For while the significance of the symbols and graffiti changes or dissipates entirely, the impulse to make these marks endures: to assert will and intelligence, a testament to human presence, in an otherwise indifferent universe. As it is with marks on walls, so it is with marks on canvas. This is why Tàpies's paintings are at once simply what they are, and so much more.

Delvaux: Fairy-Tale Maker or Formula Painter?

MAY 1, 1980

James Ensor, René Magritte and Paul Delvaux are Belgium's three best-known twentieth-century painters.

Ensor (1860–1949) was the strongest artist. Magritte (1898–1967) was the most fertile idea man. Delvaux (born 1897) is the one whose work has been sent here for the "Belgium Today" observance of that nation's 150th anniversary.

Delvaux is usually represented with a single reproduction in most anthologies of Surrealism and in the more comprehensive surveys of twentieth-century art. The fifty or so oils, watercolors and graphic works on display at the San Francisco Museum of Modern Art do not add much to the standard picture.

Delvaux was almost forty before he encountered the painting of Giorgio de Chirico and turned to Surrealism; he destroyed many of his earlier works. A few, dating back to the mid-1920s, are here: a dark, Cézannesque landscape; heavy, statuesque female figures akin to Picasso's Roman style; softer, more vulnerable ones, in thin watercolor and a Rococo pen line, that are closer to the sugary side of Marc Chagall.

By 1940, as far as the present show goes, Delvaux had begun to paint The Picture. Its earliest version here is a large canvas called *The Man in the Street* in which a bowler-topped man—typical of Magritte's dapper protagonists—stands engrossed in a newspaper, oblivious to Classical ruins and a wasted landscape behind him, as well as to three female nudes nearby; they are equally self-absorbed, each in her own reality, or dream.

Subsequent paintings are hung in no strict chronological order, but it scarcely matters with Delvaux. Essentially, he has continued to paint the same picture over and over, with minor variations in setting and mood. Classical architecture sometimes gives way to sumptuous Baroque interiors, empty waiting rooms, suburban landscapes or streets that pass between monotonous row houses. For a time, the somnambulistic figures are replaced, or joined, by Ensor-like skeletons.

In general, the nudes grow more slender, flaccid and pallid; the settings, especially in Delvaux's paintings of the past decade, become more sparse and generalized; the sky is more often nocturnal or, rather, suffused with the eerie twilight which, in high summer, glows almost to midnight about Brussels, with its orderly files of look-alike flats, and which similarly found its way into many of Magritte's paintings. Surrealism is often not the invention it seems.

The great problem of Delvaux's work is not that he has basically painted just one picture; it is that the picture has not lent itself to development, to the kind of organic growth by which an artist and his work create each other in tandem, and evolve toward ends that even the artist himself could not have foreseen—thus bringing into being forms that had not existed before.

To be sure, Delvaux's paintings, like

Magritte's, are more "painterly" than reproductions of his work usually indicate: most often, softly brushed and creamy—or rather (powdered) milky, for the surfaces, while opaque and fluid, are also somewhat dry.

But, for all that, The Picture is basically a form of *illustration*, depicting a species of mute, immobile theater—a few standard backdrops against which the same cast appears again and again in various charades. Unable to grow in form, The Picture changes only in the shuffling and reshuffling of the same images—primarily borrowings from de Chirico and Magritte, almost clichés before Delvaux had begun.

At most, Delvaux is a maker of fairy-tale illustrations that sound a single minor key of languorous melancholy. At worst, he is a Walter Keane–style formula painter who adds little or nothing to his sources, other than a preference for bare bottoms and bosoms.

But that is no doubt enough to secure his place in this branch of pictorial, "realistic" Surrealism, the edge of which dulled soon after its origins in de Chirico's haunting early paintings, and Max Ernst's collages. With Salvador Dali's shrewdly exploitive paintings of the 1930s, it became the first twentieth-century art style—but not the last—to be indistinguishable from kitsch.

'Yesterday'—and an Exciting 1970

MAY 4, 1969

"Just Yesterday," which opened last week at the San Francisco Museum of Art, is a show that focuses somewhat narrowly on "a major development in the art of the Bay Area during the past eight years."

September, 1970, just published by the new Dilexi Foundation and Lawrence Halprin & Associates, is a prospectus of an all-encompassing happening scheduled for San Francisco next year. These two unrelated events offer an intriguing spectrum of the prevailing mood of Bay Region art today—er, "just yesterday"—and, to sustain the metaphor, tomorrow, or perhaps the day after. And they follow with a strange, but inexorable, logic.

"Just Yesterday" was organized by curator John Humphrey as a sequel to "On Looking Back," his survey of Bay Region art from 1945 to 1963 last summer; in the early publicity, the current show was entitled "On Looking Around." The change in title suggests a certain retreat from contemporaneity, a resignation to the inevitable gap between the creative act and the time when those of us who make up the so-called art establishment get around to recognizing it, and this suggestion is borne out by the show; for the most part, it is already history.

The change also suggests that at some point the idea of "Looking Around" was modified, or dropped, in favor of a more restricted theme, and this, unfortunately, is also confirmed. The "looking" has been done in all the most conspicuous places, notably the faculties of the San Francisco Art Institute, and the University of California at Berkeley and at Davis, and it has centered on the most conspicuous trend, namely biomorphic, erotic, Dada-Surreal, mythological symbolism; in a word, Funk.

As a retrospective of historic Bay Region Funk, etc., "Just Yesterday" is a magnificent, flamboyant and probably definite survey. It contains sixty works by twelve seminal artists, arranged in a way that underlines the strong influences they have exerted on one another, and a general development from crusty, low-keyed pieces with roots in Abstract Expressionism into the wildest forms of Dada, Surrealism and Symbolism, with, in a few cases, a striking synthesis of the old-fashioned biomorphic aesthetic with the new aesthetic of the machine.

The first room contains the earliest pieces, and it underlines the crucial role performed by ceramics in the transition from Abstract Expressionism to Funk. The accidents of shaping, firing and glazing, the surface gnarls, eruptions and crusts gradually begin to function as forms and images with their own meanings and associations. Harold Paris is represented with a craggy, gargoylesque 1957 figure, a gnarled 1961 bronze tableau and a 1963 construction of broken ceramic slabs and eruptions which remind one that this smoothest of current sculptors was once one of the grittiest.

There is a pair of Peter Voulkos's ceramic transformations of the shapes of pots, as well as his monumental geological upheaval of bulges and creases, the *Little Big Horn* from the Oakland Museum. Robert Arneson's two early pieces are reminders that he was not always as slick and coy as the high-glaze ceramic telephone which represents his more recent work; James Melchert's 1963 *Son of Slow Boat,* with its gutsy tubes coiled within a totemesque box of weathered wood, bears a similar relationship to his new *Game in Layers.*

The 1963 watercolor drawings by Jeremy Anderson, with their maps and floor plans of Sacred and Profane Groves and the "Purple Passages" in the Palace of the Legion of Dishonor, spotlight the black literary current which runs beneath so many of these visual metaphors. So do the new paintings of Fred Martin, with their schematic phalluses and chalices swirling amid a more abstract calligraphy of darkish color on a gray space.

William Geis's clawlike forms of painted plaster and fiberglass, with their geometric armatures and bases and schematic painted images, form an inspired link between the show's first section and the sections devoted to more recent pieces, in which browns and grays give way to gaudy, cartoon-inspired colors and natural materials generally yield to the man-made. There is an inspired juxtaposition of Arlo Acton's 1964 construction combining richly stained woods with the gaudily painted sphere of a cement mixer and Robert Hudson's spindly, open-ended *Inside Out* sculpture of the same year.

The classical feeling inherent in the dynamically balanced structure of Acton's piece, which looks like a fantastic moose, comes to the surface in his later rocking and spinning titanium spheres; in Acton's newest work—a large suspended ball which swings above a second ball that rests in a triangle of water, setting up chain reflecting images from all over the gallery—the organic spirit of Funk merges with the architectural spirit of the High Renaissance.

Acton's monumental new work is one of the finest contributions of "Just Yesterday." Another is Harold Paris's somber black room, called *Conversations on a Black Afternoon, April 6, 1968, 6:01 p.m.;*

it is a tomblike monument to Martin Luther King, Jr., and one feels a blast of chill air while stepping inside, where a pair of inscrutable, organic forms push up from the floor with somber moment.

The show's finest contribution to yesterday is its revival of the work of Don Potts. His *Up Tight and Out of Sight,* with its laminated wood floors edged by fur pieces that rub together as the floors wobble on suspension bases, is a monument of kinetic eroticism. So, despite its warped, shrunk and off-center condition, is Pott's *Rocker,* with the lithe, dynamic arabesques of its outline and its wealth of hilariously suggestive associations.

The *November Work Table* of William Wiley exemplifies the newest development of Dada-Funk toward an antimonumental, quasi-documentary expression of the most nonchalant and casual kind.

Norman Stiegelmeyer's paintings range from the 1965 *Baptism* to the 1967 *Toward a Brighter Realm,* but the brighter realm expressed in his most recent work has not been included; even so, his painting has only the most tenuous, superficial relationship to the rest of the work on display, and it serves mainly as a jarring reminder of how much of significance in Bay Region art during the past eight years falls totally outside the Funk purview.

Funk art is, of course, Bay Region art. It says so in the *New York Times.*

But to consistently spotlight Funk and leave the vast variety of other vital local expressions out in the shadows is to perpetuate a romantic myth about Bay Region art which is increasingly untenable.

One ingredient of this myth is that Bay Region art is still an underground art; another is that no one is making any money out of it. This may have been true

once but Funk has become successful, and academic, almost in spite of itself.

This ingrown situation is inspiring artists to respond in various ways. Potts is working with machinery in his studio, and Paris is currently creating a room which he plans to complete by sealing it up forever.

Another reaction is exemplified by the silly show of "idea" art at the San Francisco Art Institute, a potpourri of ephemera that no one would look at twice were it not occupying an art gallery and attended by the customary publicity and theorizing. It is the ultimate babbling offspring of artistic inbreeding.

September, 1970 is also a work of idea art in its present stage, but it represents a reaction of a diametrically opposite, tremendously exciting kind. Its goal is "to use an entire city and its population as an art medium" through "a series of related urban events designed to deal with the city—specifically San Francisco—as a place of creation and involvement for its citizens and for a group of especially invited artists from all over the world who will design events using the city as their medium."

The prospectus for *September, 1970* comprises a "score" for executing and coordinating these urban events, which is as fundamentally simple, and as far-reaching in implication, as anything Pythagoras ever conceived. The city is divided into thirty-five parcels of one square mile by superimposing a page from the 1970 calendar, from August 30 to October 3, over a map of San Francisco; each of thirty-five invited artists will be responsible for events taking place within the square mile of the city that lies within his particular day, a couple of which fall out in the water off the Golden Gate.

The score is further developed into a third dimension, in which the topography of the various parcels is correlated with the day's twenty-four hours to work out a system for peaks and valleys of activity. Finally, there is a complex system for relating events taking place in different parts of the city, and another for relating events everywhere in the universe.

The Dilexi Foundation is currently at work securing backing for *September, 1970,* a factor that fits less neatly into predetermined scoring, and one wonders in what way the score will finally be worked out to include the most unpredictable factor of all, the people.

Jim Newman, the foundation's director, says he wants as much as possible to steer clear of "bringing art to the people," to draw upon existing grass-roots events, stimulate others, and use the mass media and other devices to make people more aware of what's really happening in their daily lives. A good idea, but it presents the danger that a handful of people will be meditating on the significance of It All, while nothing at all is happening for everybody else. And why invite artists when what is really needed are neighborhood organizers?

On the other hand, giving artists undue control over the project could result in a self-defeating kind of cosmic neighborhood arts program, even if there were such beneficent results as inviting Christo to put a giant brown paper bag over the new Bank of America building.

All this really means is that the infinite possibilities of *September, 1970* include the possibility of failure. They also include the possibility of a totally unprecedented expression of life as an art form, and I, for one, hope that they are given the chance to pull it off.

'Realism'—A Wide Range of Styles and Approaches

FEBRUARY 17, 1980

One of the paradoxes of "Realism," the big group show put together by Carl Worth and Marvin Schenck at the Walnut Creek Civic Arts Gallery, is that it makes its "statement" primarily by means of abstraction.

A principal attribute of "realism," or relatively literal representation, in art—and, no doubt, a great advantage to most realist painters—is that it can so successfully conceal what it is saying behind what it seems to say. Abstract art stands naked—an artist's intention either is revealed, a fully realized union of appearance and expression, or it is obviously nothing, a mere decorative (or indecorous) surface with nothing underneath.

"Realistic" art, on the other hand, offers a surface—a picture to look at—as well as a certain "objective" standard of "technique," that can beguile a viewer into believing it is unimportant to investigate whether anything else is occurring behind it. Abstract Expressionism challenged one to look not at, but *into* a painting. When applied to figurative art, this approach had its disadvantages; one sometimes looked right past things that it was important to see. But the perils are even greater when this kind of interior perception is abandoned altogether to focus exclusively on the externals of imagery and style, a development that has been encouraged by Formalist abstraction as well as the revival of realist painting, and its renewal of emphasis on iconography. Satisfaction with surfaces alone has fostered a surface art—as it has superficiality in other areas of contemporary life: surface political candidates, surface television news, surface ...

In fact, the most interesting thing about "Realism" is that it brings together work by thirty-four painters who use a wide range of styles and approaches, whose subject matter runs the gamut from landscape to freeways, flowers to bathrooms, and whose paintings add up to an inescapable, overwhelming impression of depressing sameness—a sense that behind them, there exists nothing at all.

There is an overriding dumbness, in both senses of the word, not only to the choices of imagery but also to the ways in which it is treated. Worth points out that a sense of "distance" arises partly from the deliberate omission of the human figure in the choice of paintings for the show.

But it is characteristic of the Photo Realist approach that, even when the figure is present, it is treated as still life— or, rather, as simply spots of light and shade, or color, like any others, on a flat surface. And while relatively few of these paintings could be called Photo Realist per se, the Photo Realist esthetic is present in virtually all of them. What one misses is not the absence of images of people in the pictures but the absence of a person—an artist—inside of them.

This vacuity is thrown into relief by the few paintings here in which it does not appear—by Wayne Thiebaud, Gordon Cook, Charles Gill, Anton Gintner. Thiebaud's *Delicatessen Counter* from the Oakland Museum—although not one of his best paintings—and Cook's small watercolor-and-pencil *Top,* reflect a real *involvement*, paradoxical and equivocal though it may be, both in the subjects and

in the means and materials—the *artifice*—by which they are translated to canvas. There is a sense of both anxiety and overriding, superreal presence, as though acutely conscious of the basic impossibility of trying to recreate the illusion of reality, the painters seem to succeed in infusing a "lie" with the power of truth through the sheer persuasiveness of their effort to do so. The real "subject" of their work is not objects or surfaces, but the obsessive intensity of their arguments. It may not be irrelevant that Thiebaud, Cook and Gill share roots in the Bay Area Figurative tradition, which was basically a branch of Abstract Expressionism.

Gintner achieves a soft-spoken, Hopperesque feeling in his subtly atmospheric paintings of the Nimitz Freeway and the shabby Art Deco of *Venice, CA.* One can also sense an oblique involvement in the surrealistically lurid display windows of Jack Mendenhall's paintings, in the muted atmospheres of Willard Dixon's landscapes, and in Robert Bechtle's Homeresque *Warm Springs Patio.*

Most of the paintings, however, are basically little more than surfaces—sometimes effulgent, as in Joseph Raffael's watercolor, *The Season of the Frog;* sometimes cool and austere (George Dombrek); sometimes intricate and detailed (Setsuko Karasuda); occasionally soft and seductive (Wilma Parker, Mary Snowden); often hard, polished and slick (Chris Cross). One painting seems virtually interchangeable with any other. Soft-focus or hard, "painterly" or crisp, distant vista or close-up "abstraction," this is painting that fundamentally has only one thing to say: a pedestrian, nine-to-five professionalism in which technique and effects are basically all that count.

Even the landscape paintings of Ralph and Martha Borge—borderline kitsch (an older kitsch, as distinct from the contemporary variety)—have a stronger sense of involvement, of feeling, than most of the other work here.

In the end, the "realism" of most of the paintings in "Realism" seems paradoxically immaterial; in any basic sense, they are primarily abstract—removed, via the use of photography or technical approaches, not only from the subject, but from the artist—or at least from all but his eye and fingers. This work sometimes seems a counterpart to quilting.

If Bay Area Figurative painting was basically a branch of AE, the work in "Realism" is principally an outgrowth of the cool Pop art and Formalist abstraction of the 1960s: Pattern Painting in which the patterns happen to take the form of images recognizable in the world of "reality."

Its esthetic, if such it can be called, is the commonly held view that what one paints (or sculpts or photographs) is of no importance; it's how it's done that counts. But to thus glorify technique and style is as erroneous as saying that the subject is all-important. Anything less than a total fusion of form and content leads to illustration on the one hand, decoration on the other. Much of this "realist" painting is decoration done in an illustrational style. But a combination like that can scarcely miss—and hasn't—in the supermarkets of contemporary art.

Realism, Romanticism and Leather

FEBRUARY 24, 1978

It would be hard to imagine two more sharply opposed groups of pictures, both falling under the broad umbrella of "straight photography," than the displays by Weegee and Robert Mapplethorpe at the Simon Lowinsky Gallery.

Weegee—aka Arthur Fellig—was, of course, the celebrated New York news photographer whose starkly immediate, harshly illuminated views of the undersides—sometimes soft, more often tough and seamy—of city life were compiled in one of the most memorable photography books of the late 1940s, *Naked City.*

In later years, Weegee ventured into more experimental techniques, but the exhibition contains only one example of this interesting, if often gimmicky, work—the familiar 1960 *Marilyn Monroe,* in which the face is distorted to a focal point in a grotesquely twisted pout. The bulk of the collection consists of work dating from throughout the 1940s—straightforward, blunt, generally nocturnal scenes, spotted in the violent glare of the old-fashioned flashbulb: a bloodied body on a sidewalk in the Hell's Kitchen; a *16-Year-Old-Boy Who Strangled a Four-Year-Old;* a dowdy frump observing poshly decked out arrivals at a concert; children sleeping on a Lower East Side fire escape.

It is tempting to see Weegee's mordant realism—or what passes for such, for "realism" in photography, as elsewhere, is principally a matter of convention—as an anticipation of the photography of Diane Arbus. But, although Arbus was an admirer of Weegee's work—and, one suspects, the prestige her photography attained has played a role in the increasing artistic respectability that Weegee's work has enjoyed in recent years—there are important differences in their esthetics.

Weegee's photographs lack the obsessive feeling of Arbus's (one doubts he would have taken much interest, for example, in the hapless retardates upon which she concentrated in her last works); they are, rather, the candid surface impressions of a fascinated, but detached, voyeur. And they bear the inimitable stamp of their time and place; one can practically smell the cigar and the exploding flash, hear the city editor barking in the crisp, metallic tones of Humphrey Bogart. Which is to say that the "realism" of one era becomes the "romanticism" of another.

Mapplethorpe is a distinguished collector of photography, specializing in quite respectable work from the nineteenth century, some of which is on display at the University Art Museum in Berkeley; his own photography is, one

might say, something of a contrast.

Mapplethorpe's primary subject is heavy-leather, hardcore S-M—men in wet suits, bulging crotches, here and there a fully exposed genital (Lowinsky says he edited out some of the heavier imagery, which is scheduled to be shown next month at 80 Langton Street); these images are interspersed with somewhat more neutral ones, such as a nude shot of Patti Smith and, oddly enough, close-ups of flowers. Given the context, these take on a curious fleur-de-mal quality although one suspects that, seen by themselves, they would scarcely command a second's attention.

In fact, subject matter aside, Mapplethorpe's photography is pedestrianly conventional: rigidly posed, crisply focused, somewhat melodramatically illuminated in the clichéd style one might find in the commercial photography of the slick glamour magazines. The message is the message. It is, at any rate, consistent—in contrast to the naturalism of Weegee's work, with nowhere an unfalse work. But then artificiality is of the essence of decadence, which is really just another form of conspicuous consumption.

Imitative Realism Has a Way of Coming Back

JULY 13, 1980

"Art does not reproduce the visible; rather, it makes visible," Paul Klee wrote in 1920 in his "Creative Credo," a statement which itself has become a credo for most art of the twentieth century.

Klee thus summarily shut the door on a tradition of imitative art that, if Pliny the Elder is to be believed, must already have been long established by the fifth century B.C., when the artists Parrhasius and Zeuxis engaged in their fabled competition to see who could create the most convincing illusion of objects in the "real world."

However, in art, doors that seem to have been sealed shut by one generation have a way of being reopened by a later one. Imitative realism, or "illusionism," in particular, with its almost primal fascination—akin to that of a sleight-of-hand act—always has a way of coming back.

At a time when virtually everything is In, and styles and forms which had long seemed safely dead and buried are being exhumed, if not always revived, it is not, therefore, surprising that trompe l'oeil illusionism has been among the few discernible trends in the painting (and some sculpture) of recent years. It is now the subject of an extensive survey of more than eighty artists, "The Reality of Illusion," that fills the Great Hall at the Oakland Museum. Organized by the University of Southern California Art Galleries and the Denver Art Museum, it is, by all odds, the most abject display of contemporary art since the big survey of that other current trend, "Narrative Art," appeared at the University Art Museum a year or so ago.

It was once commonly theorized that art inclines to abstraction in cultures, or times, of great stress, and to realism when societies feel more confident. If that theory is correct, this would scarcely seem to be an age that one could expect to produce great monuments of intensely committed artistic "realism." But then realism, or "reality," in fact seems to possess a tenuous, extremely equivocal status among most of the work here.

True, there is a quantity of things that fall solidly within the mainstream tradition of straightforward, trompe l'oeil deception, most notably Duane Hansen's installation, *Self Portrait with Model.* Trompe l'oeil, to be convincing, cannot depart radically from depicting the shallow space and the kinds of objects that correspond most closely to the flatness, and the scale, of the painted canvas itself, Alfred Frankenstein observed some forty years ago in his pioneering study of the trompe l'oeil tradition in nineteenth-century American painting. With the advent of such new materials as the polyvinyl acetate with which Hansen molds his lifelike, life-sized figures—and the contemporary willingness to accept as "art" a form of literalistic replication that perhaps belongs more appropriately to the wax museum—the range of possibilities that trompe l'oeil can successfully encompass has obviously greatly enlarged.

But such virtually unqualified exercises in virtuoso, eye-fooling deception are in a distinct minority. In almost every case, the artists here are at pains not only to essay a visual deception, but more or less clearly to let the viewer know, almost in the same glance, precisely the extent to which he is being deceived. Thus, Richard Haas frames his view of the New York skyline, seen through ajar french doors, with a doorjamb of real wood; it

functions not to enhance the verisimilitude of the illusion but, by pitting "real" object against painted image, to emphasize its artifice, its physical existence as mere marks on a flat surface.

Kathleen Calderwood pays tongue-in-cheek homage to William Harnett by rendering, against a backdrop of painted fragments from the Sunday comics, a hunting still life that centers around a plucked Donald Duck. Sylvia Mangold's painting is a veritable Scholastic dialectic between, or among, varying layers or levels of physical, tactile "reality" and sleight-of-hand, or -eye, illusion.

Although Photo Realism per se is, somewhat surprisingly, conspicuous by its virtual absence from the show, such work as this is basically an extension of the Photo Realist esthetic. It is concerned, not with the replication of *things*, but the replication of *surfaces*—not with representing or picturing concrete, three-dimensional objects in "the real world," but with picturing pictures of things. This is, in essence, a form of abstraction rather than of "realism," or even of a thoroughly committed illusionism—a variety of Pattern Painting in which the patterns happen to take the forms of recognizable images. It is not given to a self-confident affirmation of reality, but to calling it into question.

It may be, then, not the expression of an overpoweringly self-confident culture but, rather, of a superficially self-satisfied one—one that feels on secure footing while contemplating the "objective" verities of the traditional technical virtuosity, and even when indulging in the "reality sandwich" conundrums and sophisms dear to undergraduate philosophy students; beneath the flawlessly engineered surface, however, it seems virtually paralyzed by a dreadful insecurity about what it really believes.

However, this is probably to take too seriously a collection of work, most of which has as its highest ambition enticing itchy-fingered viewers to drive security guards up the wall.

The largest single contingent of work within the exhibition represents a genre that has been given the label Abstract Illusionism and is a kind of Photo Realist abstraction. Its subject matter is not any recognizable imagery from the "real world" at all, but abstract painting—most often, the kind of post-Formalist abstraction that was on the ascendancy early in the 1970s, in which a lingering geometric substructure—targets, grids—is overlaid with the thick, impasto surface effects—brush marks, brightly colored spatters and globs—that came to be emphasized when people like Georges Mathieu and Antoni Tàpies were turning Abstract Expressionism into "confectionistic" decoration. Such painting is translated by Abstract Illusionists like James Havard, Joe Doyle, Jack Lembeck, Richard Johnson and James Reed, into a kind of Photo Realist *representation* of itself. Some of the surface globs are as thick as they appear, but they more often are thinly brushed, or sprayed, so that they only look that way, via the play of advancing and receding colors, and meticulous, trompe l'oeil modeling and shadows.

The work of some of these painters is more "painterly" than others; in some, the surface forms seem to hover over an illusion of greater depth. But most of these paintings are as interchangeably alike as the most cliché-ridden examples of more

conventionally Photo Realist pictures, as puerile and empty as the kind of abstract painting that they imitate, or parody, and more vulgarly garish. They look like canvases on which someone has spit out greater and lesser amounts of half-eaten jelly beans. Except when they look even worse, like Michael Gallagher's gaudy excrescence of illusionistic brush strokes and grids.

Complementing such illusionistically "painterly" examples of Abstract Illusionism are various examples of geometric abstraction in which an illusion of depth, achieved by tricks of perspective or trompe l'oeil shadows, plays a significant part: works by Ron Davis, Allan d'Arcangelo, Jack Reilly. On the other hand, Abstract Illusionism shades by degrees into paintings in which the subject of the illusion is relatively more recognizable: Tschang-Yeul Kim's close-up views of enlarged water droplets and Stephen Posen's paintings of crumpled fabrics; Richard Hoder's John Haberle–like aggregation of trompe l'oeil ticker tape, typewriter ribbon and ruled notebook pages; George Green's vertical bands of overripened color, which look like dangling strips of Naugahyde; Jill Hoffman's cast latex *Information Wall;* and—perhaps the most successful of the show's illusions— the canvas painted with an image of plywood streaked with runny washes of white paint, and called *Plywood with Rolled on Washes* by the former Photo Realist celebrity, John Clem Clarke.

There are a few isolated works that make perception itself their principal subject, such as Tom Hatch's assemblage of reflecting mirrors, transparent glass and little model chairs and tables, and Jay Willis's similar, Exploratorium-like installation. There are miscellaneous things such as Jack Radefsky's screen with its schlockily cosmetic, spray-painted shadows. There are more things in the imitative vein of Hansen's tableaux: Marilyn Levine's ceramic imitating leather, Lukman Glasgow's ceramic imitating rope, rock and a chrome-plated faucet.

And, heaven be praised, there is even one exceptional work of art, a painting by Guy John Cavalli that plays spacious planes of subdued color against narrow bands of subtly graded pastels, creating an illusion of folds that advance and recede in space—but, much more important, an *expression* in which evocations of vibrant energy are magically harmonized with a sense of profound serenity.

Art need not, of course, be abstract to "make visible," as so many Modernists for so long held that it must. Abstract art always "represents" ideas, feelings, intimations, that lie beyond itself—or else it is mere empty decoration. "Representational art," on the other hand, if it is art at all, does not tie itself so slavishly to the world of appearances, to surfaces, or to "technique" that it fails to come alive as a self-sufficient *organism*, a new fact that takes its place alongside other forms of life existing in the world of "real things."

In an exhibition where so much work labors so hard to represent, to illustrate, to make some kind of point about the nature of perception or "reality," Cavalli's is the one work that seems to aim, simply but fundamentally, to *be*. Which is probably why it seems hopelessly, and rather gloriously, out of place in this truly forlorn company.

A Sculptor Who Broke Barriers

JANUARY 24, 1980

Alvin Light, who died last Friday at the age of forty-eight, was a sculptor whose work stood for many of the most enduring values in the tradition of Bay Area art—or art in general.

Born in Concord, New Hampshire, in 1931, Light grew up in Stockton, California. He enrolled at the San Francisco Art Institute in the early 1950s, and remained there—as a teacher after his student years—for the rest of his life.

The 1950s were an explosive time in the local art schools, studios and whatever other spaces artists could find. Beat artists were concealing esoteric insights in sarcastic, outrageously funky assemblages. New Realist figurative painters like David Park, Elmer Bischoff and Richard Diebenkorn were commanding international attention. The epic, visionary abstraction that Clyfford Still had achieved when he was teaching here in the late 1940s had largely solidified into a vocabulary of forms among his more slavish followers, but Abstract Expressionism remained a vital force.

It branched, on one hand, into an energetic, improvisatory, jazz-related action painting. On the other, it developed into the grave, weighty, anxiety-ridden expression epitomized by Frank Lobdell, whose heavily painted, bone or clawlike forms—neither totally "abstract" nor quite "figurative"—seemed to struggle for freedom from forces that bound them to the earth. It seemed somehow tenuously to span the impossible chasm between Still's conception of art as *revelation*—an Absolute beyond criticism or even comment—and the less transcendent and forbidding notion of existentialist trial-and-error, search-and-discovery, associated with de Kooning.

Setting up a studio with Manuel Neri in a cramped basement beneath the Caffé Trieste in North Beach, Light developed an expression that seemed to parallel Lobdell's in the medium of wood. Breaking the barrier that had traditionally divided the territories of painting and sculpture was a common goal of many artists in the years just before the purism of the 1960s gained sway.

In Los Angeles, Peter Voulkos attacked clay with the unprecedented, violent force with which artists like Pollock and de Kooning had attacked paint. Approaching his less malleable organic material with a combination of patient respect for its properties and willful self-assertion, Light created a similar Abstract Expressionist sculpture here.

Working with rich natural woods (and an occasional fragment of furniture), Light chiseled, chipped, notched, hollowed, mortised and laminated to make great, rugged chunks that have a raw, expressive vitality. He joined these together in towering, gnarled, convoluted forms that, like Lobdell's, were not figures but, at their strongest, were extraordinary *organisms*, totemic and monumental and

also alive with an athletic, acrobatic torsion, thrust, isometric tension and soaring expansion.

These were sculptures that preserved the immediacy and movement of gestural painting—and frequently included daubs of color along with the richly textured marks of the saw, chisel and ax. And they were assemblages that had the tough, intractible unity of objects produced by natural forces: rocks, pinnacles, eccentric trees.

Light's work had a certain influence on the so-called polychrome movement that developed in the early 1960s—the early hybrid painting-sculpture of Robert Hudson, William Wiley and William Geis. But while their work turned increasingly to parody and satirical grotesquerie, Light continued to follow his own increasingly solitary path.

His solemn, self-contained art did not change dramatically; but it maintained its force, depth and soft-spoken authority. His recent work seemed closer to the ground but less earthbound and more open, capable of imminent flight.

Light was not prolific; he showed rarely. He had worked for years in a studio above Harrington's bar on Front Street. His quiet, but forceful and uncompromising work was a major landmark of Bay Area art, and a more important contribution to the larger scene than Light was credited with when he was alive. A memorial exhibition is much in order.

Hockney's Delicate Balance

NOVEMBER 23, 1979

There is a certain subspecies of person who might be categorized as the Professional World Traveler.

He is usually self-possessed, urbane but unpretentious, with no strong political or social attachments that would prevent him from going to a given country, from staying at the Hilton or the Y. He has visited most of the major capitals of the world, but never lived in any very long.

In many places he has acquaintances with whom he stays—but few, if any, intimate friends. He is often fluent in several languages, without having much of great import to say in any of them. But he is capable of holding our attention, to a point, with accounts and anecdotes that skip lightly over the general and the abstract, and dwell on the specific and the concrete—people, places, events.

This has always been much my impression of the work of David Hockney, and so the title of the big show of his prints and drawings now at the M. H. de Young Memorial Museum seems particularly well chosen: "Travels With Pen, Pencil and Ink." The exhibition—the first full-scale survey of Hockney's work to appear in an American museum, according to one of the extensive wall legends by Robert Flynn Johnson, the show's curator—includes more than 150 works, filling almost the entire space recently vacated by the big "Treasures of Tutankhamun" show.

It seems vastly disproportionate to Hockney's considerable but really quite modest, limited and greatly overestimated achievement. It might well be too much for any show of intimately scaled, more or less informal, graphic works. Despite a commendable installation, all but the most ardent Hockneyite is almost bound to OD.

There have been several reasons for Hockney's popularity in recent years, many of them specious: his much spotlighted homosexuality and identification with the gay life-style, for example. Figurative painters in general, on the defensive since the 1940s, were quick to enlist him in their continuing polemic—essentially a matter of art politics—against abstraction.

But the principal strength—and also limitation—of Hockney's art is probably its attitude of disengagement without being feelingless, a stance that appealed to the past decade's general disenchantment with passion while stopping short of nihilism and parody: detached but not unsympathetic, affectionate without being deeply committed, a delicate balance of sentiment and irony.

Hockney's earliest graphic works from the early 1960s obliquely reflect the irreverence of Pop art in their playful and somewhat perverse takeoffs on historical art styles—*American Cubist Boy, Berliner and Bavarian,* the latter both caricatures out of George Grosz.

In subsequent works, Hockney alternates between two basic styles—or, rather, approaches, for he is principally an eclectic who has no particular style of his own, but an attitude that enables him to handle many different styles with a distinctive personality.

Hockney generally returns to the pastiche approach of his early drawings—most often a mixture of "modern" idioms and archaic or quasi-primitive ones—when he turns his attention to more fantastic subjects: illustrations of Grimm's fairy tales, a suite devoted to Picasso's *Blue Guitar.*

Like most travelers, however, Hockney is at his sharpest when he is simply relating facts—specifics—that he has ex-

perienced directly, and what he feels about them. He does this most efficiently and thus effectively, in a plainspoken, almost prosaic style that is just a stray hair (or less) away from academic illustration in an old-fashioned, Pre-Raphaelite sense.

Perhaps his most satisfying things are the many informal portraits (which he treats almost with the detachment of still life) of *Henry* (Geldzhaler) and *Celia*—the former, a sequence of impassive masks that sometimes seem to be the real faces; the latter, almost a different person each time she is portrayed, yet, in many ways, merely her various masks.

Hockney is also frequently able to convert a modest still life into a kind of portraiture: chairs upon which people have left hats and other personal belongings; views from hotel windows, which sometimes imply much of the character of the city that lies beyond.

"It can be any color; it's movable, it has no set visual description," Hockney is quoted on his fascination with water. This seems true also of almost every facet of his art. One could, perhaps, call his measured, reserved expression a kind of contemporary classicism, a balance between the excesses of Expressionism and the tautologies of mere "information."

One can also call it tepid, bland and noncommittal, a clever compromise between sentimentality and a dry, tongue-in-cheek mockery.

Whatever, it seems to correspond to a state of mind that has run strong in our cultural life during much of the last decade. And, for me, a little of it goes a very long way.

Arneson's View of Life in Sculpture

DECEMBER 4, 1981

Robert Arneson, whose ceramic sculptural bust of Mayor George Moscone has created a furor as the artistic centerpiece of the new Moscone Center, says he considers himself to be a contemporary American "realist."

However, as many observers of contemporary art have discovered by now, realism in American life today is almost inseparable from so-called pop—pop artifacts, pop "culture," Pop art—and, for that matter, from the surreal and irrational.

Arneson, the Benicia sculptor whose reputation as an artist is international, is aligned in a general way with contemporary writers such as Kurt Vonnegut, Thomas Pynchon, Tom Robbins or William Burroughs, who present a view of life that often resembles a caricature or cartoon. This is basically what Arneson has done in his representation of San Francisco's assassinated mayor.

Moscone's head—the only portion of the sculpture visible at the hall's grand public opening on Wednesday—straddles a fine line between photographic realism and the kind of caricature one finds in a David Levine drawing. The somehow grotesquely inane smile, the eyes, the entire expression has the feeling of a mask—the kind of mask that politicians characteristically wear when they are up for election, shaking hands, kissing babies, speaking on the tube. It amounts to a kind of caricature of a contemporary politician.

The pedestal—which city officials eventually decided, at least temporarily, to unveil—is what gives the bust its wider meaning, its social context. Conceived, in Arneson's words, as a "montage of graffiti, something like the New York subways," it is covered with crudely inscribed lettering and schematic, cartoonlike images, somewhat the way a child might fill up a blackboard. Some of the words and images—many of them provided to the artist by Moscone's widow—are biographical, several extremely personal. There are a few of the mayor's favorite sayings—"Duck Soup," "Is Everybody Having Fun?" There are the words "Shorty Roberts at the Beach," a mystery to Arneson himself, but referring to one of Moscone's favorite old San Francisco hangouts in the days before he became a public figure. There are the words "Hastings Law School," referring to Moscone's educational background.

Other phrases and symbols—many of them taken from newspaper headlines and reports—center on the assassination, which, as Arneson points out, is "a part of Moscone's life."

The murder of a public figure is also part of the life of the body politic. So there are spatters of red glaze that suggest drops of blood, imitation bullet holes, the profile of a pistol over the words "Smith & Wesson," "Chief's Special." There is an image of City Hall, with the words "Leaky as a Sieve," quoting from a contemporary commentary on City Hall security. There is the phrase "He Hated to Lose" (referring to Moscone's assassin, Dan White), together with a shadow which leads to "Room 237," the office number of assassinated Supervisor Harvey Milk, and then

the words "Harvey Milk, Too"—a telling touch, since it serves as the only reference in the entire center to the fact that Moscone was not the only public figure assassinated on that day so many people might like to forget. Elsewhere are the words "Feinstein Becomes Mayor."

Part of the virtue of Arneson's piece is that it does not permit us to forget a historic event which, if people are to be fully aware of the forces that help shape the collective life of that amorphous but very real thing they call the public, people had damned well better remember.

Perhaps the strongest aspect of Arneson's sculpture as a work of public art is the broad picture of the times that it so graphically, if schematically, portrays. It pictures the life of a rather ordinary man, a politician who became the mayor of a major American city and was gunned down by another politician who was, if anything, an even more ordinary guy. It does this in a way that combines the flat and emotionless reportorial style of the daily newspapers with the kind of shorthand symbolism found in cartoons. The form is therefore an expression of irony, and a mirror of irony as well, mixing the banal and the extraordinary—the realistic and the caricature.

Arneson has achieved here the same kind of blurring that is sometimes associated with watching television, where factual accounts may be perceived as both grotesquely vivid and curiously remote and unreal at the same time.

The work, in essence, typifies Arneson's artistry. The sculptor, whose pieces have been exhibited in many of the most prestigious museums in the United States and Europe, is recognized as a major influence in the development of a "ceramics movement" that has been strongly rooted in the Bay Area and has sprouted up throughout the nation in various forms.

The movement—led by Arneson and Peter Voulkos, another San Francisco artist whose works began receiving attention in the 1960s—essentially caused ceramics to be recognized as a major medium for sculptures. Especially, in Arneson's case, these sculptures are funky, cartoonlike images and everyday objects. Among his earliest works, for example, were life-sized sculptures of a six-pack of beer and a toilet.

Arneson's style has been copied by endless numbers of imitative artists, so that by now pieces of so-called ceramic sculpture may be found at crafts fairs.

Arneson, who both lives and works in his studio in Benicia, has also been a professor of art at the University of California at Davis for twenty years. It is a certainty that given his noted style, the San Francisco Art Commission, which assigned Arneson to create the Moscone bust, knew very well the kind of work that would likely result.

In his frequent ventures into self-portraiture, Arneson has been as grotesquely ironic about himself as he has in his portrayals of others, many of well-known artists, as well as Moscone.

Our Public Sculpture—A Disgrace?

AUGUST 23, 1983

Historically, the Bay Area has not been one of the great meccas for students of contemporary public sculpture.

There is no deficiency, God knows, in the sheer numbers of big outdoor pieces which in recent years have risen almost as prolifically, and seemingly indiscriminately, as the ubiquitous orange cones which multiply around the trenches, foxholes and sundry other booby traps that have turned San Francisco streets into a kind of asphalt Verdun. Art world professionals such as George Neubert, during his nearly ten years as chief curator of the art division at the Oakland Museum, and Diana Fuller, who heads the two-year-old Project Sculpture: Public Sites program at Fort Mason, have made public sculpture the object of efforts that amount almost to personal crusades.

Yet, the results of all this activity have been unextraordinary. The Henry Moore bronze in front of the Louise M. Davies Symphony Hall is too small for its site; the Peter Voulkos at the Hall of Justice is too big; the Louise Nevelson at Golden Gateway Center is too cramped in an atrium where only a portion of it can be seen at any one time.

Much of the sculpture has simply been so undistinguished (Mark di Suvero's and Michael Heizer's pieces in Oakland, the Tony Smith at the San Francisco Museum of Modern Art) or downright bad (the Michael Todd at Fort Mason) that no miracle of siting or magical marriage with architecture could save them. The San Francisco Arts Commission's readiness to acquiesce with eager complaisance to the most brazen of political assaults on its authority has deprived the city of such an outstanding work of public sculpture as Robert Arneson's bust of Mayor George Moscone.

On the other hand, the pile of life-sized bronze corpses designed by George Segal to memorialize the Holocaust is apparently destined to go in place overlooking the Golden Gate below the California Palace of the Legion of Honor with nary a peep of protest from the commission, despite a flurry of public criticism of the sculpture's wax museum banality since word went out that the work had been accepted—by which time its permanent installation had already become virtually a fait accompli.

At best, all this time, energy—and money—have netted a few respectable works of large-scale sculpture—the Fort Mason di Suvero and Charles Ginniver, the works of Fletcher Benton and Peter Forakis in Oakland—that are the equals of some of the better pieces of Benny Bufano. The most exceptional big outdoor sculpture in the Bay Area—George Rickey's *Two Red Lines*—is effectively confined within museum walls, in the central courtyard of the Oakland Museum.

The record has not changed materially with the addition of five more pieces of large-scale sculpture in recent weeks: three as part of the remodeling and expansion program of the San Francisco International Airport, and thus additions to the permanent collection of the City and County of San Francisco; the other two in an outdoor mall at the new Golden Gateway Commons.

With the most impressive, and expensive, of the three new airport sculptures, a $188,000 construction of painted steel by Rufino Tamayo, we gain yet another distinctive, if scarcely earthshaking, work of

public art. Composed of triangular planes of various sizes that unfold from a vertical axis, *Conquest of Space* suggests a winged humanoid in the process of effecting a metamorphosis into a rocket ship— or is it simply a folded paper glider? Its sharp-edged, red and blue painted geometric shapes—which curiously match the tail-piece design of Philippine Airways planes pulled up outside—contrast strikingly, but tastefully, with the organic forms of the pond and rocky surrounding garden that fill the irregularly shaped courtyard of which the sculpture is the centerpiece.

Approaching the sculpture head-on, the symmetry of its composition seems overly rigid and static; viewed from any distance from the side, when the pond is functioning as a fountain, *Conquest of Space* is conquered by water.

But the sculpture occupies its space with a quietly forceful presence. The dialogue among its forms—and the shadows that one casts across another—changes in interesting ways as one circles the courtyard. Its metaphorical expression of flight and confidence seems appropriate for the airport setting.

One might question the appropriateness of greeting international visitors to San Francisco with a sculpture (one of his first) by the most celebrated living painter of Mexico. But given the spacious, outdoor and highly public location, it is certainly difficult to think of any local sculptor, now that Peter Voulkos is no longer doing large public pieces, who could be expected to have come up with anything as effective.

Given the competition—Arnoldo Pomodoro, Stephen De Staebler, Manuel Neri, Robert Graham and Bryan Hunt

were all considered for the space—it is harder to understand why one of the indoor commissions, for $100,000, was given to a sculptor from Japan, Seiji Kunishima, for *Stacking Stones,* five big chunks of granitelike stone that tower perhaps twelve feet high at the south end of the terminal entry. But then vitality and force of expression do not seem to rank high among the criteria for public sculpture, one of the reasons most of it is so disappointing.

Robert Irwin's $130,000 pair of *Black/White Ceremonial Gates, Pacific/Asian Port of Entry,* jammed into narrow atriums just inside the terminal entrance, will come as a shock to anyone who still associates the Los Angeles artist with the ethereal, virtually subliminal expression for which he became celebrated in the 1970s—environments that were minimally altered to make the viewer's processes of perception the principal "subject" of his works. Rising above two large chunks of onyx that resemble something one might see in the window of a Chinatown store devoted to the more posh forms of chinoiserie kitsch, these two pieces of painted aluminum and steel are Objects with a vengeance. Each consists of two vertical columns, which support two horizontal, rectangular platforms and, inserted into notches at their tops, upright squares. The plane surmounting the black "gate" is perforated with a geometric grid of nine small square holes. The topknot of the white piece is cut with sinuous rivulets that suggest stylized ripples and clouds.

With all the talk, much of it his own, that has surrounded Irwin's work in recent years, one expects work of a different order than public sculpture of such a con-

ventional kind, but that is essentially what these pieces are: decorative; somewhat precious; expressive primarily, as so many works of public sculpture are, of civic wealth and power—taste, luxury and the expenditure of large sums of money.

In contrast to the airport, where the size of both space and public perhaps makes almost inevitable a certain impersonality in its public art, the challenge of the new Golden Gateway Commons was to select sculpture that might add warmth, intimacy and a touch of nature to an architecturally cold, luxury condominium complex that snuggles almost directly against the busy and noisy Embarcadero Freeway. Marisol's chunky, ruggedly chiseled *Portrait of Georgia O'Keeffe with Dogs* is fey and whimsical, but it suffers the usual fate of sculpture that undergoes a translation from its original medium— wood—to a different one (bronze) and it is tucked away in an obscure location where it seems not so much to be "installed" as to lie in ambush.

Claire Falkenstein's *Tide Pool* is even more drastically undone by its architectural setting, a thicket of convoluted copper tubes and spouting water crammed into a narrow planter box under a staircase. Here, water is conquered by the roar of automobiles.

Meanwhile, a proposal that could produce one of the city's most extraordinary works of public sculpture is entangled in bureaucracy. Roger Berry—whose *Duplex Cone* in Arrowhead Marsh Regional Park in the East Bay is, with Rickey's, one of the few works of public sculpture in the Bay Area that could be described as authentically visionary—is an artist who brings the magic of Stonehenge up to date in precisely calculated structures that make the play of light and shadow brought about by the daily, and the seasonal, movement of the sun an integral part of their structure and expression.

His *Rising Wave,* proposed to occupy a plateau on the south shoulder of Twin Peaks, would comprise a series of seventeen steel poles, each ten feet tall, laid at varying inclines along an axis thirty-six feet wide. They would be arranged so that, as the sun rose or set, the poles to the east and west would cast a single narrow shadow across a pole at the center rising parallel to the axis of the earth and pointing to the North Star—at the pole's base in the summer, at its tip in the winter, at dead center during the equinox. When one walks around the sculpture, all the poles would appear to cross, forming lines that intersect every point on the horizon where the sun rises and sets throughout the year.

One would hope that such a majestically conceived work of environmental sculpture will meet with nothing but encouragement. In the midst of the frayed nerve endings of contemporary urban living, Berry's piece could be a refuge of tranquility and reconciliation with the grand design of the universe. But there are murmurings that the Parks and Recreation Commission may want to preserve this area as "open space"—although it lies virtually in the shadow of the colossal TV tower that looms into the skyline just a few hundred feet away. And given the record of city commissions where public art is concerned, one can expect just about anything to happen, so long as it is politically expedient.

An Artist's Responsibility

OCTOBER 14, 1971

It often happens in court trials that the critical issues are sidestepped in the narrower dispute over the guilt or innocence of a defendant of the specific charges brought against him.

Thus, in the case of the Government vs. Sam's Cafe—to my knowledge, the first time an instance of Conceptual art has been brought before the courts—the acquittal of the three defendants on charges of sending vile matter through the mail simply leaves hanging a crucial question involved in the practice of Conceptual or Process art. That is the question of an artist's responsibility to his medium, when that medium includes people and especially when these people become participants in a work of art through no choice of their own.

Sam's, you may recall, was brought to trial over a Conceptual artwork pulled off last March. The three artists who work under that collective name—Maro and Terri Keyser and David Shire—mailed bills to twenty thousand Bay Area residents demanding prompt payment to a "Sam's Collection Agency" of $76.40 for unspecified reasons and listing telephone numbers of the *Chronicle,* KRON-TV, KQED and the Bank of America to call for further information.

The four switchboards received thousands of irate calls, and a few checks for the amount were actually received at KRON, the address listed for "Sam's Collection Agency."

A part of the piece was a "press kit" sent to news media people—a placard with pictures of the three artists, three tightly sealed bottles of a substance later determined to be human feces, a pamphlet called "The Brand New Testament" that explained the rationale for the process piece, and the statements "Excrement," "Touch Our Sacred Stools," "Sam's Cafe cashes in on Christ" and "An art movement like a bowel movement."

Following a press conference staged two days after the event on the front stairs of the First Unitarian Church, the three East Bay artists were arrested, initially on charges of using the mails for fraud and for mailing "filthy and vile" substances. The fraud charges were dropped, because there was no way the defendants could have received any money, and the trial which took place Tuesday before United States District Judge Alfonso J. Zirpoli was on the latter charge alone.

At the trial, I testified that in my opinion the event was a work of Conceptual or Process art, involving a "calculated use of the environment" toward the end of making "people see things in a way they haven't seen them before."

Overall, I think that judgment to be accurate. The primary aim of Sam's process piece was to produce an "inversion of the mass media" by introducing a few alien elements into the normal flow of the system of communications.

By so doing, Sam's revealed in a lucid and brilliantly calculated way a number of truths about the artificiality of the established lines of communications that are about all that holds society together amid the complexities of the contemporary age. It pointed to the absurdity of a credit sys-

tem wherein the relationship between money spent and goods received has become so nebulous that people don't even know for sure what their outstanding debts are—and to the tyranny exercised by collection agencies in this situation.

It showed how easily the press can be manipulated to serve the wants of a few people, and to make others captive audiences of their whims or insanities. Ditto for the mail. Above all, it revealed the fragility of our highly sophisticated communications networks and the dangers that this holds given the gullibility of people.

Similar things go on in the area of espionage as a matter of course—radio frequencies are jammed, or other alien ingredients are introduced to snarl up the enemy's communications. Sam's showed how easily the same thing can happen to our own.

The inclusion of human feces in the press kit, it must be conceded, had only a peripheral, attention-getting relationship to the main event—attention-getting is what press kits are for. Sealed up as it was, it seemed inoffensive enough in comparison to the dog litter that abounds everywhere on the street. It was deplorable in a way, not because it was filthy but because it was juvenile. But it wasn't nearly as deplorable or juvenile as the government's attempt to make a mountain out of a cow pie—another thing that Sam's process piece was basically about.

In the face of these socially redeeming values, it seemed fair to give Sam's "media inversion" full benefit of the doubt, not only as a work of Conceptual or Process art, but as an immensely effective one, and of sufficient importance to justify the inconvenience or offense it may have caused some people.

Because art teaches us to see in new ways, the art experience can often be a highly unpleasant one, whether it be Grünewald's agonized crucifixion on the Isenheim altar, or a photograph of a Depression farm worker by Dorothea Lange; when art involves a social comment, it can be especially so. But this experience has, in the past, been largely limited to a relatively few people—spectators on a more or less voluntary, take-it-or-leave-it basis.

When people become involved as unwilling or unwitting participants in a work of Process art, the artist must draw a distinction and arrive at balance between the responsibility to illuminate, perhaps shock and even outrage his audience, and the obligation to treat his human medium with fundamental consideration and respect.

This includes assuming responsibility for what is known in the systems engineering biz as "spin off," or the unpredictable by-products that can result from a calculated act. One can argue that these responsibilities are sluffed off by practically everybody else, from the military's and the Congress's disregard for human life involved in warfare, to the cigarette companies' disregard of the link between smoking and lung cancer. But I, at least, expect artists to have more responsibility than people like that.

Magical Demonstration

Terry Fox is one avant-garde performer who never loses sight of the fact that an artist makes a legitimate claim to our attention only through his art, rather than the other way around, and a riveting demonstration of his magical work is on display at the University Art Museum in Berkeley.

On the surface, Fox's work falls within the fashionably far-out genre of Process, "body" or performance art. All too often, the outpourings from this school turn into narcissistic exercises in autistic theater by artists about whose personalities or psyches most of us couldn't care less.

Fox, however, has forged a uniquely compelling form of his own which brings together art and personal experience in the most forceful manner since Abstract Expressionism.

Fox has spent the past several years in and out of hospitals undergoing increasingly hair-raising (and successful) treatments for cancer. Such a biographical note would be completely irrelevant in discussing the art of a Frank Stella or a Richard Estes, but Fox has developed this experience into an entire esthetic.

At the same time, one mentions this fact because it helps illuminate his art, and is probably the source of its personality and power, not because it is essential to feeling it. Fox's work is dedicated to drawing us into, through and out the other side of this experience on its deepest philosophical level, as well as in a most direct and physically gripping way. It does so magnificently on its own artistic terms.

In her exhibition catalogue, which actually is a full-dress pictorial retrospective of Fox's work, Brenda Richardson observes that viewers often find his pieces morbid and depressing, in contrast to the "exhilarating, uplifting" feeling that he intends. This has been true of my own reactions to Fox's past performances.

The present piece, however, seems to encompass and interweave both ends of the emotional spectrum more fully, and is therefore, to me, at least, Fox's largest and most enriching work to date.

The exhibition consists of two interrelated parts that fill adjoining galleries. The first, which Fox regards as a kind of orientation room, contains a schematic "model" for the environment that occupies the second gallery, plus a group of photographs based on its various ingredients.

However conceived, the "model" inevitably invites reading as a symbolic, pictographic human figure: Its backbone is a weathered palm spine; its genitals, an eye tooth protruding from a rotten apple half; its head, a disk-shaped labyrinth.

On one side, a stale slice of bread has been wrapped to form the stump of an "arm"; on the other is a vial of blood. The whole is laid out on a blackboard covered with scrawled, repetitive, chantlike phrases and erasures. It all conveys a sense of the utter fragility of human life.

Fox's actual environment is more difficult to describe because he is in there working on it from time to time.

Physically, it is nothing more than a semi-transparent curtain that creates a hermetic space behind it. From inside the museum, you see only vague shadows moving on the other side, but you can go onto the balcony outdoors and get a clear view of this "backstage" area through the wall-sized windows.

The whiteness of the curtain gives this space a blanched, sterile look that conjures up sensations associated with hospital surgery rooms, although the paraphernalia inside of it—basins, can-

dles, vials, mirrors—suggest equally a place where magical rituals and incantations are performed. When I was there, Fox was enacting just such a rite, carefully pouring flour on the floor, shaping it into riblike arcs, carving a "canal" into the center of each one, then sipping water from a basin and letting it fall from his mouth, drop by drop, until each canal was filled. Each step was carried out with the methodical regularity of a pulsebeat, and the slowness of a geological process.

Brenda Richardson says the point of the piece is what Fox does with the space, not the spectacle of him doing it. This sounds pretentious until you actually see Fox, who is both there and not there, never exposing his face, revealing no sign of intense concentration, acting simply as the neutral agent of an inevitable act. The reflections of the outdoor landscape on the window behind which this takes place add still another dimension to the ambiguous effect, and, at least one day, one could look into a long mirror to see only Fox working against a transparent backdrop of glass, trees and sky, the entire scene transported into a realm of pure illusion.

Watching Fox perform his slow, hypnotic ritual, one gets the sense of peering through a membrane that forms a flimsy barrier between the mundane and the magical, to glimpse a secret chamber where life is being made and moves according to an eternal time scale.

Of course, the piece may look altogether different by now. Like life itself, it is a work in process, and one can view it only in glimpses. But one brings away from it an altered sense of time and rhythm that runs as a new undercurrent to day-to-day experience.

A Knockout of a Performance Piece

JUNE 6, 1981

With the resurgence of machismo—Billy Martin, Ronald Reagan—among mainstream Middle Americans, and a new "subculture" attracted more by violence than by house-husbandry, it is not surprising to find a new audience for what used to be called the manly art of self-defense.

And so two young Latino professional fighters stood at stiff attention in the ring at Kezar Pavilion Thursday night, staring solemnly, a bit bewildered, over a crowd dominated by New Wave art world types as a punk rock group screeched out an electronic version of the national anthem. The music sounded like a Salvation Army band playing in the pinball arcade across from the trans-bay bus terminal.

Both boxers were pros who had been in a few fights before, but clearly they had never seen a match quite like this. They were paired in the first of four real-life matches, preliminary to a main event that marked the professional boxing debut of two local Conceptual artists, Tony Labat and Tom Chapman.

As a work of "performance art," of course.

Labat and Chapman, not exactly among the best-known figures in the Bay Area art world before the prefight promotion moved into high gear a few months ago, were fighting a "grudge match" of the kind that used to take place barefisted in alleyways, but is said to have joined darts and softball among more formal athletics favored by jocks of the tavern set.

The story goes that Chapman, whose previous artistic activity is shrouded in vagueness, issued Labat, a video artist, a written challenge for reasons which, at least to Labat, have remained a mystery. They hired two promoters, Dan Ake, a former sculpture student at the San Francisco Art Institute, and Richard Simmons, who left his job as curator for film and video at the Everson Museum of Art in Syracuse. The promoters got Athletic Commission sanction, put together a card of other fights and lined up judges, referees, announcer, timekeeper and ring doctor. The two welterweight artists went into training, Chapman at Newman's gym, Labat in a ring in his studio.

And they began soliciting sponsorship, and setting forth the inevitable Rationale for It All: "The work interfaces with and supports the subculture of professional boxing…. As an artwork, the piece extends Realist tradition by relating to the world around us, while exploiting allegorical and philosophical content." What took place before some five hundred people in the gritty auditorium after the Units—two synthesizer players and two drummers—had played "The Star-Spangled Banner" was a mixture of "Realism" and the bizarre—a long way from the spirit of Piero della Francesco, if not

from certain forms of Modern art. Arthur Craven, for example, one of the original Dadaists, fought with Jack Johnson when the deposed heavyweight champion was on the skids in Barcelona in 1916 (Craven was KO'ed in the first round).

Three of the four bouts among more or less seasoned professionals were pure George Bellows realism—with the prominent exception of the presence of Carol Doda, billowing under a silvery lamé suit like a white balloon in a straitjacket. She tippy-toed around the ring with number cards between rounds.

The card's third fight paired two women in an elimination for the women's flyweight title. Angel Rodriguez, a slender Latina tattooed on both shoulders, withstood a bloodied nose to break down her opponent, a gutsy Chinese-American named Louise Loo, with a steady barrage of body punches that the referee halted midway through the fifth round. Her victory was celebrated with a miniature Mardi Gras of frenzied percussion banging, shrieking and dancing by a brigade of Rodriguez's female supporters.

At the door to the dressing room after the fight, a short woman with close-cropped black hair pushed her way past the security guards: old fight types with bloodshot faces and the gray aura of stale cigars. "Let me through, I'm her lover!" she exclaimed.

After this, the "artists'" matchup, while clearly the central attraction for a roaring audience that seemed to give Chapman a slight edge, was something of an anticlimax—though they poured it on with a "realism" that seemed quite unfeigned through four abbreviated (two-minute) rounds. Chapman, who looks like a welterweight version of the ninety-eight-pound weakling who always got sand kicked in his face and lost the girl, displayed a passable left jab. Labat, shorter and more muscular, showed nothing. But by the second round, both were flailing away, and the judges eventually decided that Labat had landed more punches.

I joined *Chronicle* sports columnist Lowell Cohn in the victor's dressing room, where he was conducting a postfight interview with Labat, just like in real life. Had Labat learned anything about art from the fight?

"I didn't learn s— about art," Labat replied, his left eye squinting through a shiner.

I'm not sure I did, either. But I did learn a couple of things about boxing. Though it was fun, I don't think I'd go out of my way to see two Conceptual artists fight again. But I'd like to be on hand when Angel Rodriguez has another match.

The Perverse Beauty of the Bomb

NOVEMBER 10, 1983

"The test of a first-rate intelligence is the ability to hold two opposed ideas in the mind at the same time, and still retain the ability to function," F. Scott Fitzgerald wrote in a remarkable trio of essays that appeared in *Esquire* in 1936, and were later collected in a volume called *The Crack-Up*.

This observation came to mind after a program of Bruce Conner films at the Castro last Friday—part of the Film Festival's Bay Area Filmmakers Showcase— that ended with his 1976 epic, *Crossroads*.

Crossroads is what they call a "difficult" film. This is partly because of the sheer insistence of its slow, measured tempo and obsessively repeated images. At thirty-six minutes the longest of Conner's films, it shows the same atomic bomb explosion— footage of the first underwater A-bomb test at Bikini in 1946—twenty-seven different times: from the air, from boats and land-based cameras; distant and closeup; at normal speed, slow motion and superslow motion.

The main difficulty, though, is the extraordinary transfiguration that occurs during the film. The first explosions convey a sense of the awesome horror of the bomb's destructive power. But gradually the images—the immense, swelling cloud, the massive column of water that wells up beneath it, the deadly vapors as they relentlessly expand until they flood the screen in a dazzle of light—these, and the thunderous accompanying roar, immediate or delayed, all begin to take on a perversely majestic beauty.

And as the film concludes, to a hypnotic soundtrack by Terry Riley (the earlier sound effects are by Patrick Gleeson), the explosion is removed from the realm of historic phenomenon and assumes the dimensions of a universal force that is brought into a kind of transcendent harmony, part of the impersonal, indifferent workings of the cosmos.

The film thus becomes a sort of exorcism. Even the mushroom cloud, it seems to suggest, may have a silver lining.

This is not a sentiment that goes down smoothly in this time of acute nuclear jitters. A bit like *Triumph of the Will*, Leni Riefenstahl's classic movie of Hitler's 1934 Nazi party convention in Nuremberg, *Crossroads* seems, if not to glorify, at least to find an overriding beauty and grandeur in something we all hold in loathing and horror.

Conner is one of the last people one could ever accuse of being "pro-bomb"; the entire thrust of his art always has been the exact antithesis of the ideals of those who traffic in aggression, exploitation and coercive power. Yet, it is not difficult to understand how people might interpret a bomb movie that is not an overt condemnation of nuclear holocaust to be, if scarcely "for" it, at least an invitation to indifference.

In introducing the film, Conner acknowledged that it sometimes has been criticized for "estheticizing" the bomb. It is a charge he did not vigorously deny. He made the movie, he said, to examine an image that had obsessed him since he saw the earliest pictures of it, and to look upon atomic annihilation as an eventuality that might happen in spite of all our best efforts to prevent it. For an artist of Con-

ner's (and my) generation, this can hardly be an irresponsible point of view.

Somewhat like first love, the onset of nuclear jitters tends to make its victims feel that the phenomenon never has been experienced by anyone before with quite this magnitude of seriousness and intensity. But one of the abiding discouragements for those of us who have lived in the shadow of the bomb since childhood is that, for all we may have done for two generations to try to reduce or reverse it, the threat is as grave as ever.

There is something frightening and coldly repelling about the suggestion *Crossroads* raises that the esthetic (what we see as awe-inspiring and beautiful) may have nothing whatsoever to do with the moral (what we see as a good, desirable, right way to live our lives).

Friedrich Nietzsche saw art as "beyond good and evil" and Karl Marx warned about the dangers of "estheticizing" politics (although he saw nothing wrong with politicizing art), but we are accustomed to think of art as being identical with what we call the humanities, or at least of sharing the same humanistic ends.

We do not like to be reminded that some of the butchers of Nazi Germany spent their spare time listening to Beethoven and appreciating old master paintings—that, as the literary critic George Steiner pointed out, "knowledge of Goethe, a delight in the poetry of Rilke, seemed no bar to personal and institutionalized sadism."

Nonetheless, the gap often remains between our esthetic responses and our moral ones. Seeing *Triumph of the Will* did not diminish my abhorrence of Nazism and the things it stands for, but I was appalled to find that I was moved in spite of myself by its mythic sweep and spectacle.

Seeing another new office or hotel tower rise in downtown San Francisco under the cold light of day always conjures up for me a repellant image of Mama Cass, already overstuffed and choking to death on one too many sandwiches. Yet seeing these buildings from Twin Peaks or Bernal Heights at night, their windows shimmering with dots of light like a beached Milky Way, is a spectacle of undeniable beauty.

(It would be nice if they were stage drops, which we could gaze on in wonder for a time when the mood struck and then roll up while we went on with the real business of our lives.)

We Westerners also do not habitually take strongly to the kind of "fatalism" that seems to be engendered by the notion of forces that transcend our activities and concerns in the everyday world of the senses. This concept is central to most Eastern philosophies (it is probably no accident that the predominant "color" of *Crossroads* is white, which in the East is the "color" associated with mourning and death, and practically everywhere is the symbol of illumination).

But the glory of Western culture has been an unshakable faith in the power of action in the real world.

The evidence suggests, however, that after material and social needs have been more or less satisfied, and the principles of the Golden Rule reasonably well observed, a hunger remains—a purely exis-

tential hunger of the sort described by Dostoyevsky or by Knut Hamsun in his novel, *Hunger,* that remains impervious to Utopian social engineering. It is, perhaps, this basic area of human need that the esthetic exists to fulfill.

Are art and humanism, the esthetic and the moral, then unalterably opposed? Probably, but that brings us back to Fitzgerald.

"One should, for example, be able to see that things are hopeless and yet be determined to make them otherwise," he continued in *The Crack-Up.*

At its further extreme, lofty meditation on the illusory and transient nature of worldly things can end in crippling, not to say suicidal, indecision, inaction and hopelessness of the kind represented by the outcasts of India. On the other hand, action without reflection tends to the release of blind and mindless energy—of the kind produced by, say, an atomic explosion.

The moral impulse—the sense of our kinship with each other—provides the will to keep trying to make life more and more livable, for others as for ourselves. When all else fails, as it so often does, the esthetic—the fleeting intimations of our kinship with forces much larger than ourselves—makes the idea of death bearable, and of life that has otherwise become impoverished, desensitized or brutalized, tolerable. And in the atomic age, Fitzgerald's definition of "a first-rate intelligence" may well be the only formula for survival.

Cartier-Bresson: 'Life Is Art'

MARCH 20, 1969

If this department had powers of subpoena, assigning grade points or any other sanction, I would order everyone who professes an interest in photography—or in life—to visit the San Francisco Museum of Art to see its exhibition of Henri Cartier-Bresson.

Organized by the Museum of Modern Art in New York, the show contains more than 150 photographs that form a retrospective view of Cartier-Bresson's art from the early 1930s up to the student demonstrations in Paris last year.

"Life is art" is very much a contemporary conundrum, yet it forms the underlying philosophy for everything that Cartier-Bresson has done. His earliest photographs are rather obviously artful in a vein that still preoccupies many photographers today. They stress striking, Surrealistic juxtapositions of posters, people and mannequins. One still-life tray of fruit, on a sheet of newspaper behind a fine screen, has the mysterious properties of a Joseph Cornell box. But Cartier-Bresson abandoned these devices at a rather early stage for a more subtle ordering of affairs in which life runs parallel to art according to basic structures, forces and moods that seem to govern them both.

Cartier-Bresson has summed up his esthetic philosophy in the famous phrase, "the decisive moment," but it is revealing to see in what particulars that decisive moment consists.

In his landscapes, it most often occurs when the countryside reveals itself in terms of forceful geometric patterns, while houses, animals, workmen and other forms of life are frozen in more dynamic, rhythmic relationships; momentarily, they are as permanent as the countryside itself, but they are always on the verge of moving, changing, passing on, while the stage over which they move will remain forever.

In portraits, the decisive moment occurs when expression is most revealing—there is a wild-eyed Samuel Beckett and wall-eyed Jean-Paul Sartre—and also when the figures are related in the most telling fashion to their surroundings: Alberto Giacometti rushes out for breakfast, his head covered by his jacket against the rain, behind a foreground tree that suggests the elongated isolation of a Giacometti sculpture; an aged Pierre Bonnard sits surrounded by drawings which contrast with the bleak walls of his studio, while Henri Matisse is surrounded by birds.

These are the existential heroes; in his genre photography, Cartier-Bresson deals most often, and most successfully, with the very old and the very poor, people who have all come to terms, in different ways, with their surroundings.

His old Provençal women listening to Charles de Gaulle are rooted against old stone facades that seem as weathered and

eternal as their wrinkled faces; children, on the other hand, provide a transient spark of dynamic activity. But there is an almost Oriental spirit of acceptance behind the strongest of Cartier-Bresson's photographs; even with seats in front of a decrepit store in Jackson, Mississippi, the viewer is left to make of it what he will.

Cartier-Bresson has said that content cannot be separated from form. At least one photograph, of picnickers on the banks of the Marne, might have been taken by Georges Seurat if he had ever taken up the camera. Whether or not Cartier-Bresson was directly inspired by Seurat's compositional theories is a question I have never seen raised, but clearly he has discovered how to make corresponding uses of horizontals, verticals and curves to underline the feeling and mood of the photographic image.

The exhibition also reveals, as no reproductions can, that Cartier-Bresson is an Impressionist of the camera. Occasionally, he employs hard-edge contrasts of light and shadow when it serves his purpose; in other photographs, the grain of the print becomes an Irish mist, a concrete plaza or the ashen skies above Mount Popocatepetl, and the infinite range of values that can be derived from black through gray to white take on the richness of a painter's palette.

Immensely Moving Blunt Visions

MAY 31, 1979

The career of Robert Frank has moved through some curious twists and turns.

His first book of photographs, *The Americans,* produced some shock waves when it was published in 1958, but by the time the originality and power of his work were becoming widely appreciated, *The Americans* had passed out of print. Frank's approach became one of the most influential forces on a generation of young photographers in the late 1960s, but by then, Frank had abandoned the still camera to concentrate on motion pictures. He has returned to still photography in recent years, and for the first time, he has begun to exhibit and sell his work in commercial art galleries; yet his current show, at Simon Lowinsky Gallery, contains only early pictures.

Finally, there are the pictures themselves—twenty from *The Americans,* many of the others previously unpublished. When *The Americans* first appeared, many critics were scandalized by the blunt, sometimes brutal frankness (pardon) of its vision. The photographs remain immensely moving, but they are no longer shocking. They are classic images by one of the great masters of the photojournalist tradition.

The "realism" of today becomes tomorrow's "classicism" (or "romanticism"). Photojournalism—as "realistic" art in general—thus involves a continuing search for fresh and more convincing metaphors for life to replace those that have become conventionalized through overuse. When the photography of Bressaï and Cartier-Bresson first began to receive wide exposure in the 1930s and 1940s (and it is really to their "school," rather than to the Depression-era social commentators, that Frank belongs), their visions were identified largely with the "realism" of the subjects that they portrayed; by the 1950s, their photography had come to stand primarily for Art.

Frank shifted the elements of the equation closer to life once more—the *feel* of life, if not, in the most literal sense, its look (as Dwight MacDonald once pointed out, for example, we tend to "read" black-and-white photography as more "realistic" than "natural" color). In so doing, Frank created an art that had a new vitality and impact.

When *The Americans* first came out, much was made of Frank's status as a new arrival to the United States, but there are some earlier photographs of Paris here, and they reflect the same alienated, fascinated, nonjudgmental and somehow anguished vision. The differences between Frank and Cartier-Bresson are most apparent where they seem most alike. The two nuns walking past the big BYRRH

truck, for example, are a typical C-B subject, but he never would have let all the foliage in the foreground dominate the entire composition.

In these early European photographs, and in his later photography in the United States, Frank introduced a sense of randomness, of energy, of a continuum of life that goes on beyond the edges of his pictures, that was alien to "the decisive moment" of Cartier-Bresson. He photographed subjects of an unpicturesque ordinariness that Bressaï would not have bothered with. And there is his handling of black and white—sometimes grainy, sometimes blurred, suggesting the "real" grit of roadside cafes and bus depot men's rooms, but also immersing them in an aura of lyrical, sometimes almost visionary beauty.

Eventually, of course, Frank's approach hardened into an academic style, as witness the work of a young photographer in Lowinsky's backroom, who crops images with a self-consciousness that Frank himself would abjure. Frank's photography, in its turn, has taken on a feeling of romanticism and nostalgia, if not yet of the picturesque. Enter Diane Arbus, Weegee and "found object" photography: *Evidence* or *From the Picture Press*.

The Stylish Mr. Richard Avedon

MARCH 6, 1980

Like Andy Warhol in an era before High Tech and High Chic had lost some of their glitter, Richard Avedon is a product of a peculiar sadomasochistic entente—or is it just a shadow play?—in which the more ruthlessly the world of High Style professes to feel that its blood has been drawn, the more fiercely it embraces and lionizes the supposed assailant.

Thus we have Roland Barthes, the fashionable French semiologist, enthusing over the subjects of Avedon's celebrated portraits as "corpses [that] have living eyes." His photography is hailed as unflinchingly honest, a profound critique on the hollowness of beauty.

Meanwhile, celebrities pay Avedon five thousand dollars apiece for these unflinching photographic exposés. And Macy's has picked up most of the tab for the largest show of Avedon's photography ever assembled, which opened yesterday at the University Art Museum in Berkeley.

It provides ample opportunity to decide if Avedon is really the brilliantly subversive court jester or just another pet ocelot.

Few, if any artists, could stand up to an exhibition of more than four hundred of their works. Certainly, Avedon cannot—in spite of a stunning installation that amplifies all the tricks of contemporary advertising layout design to environmental dimensions.

The mammoth display begins with Avedon's earliest photographic efforts, a group of street pictures taken just after the Second World War in Sicily and Rome. There is nothing the least bit distinctive about them, although some of the show's strongest pictures are installed in this same section. These include the portraits of Humphrey Bogart (1953), Fred Allen (1954), Dwight Eisenhower and Ezra Pound (1958)—straightforward, but penetrating, studio portraits, which had not yet turned into formula.

There is an immense plethora of Avedon's commercial fashion photography—a roomful of pictures from the 1950s that resemble movie stills, with models like Audrey Hepburn and Suzy Parker at Maxim's or the Folies Bergère; another from the 1960s, when backgrounds begin to blur or fade out altogether, and models like Jean Shrimpton and Twiggy appear, often looking as though they are jumping around on a trampoline. As *style*—modishly emaciated silhouette, strictly choreographed movement—increasingly becomes the *substance* of Avedon's photography, the size of his prints correspondingly grows.

It is not for his fashion photography, however, but for his portraits of the past decade that Avedon is able to commandeer almost half the exhibition space of a major art museum. In these, the conventions of the passport, or ID photo, are exaggerated, and enlarged, sometimes to the size of a Clyfford Still painting.

These portraits recall Diane Arbus in their confrontational bluntness, as well as

the early twentieth-century German photographer, August Sander—although Sander was richer and deeper than either. They recall Warhol in their standardization, repetitiveness and vacuity.

But most of all, they suggest a curious inversion of the fashionable studio portraiture of Yousuf Karsh. Avedon's subjects are as unvaryingly and melodramatically "laid bare" as Karsh's are relentlessly idealized; Avedon's formula is therefore an excess of light, as Karsh's is an excess of shadow. Karsh's images are icons enshrined for the ages; Avedon's are made into cadavers before their time. Although they seem to concentrate on the sitter to the exclusion of all else, Avedon's portraits are, first and last, *Avedons*. We learn as little—and as much—of their subjects as we do from Karsh's portraits.

Avedon's mannered portraiture represents basically a new mode of idealization, if not exactly glamour. If its emphasis on grit and decay now seems more convincing than Karsh, that may say more about the times than about Avedon's "honesty." Indeed, the most interesting thing about Avedon may be why the same kinds of people "of accomplishment" who two decades ago might have had themselves immortalized by Karsh now rush to submit to Avedon's great leveler, to have their warts and wrinkles counted and be measured for their burial togs. It's one way, I guess, of showing that you're just one of the gang.

A Sense of Identity: Revelation about Arbus

OCTOBER 15, 1980

Given the clear picture—indeed, the stereotype—that most of us have of Diane Arbus, based on photographs that have been reproduced often enough almost to become icons, who would guess that a show would come along that would dramatically enlarge one's vision of Arbus's expression?

That is precisely what happens, at least for me, in the exhibition "Diane Arbus: Unpublished Photographs" at the Fraenkel Gallery. It comes as a revelation.

I have always thought of Arbus as one of the great photographers, but as a severely—perhaps fatally—limited one. Her special province was the morbid and the grotesque: freaks, transvestites, glazed-eyed superpatriots and pimply kids.

Within this sphere, her work was masterful—at its best, with a haunted, unforgettable presence and a rare sense of identity between photographer and subject, as though Arbus were not merely portraying the human freak show, but projecting herself somewhere inside her subjects, viewing them through their own eyes.

But these very limitations seemed to call certain aspects of her art into question. Photographing freaks and oddballs—or making ordinary people look like freaks and oddballs—can be, after all, one of the easiest photographic cheap shots; the grotesque is not that far removed from the picturesque, and has a similar appeal to the lowest level of taste, as the work of many successful schlock artists specializing in grotesque subject matter has amply demonstrated.

Moreover, the more one saw of prints and reproductions of Arbus's work, the more one grew aware of a sense of steely hardness about many of the images, a suggestion that the subjects were, indeed, being ruthlessly transfixed with pins and presented, like so many specimens, for our bemused examination. Perhaps Arbus's expression had not been so empathetic after all.

These impressions are all overturned by the two dozen or so photographs from the Diane Arbus estate that make up the present exhibition. This is partly because they embrace a greater range and variety of content than I, at least, had ever been aware of in Arbus's work, and partly because these are "vintage photographs"—i.e., printed by Arbus herself, and thus definitive of what she was seeking to express—a factor that transforms even the kinds of patented "Arbus-style" images that one had thought one knew so well.

The range and variety are exemplified by any number of pictures here: a romantic couple *On the Pier,* the poetic everydayness of the scene unmarred by any darker undertones; *The Barbershop,* a slice of life with a gritty lyricism and seeming randomness that brings to mind Robert Frank; photographs of impoverished blacks in South Carolina that are as soberly powerful as social documents as the Depression photographs of Dorothea Lange; the *Young Girl at Nudist Camp,* somewhat overweight, as Arbus's nude subjects often were, but soft, tender, vulnerable rather than grotesque; and the *Nudist Camp Beauty Contest,* which is grotesque, but even more humorous.

Indeed, one of the great surprises of the show—in pictures like *Four Santa Clauses* and *Moving Rocks at Disneyland*—is how much humor is sometimes to be found in Arbus's pictures. And one's awareness of this contributes an added di-

mension—a warmth and resonance—even to such more characteristic Arbus subjects as the *Muscleman,* his body impeccably sculpted, standing beside a heroic trophy in a bleakly shabby interior that has the look of a cubicle in hell.

The transforming effect of the printing process is everywhere subtly but decisively in evidence; in fact, other than seeing earlier and later prints made from the same negatives by Bill Brandt, I can think of no other work that so dramatically demonstrates how integral the printmaking process can be to the very essence of the photographer's art.

The prints made from Arbus's negatives by others have seemed most often to have been guided by conventional standards of what a "good print" should be: sharp, clear, without surface flaws. But Arbus herself was indifferent to what passes for "print quality"; most of her prints here are grainy, partially blurred, edged with dark shadowy areas, occasionally making no effort to conceal a scratch or other flaw in the negative.

Technique is, of course, relative: what is right for Ansel Adams is totally wrong for a photograph by Arbus, and vice versa.

The pictures here demonstrate that fact quite clearly: together with the conventional hard, brittle "finish" one so often finds in prints of Arbus's photographs goes the sense of voyeurism, the "cruelty," that sometimes seems to attach itself to her work.

What remains are photographs that are at once exceedingly simple and extraordinarily complex: haunting, poignant, lyrical, compassionate, richly human—indeed, at their most powerful, tragic in the fullest meaning of the word.

The Cunningham Paradox

MARCH 6, 1983

Like Benny Bufano, Imogen Cunningham created a personality that was larger than her art. Her image was an irresistible mixture of sugar and spice and piss and vinegar: a nonagenarian gamin who dressed like a Victorian hippie, skewered pretension and phoniness with a quick and caustic wit, kept working until the week before she died (in 1976, at the age of ninety-three)—and, of course, had spent all of her adult life as a photographer.

This role as a photographer was an essential part of the Cunningham image, the cachet to the rest, but it was always pretty much taken for granted. Cunningham—it is still tempting to call her simply Imogen, such was the force and charm of her personality—might herself tell you, as she sometimes did, that her principal distinction was having lived "longer than most other photographers." Still, it was generally more or less assumed that anyone who had been involved with photography as long as she, who had been associated with the Westons, with Ansel Adams and Wynn Bullock, who had photographed Alfred Stieglitz and Minor White, was an artist to be reckoned with in their company.

One might hope, now that a few years have elapsed since her death, the effort could begin to disentangle the Cunningham legacy from the Cunningham legend. Perhaps a clearer picture of her achievement will emerge before the current Cunningham centennial observances have ended (smaller shows will be opening later at Focus Gallery, Camerawork and the San Francisco Art Institute). But it does not at all come into focus in this exhibition where it might count the most: a big, one-hundred-print survey organized by the American Federation of Arts, which will go on the road for three years after its opening run at the California Academy of Sciences.

Drawn from private and public collections, the one hundred prints are all Cunningham's own and are mostly "vintage"—contemporary with the date the negatives were first developed. This is the source of a number of small revelations. Differences in tone and contrast transform images one is accustomed to seeing only in reproduction, if at all (some pictures have not been displayed or published before), into almost entirely different photographic statements.

But the selection, by curators Susan Ehrens and Leland Rice, leaves many serious, indeed crucial, omissions. It ends up by confounding further what has always been one of the most puzzling aspects of Cunningham's photography: that for all the decisiveness of her personality, or at least her public persona, her identity as an artist was always elusive. And we get still more of the Imogen Image: a poster with a picture *of* Cunningham (by Jim Alinder) rather than a photograph *by* her and, as a kind of last minute *deus ex machina*, at the end of the long gallery, a monitor that plays videotapes of Cunningham's appearance on the Johnny Carson show.

This was, avowedly, not the organizers' intent. In fact, Ehrens said, one of their principal aims was "to rescue" Cunningham's accomplishments as an artist from her reputation "as a crazy little old

lady." They cannot be faulted for conscientiousness. They have gone about this task with the rectitude characteristic of the professional art historian: that is, with lots of rigor, and almost no imagination.

Thus the show begins with a selection of platinum prints from Cunningham's earliest years as a photographer of landscape and campy sylvan allegories in the gauzy, soft-focus, "Pictorialist" style that defined Art Photography in the first two decades of the century. As the definition of Art Photography shifted in the 1920s to the more formal, sharply focused and abstract approach of Edward Weston and the f/64 group—of which Cunningham was, of course, a charter member—we are given her *Banana Plant, Iris, Magnolia Blossom* and *Two Callas* and the nudes and fragments of torsos and breasts.

There are, of course, the portraits that form one of the recurrent themes of Cunningham's career: the haunting picture of Frida Kahlo; a wonderful pair of Stieglitz, one looking defiantly upright, the other warmer and more at ease, as though Cunningham had just told him a funny story.

But there are none of the superb photographs from Cunningham's later years which, in a sense, come close to photojournalism: the unforgettable study of the Coffee Gallery in late 1950s North Beach; the dispassionate but penetrating views of the late 1960s Haight-Ashbury; the probing, deeply compassionate, if not always closely focused, portraits of old people of her series *After Ninety.*

Instead, the show closes out with a group of Cunningham's late double-image portraits and another of her still-life setups of dismembered dolls. Never mind that most of those faces seen through leaves seem contrived, or that the doll pictures add nothing to what Surrealist photographers have been doing with dolls since the 1930s—such experiments are the hallmark of the Art Photographer.

There is certainly nothing in this that falsifies the historic record. Cunningham was proficient in virtually everything she put her hand, or lens, to and there are memorable images here from practically every phase of her career: the jewel-like *Snake in the Bucket;* the formal geometry of *Triangles* and *Fageol Ventilators,* which demonstrate Cunningham's interest in the Constructivist photographers active in Germany between the two world wars; a few of the plant forms from the turn of the 1930s, especially those that she transformed into almost calligraphic silhouettes; a few of the nudes which, like Weston's, are never abstracted to the point they lose their flesh-and-blood sensuality.

But the emphasis that Rice and Ehrens have put on this aspect of her work is, I think, misleading and in the end even self-defeating. Ehrens says a biography she has recently completed will show that Cunningham was not "a Weston follower," but in fact influenced Weston's turn toward more abstract imagery. "She did her magnolia blossoms before he did his peppers."

Well, could be, but Ehrens then goes on to say how Cunningham was herself influenced by the photographic abstraction of the Germans. At any rate, the *art* ques-

tion, as opposed to the historic one, is not who did what first, but which images take on a greater life in the imagination and remain more indelibly in the mind. And these are much more often Weston's than Cunningham's.

"The North Beach and Haight-Ashbury and *After Ninety* pictures were deliberately omitted because I don't feel that Imogen was a documentary photographer," Ehrens said. But in a sense that's just what this show tends to make of her. Sooner or later, all but the most transcendent works of art revert to the status of objects that record more or less faithfully the history of taste.

Cunningham's early Tonalist pictures, like all but a handful of masterpieces by Edward Steichen and a few others, have become nostalgic period pieces, redolent of dancers wearing wispy togas, and amphitheaters in eucalyptus groves. So, with a very few exceptions, have her later, Westonesque studies of flowers and leaves and shells—records, or documents, of another chapter in the history of photography and of a certain life-style associated with Isamu Noguchi lamp shades and shingle houses in the Berkeley hills and cottages in Carmel, California. Cunningham was a good artist, but not a great one, and to concentrate on her role as a conventional Art Photographer is ultimately to trivialize her real achievement.

This, I think, is found most often in those photographs that are straightforward, un-self-conscious and no-nonsense as she herself was, or seemed to be. Almost always they are pictures of people,

viewed as complex personalities and/or as persons who pursue distinctive styles of life: "portraits" and "documentaries," if one has to give them a label. They reflect, not necessarily a profoundly original vision, but what seems to have been an untiring and continually self-renewing inquisitiveness. If there was a single constant in Cunningham's photography, it was this curiosity that directed it in so many byways, and always brought it back to explore still one more time the inexhaustible subject of who we are and how we live.

Thus, the paradox that this bluntly individualistic photographer was at her best in photographs that are most self-effacing, filled with the intense presences of other people. She did not always succeed in this: even the portraits and the other "people pictures" sometimes seem too coolly detached. But in her most memorable photographs—so many of which, in the name of "Art," are not on display here—inquisitiveness made the magical leap from fact to truth that converts curiosity into empathy: the personality transcending itself.

As Cunningham herself once described it, in what could stand as a concise summation of her work: "Feeling ourselves into and learning to know another.... It [empathy] is not easy—in fact it is almost unattainable. So in the end the photographer has to be satisfied with the contemplation of the shape. Even this is no small assignment. If one can succeed in getting some kind of an aesthetic result out of it—so much the better."

On Criticism

similar in some respects to the monumental pieces he exhibited a couple of years ago — towering columns of irregular ceramic slabs placed one on top the other, with three of their sides cut sheer; the fourth, the "front," combines mangled human forms — fragments, bones — with gnarls and folds that more nearly resemble congealed lava.

But the structures have become less pyramidal or wedge-like, more slender and upright, generally towering nine feet or more high. And they are more abstract.

The tendency for a breast, a foot or a knee-cap obtrusively to "pop out" from the more firmly imbedded forms has been curbed: the new sculpture projects more the frangments of the figure, or of bones turning into rock. With a few exceptions, the color with which deStaebler impregnates his material is also more subdued, and controlled.

But while the new pieces are more harmonious on the surface, they also seem more arbitrary in structure and concept, in the way that a lava formation is more arbitrary than the construction of the human figure. The great dilemma of deStaebler's expression is arriving at a precarious, delicately callibrated balance between figuration and abstraction, between form and dissolution; its attainment, when it occurs, gives his strongest work its sense of deep internal tension.

It is achieved here, it seems to me, in the relatively small "Right Sided Woman Standing," and ap-

tures. But for the most pa opting for a more abstrac proach, deStaebler seems r have resolved the dilemma so as to have evaded it.

The pieces are all quite b ful, as natural outcroppings o can be quite beautiful, but m them seem rather too easy the skin.

Although the range of al in deStaebler's sculpture is he uses his references expres and absorbs them into a col ...m of his own. The problem ...iveira's new paintings is gratuitous eclecticism.

All belong to a series "Swiss Site." Two or thre almost straight caricatur Turner, with hazy, light-per atmospheres, intimations of mering reflections and dus houettes. Most are more like between Turner and Dieben "Ocean Park" paintings, with vocal interior "edges" that luminous atmospheres from emerges the halo-like image distant tower. A few contai and traces of imagery that s William Wiley — a checker flag, a funky pyramid, a wh arabesque with candy stripin

Oliveira is masterful a dling the effects of atmosphe painterly surfaces, and the ju where they coincide; on th face, many of these new pai look spectacular. But, for wildly casting about for sign imagery, or "content," in th these paintings seem to be n but seductively vaporous effects. They are like a new

The Good, the Bad and (Ugh) the Mediocre

APRIL 17, 1980

It is a common belief that critics seek out the worst in everything, that we love to hate.

Although critics rarely admit it, there is a grain of truth in this assumption.

In fact, a critic approaches his subject with much the same hopes as anyone else: that time and effort will be rewarded by an overwhelming experience or, at the very least, by a more intense and meaningful one than might otherwise be enjoyed by, say, going to the movies or the beach. Critics—perhaps more than most people because, proportionately, we encounter it so rarely—*love* a great work of art.

But we also enjoy an awful one—a work that is the absolute pits, with no redeeming features to stand in the way of a relentless critical trashing. The kind of performance that sends most people rushing to the exit sends us gleefully to our notepads, jotting down *mots* for the next day's review.

What most critics really despise—or at least what presents the greatest difficulties—and audiences are far more tolerant of is mediocrity: the painting or sculpture, book, movie or play that has its good points and its flaws, that is uninspired but professional, a more or less run of the mill, proficient bore. This is to say—considering the eight per cent or so of things we see that are truly terrible—about ninety per cent of what most of us encounter.

Mediocrity is troublesome partly because it is so difficult to write about. Such phrases as "not without talent," "a certain merit," "interesting but flawed" do not make editors happy. They are as boring to write as to read. Another routine show, another routine review.

The alternative is to jazz things up—to exaggerate merits or defects, so that what barely engages attention becomes "compelling" or at least "generally absorbing," or a feeble work that has its moments becomes "utter dreck." It makes livelier, more decisive copy. We can sometimes even talk ourselves into believing it. But it is also less than honest.

Mediocrity—since it is such a relative matter—also forces a general decision of how "tough" one should be. Does one give the artist an encouraging pat—"support the arts"—so he will go on to more mediocrity, or stomp him into the ground, incurring the ire of those who feel that skill and sincerity should be enough?

The dilemma takes its clearest form in jurying shows. The exceptional work, if any, separates itself from the rest almost instantly. The trash is equally clear. But then there is often little or no perceptible difference between the lower end of the work that one finally admits, and the top end of the rejects—unless one chooses to reject almost everything.

This illustrates the most pernicious aspect of mediocrity: it works to level, to numb the sensibilities in a way that abject

awfulness—which can be stimulating, in a perverse way—does not. Stand in a schlock shop half an hour and you begin to distinguish the less bad from the more; mired in the morass of relatives, you accept the lesser evil—that is, mediocrity.

A critic cannot, of course, ignore the vast gray pall of the mediocre. He would have so little to write about, he would have no job. Also, with no ocean, there could be no waves.

But neither can he condone it. Unlike most other things, if art is dulling—if it offers no quickening insights, no deep or revelatory experience, but is only a more prestigious way of passing time than watching television—it loses its only real justification for being.

In Jean-Paul Sartre's *Nausea,* a character speaks of "privileged situations": those moments in life that correspond to the passages in a book which the illustrator chooses to illuminate, thereby setting them apart from the gray body of text. Great works of art—and this can include a great failure, or a work that contains a single transcendent detail—are among the rare experiences that accomplish this, cutting through the gray overcast of daily living, the realm of routine competence, routine talent, routine good this or good that. They can help point the way toward reaching greater clarity and illumination on our own. Anything less merely adds further to the opacity.

Mystical Vision versus 'Quality' Art

AUGUST 30, 1979

"Red Mountain" and "Green Mountain."

Harold Rosenberg and Clement Greenberg, the twin peaks of American art criticism in the twenty-five years after World War II, epitomized the classic polarities of esthetic attitudes: Romanticism versus Classicism, process versus object, hand versus idea, content versus form, autobiography versus history.

Both had been intimates of Hans Hofmann and continued wildly to overpraise his work. Otherwise, their writings frequently amounted to a continuing personal argument, although one rarely printed the other's name. What Hofmann had tried to synthesize in his teachings—Expressionism and Cubism—Rosenberg and Greenberg each elaborated separately. Rosenberg developed the more mystical side of Hofmann's thought ("the search for the real") into his celebrated theory of action painting: "What was to go on the canvas was not a picture, but an event."

Greenberg coupled Hofmann's analytical approach to color and space with a Darwinian outlook brought over from Marxist social philosophy to produce his esthetic of Formalism and "linear evolution": the idea that every art form had an appropriate line of historical development, based on "purifying" itself of elements that properly belonged to other media. Thus, painting should rid itself of pictures (photography), depth (sculpture), incident (drama), and approach as closely as possible its "nature" as mere color on canvas.

Rosenberg's strength lay in the power of his vision, his notion of art as an existential act—decisions, choices, recognitions, commitments—through which not only art, but a life, is created. When he wrote in general terms, he seemed able to penetrate, with a rare and poetic eloquence, to the very core of the creative process.

Greenberg's strength lay in his eye, his ability to recognize "quality" in art that did not necessarily conform to his ideas. He was one of the earliest supporters of Jackson Pollock, and among the first critics to recognize the originality of Clyfford Still, Mark Rothko and Barnett Newman.

Greenberg's weakness was his theory, which may have validity for progressive refinements of science and systematic philosophies, but seems dubious in relation to human history, and dangerous when applied too rigorously to art.

During the 1960s, it became more and more of a straitjacket; its logical consequences were Minimalism and the ultimate "purity," Conceptualism. Finally, acting in the name of history, Greenberg came to the hubris of assuming that his "objective laws" took precedence over the artist's wishes when he sought to remove paint from David Smith's sculpture.

Rosenberg's weakness was in the application of his ideas. They fit Willem de Kooning, and touched on the inner life of Rothko's and Newman's paintings where Greenberg's analyses only scratched the surface. For a time, Rosenberg tried to extend his idea of action painting to encom-

pass the neo-Duchampian work of people like Robert Rauschenberg and Jasper Johns. But he seemed to fall back more and more on pure personality and social ties—the old Tenth Street crowd. He ended his last anthology with the suggestion that perhaps criticism should confine itself to established historic figures.

Robert Musil, in his monumental dissection of the modern era, *The Man Without Qualities,* distinguished between "the artistic, creative mind" and the scientific one, "the personality and the work, the greatness of a man and that of a cause…. There is, oddly enough, time and again a new personality to carry the cause on; on the other hand, wherever the personality is what counts, after a certain height is reached, the feeling occurs that there is no longer any adequate personality there and…all that is truly great belongs to the past."

The feeling that there are no heroes is widespread today. Yet, in art, it is the "cause" that now seems to have reached a dead end. New individuals seem likely where, at least for the moment, new movements do not.

The "scientific" mind has been closely bound up with the avant-garde for much of the Modern era, perhaps more than has been healthy. Perhaps the end of this alliance, and a return of "the personality," is what is meant by "Post-Modernism."

The De-Meaning of the Artist

JUNE 5, 1980

One of the most disconcerting things about writing is the way the same words can mean so many things to—or from—different people.

George Orwell foresaw language impoverishing itself to the level of reflex as society grew more homogeneous. But society has become more splintered, and communication among different points of view, more and more complicated.

For example, I was recently reading a critique in which the writer says of a certain artist that he has "skirted the dangers of expressionism.... The self is present only through actions which allow the body to draw its limits and discover its scale... At each step the artist's concern is simply to make good, strong, self-substantiating paintings." And the writer quotes the late Roland Barthes: "Work substitutes for interiority."

These utterances were clearly intended as high praise—well, perhaps praise is too strong a word at a time when criticism, like art, is generally expected to shun strong indications of personality or commitment ("the dangers of expressionism"), but is looked to primarily to provide a fuzzily soporific "positivism," in the sense that word assumed in the homilies of Norman Vincent Peale. "Positivism" helps bring the rubes in.

Personally, I can think of nothing more damning that could be said about an artist's work. Ruling off grids, filling surfaces with mere marks, simply putting "good, strong, self-substantiating" *things* together—the kind of *activity* that is done simply to keep busy, to maintain one's "professional" status, to make sure the grant money keeps coming in—all this seems to me to have no more to do with art than does knitting or needlepoint.

To say that "work substitutes for interiority" is to say that the anonymous labors of a journeyman monastic copyist could replace the writings of Augustine. It equates whittling and bead-stringing therapy in the catatonic ward with philosophy and art.

When the meaning of words changes, it of course reflects—and contributes to—changes in conditions and in values. At a time when "art" has become a major industry, while the academies mass-produce certified "artists," it is scarcely surprising that "professionalism" is no longer a pejorative, but a kind of compliment. Feeling obliged to find something "positive" to say amid the deluge of mediocrity—to keep the economic wheels turning—commentators have glorified decoration as Pattern Painting, illustration as New Realism, simple quirkiness as "individual vision."

Style, which can be taught, is exalted as substance, which cannot; conversely, raw "idea" is seen as sufficient in itself, without regard to form. The once-devastating adjective *academic* rarely appears

in criticism anymore, although there is more academic art, in more varieties, than ever.

But criticism is also changing, frequently becoming a disguise for simple exegesis or appreciation in which the underlying premises—the very nature of an expression as distinct from its "quality"—are never seriously questioned. For many people who clamor for, or complain about the absence of, criticism of their various activities, it is clear that criticism has become synonymous with publicity.

"Expressionism" in art has often bred excesses, a mindless emoting or mannered rhetoric; this has usually been reacted against by an emphasis on *idea* that eventually breeds its own excessive preoccupation with theory. Barthes's equation of art with mere "work," however, would suggest that theory as well as expression has come to the end of its tether.

The fact that authentic, transcendent art is always difficult to find is scarcely reason to deny its existence and surpassing value, nor that of the interiority—thought, feeling, reflection—from which it springs. *Cynicism* is another word that signifies many things to different people. But, for all the aura of benevolent acceptance that seems to surround Barthes's remark, I can think of nothing more truly cynical than the willingness to settle for less than one can have, to accept virtually whatever is—the esthetic of mediocrity.

Distinguishing between Artist and Artisan

MAY 8, 1980

About the first question anyone asks an "art critic" is "Do you paint?"

And, after the negative answer, one is likely to hear the old epigram of George Bernard Shaw: "He who can, does. He who cannot, teaches."

One epigram, of course, can always be answered with another, in this case the New Mexico folk saying that Alfred Frankenstein was fond of quoting: "You can't ring the bell and march in the procession."

Artists, as a rule, are terrible critics of the work of other artists. Quite properly, artists are most often totally absorbed in their own visions. They do not look with favor on those who work another side of the street—nor, for that matter, on those working the same side.

Beyond this, a mere knowledge of a single technique, such as painting or lithography, would be of little use to a critic at a time when so many people are experimenting with new materials and processes—or, in some cases, producing nothing tangible at all.

The main problem with such a question, though, is that it reflects a confusion of art with craft—with the technique, material and *form* into which art of a certain kind is sometimes cast.

It is a curiosity of Western culture that the word *art* has become practically synonymous with visual forms, particularly with the work of painters and sculptors. The most uninspired effort, if it addresses the proper "issues" with due professionalism, claims the attention of galleries and museums devoted to "art." Yet real artists working in other forms— jazz, for example—have had to struggle for recognition.

A similar confusion exists with the word *poetry*. One calls something poetic when it possesses a certain quality of feeling and gives rise to a peculiar form of experience. But poetry also has come to signify certain *forms* of putting words together. Only a fraction of the writing in these forms is really poetic.

The distinction between artisan and artist is dim or unknown in most non-Western cultures. Other distinctions, however—and crucial ones—exist. The difference between an object of worship and a utilitarian woven basket is generally as clear as that between a Rembrandt and a teapot.

In recent years the traditional distinction between art and craft in Western culture has been breaking down. Thanks to the prestige and glamour that have come to surround the notion of "art," elegant raku pottery, weavings, batiks—beautifully made but purely decorative objects of all kinds—have been moved into the museums; places call themselves "galleries" that are really chic shoppes.

The trouble with the traditional distinction, however, is not that it has been too restrictive, but too encompassing. The artisan who does handsome tie-dyes deserves no less dignity than someone who does Pattern Paintings on stretched canvas. But

both belong in the craft shop— along with the elegant plastic paperweight sculpture, the interior decoration masked as abstract or figurative painting.

Conceptualists performed a useful service in reemphasizing the distinction between art as idea, or experience, and as craft, or objects of merchandise. But they bogged down in equating "art" with certain forms of their own.

A work in any form can have all of the "right" elements and still lack that extra dimension that would make it art. Albrecht Dürer distinguished between painters and "the artistic painter" and noted (no doubt a bit severely) that "the world often goes without" one of the latter for two hundred or three hundred years. Such artists as Clyfford Still and Mark Rothko repeatedly emphasized that what counted in their work was not the forms, but the emotions and ideas they represented.

The principal difficulty—and task—of criticism is to try to penetrate beyond the craft, the form, to the art, if any, that lies within. Where it exists, it is beyond criticism, or at least analysis. One does not say of a great painting that a yellow area or a shoulder is beautifully executed, that the surface and colors are appealing. It is a living organism to which one responds as to other living things—or it is just a picture, a more or less handsome artifact not different in kind from a carpet or vase.

The Critic Isn't a Cheerleader

SEPTEMBER 13, 1979

The editor and publisher of another local paper, the story goes, approached a critic who had written a "negative" review and asked, "If you don't like it, why write about it?"

The critic's reply, if there was one, was not reported. Any response, perhaps, would have been fruitless, under the principle of "If you gotta ask, you'll never know." When positive thinking and serendipity begin to take precedence over balance and honesty in any branch of a newspaper, the values of journalism have become hopelessly subverted by those of advertising and public relations.

The inclination to confuse the functions of criticism with those of promotion is common among cultural entrepreneurs and frequent among artists and their more dedicated followers. The argument is that "negative" reviews "hurt," and it is the responsibility of criticism to support the arts—and help fill the house.

How much does a critic owe to "the arts" in general, and their economic well-being? Clearly, he should have a basic love for the form of expression that consumes so much of his time and energies—and, from this love, "knowledgeability," "perspective" and so on hopefully continue to develop. Practically speaking, because the critic is a participant in a symbiotic relationship, his livelihood is dependent on the general well-being of his "partner."

The critic is also responsible, however, to his readers—to give as clear an account as possible of his impressions to help them judge how to spend or save their time and money. He is responsible to a certain set of standards—"esthetics," if you like, or Art in the abstract, although these standards are necessarily and properly "subjective," the outgrowth of quite concrete experiences (including esthetic ones) of a life in progress.

And, in the end, his final responsibility, like that of everyone else, is to his own conscience.

Properly speaking, criticism is not a "profession" but a faculty that each of us exercises. A good artist is a severe critic—of himself and, usually, of others. A good critic will be sufficiently creative to reach some understanding of the artist's intentions and problems.

The past half-century has seen a shift from a notion in which "professional criticism" identified itself primarily with the interests of the audience, or "laity," to one that tends to give priority to the artist (or professional) and his "intent." There are advantages to this change. The critic of former times tended to share the public's hostility toward disturbing individuality or innovation—to be a Philistine disguised behind a sophisticated gift for sarcasm and epithet.

But the gain in rapport between critic and artist has been bought at a high cost of credibility on the part of the audience. The

trouble with most criticism today is that it takes its stance too deeply *within* the system. It becomes an exercise in appreciation, scholastic exegesis or apologetics in which the artist's good intentions are given priority over actual experience.

The "power of criticism" is nebulous. The evidence is clear that "negative" criticism is powerless to stay the growth of commercial fads like disco. It does seem likely that "positive" criticism can entice people to try something unfamiliar—but it's not likely to bring them back if they are disappointed.

The one sure thing is that criticism is not likely to have "power," or any other value, if it sacrifices its independence, and the precarious balance of its proper stance at some midpoint between artist and audience—and not simply as a one-way conduit.

The function of criticism is not to seek acceptance—consumer acceptance is the goal of advertising—but to try and provide audiences with insight and illumination, and artists with an honest, hopefully informed reaction so they will not be merely shouting into the wind—or through a mouthpiece.

A Question of Ethics

OCTOBER 4, 1979

If an art critic is visiting a gallery and his wallet is picked from his pocket, is it ethical to accept a dealer's offer to loan him five dollars?

Yes, as long as he pays it back.

This and similar questions of great moment are treated in a document entitled "Principles and Code of Ethics for Art Critics," which arrived in last week's mail. Drafted by a student at a local university, it includes my name among those thanked "for giving so freely of their time and experience." As I recall, my contribution was a brief telephone conversation in which I stated my belief that codes of ethics are ridiculous. The draft "Code of Ethics for Art Critics" does not prove me wrong.

It begins, in an appropriately jesuitical fashion, by expounding on the fundamental laws of propinquity. It is verboten to review a show that includes a sculpture by one's husband or paintings by one's mother, but OK to review a show in which one's cousin is represented. "The relationship...is not so close that she would be presumed to have a financial interest in her cousin's success."

The code does not say what should be done if the cousins share another kind of closeness; indeed, it quaintly sidesteps the entire question of *affaires de coeur* or other organs. But since most of the code is all mixed up with some bizarre notion that art is somehow supposed to be fair—as though it were some kind of competitive race and everyone should have an equal chance to win—one may perhaps assume that the critic may indulge in a certain amount of hanky-panky with artists and even dealers, so long as it is equitably spread around.

Most of what the code does have to say centers, predictably enough, around money. It performs some delicate acrobatics to reconcile the principle that "the critic has the right to lead a full personal and professional life" with the injunction that he should render "fair and impartial judgment" on the work that he reviews, avoiding the dimmest shadow of that old bugaboo, "conflict of interest."

We are told, for example, that "the critic has the right to enjoy the ownership of works of art" but should not "review the work of an artist if he owns more than one major or two minor works by that artist."

It is perfectly all right, the code goes on, for a dealer who served as best man at a critic's wedding to present the critic and his wife with a painting valued at more than twenty-five thousand dollars for their twenty-fifth wedding anniversary. "His relationship with the art dealer is primarily personal rather than professional."

A critic who has written "a severely critical review of an artist" may accept a gift from the artist of "a twenty-five-pound bologna sausage worth over fifty dollars...in the spirit in which it was offered. It could not be construed as a bribe." That must mean I can ethically keep an object purported to be one hundred percent B.S. that was recently delivered.

As I recall, my stated objection to

codes of ethics was based on two main points. One is that most professions that have them are loaded with crooks—who are often those who observe the letter of the code most ostentatiously. The other is that they confuse substance with shadow.

A critic's only legitimate "interest" is trying to illuminate whatever art he sees, to be partisan toward what he feels is valuable and against what he feels is meretricious, whatever the surrounding circumstances may be. The "draft code" is based almost entirely on the false equation of art with money and "success" that dealers and collectors have managed to create. It would turn the critic into something that critics from Baudelaire to Harold Rosenberg—intensely committed, partisan people—would never have recognized, a kind of faceless, impersonal broker or investment counselor or referee handing out the sweepstakes trophies.

"A specialist," John D. Graham wrote in his *System and Dialectics of Art,*" "is a man trained to perform a profession conscientiously but not necessarily honestly. Conscientiousness is a conventional way to escape the responsibility of an all-encompassing honesty. Honesty implies the responsibility of choice."

By the way, if you suspect the dealer of lifting your wallet, do you still have to pay him back his five?

Inflation Invades the Art Support Structure

JULY 17, 1980

The San Francisco Art Dealers' "Introductions '80" is well into its run, and I have managed thus far to see thirteen of the eighteen shows that have already opened within the city.

The stats, as they say, are not impressive: Of twenty-three artists, one—Roger Berry at the Shirley Cerf Gallery—is showing exceptional work, and another, Larry Thomas at Jehu Gallery, stands somewhat above the general run of mediocrity, or worse.

That makes two for twenty-three, or an average of .087—an abysmal percentage in almost any league, excepting, perhaps, the late San Francisco Art Festival. But about par for the Art Dealers Association's annual nonevent (it even comes with a Mayor's Proclamation this year)—and not all that far below the regular season average.

Percentages, of course, count for little in the world of art. The laws of averages and probability do not really operate. One can look at a hundred terrible shows, and the chances that the next show will be better do not improve. On the other hand, it is arguable that the emergence of one good artist justifies a thousand misfires.

Still, show after show of such routinely mediocre work can lead to the kind of despondency that Sherlock Holmes suffered between cases. And to questioning the real viability of what has come to be known as the "Support System"—or of system in general, which is predicated on large numbers and norms, in an area where the object is not quantity or averages, but the unique and the exceptional.

The Art Support Structure—the term evokes the image of a giant jockstrap—as it now exists, is a product of the overall inflationary, bull-market consumerism that shot into high gear in the early 1960s, when art became one of the new, mushrooming "leisure-time industries." And the art world, while continuing to pay lip service to the notion of quality, rushed to be a part of the gross national product.

Student bodies in the art academies skyrocketed. More degrees produced more teachers, to teach more "artists." This influx had to be accommodated, so there were more galleries to help them hawk their wares, abetted by an aura of glamour and chic painted by a largely uncritical art press. There were national endowments, and new foundations from the "private sector."

And there became professional proposal writers, lobbyists and lawyers for the arts and a motley host of other functionaries involved in dubious activities where the word *art* is rarely used in the singular. The only thing that declined during all this was standards.

One of the most alarming aspects to this runaway expansion has been observing museums submit to the pressure to become a part of the big, happy Support Structure—a pressure from which, indeed, criticism has also not been immune. For example, docents from both the San Francisco Museum of Modern Art and

the Oakland Museum are being used to guide viewers through some of this year's "Introductions" shows; in effect, giving the museums' imprimaturs to work hanging in commercial galleries that—at least one hopes—has not even been viewed by their curatorial staffs.

Systems have a way of turning into Frankenstein monsters—dedicated to their own perpetuation and increase, and never questioning their premises. Activities that may initially have value turn into annual events, each with less reason for being than its predecessor.

Artists, of course, need to expose their work—although it is questionable whether it is to the advantage of a really serious artist to show in a context increasingly difficult to distinguish from a store. And as long as degree-carrying professionals continue to proliferate, the art world's bullish expansionism is not likely to abate.

Harold Rosenberg, in one of his final reviews, said that for the immediate future, we probably can expect, for the most part, a kind of sophisticated commercial art. That is pretty much what "Introductions" is proffering.

Someone, however, also has to stand outside this system, to support, not "the arts," but the idea, or ideal, of Art itself. A critic properly must remain, as Socrates put it, a gadfly on the steed. And museums should concentrate on distinguishing the horse from the horse droppings.

The Trouble with Group Shows (Cont'd)

SEPTEMBER 1, 1983

"I know you don't like group shows, but if you did, what kind of group shows would you put together?"

"Come again?" I replied. It was like being asked what I would do in a restaurant that served only different kinds of yogurt, or sauerkraut.

The caller came again, explaining she was involved with a new organization devoted to displaying work by young, "emerging" artists. Questions like this make you wonder if haranguing for years on a given subject ever does much good.

Well, after a period of time, things that go without saying need to be said all over again.

It is hard to figure which kinds of group shows are most objectionable: patent space-fillers or shows that obviously consumed some time, effort and expense; grab-bag shows that make no point whatever—the current group show at the newly renovated Arts Commission Gallery is an outstanding example—or "theme" shows that reduce individual works to the role of *illustrating* ideas that are often of more relevance to the curator than to the artists (or most viewers).

Probably the worst are those that purport to give exposure of new, "emerging" talent. The group show has become institutionalized in recent years as the standard, or at least the most expedient, device for absorbing a plethora of certified new artists, ink scarcely dry on their MFA degrees, into the System.

For all the inflationary growth in the number of galleries, museum shows and other attributes of the Support System, exhibition space remains in relatively short supply. The group show, so the logic goes, is the most equitable way of spreading it around.

Yet a group show may well be the most unfavorable of circumstances for a new artist to introduce his work. Whatever his or her achievements—and, with most young, "emerging" artists, these are likely to be uneven at best—even the most helter-skelter of group shows creates a framework, a context, that inevitably affects the way in which an artist's work is seen.

If the show carries a label—"Neo-Expressionism," "Geometric Abstraction"—it tends to attach itself to the work of all the artists in it.

Often, a kind of Gresham's law sets in, so that better work takes on the taint of the poorer. At best, the expression of one artist is qualified, and subtly altered, by its proximity to that of another, in much the same way as images take on different meanings according to the way they are juxtaposed in a collage.

Rather than taking their places as part of an integral, continually unfolding organism, as an artist's works do in the framework of a one-person show or retrospective, in a group show they compete with the work of other artists, or neutralize each other, simply blending into the mass. It is perhaps no accident that the vogue of the group show has coincided

with an era teeming with "emerging" artists who somehow never manage fully to "emerge" from the herd.

Probably the most unfortunate by-product of group shows, however, is their far-reaching effect, not on recognition or careers, but on the very sensibilities of the people who take part in them.

For those involved in organizing exhibitions, the group show has become a handy expedient for substituting a wimpish responsiveness—to external, "objective" pressures of movements and trends, or art world politics—for real responsibility, which involves making hard-nosed, personal and inevitably controversial decisions and choices. Yet art, at least in theory, remains one of the few areas of life where quality, not quantity, is supposed to be the guiding principle.

To the young, aspiring artist, the group show makes a statement of a quite different kind from a one-person show. The one-artist show, and particularly the museum retrospective, says: "If you dig in, experience deeply, work seriously, and manage eventually to identify yourself as an individual and an artist, your work may hang in a show like this some day."

The group show, and especially the trend show, says: "If you can psych out what dealers and curators are displaying at the moment, and contrive some kind of variation on it, you can get a piece or two in next year's survey."

The group show encourages artists to think in collective terms rather than individual ones, even though art is the loneliest of enterprises in which, finally, the artist himself can be the only judge. It fosters relative rather than absolute values, even though the only thing that matters in art is not the relationship of an artist's work to that of his peers, but to his own vision and goals.

The individual show celebrates exceptionality. The group show wallows in the typical—that is, in mediocrity.

"There must be some kinds of group shows you'd approve of," the caller persisted.

Well, yes, I had to acknowledge. You might partition a space four or five ways to give each of four or five artists what would amount to individual shows. Or, if you had a genuine *idea*, you might build a show around it with the work of artists whose identities already had been firmly established, and the meaning of their individual expressions become generally known—provided acknowledgment was made that the exhibition was basically a kind of assemblage of found objects, and the relationships drawn among them a creation of its curator.

"Thank you. You've been most helpful." She was audibly relieved as she said good-bye. As long as people keep wanting to do group shows, and artists are willing to take part, nothing I can say is going to stop them.

Tut: Up against the Madding Crowds

JUNE 21, 1979

It is one of the vagaries of modern journalism that events are often represented to—and by—the media in a different guise from the ones they take when they go public. The best foot goes forward for the fourth estate; the lumpenprol get the one that smells a bit.

Thus, at a press review a couple of weeks ago, I joined a small crowd of newsmen and television persons at the M. H. de Young Memorial Museum and spent a leisurely morning viewing the "Treasures of Tutankhamun." At 4 P.M. last Thursday, as a ticket-carrying member of the masses, I returned and saw the King Tut Show.

The two experiences coincided more or less at certain points—such as when looking at most of the objects made of wood, alabaster and other semiprecious stone. By sharply jostling a mere half-dozen people and overturning a wheelchair at the Tut Show, I was able to close right in on such things as the alabaster lion and Tut's baby chair, and contemplate them almost as unmolestedly as at the press review.

But if the object is made of gold—and especially if it is the celebrated gold mask or the intricately engraved gold shrine—forget it. The "Treasures of Tutankhamun" is the splendid, three-thousand-year-old artifacts—fifty-five of them, most quite small—that you have been seeing and hearing so much about. The King Tut Show is mostly hundreds of people.

At the press preview, I walked directly up to the gold mask; I could have stayed long enough to stare it down. At the Tut Show, the mask, the shrine and, to a slightly lesser degree, the little gilded head in the entry hall were surrounded by tightly packed knots of people, trooping patiently and at a glacial pace, toward the glittering reflected light. We spent perhaps five minutes along the outer edge of the cluster massed before the mask, advancing perhaps five feet. I calculated another fifteen or twenty to reach the mask, and perhaps five minutes more to extricate ourselves from the crowd milling reverentially around it.

Under the circumstances, the Tut Show is a thing that is sometimes heard but not seen—most often, snippets from the dollar guidebook recited in a flat, nasal, detergent-commercial monotone that falls rather short of the pear-shaped narration provided by Orson Welles on the portable recording. There are snippets that are not in the guidebook. "Tut had a sagging stomach." "They had a thing about tongues." "Look at Tut's tits." "But, Timmy, if I take you outside to the bathroom, they won't let us back in!" Although the objects themselves are under glass, it is also a highly tactile show—elbows, feet, a left and a right to the shins.

In truth, the show is full of things that are more worthwhile viewing than the gold mask. Compared with the exquisite gilded wood figures and the lustrous alabasters (like skin), it is clunky and garishly ostentatious. But the crowds encircling the mask and shrine do not diminish.

Indeed, since the crowd control system is designed to prevent long waits outside by providing a regulated and continuous flow, the clots of people waiting inside are likely to stay about the same size until the end of September. They may even contain some of the same people.

One solution would be to elevate the mask to the level of the overhead signs, where it could be seen from a greater distance. Eye contact would be sacrificed, but the gold image could be salaamed to. A more practical one would be to move it to the more spacious adjoining gallery, and organize a formal line that would be kept moving around it, as viewers must file past the Crown Jewels at the Tower of London—or did with the jade suit that was the star attraction of the big Chinese show a few years back.

I thought of leafletting the staging area outside the museum with promotional material to generate excitement over Tut's baby chair: a special curse; a mysterious metallic inlay that could have been melted down from space vehicles. While the crowds lined up to see the baby chair, we could spend all afternoon gazing at the mask.

But for now, the best bet is to let the gold draw off most of the spectators, view the rest of the show as best you can, and then take a good, long look at the many replicas of the accursed mask in the museum's souvenir shop.

Is This the Age of 'Toleration'?

SEPTEMBER 4, 1980

It seems to be among the perversities of human nature that people can so often agree on abstract sentiments, and then part company altogether on their application.

In discussing art, one can converse at great length, and with impassioned enthusiasm, about the necessity for inspiration, vision, originality, energy. But eventually it will almost always turn out that one person is talking about Jackson Pollock and the other about Josef Albers, that one's paragon is Mark Rothko and the other's Max Ernst—twains that just will not meet.

Compounding the perversity, where there is agreement on specifics it is more apt to be "negative" than "positive." One is more likely to find those who concur in the judgment that Willem de Kooning's recent paintings are not as good as his early ones, for example, than in the conviction that Clyfford Still was among the century's most profound artists.

Time affects the operation of this principle, but only somewhat. The more distant in the past, the more individuals and issues become "safe," beyond criticism; the more contemporary, the more chaotic judgments become.

Not that the present time is notable for critical acumen, or readiness to dissent. On the contrary, it tends to evade discriminations; "opinionated" has become a derogatory word, and real clashes of intensely held beliefs, a rarity. One senses the absence of agreement most often, not through any vociferous dissent, but a mild demurrer, a shrug and that dreadful cliché, "different strokes for different folks."

"Toleration" has become a kind of collective psychic miasma in which differences that might be disturbing are not so much accepted or rejected or even examined very closely, but are simply neutralized. Its corollary is an unarticulated feeling of general malaise—a dim sense that everything may not be so rosy as many seem to be struggling so hard to believe. Or, at best, a kind of generalized grumbling, like farmers on the weather. On the surface an era dominated by "positive thinking," ours is really a time of an almost crippling lack of convictions.

Such a condition is not, of course, confined to contemporary art. It is the art world's equivalent of the drift that has become increasingly manifest in political affairs, when more and more people, if they vote at all, cast ballots against rather than for, and the "convictions" of "leaders" and followers alike are a kind of watery pabulum squeezed from the amorphous sponge of the opinion polls.

A candidate for public office with even a modicum of individual vision becomes branded as a "flake"—the rough edges quickly reduced until there is nothing left to stand out from the mainstream of mediocrity. When decision and the urge for change are regarded by a majority as akin to insanity, the only alternative is a continuation of the status quo.

Perhaps this is the only feasible course for politics in the nuclear age. Whole populations have, after all, killed each other off over differing constructions of abstract sentiments, like peace and love and brotherhood, in which most of them profess agreement in principle. The age of heroic men of action like Alexander the Great seems pretty well past. Considering the reaction to LBJ's foreign policy, think of how pan-Hellenism would go over today.

Art, however, acts in a different realm. Its impact is nonmaterial (though it can be no less substantial); it works in an interior world, on one individual at a time. Its fruits are subversion rather than conquest, warfare or overt revolution. It may be one of the last havens for the absolute, in which individuality can still flourish more or less in total freedom— and act with absolute responsibility.

We are in bad trouble when we begin to pussyfoot about our art as we do about our politics: when it becomes a matter of such indifference that people do not bother to articulate and defend their views, to express strong praise or intense damns; when so few people seem sufficiently *driven* to risk making a "mistake."

It is hard to find in all of history figures of whom one can conclusively say they were "mistaken." Except, perhaps, for those who, like the rabble in the anteroom of Dante's Inferno, had done nothing to warrant either praise or infamy.

How to Get Rid of Superlatives

JANUARY 5, 1978

By chance, the opening of the new year coincided with a project that took me through back issues of various art journals from the late 1960s and early 1970s.

It was amusing to review all those Brave New World prophecies and panegyrics (not to mention the utterly indecipherable nonsense). The art object was dead, boundaries between art and "life" were collapsing, and the Age of Aquarius and the Global Village were at hand.

There were all those quotations from Marshall McLuhan (whatever happened to...?); eulogies to Jules Olitski (named the most overrated artist of the past seventy years by several critics responding to a recent *ARTnews* poll); paeans to scores of other painters, sculptors, conceptualists and whatnots who are already almost as forgotten as Joseph Hergesheimer, the sentimental novelist who beat out such contenders as Ernest Hemingway and William Faulkner to be voted the best American writer of his time in a *Literary Digest* critics' poll of the early 1920s (he even got H. L. Mencken's ballot).

But the smirk suddenly turns to an embarrassed blush as one stumbles upon a passage of hyperbole that one recognizes as his very own—the comparison of some third-rate local artist with Matisse or Picasso, the use of superlatives that are more appropriate to advertising copy (and frequently become appropriated as such) than to the kind of balance, perspective and considered judgment which should be the ideals of criticism.

The bullishness (in both senses of the word) that has dominated art writing during the past decade and a half, at least,

was the product of several factors, among which two particularly stand out.

One is the zealotry (and, its obverse, defensiveness) that have traditionally accompanied the crusade on behalf of innovation and "Modernism" in the arts. Sensitive to the oversights of great talent that darkened the history of art criticism in the late nineteenth century and early years of the twentieth, and aware of the general hostility that major changes in the arts once called forth, Modernist critics have hastened to defend, promote or "explain" virtually anything that has carried a gloss of novelty. The assumption was that what was good for the art world was automatically a boon for art itself.

Through a curious kind of doublethink, the champions of Modernism managed to maintain a draw-the-covered-wagons-in-a-circle stance at the same time that the Philistine "attackers," fresh out of art appreciation classes, began flocking in droves to the proliferation of museums and galleries that specialize in contemporary art. The critic to whom "modernity" or "innovation" was a prime criterion has found him- (or her-) self in the paradoxical position of defending the production of, first, an "avant-garde" academy and, more recently, sheer "avant-garde" schlock tailored to meet the demands of the new art market.

The second factor is a kind of can-you-top-this mentality which is endemic to art, as it is to any other effort to achieve transcendence, but can also result simply in a proliferation of superfluities and a compounding of mistakes when misapplied. In journalism, the temptation is to apply a

superlative to a relatively ordinary occurrence, after which it becomes necessary to pile up further superlatives to describe events of only slightly greater import, and so on in an inexorably escalating progression.

It is indicative of this situation that we have dozens of synonyms for "great," and perhaps an even larger number for the hopelessly awful, but very few words that apply to the various shadings of that vast gray area between extremes in which most of the work that we are called upon to evaluate actually lies. The word *mediocre* has come to connote "pretty bad," when actually it means simply the norm.

Sam West, the late collector and all-around character from Oakland, used to have an admirable perspective on all this. He would refer to most of his favorite artists as "third-rate"; certain historic figures were "second-rate" and, on rare occasions, "first-rate," although that was largely a Platonic ideal.

It wouldn't hurt to see this perspective carried over more consistently to the realm of criticism, reserving superlatives for the rare occasions on which they are warranted, restoring "mediocrity" to average standing, and reintroducing such adjectives as *decent* and *respectable* for the positions of seven and eight on a scale of ten (insofar as such spectra have any meaning at all)—about as meritorious as most work gets.

I hereby resolve, then, to banish gratuitous superlatives from my writing in 1978. Utterly absolutely.



in the
etely.

s Mon-
ructiv-
tion of
e into
strain
ed the
xpres-
ll art,
e most
ary."

ems to
right
ions it
two of
ell as
ry ex-
ire of
is, 109
inting
Berrg-

ped a
undly
ast by
to the
ons of
barian
sels —
al and
tempo-
his art
e gives
ng the
rich in
d that
other
ent in
st both
eology
nd the
decay

forms
ematic

Middle column:

similar in some respects to the monumental pieces he exhibited a couple of years ago — towering columns of irregular ceramic slabs placed one on top the other, with three of their sides cut sheer; the fourth, the "front," combines mangled human forms — fragments, bones — with gnarls and folds that more nearly resemble congealed lava.

But the structures have become less pyramidal or wedge-like, more slender and upright, generally towering nine feet or more high. And they are more abstract.

The tendency for a breast, a foot or a knee-cap obtrusively to "pop out" from the more firmly imbedded forms has been curbed: the new sculpture projects more the frangments of the figure, or of bones turning into rock. With a few exceptions, the color with which deStaebler impregnates his material is also more subdued, and controlled.

But while the new pieces are more harmonious on the surface, they also seem more arbitrary in structure and concept, in the way that a lava formation is more arbitrary than the construction of the human figure. The great dilemma of deStaebler's expression is arriving at a precarious, delicately callibrated balance between figuration and abstraction, between form and dissolution; its attainment, when it occurs, gives his strongest work its sense of deep internal tension.

It is achieved here, it seems to me, in the relatively small "Right Sided Woman Standing," and ap-

Right column:

tures. But for the most pa opting for a more abstra proach, deStaebler seems have resolved the dilemma so as to have evaded it.

The pieces are all quite ful, as natural outcroppings o can be quite beautiful, but n them seem rather too easy the skin.

Although the range of a in deStaebler's sculpture is he uses his references expre and absorbs them into a co form of his own. The proble Oliveira's new paintings is gratuitous eclecticism.

All belong to a series "Swiss Site." Two or thre almost straight caricatu Turner, with hazy, light-pe atmospheres, intimations of mering reflections and dus houettes. Most are more like between Turner and Dieber "Ocean Park" paintings, wit vocal interior "edges" that luminous atmospheres from emerges the halo-like imag distant tower. A few conta and traces of imagery that s William Wiley — a checke flag, a funky pyramid, a wh arabesque with candy stripin

Oliveira is masterful a dling the effects of atmosphe painterly surfaces, and the ju where they coincide; on th face, many of these new pa look spectacular. But, for wildly casting about for sign imagery, or "content," in t these paintings seem to be r but seductively vaporous effects. They are like a new

Satire

Sipping My Way through the Galleries

AUGUST 2, 1979

Sometimes it helps me put contemporary art in perspective when I make the rounds of the galleries together with B.S. Sneer, the distinguished and outspoken art world emeritus.

It is never easy persuading him to come. "You know as well as I that you're lucky if you see half-a-dozen good shows of new art in a year," he always says. "The rest is mostly B.S."

But he agreed to join me Tuesday afternoon, and we met on the street in front of the Trendy-Vogue Gallery.

"Oh, we're so *happy* you're here," squealed Cindy Smarm, the gallery girl, as we walked in, rushing past Sneer and throwing her arms around me. "Bernard Beret is showing such *unusual* work, and we're so anxious to know what you *think* about it."

"I look forward to seeing it," I said, trying to look over her shoulder, but all I could see was the figure of Vera Vogue approaching behind her.

"It's a—er, a very *difficult* show for many of Bernard's followers," she said, handing me a cup of coffee. "You know how it is when an artist turns his back on the style everyone is familiar with and pushes ahead into unknown territory. *Tough*. But I know *you'll* be able to rise to the challenge and help interpret to everyone what Bernard is doing."

"I hope I may have the opportunity," I murmured, trying to edge around the side of Vera Vogue but, in the process, bumping head-on into Twyla Trendy.

"Whatever else you may think about the show, you have to recognize its *authenticity*," she said, handing me a bottle of Calistoga water. "He's so *sincere*. And you must remember Bernard has had to *struggle* for so long. Years ago, you know, he became allergic to oils and had to give up painting."

I nodded, grasping the neck of the Calistoga water bottle with my teeth so I could have a free hand to hold the glass of wine that Cindy Smarm was passing to me.

"Later, he became allergic to acrylic," Vera Vogue recalled, shoving under my arm a heavy ream of papers headed "Artist's Statement."

"Watercolor, too," added Twyla Trendy, stuffing a photograph and a title list into my mouth. "If it hadn't been for Conceptualism, his career would have been shot long ago. As it is ..."

"He's had so many personal hardships, too," Vera Vogue interrupted, waving in front of my face a periodical that had included Beret's name in a list of three hundred artists taking part in an unjuried group show in Yreka. "A couple of months ago, his wife ran off with his mistress, and Bernard has taken it so hard.

He's an alcoholic, you know."

"It would have been better if you'd come an hour ago," said Twyla Trendy glumly, looking over her shoulder. "The negative space seems so much more *positive* when the morning sun shines through the window. It's kind of hard to tell the negative from the positive now...."

"I'd be happy to see either," I gagged, rolling around on the floor with Cindy Smarm and trying to spit out a press release that she was pushing down my throat. We bumped into a desk, overturning a box of little round, red "sold" stickers, and they came snowing down on us.

I must have blacked out after that, for the next I remember, I was out on the street again, receiving mouth-to-mouth resuscitation from B.S. Sneer.

"Did you manage to catch a look at any of the work, B.S.?" I asked, struggling to my feet, taking my torn shirttail and wrapping it around my arm as a tourniquet.

"Oh, yes. They never bother me now that I'm only a spectator. It was just the usual B.S."

"That was my impression," I replied, as my left eye swelled shut. "But until you can achieve a certain detachment, you can never be sure."

Sneer Takes on the Urban Cowboy

AUGUST 28, 1980

I rarely go to openings. But in the interest of keeping thoroughly abreast of happenings in the art world, I broke precedent last week and made the first-night party at the Trendy-Vogue gallery for the annual one-man show of the famous Bluegrass Dadaist, Waylon T. William.

For moral support, I persuaded B.S. Sneer, the distinguished and outspoken emeritus, to come along. Sneer agreed, disguising himself as E.G. Seymour, the celebrated avant-garde critic from the East Coast.

The gallery was crowded when we arrived, Sneer wearing an orange, punk-style toupee, his face mostly concealed behind a false nose and mirrored sunshades. The sound of hoedown music came from across the room, and straw was discreetly scattered across the floor.

We pinned on "Sneer Sucks" buttons at the door, and sidled past a few pieces of William's sculpture—a buckboard carved with money graffiti; a stuffed longhorn daubed with paint and girdled with a wagon wheel; a skeletal tepee and a large group of haphazardly assembled fetish bundles—whittled sticks and dessicated frog and lizard carcasses—in a variety of sizes.

"For the low-cost, high-volume trade," Sneer muttered through his false whiskers, narrowly escaping being snared by a hanging lariat.

In the middle of the floor, Buncomb ("Bunk") Bluechip, the premier contemporary art collector, was watching his personal decorator carefully measuring the exhibition's biggest piece, a corral containing a giant tumbleweed, to see if it would fit into his home. Vera Vogue watched him anxiously as she sat at her desk, next to the teletype connected to the major galleries on the East Coast and in Texas, gathering in checks, making out receipts, answering the three telephones at her side and assigning red dots, and fractions of dots, to Cindy Smarm, the gallery girl, who rushed about pasting them in place.

A knot of people had gathered in a far corner, where a vigorous auction was developing among a group of collectors who were competing to buy a big uprooted tree stump with a hatchet buried in its top, beside a splotch of red paint.

"One of William's most monumental achievements," the museum director, A.D. Straddle, solemnly intoned as Twyla Trendy frantically chalked the bids onto a blackboard.

"We will be most happy to accept the work as a donation to the permanent collection, thereby assuring a substantial tax deduction to the winning bidder," he added, after which the bidding quickly doubled. "Such prices for a local artist constitute a milestone in the cultural life of the Bay Area."

We joined a long line of younger artists, junior curators and administrators of alternative spaces, hoping it would lead

to the bar, but instead at its end we found Phil Fund, the representative of the National Endowment, who was filling his appointment book.

We moved through a wigwam and past a birch bark canoe until we found ourselves standing alongside two of the gallery's other artists, Bernard Beret, the old-time Abstract Expressionist, and Thalia Tie-Dye, the Pattern Painter.

"It's the same old fun and games," Beret muttered. "Just like his last show."

"It's dumb and…" Thalia Tie-Dye broke off as Waylon T. William, in his denims and black cowboy hat, sidled up beside her.

"Great show, Waylon," she said.

"Stunning achievement," echoed Beret. "Some real breakthroughs."

William squinted in my direction, but I ducked behind Sneer.

"E.G. Seymour, the avant-garde critic from the East Coast," he introduced himself portentously. "I must remark that in terms of concept, originality, substance and in absolutely every respect, I find your new work to be …"

At that moment, his vision obscured by the sunshades he was wearing, Sneer tripped over a fishing line that was stretched across the floor, and his disguise flew across the room.

"Why, it's B.S.!" William exclaimed.

"Exactly," said Sneer.

Another Evaluation by the Illustrious Sneer

JULY 10, 1980

When Twyla Trendy called to notify me that her gallery was displaying an unprecedented installation piece by the celebrated European avant-gardist, Miguel Stiletto, I figured it was time to call again on B.S. Sneer.

Such a monumental event clearly needed the perspective that only Sneer could give it.

"It sounds like so much B.S.," he muttered.

A dapper man with a pen-line mustache was standing next to Twyla and her beaming partner, Vera Vogue, as Sneer and I arrived.

"Signor Stiletto," I moved to shake his hand.

"Stan Scam," he snapped. "Stiletto's agent. Stiletto only talks to network TV."

I peered cautiously into what appeared to be a window at the beginning of a mazelike structure that had been constructed throughout the gallery, then jumped away as I recognized my own image reflecting back.

"A portrait of the artist," Scam explained, pointing to the mirror. "Stiletto's art," he went on, solemnly, "is nothing less, nor more, than life itself. Literalist painting and sculpture, real time, real space, information, data—there was only one way, one more step, that the avant-garde had to go, and Stiletto has taken it. The viewer becomes the artist."

Entering the maze, Sneer stumbled over a rock, landing on a pile of old clothes that was strewn across the floor.

"Clothes, rock," Scam intoned. "Facts, sensible objects. No rhetoric. No metaphysic. No symbol. No poetry. No significance.

"An art of pure phenomenon, of substance, existence in the absolute," Scam continued, as we examined a display of snapshots haphazardly pinned to the wall—pictures of dust bowls, vacant lots, empty corners, and a few prints that were just black and white squares. "No interpretation, no critic, no middleman."

We passed a little rack of pamphlets and Acoustiguides, and followed Scam further into the maze, past racks of disgusting dirty dishes, through a tableau of a suburban living room where a television was playing soaps, past a series of Photo Realist paintings of supermarket shelves, and wax replicas of TV dinners, Big Macs and overstuffed burritos. Projected on a wide screen was a film loop showing close-up views of pavement as seen from a car on Interstate 5.

He paused contemplatively before a long table covered with scrapbooks stuffed with detritus—candy wrappers, bus transfers, cigarette butts, rubbers, wads of bubble gum.

"The social anthropology of the streets," he whispered reverently.

Entering another room, Scam began to kick and toss about a layer of old leaves and other trash that was scattered about the floor.

"Randomness. Chance. Everyman an artist!" he exalted, a light froth forming on his lips.

I looked behind for Sneer, who was trying to extricate himself from something sticky he had stepped in.

"Compost," Scam cried, ecstatically. He rushed toward a door at the end of the corridor, but, overpowered by a familiar smell that rushed out when he opened it, Sneer and I took another turn and suddenly found ourselves in the midst of an astonishingly lifelike illusion of a city street.

A passerby approached, hacked loudly and spit on my shoe. I realized, with a certain relief, that this was, indeed, the real world. We sat on one of the granite blocks by the UN Fountain, next to a grizzled man in a rumpled trench coat who was swigging from a brown paper bag. He introduced himself as Miguel Stiletto.

"The show itself," he gestured about him grandly, his eyes glazing. "Post-Modern, postcognitive, pure, unaltered reality...."

"You could call it quotidianism," I offered lamely, wishing there was a place to hide from Twyla Trendy and Vera Vogue, who had materialized beside us and were raptly gazing at the torpid movements of a sleeping wino.

"I call it absolute bull...," Sneer began.

"Why, B.S.!" Twyla interjected sharply.

"Just so," Sneer said. "B.S."

A Thousand Flowers Blooming

FEBRUARY 7, 1980

Last week I made my annual visit to an art world seminar. Its subject was "The Spirit of the '80s."

The lobby was filled with little folding tables covered with pamphlets: "How to Take a More Random Photograph"; "Careers in Proposal Writing"; "Abstract Expressionist Surfaces Made Easy: Automatic Angst for Pattern Paintings." I made my way through a group of pink-haired performance artists who were rolling about the floor and speaking in tongues, accompanied by a punk rock group.

A scuffle was taking place among the panelists, each of whom wanted to sit next to the delegate from the National Endowment for the Arts, Phil Fund. The moderator, the director of the Museum of Post-Post-Modernist Art, A.C. Straddle, after taking a vicious kick in the shins from P. Barnum Turnstyle, curator of the Center for Post-Avant-Garde Studies, finally resolved the issue by having a blackjack table brought in to replace the one that was normally used.

With Fund in the dealer's place, the others took their seats in a semicircle, equidistant from him, ducking as an occasional beer can or sanitary napkin was hurled from the audience.

"As I see it," said Straddle, thumbing through a pile of Chamber of Commerce literature, "the center of gravity has begun to shift from the East Coast toward the Pacific Slope. I would like to propose that we can build an art scene here that will rival New York. Permit me to suggest that the 1980s call for a new commitment to minimizing discord, and optimizing cooperation and participation from the entire community."

"I must commend your museum for its efforts in that regard," said Fund. "Big group shows like the recent tie-dye exhibition and the upcoming leather show really spread it around."

"As we all know, the course of Modern art has been a continuous evolution in which more and more things that were once considered trivial have been made to seem important," proffered Ibid Opcit, the noted art historian. "As we advance further into the post-Post-Modern age ..."

"Exactly," agreed the avant-garde photographer, Asa Click, who was haphazardly taking pictures under the table.

"Would you like to address the issue, Mr. Lithp?" Straddle inquired.

"Lithp," he corrected irritably. "I think it imperative that we couple our effort to include more people with an attempt to revive a tone of th-th-"

"Seriousness," Sandra San Jose offered.

"One thing I am doing is to remodel my gallery to give it the more serious look of an alternative space," said Twyla Trendy.

"We will soon be initiating an ongoing

program to help eliminate differences between commercial galleries and alternative spaces," said Fund. "Used brick walls, sawdust floors ..."

"As I see it," said Straddle, "our major stumbling block is going to be enlisting the cooperation of the critics. I would suggest that they have become far too critical."

"Yes, in the old days, even though no one else took us seriously, we at least always knew how good we were," sighed the dealer Vera Vogue.

It seemed time to rise to my defense, but B.S. Sneer, the distinguished and outspoken emeritus who was seated beside me, took the floor.

"All this about participation is B.S.," he said. "You can participate in art more fully by looking at one great work than by turning out a million mediocre paintings or performance pieces. If you're interested in careers, why don't you go into proposal writ ..."

Sneer's participation ended in an explosion of catcalls, and he left the hall in a shower of bottles, bubble gum and goobers. When I last saw him, he was surrounded by the performance artists who were speaking in tongues, his own mouth working furiously. It was impossible to hear what he was saying. Velma Video was taking his picture.

The Great Hamburger Controversy

OCTOBER 16, 1980

It is not often that a critic for a daily newspaper gets involved in the rarefied world of art historical controversy.

So I was greatly intrigued when Professor Ibid Opcit, the distinguished art historian, invited me to serve as an observer in an attribution dispute in which he was involved with another scholar of great eminence, Dr. Errata Phd.

At issue, the professor explained as we drove to Marin County, was one of the most important sculptures belonging to Buncomb ("Bunk") Bluechip, the premier collector of contemporary art. The work was a plaster-of-paris hamburger that had traditionally been attributed to the famous Pop artist, Klaus Thunderbird; indeed, it was one of his most renowned pieces.

Bluechip had just made public his intention to donate the work to the Museum of Post-Post-Modernist Art, when Dr. Phd had raised strenuous objections to its authenticity; indeed, he had suggested the work was a forgery. The scandal could be most grave. At stake were the reputations of several people: the dealer from whom Bluechip had bought the sculpture; Professor Opcit, who was retained as the collector's advisor and had counseled him to buy it; the museum curator, who had offered to accept it. Not to mention a tax deduction of several hundred thousand dollars.

"Why not just check with Thunderbird?" I asked.

"Hell, he turned out so many things, he can't tell them apart himself," Opcit replied.

Bascomb rushed up to meet us, waving his tennis racket and dripping water from his Olympic-sized hot tub, as we pulled into the driveway of his hillside estate. Phd had already arrived, and standing next to him I recognized B.S. Sneer, the distinguished and outspoken emeritus, who curled his lip in greeting.

The two experts exchanged curt nods, and a quick maneuver by Sneer prevented Opcit from clipping Phd on the head with his cane.

"Muscle in on my act, eh," the professor glared. "What's in it for you?"

Bluechip stepped between and guided the two august savants into his home, Sneer and I following. The collection was indeed impressive. The premier local artists were all represented with major works: Waylon T. William, with a willow divining stick surrounded by rusted barbed wire; Sandra San Jose, with a ceramic sanitary napkin; Melinda Macrame, with a pair of hand-knit baby booties; Rad Populo with a cast bronze fist clenched around a plastic dildo.

The *Hamburger* was the centerpiece of a room given over to contemporary trends by big-name East Coast artists: a red-and-white checkered tablecloth by Pattern Painter Diego Deco; a mural-sized

color photograph by the celebrated New Wave punk artist, Pissant Puke.

"A hamburger sandwich to the very life," Opcit extolled, licking his lips.

"Precisely the problem with it," snapped Phd. "Thunderbird's style is never that realistic. He is more of an Expressionist."

"Quite true," replied Opcit. "Yet as everyone knows, he did have a very significant Realist Period, between May 2 and 7 of 1962. The glaze in the catsup is most characteristic of that phase, as is the facture of the bun."

"You can see for yourself, it lacks Thunderbird's authority," sniffed Phd. "It is obviously the work of a minor follower, if not an out-and-out fake."

"If I may interrupt, I think both of you gentlemen are in error," said Sneer, putting a hammerlock on Phd, who had just dealt Opcit a vicious jab to the kidneys. Putting his two index fingers in his mouth, Sneer emitted a shrill whistle and picked up the hamburger. A large Doberman ran up, sniffed gingerly at the object in Sneer's hand and gulped it down.

"A ringer!" the two scholars and the collector exclaimed in unison.

"Indubitably attributable to Big Mac," said Sneer. "But once you start to dabble with B.S., it can be hard to tell a fake from the real thing."

The Alternative Is Nothing to Sneer

NOVEMBER 20, 1980

I try to keep my friend B.S. Sneer, the distinguished and outspoken emeritus, abreast of important new developments in the art world, and so, when the announcement arrived in the morning mail, I read it to him over the telephone.

"Antispace, an alternative to alternative spaces," read an affected childish scrawl.

"It's the latest thing in New York," I explained. "Radical artists feel that alternative spaces have become elitist, co-opted by the establishment. They're removing themselves from the art world by setting up spaces in tenements, and opening them up to work from the neighborhoods and kids off the street."

"Sounds like even worse B.S. than usual," Sneer snapped. But he agreed to meet me at the new antispace the next evening.

The address was on a dimly lit street in the heart of the Maltese-American ghetto. I found Sneer standing before the darkened doorway of a decrepit warehouse. A bullet whizzed by.

"Are you sure this is the place?" I asked.

"What do you expect?" Sneer muttered. "I just saw Buncomb ("Bunk") Bluechip, the collector, go in with two armed bodyguards."

We proceeded into the menacing depths of a long corridor, toward the din of some raucous music. Shrieks came from behind closed doors.

We found ourselves in a dilapidated loft. Assembled in a tight little knot were E.G. Seymour, the famous avant-garde critic, and Ernest Conn, the conceptualist, and Professor Irwin Irwin, the phenomenologist and world's foremost authority. Milling about them were sullen-looking adolescents in black denims and ragged bomber jackets. The walls were plastered with crude drawings of murders, suicides, muggings. Graffiti filled the spaces between.

I edged my way to a shabby table where Rad Populo, militant spokesperson for the Maltese-American artist community, spoke in low tones to Phil Fund, chief grantsman from the National Endowment for the Arts.

"The alternative space movement has become exclusive," he snarled from the side of his mouth as he hurriedly filled out forms that Fund kept pushing in front of him. "New Wave is estheticizing politics. This is the real thing, man.

"We're reinventing the dialectic through art. European culture has been carried by Elites. Eventually, it had to broaden to include the bourgeoisie. It's time now to include all people."

He was interrupted by hoarse shouts from a group gathered around a surly-looking girl. Bluechip was admiring her drawing of a gang rape, trying to bargain down her price. A.C. Straddle, the museum director, and the dealers Twyla Trendy and Vera Vogue were offering her shows.

"Don't buy anything in this f——ing

elitist place," a wasted young man hollered. "I'll show you real antispace."

We followed him down the hall to a heavily patched door. Inside, a dozen teenagers were sitting in a circle on the floor, passing around a hypodermic needle. "The antispace movement has become exclusive," the young man grumbled. "Why restrict it to people who do art?"

Suddenly Sneer, who had dropped from sight, motioned me to follow him to an obscure doorway down the hall. Inside was a painter's studio, with a dozen canvases along the walls—works of astonishing originality and power.

"Why...these are magnificent!" I exclaimed to the artist, a nondescript person of middle age who stood in the doorway. Behind, that hall had filled with art world people who took no notice of us as they moved from one antispace to the other.

"The name is A. Hunger," the artist said.

"But why have you never shown?" I asked.

"Where?" the artist replied. "In some supermarket museum group show for 'emerging artists'? In a commercial art *store*? In one of these alternative circuses, where they can't wait to invite the rest of the art world in?"

Sneer cleared his throat. "For artists who aren't into any kind of B.S., there just doesn't seem to be any real alternative now," Sneer said.

Another Surprise from B.S. Sneer

MAY 14, 1981

Last weekend, I made my annual visit to a seminar on contemporary art.

The leaders of the local art world had gathered for a luncheon at Original New Old Joe's of Daly City, No. 2. The lobby was crowded with paintings perched on little easels: sunsets and foamy waves, leathery faces of wizened Indians and grizzled cowboys, the lone cyprus tree at Point Lobos. A table near the door carried a pile of slick brochures that read: "Proto-Post-Modernists: A Treasury of Neglected Masterpieces."

"As you all know," A.C. Straddle, director of the Museum of Post-Post-Modernist Art, began, "the celebrated avant-garde critic, E.G. Seymour, has paved the way for the most lucrative... er, *revolutionary* contemporary art movement in recent years with his insight that Post-Modernism represents not merely a tendency among younger artists to revive historic styles, but an opportunity for all of us to rediscover the great precursors of the Post-Modernist movement—the hundreds, indeed thousands, of unsung artists who have bypassed Modernism all along."

"The avant-garde has caught up with traditionalism," Seymour triumphantly declaimed.

"The past is always being altered by the present," Professor Irwin Irwin, the phenomenologist and world's foremost authority, solemnly intoned. "What with New Imagism, and the dramatic revival of interest in academic realists of the nineteenth

century, it was only a matter of time before scholars turned their attention to the courageous underground that has continued to keep Pre-Modernism alive to inspire us in this Post-Modernist age. Professor Ibid Opcit and Dr. Errata Phd, as I understand it, are now working around the clock in a race to be the first with his revisionist history of twentieth-century art."

"It's so exciting now that it's chic to be kitsch," sighed Vera Vogue. "Twyla and I have been buying up the inventories of all the galleries along Fisherman's Wharf and in Sausalito, and next I'm flying to Taos...."

"And tomorrow is our opening for the first museum show of the great Western American painter, Coot Crock," squealed Jackie Pleasant, the Post-Contemporary Museum's PR person, nudging awake a grizzled old man alongside.

"Museum world always puts me down as a commercial painter," he cackled. "But Mizz Trendy promises in a year I'll hit five figgers. Ain't money like that in the tourist shops."

"The potential is absolutely staggering," gasped the premier local collector Buncomb ("Bunk") Bluechip, who the previous week had set a new world record with his purchase at an auction for $3 million of a Grace Hudson crying papoose painting. "Every region of the country has its undiscovered pioneers and overlooked masters. The big Proto-Post-Modernist exhibition that A.C. is planning is bound to

revolutionize the entire market."

"Don't forget our own show of masterpieces from the Hearst Castle," interjected P. Barnum Turnstyle, director for the center for traveling exhibitions of treasures and antiques.

"In this pluralistic age, we will not yield in our total commitment to absolutely everything," said Straddle. "Although, of course, if Proto-Post-Modernism really takes off, and the economy turns around, there is the regrettable possibility we may have to deaccession our Picassos and Mondrians...."

He interrupted as Coot Crock's beard and nose suddenly fell into his soup. As the disguise slipped off, and people began pushing him angrily toward the door, I recognized the distinguished and outspoken emeritus, B.S. Sneer.

"B.S.!" I cried, rushing to his aid.

"Such *negative* expressions are not permitted here," snarled Vera Vogue. "Things change and we all must be supportive and keep up."

"Indeed. After all, this," Trendy paused portentiously, pointing to a big Crock painting of a weathered barn, "is the art of our time."

I was felled by a blow from behind. As I blacked out, I dreamed I was in a tag-team match against Vera Vogue and Twyla Trendy. They were both in the ring at the same time, pushing me back and forth. I kept trying to tag Sneer, but he stood just out of reach across the ropes.

similar in some respects to the monumental pieces he exhibited a couple of years ago — towering columns of irregular ceramic slabs placed one on top the other, with three of their sides cut sheer; the fourth, the "front," combines mangled human forms — fragments, bones — with gnarls and folds that more nearly resemble congealed lava.

But the structures have become less pyramidal or wedge-like, more slender and upright, generally towering nine feet or more high. And they are more abstract.

The tendency for a breast, a foot or a knee-cap obtrusively to "pop out" from the more firmly imbedded forms has been curbed: the new sculpture projects more the frangments of the figure, or of bones turning into rock. With a few exceptions, the color with which deStaebler impregnates his material is also more subdued, and controlled.

But while the new pieces are more harmonious on the surface, they also seem more arbitrary in structure and concept, in the way that a lava formation is more arbitrary than the construction of the human figure. The great dilemma of deStaebler's expression is arriving at a precarious, delicately callibrated balance between figuration and abstraction, between form and dissolution; its attainment, when it occurs, gives his strongest work its sense of deep internal tension.

It is achieved here, it seems to me, in the relatively small "Right Sided Woman Standing," and ap-

tures. But for the most pa opting for a more abstra proach, deStaebler seems have resolved the dilemma so as to have evaded it.

The pieces are all quite ful, as natural outcroppings can be quite beautiful, but n them seem rather too easy the skin.

Although the range of a in deStaebler's sculpture is he uses his references expre and absorbs them into a co form of his own. The probler Oliveira's new paintings is gratuitous eclecticism.

All belong to a series "Swiss Site." Two or thre almost straight caricatur Turner, with hazy, light-per atmospheres, intimations of mering reflections and dus houettes. Most are more like between Turner and Dieben "Ocean Park" paintings, with vocal interior "edges" that luminous atmospheres from emerges the halo-like imag distant tower. A few contai and traces of imagery that s William Wiley — a checke flag, a funky pyramid, a wh arabesque with candy stripin

Oliveira is masterful a dling the effects of atmosphe painterly surfaces, and the ju where they coincide; on th face, many of these new pai look spectacular. But, for wildly casting about for sign imagery, or "content," in th these paintings seem to be n but seductively vaporous effects. They are like a new

On Music

The Impossible Position of the Artist in Today's Jazz Scene

OCTOBER 24, 1976

In some ways, the position of the jazz artist (or of any artist worthy of the name) in today's society is an almost impossible one.

Most conspicuous are the pressures which have been pushing (or is it pulling?) jazz musicians into the bottomless abyss of hack, commercial pop entertainment. Gradually (like the topless dancer working her way through ballet school) or suddenly, with or without recourse to a litany of feeble rationalizations (Back to Roots; It's Gotta Communicate to the People, or It's Elitist), one musician after another has vanished in the "crossover," R & B mire—whereupon the term "artist" becomes an empty perversion for the use of record company flacks (cf., "recording artist").

There are the equally familiar brickbats hurled by reactionary critics and fans at anything that smacks of innovation or unconventional expression. Although Duke Ellington's axiom, "It Don't Mean a Thing If It Ain't Got That Swing" carries as much force as ever, how many times have artists, from Cecil Taylor to Anthony Braxton, had to prove all over again that *swing* is by no means a mere synonym for syncopation, or any other isolated element of jazz.

Finally, and in some ways most pernicious of all, is the threat that comes from various spokesmen for the so-called jazz avant-garde, whose attitude is that jazz must follow a more or less clear-cut dialectic, or straight-line course of continuously self-regenerating "evolution."

This attitude is pernicious partly because it is prone to overlook the marginal fringes from which genuine creative revolutions are most likely to emerge, and partly because of its habit of elevating certain artists to standard-bearer status one season, and the next—unless they have "significantly advanced" their music—relegating them to outdistanced historical influences as someone else momentarily takes the spotlight.

At its ludicrous extreme, this notion has produced travesties that equal the Swiftian excesses to which Clement Greenberg and his followers reduced so much criticism of the visual arts during the 1960s; for example, I have seen music praised because it had virtually eliminated "horizontal" movement, which is much like saying that a painting is "advanced" simply because it is flat.

More to the immediate point, this attitude contributes to a climate in which genuine innovation becomes dangerously confused with novelty, and it imposes demands which are virtually impossible for even the most individual and powerful of artists consistently to fulfill: In effect, keep changing, or become as obsolete as last year's automobile.

McCoy Tyner, Sam Rivers and even Anthony Braxton have been subject to scattered dark rumblings of late to the effect that their music is becoming "repetitious." But perhaps the most severe victim of this bizarre transference of the principle of planned obsolescence from the realm of assembly-line commodities to the world of art has been Ornette Coleman, who, the grapevine has it (I hope erroneously), is now playing mostly rock 'n' roll.

Not surprisingly, the best rebuttal to this line of theorizing comes—as it always has—from the music. Tyner and Rivers,

for example, have remained unfailingly, almost superhumanly powerful in every performance which I have been lucky enough to hear. There is, indeed, a sense in which their musics are always the same, for they deal with massive blocks and great, sweeping currents of sound, energy and emotion rather than the fine points of melodic development and harmonic progression as they are more conventionally known. There is a danger of *overexposure* to this (or almost any kind of) expression—how often, after all, do you want to immerse yourself in a hurricane?

In fact, overexposure has become a basic problem for everyone involved in communications in today's fast-paced, omnivorous consumer economy; short of an early death, perhaps the best "solution" has been the one adopted by (or imposed on) Cecil Taylor, whose personal appearances have always been rare, and whose records remain extremely few. We need some system that would permit more artists this kind of "independence" from a schedule of continual performances and record dates, without demanding that they pay the dues that Taylor has had to do.

In another, much more profound sense, however, the artistry of musicians like Taylor and Tyner and Rivers is always different, something you perpetually experience for the "first" time, even though their music is no longer "advanced" in the sense that Braxton's or Steve Lacy's or Oliver Lake's is "advanced." In music, as in the visual arts, it has become apparent that the "advancing line" is more accurately the perimeter of an ever-enlarging circle.

Some musicians take their position on the expanding edge, and some find their places inside. While every art form has its history, every true artist is a history unto himself, who finds his own path and follows his own organic law of development. The only universal principle is the old jazz axiom, "If you don't hear it, don't play it"—and vice versa. Form then follows function.

As for the commercial pressures and reactionary brickbats, they are temptations and obstacles that artists have always had to contend with. So is all the current rhetoric about "elitism," the contemporary rallying cry of neo-Philistines thinly disguised as "humanists" or "radicals," and almost invariably a charge leveled at people of talent and imagination by those who have little of either.

Because creativity is unique, bringing into being something that had never existed before, true art is always "elitist." This "elitism," however, has nothing in common with the so-called elites of the economic and social structures; it is more like a priesthood—not a role you inherit, buy or fake your way into, yet open without discrimination to anyone, provided that he or she has the vocation, commitment and dedication to devote a lifetime to its service.

It is for the rest of us to be the artists' responsive and engaged audience; to look to them, not for the sweet nothings, but for the inspiration that we need to carry out some of the other work that needs to be done in the world; and to try and make life a little easier for them, so that so many will not give way to the temptation to go over the wall.

The Vision and Drive of Ornette Coleman

Some years before most of us realized that Miles Davis and John Coltrane were breaking new ground, Ornette Coleman burst loose with a cyclonic, cacophonic style that sounded like a turntable that had stripped its gears—and was therefore viewed as promising a rebirth, or sudden death, for jazz, depending on one's point of view.

Now his innovations, like those of Davis and Coltrane, have become part of the standard vocabulary, not to say conventions, of contemporary music. But the vision and drive that push an originator always set him apart from his followers, and Coleman—currently with a new quartet at Keystone Korner—shows that there is still no one else like him.

In contrast to much "avant-garde" music, there is never any real question that what Coleman is doing is still jazz. He does not carry you off to the exotic Near East, to deepest Africa, to outer space, or otherwise tamper with your psyche, but then he is not trying to do that. He is doing what great jazz musicians have always done: blowing, ceaselessly inventing and, in his own way, swinging like crazy.

Essentially, Coleman's music takes off from two of jazz's most basic ingredients and develops them into a unique vehicle of personal expression. One is sheer virtuosity.

Coleman's alto can project a sound as big, round and warm as Charlie Parker. He can bleat and squawk like Pharaoh Saunders—although he only does so to add an accent here and there, not as a stylistic trademark. And he can mute his tone down to a breathy whisper that is as alive and expressive as the human voice, except that only Billie Holiday could sing that way, making you hang onto the sense of every nuance and phrase.

The other ingredient is jazz's magical power to transform. If you don't fully understand what this means, try to imagine improvising a dazzling chain of thematic variations on ideas unearthed from that clunky, vintage Tin Pan Alley tune "What'll I Do?", as Coleman did in his second set on opening night.

Coleman does this by setting up a seemingly wide-open, free-form structure that seems atonal but really isn't, for it relies on a listener's inbred sense of what a conventional melody should sound like to appreciate the strangeness, and the beauty, of all the things that Coleman does between the lines.

Into this bottomless vessel Coleman hurls one thematic fragment after another, constantly modulating, wavering and weaving through minute gradations of microtones, those alien sounds that fill the spaces in between the notes on the piano keyboard.

He spats out a staccato scale or riff of five or six notes, repeats it, accelerates it, makes it ascend into higher and higher reaches of the chromatic spectrum until it takes on the force of a dam with a flood of water building up behind it; then he opens the spillways, and a torrent of free-flowing musical ideas comes pouring out.

Like Bird or Lester Young, Coleman is

a musical collagist, and every so often you can detect the outline of a familiar melody being carried along in the flood—"Que Sera," "I Get a Kick Out of You," "Pack up Your Troubles," as well as snatches of everything from calypso to Coltrane and Bird himself. Coleman does not use this device so much to make a familiar ditty pop out and provoke a knowing chuckle from the audience, however, as to demonstrate that anything—but anything—can be absorbed into his musical concept.

Coleman has extended into electronics in the makeup of his new group, which includes James Omar on lead guitar; James Williams, bass; and Billy Higgins, drums. They serve mostly to build a vibrant, pulsating, nervously restless texture through which Coleman spins his erratic, dynamically moving lines. Omar, in particular, is a superb guitarist, and is so into Coleman's ideas that he can be a perfect echo or an uncannily complementary foil to Coleman's sax; some of the most exciting things happened when both were weaving together lines so rich and complex that you didn't even have to close your eyes to envision a Jackson Pollock painting.

The new quartet lacks some of the flexibility of Coleman's previous group with Charlie Hayden, however, and its emphasis on the upbeat gets repetitious after a while. All in all, Coleman projects the image of an artist who is on top of his world rather than still exploring. But that's a big world to be on top of.

A Relentless, Restless Frequency

APRIL 19, 1974

Miles Davis has often frustrated people who insist on calling his music jazz, and equating jazz with entertainment.

Although his current date at Keystone Korner brings him back to the nightclub circuit after a long absence, Davis is as frustrating an entertainer as ever: no introductions, scats, plugs for the new album or nostalgic trips through old favorites, no native masquerade costumes or mystical mumbojumbo, no jive.

There is just a taut, wiry, strangely charismatic little man hunched over his trumpet, aiming it at the floor, and a motley-looking group of eight other musicians, totally absorbed in their work.

And there is music: massive, shattering walls and intricate mosaics of vibrant technicolor in sound, linear traceries and transparent clusters of delicate pastels, blinding flashes of crackling, stroboscopic light. It moves on a relentless current that keeps you on the edge of your chair and makes a sustained, nonstop hour and a quarter seem like ten minutes, and ten minutes seem like the whole of time.

This is not music that is played to please an audience; it is a concert transferred to more intimate surroundings. Davis demands that listeners follow where he goes, and then employs all the discipline and feeling he can muster to make sure they do.

You don't cheer when it's over but remain quiet, spellbound. A few buffs managed to holler, finger-pop and applaud right after riffs, but that was all right, too, for the music absorbs it all, just as you absorb it.

Great musical artists are like radio stations: each has his own frequency. It's there whether or not it happens to be broadcasting or you happen to be listening, and while the programming may change, it always retains its own identity.

Davis, of course, began his career in the 1940s as a bop school jazz musician. He later became one of the first to experiment with improvisation in extended form, and then went on to excursions into electronic amplification and other elements of rock.

Like the painter Willem de Kooning, Davis has always restlessly moved ahead, while his fans turn into critics who assert that he is in a perpetual state of decline. His present image, however, seems to represent a grand synthesis of all that he has done and, at least for now, he appears happy with it.

From rock, he has absorbed the insistent, propulsive rhythm and dense, electronic texture to create a momentum and a unified blanket of sound that can sustain and hold whatever he chooses to put into it, for as long as he wants to keep going—an open-ended structure that transcends all the limitations of classical or traditional jazz form.

From jazz, he has carried over the incredible subtlety, nuance, thematic and rhythmic invention—and, well, the crackling, staccato trills, the pinpoints of sound that stab the silences, the tones that bend, soar, grow hoarse and then get pure again are essentially no different from the horn that recorded "'Round Midnight" or "It Ain't Necessarily So" those many years ago. Davis has simply abstracted what was his from what was Thelonious Monk's or George Gershwin's.

From the instant the performance

begins—at precisely 9:30—that Miles Davis frequency is on the air full blast. Each instrument—drums, congas, bass, electric guitars, alto and tenor sax and flute—assumes its role in producing a web of sound and rhythm from which distinct threads emerge from time to time, play themselves out and are then reabsorbed.

Davis is playing most of the time— etching and slashing his austere, steely, angular and fragmented melodic lines or describing gripping arabesques with his horn, and also alternating on organ, which he uses for crashing dissonances and tense, unresolved chord progressions.

Prominent among the other voices are Dave Liebman, sax; Mike Henderson, bass; and Al Foster, drums. Even when Davis is just standing there, however, it's all clearly his concept: raw, elemental, primitive, and at the same time incredibly concentrated, compressed, disciplined.

Someone once said that Davis "plays the silences," meaning that you're always waiting for the other shoe to drop; when it does, however, it is not a resolution, but the beginning of another idea. Which is another way of saying that you never know where you're going when he plays, but can always see where you've been.

How do you end something like this? "I don't finish, I just stop," de Kooning once said. Davis takes a cue from Haydn's "Farewell Symphony," walking off stage, followed by the other musicians until only the conga drum remains. The music hasn't really ended, however. I can hear it still.

A 'Black Music Tradition' Is Different from 'Black Music'

AUGUST 28, 1977

Scarcely anyone would think of lumping Beethoven and the Beachboys, Hank Williams and Henry Mancini, under the catchall label of "white music." Yet one still hears otherwise knowledgeable people referring to "black music," as if Charlie Parker and John Lee Hooker, Anthony Braxton and Marvin Gaye, somehow belonged to a homogeneous musical form.

A frequent corollary is the argument that "black music" can validly be played only by black musicians—or appreciated by black audiences and written about by black writers. This is like saying that Leontyne Price cannot sing Verdi, or James Baldwin write novels.

There is, to be sure, a distinctive black tradition in music, as there has been a coherent development in music that derives from Western European roots. But as communications grow in sophistication, different traditions borrow from one another and cross-pollinate; as cultures increase in complexity and multiply in diversity, their traditions fragment and develop branches that reach in widely separated directions. In a sense, the history of "black music" in America during the past 150 years forms a highly telescoped parallel to developments in European music that took several centuries: originating out of the fabric of everyday life in ritual and festivity, gradually dividing into religious and secular traditions, the latter, in turn, evolving into self-aware art forms, on the one hand, and, on the other, equally self-conscious forms of popular music.

Because "black music" has developed so rapidly, the distinctions among its various branches have sometimes seemed less pronounced than the corresponding divisions in European-derived music, and a strong folk tradition—blues, gospel— has continued to coexist with and inform more sophisticated forms of expression (although European art music has also drawn vital infusions from folk sources— including, of course, "black music").

Nevertheless, a decisive parting of the ways in black musical tradition occurred during the late 1930s and early 1940s, corresponding to dramatic social changes. On one hand, the migration of large numbers of blacks to the cities brought about a transition from rural to urban blues, and created a market for recording companies devoted to "race music"—the beginnings of black pop. On the other, Charlie Parker, Dizzy Gillespie et al. joined a succession of black musicians who came to New York only to find that jazz had become largely absorbed into an economic network dominated by white club owners, A and R men, big band leaders and listeners.

When Bird and Dizzy and Thelonious Monk and Kenny Clarke—alienated by heritage and circumstances about equally from both white and black societies—sat down at Minton's and began playing chord changes so fast and unorthodox that few others could follow, they were, in effect, proclaiming the independence of jazz as art form: no longer dance music, entertainment or a "folk art" functionally related to "black culture," itself now beginning to fragment and evolve into a multiplicity of economic and social forms.

From a strictly musical standpoint,

bop represented a culmination of jazz based on European harmonic ideas. But while many "avant-garde" jazz musicians since the early 1960s, coinciding with the rise of black nationalism, have sought forms and expressions of greater ethnic "purity"—non-European modes, exotic instrumentation, hollers and chants—they have not thereby attracted large numbers of black listeners, any more than the use of folk motifs by Beethoven, Bartok or Ives served to "popularize" their musics; on the contrary, they have increased the complexity of their art, removing it still further from sheer entertainment.

Audiences have scrupulously recognized these distinctions that social philosophers often choose to ignore. The audience for jazz remains relatively small and, racially, highly mixed; the bulk of the black audience, like most of the white audience, is into pop music—black pop music, derived largely from the urban blues and gospel traditions, slickly repackaged as "soul" and reflecting the emergence of a black middle class as an important factor in the mass market. In terms of both esthetics and motivation, this black pop music has much more in common with pop music in general than it does with jazz, and jazz has more common ground with classical music and other art forms.

In his book *Black Music, Four Lives* — still the best exploration of the subject—A. B. Spellman stresses "the double alienation of the black artist in America," a condition so many white jazzmen tried tragically to emulate in the 1940s and 1950s with destructive plunges into booze, drugs and other attributes that became identified with the life-style of the hipster, or "white Negro."

Many things have changed for the better since Spellman's book first appeared ten years ago—in the status of blacks, of artists and of jazz. But artists, of whatever color, will always remain somewhat alienated from the rest of society, if only because they are visionaries given to a life of exploration into the unknown, in a world where most people prefer the comfort of repetition and ritual.

Jazz, from its very beginnings, has been "fusion" music; if one were to attempt to disentangle the "black" from the "white," one would end up with merely two loose strands, one sounding much the way traditional African music still sounds today, the other a mixture of European "art" music, hymnody and country fiddling. It is as senseless, and destructive, to assert that certain areas of expression should be off-limits to artists because of their national or cultural origins. The community of artists has always transcended racial, cultural and economic lines—the most innovative jazz of the 1950s and 1960s came out of "Bohemian" communities, rather than ghettos, black or white.

Their explorations and discoveries are among the most crucial happenings of our time, something all of us have a stake in. They need all the freedom and encouragement that we can give them. And we need to eliminate the antiquated, 1960s-style rhetoric and do our damndest to listen to, and look at, what they have to say.

The Remarkable Music of Pianist Bill Evans

NOVEMBER 11, 1974

As artists, jazz musicians are expected always to grow and change, while as entertainers they are under constant pressure to stay the same.

Bill Evans and his trio have managed to steer a course somewhere between these two extremes. Evans has grown, as much as anybody in the business has, but primarily by moving more and more deeply inside a framework of ideas that he laid out some fifteen years ago, rather than by moving farther out. He therefore satisfies both segments of his audience, and they formed a large and enthusiastic house on Friday night at the Great American Music Hall.

Evans was, of course, a dramatic innovator when he first emerged upon the scene with his lyrical, introspective, spare but fluid piano style in the mid-1950s, first playing with Miles Davis and later on his own.

Now you have to listen to him through all the layers of cocktail lounge imitators who have followed, just as you can only see a Jackson Pollock painting by peeling away visions of all those artsy dripped-enamel ashtrays he inspired. Luckily, this is not difficult to do. Purity is not always a virtue any more than complexity is, but on Friday Evans's classicizing genius shone through as brilliantly as ever.

Evans's music revolves around two main elements: an architect's approach to shaping and articulating a complex structure of improvisations, and a chamber musician's ability to make piano, bass and drums work together as a single, delicately balanced mechanism that creates an infinite variety of subtle shaded colors, textures and interweaving lines. Plus—and it's the plus that counts—a jazz artist's knack for making it all seem natural and easy.

Evans builds his tunes around the most traditional of jazz formats: stating the melody, standard or original; improvising on its harmonic changes; restating the tune, transfigured by all that has gone before.

The basic melody and chord changes are, however, mere foundations on which he proceeds to erect soaring vaults and arches of unexpected progressions, subtle rhythmic shifts and pastel tone colors with dusky shadows around their edges.

There's no ceiling to this structure, though, and just when its basic contours have been firmly established, Evans starts shooting melodic lines out through the top—brilliant, crystalline loops and arabesques that seem to dance and unfurl and soar through the air with a lilting, gently swinging, steadily upward-bound motion that eventually elevates the whole structure up with it.

It's like an expertly flown kite gliding on an ocean breeze—thoroughly under

control from the ground, but appearing to respond only to the elements of nature itself.

It's misleading, of course, to speak of Evans as if he were solely responsible for these musical flights. He has been playing with bassist Eddy Gomez for eight years and with drummer Marty Morrell for more than two, and the three work together as closely as Evans's left hand does with his right.

Gomez draws a remarkably resonant, reverberating sound both with the bow and with his fingers, rhapsodizing evocatively on solos and setting up dark, pulsating sound vibrations around Evans's transparent piano lines.

Morrell is more of an accompanist, but his discretely asymmetrical percussion added a complementary undertone of angularity to Evans's predominantly curvy style.

One cannot really speak of solos and accompaniment either, however, for no one in this group is interested in calling attention to his own virtuosity, but simply in contributing another building block to the whole structure. The trio consists of three distinctly individual musicians who manage to work together like a meticulously callibrated machine, and then to make you forget all about the machinery. And that is always a beautiful thing to hear.

The Purr-fectly Legendary Eartha Kitt

JULY 9, 1981

Like a landmark so familiar, you never quite get around to visiting it, Eartha Kitt is a performer I had managed to find avoidable all these years, although the echoes of her purring tunes like "C'est Si Bon" and "Santa, Baby" linger from the time I was in high school.

On Tuesday, I made up for this neglect and caught both shows with which she opened what seems to be settling into an annual gig in the Hotel York's Plush Room. It was a revelation.

In her early fifties, Kitt remains a woman of extraordinary beauty. Doffing a kind of black cocoon shortly after she appeared on stage with a five-man back-up group, she unveiled a muscular, feline figure sheathed in a moderately low-cut black gown. Her exotic, finely carved, sphinxlike face seems to concentrate itself in the unblinking gaze of her oversized eyes—glistening, flashing, transfixing.

She does not move much, but each gesture seems freighted with weight and dramatic meaning, contributing to an extraordinary presence and a general impression of controlled ferocity. Ditto, the expressions of her face, which she uses with the fine tuning of a great actress of the silent era. Her pacing is fluid and mercurial, her timing, crisp and unerring—particularly, the duration of a pause whose silence becomes charged with import or anticipation.

All this adds up to the attributes of a great cabaret performer, who happens also to sing. To be sure, Kitt is a fine vocalist, with a range that permits her to move abruptly from a blast as powerful and brassy as the trumpet section in Count Basie's orchestra, to her patented, insinuating, nasally kittenish whisper—spun-sugar edged with just enough vinegar that

you are not surprised when the sweetness suddenly drops away and she begins spitting pure strychnine.

What Kitt does, however, is more basically a branch of theater than of music. Tuesday's show included at least one routine that was almost pure theater, a poignantly funny sketch such as Lily Tomlin might do, in which a slightly tipsy, aging vamp begins to pour champagne down an obliging young waiter ("You're only twenty-three? How would you like to be twenty-four before the night is over?").

But even in the more purely musical numbers—old reliables like "I Wanna Be Bad," "C'est Si Bon," a version of "Guess Who I Saw Today" (from the "New Faces, 1952" review that first catapulted Kitt to stardom), segueing abruptly into "Leave Me"—the basic *instrument* being performed on is the audience itself. You accept this (or not), as you do in theater, to the degree that you are willing to suspend disbelief, or that the rewards outweigh the awareness that you are being manipulated.

In Tuesday's first show, Kitt absorbed herself wholly in her stage persona, which is principally that of the All-American Bitch—the mercenary sexpot, gold digger, tease with the heart of rhinestone, whose image is polished off with diction of exaggerated precision and a few handy phrases in French. She toyed with this persona, hopelessly entangling herself in an endless fur stole before beginning. "I'm just an old-fashioned girl…looking for an old-fashioned millionaire."

And, at one point, she at least seemed to drop the persona altogether, with the song "All By Myself," coupled with a sentimental, *almost* maudlin poem of her own writing. It clearly came out of her most intimate experience ("When I was young

and made love just for fun, those days are done"), and she seemed almost broken up by it when she was done.

Hers is an art of such "almosts," moving, quite recklessly when she was sharpest, along the hairline that separates stylization from camp. The first show was charged with Kitt's extraordinary command of her craft, and her sheer charisma: the audience in the intimate room sat as though mesmerized. "She's like an American Piaf," my companion commented, and it was so.

The second show, almost identical to the first, was also well crafted, but the edge was dulled. Kitt tried to make the best of repeating the same material with little more than an hour's break before an audience that included a few of the same people ("You're *still* only twenty-three?" she asked the waiter), but the show had a perfunctory, sometimes self-spoofing quality that the first set did not. "That got pretty campy," my companion commented, and this was so, too.

But you don't go to an exhaustively rehearsed, brilliantly acted play and, as soon as it is finished, see the entire performance all over again—unless you are looking for the seams. And Kitt's very special kind of cabaret performance is something quite different from a night listening to one of the great singer-*musicians*—Billie Holiday, Dinah Washington, Ella Fitzgerald, Betty Carter—where every set is different, even if it includes some of the same material.

In the case of a highly worked out, well-oiled routine like Kitt's the first set rather than the last is likely to be the better one to catch.

Thelonious Monk Led the Way in Jazz

FEBRUARY 20, 1982

Thelonious Monk was a big hulk of a man who played piano like a bear figure skating on thin ice.

His approach to music was so unique that no one was ever able to quite categorize it. It was *jazz*, God knows. In the 1940s and 1950s, Monk used to stand for hours outside his midtown Manhattan apartment listening to the sounds of the streets, and his music—his sixty-odd original compositions and the countless ways they changed each time he played them—drove with the relentless propulsion of the A-train express, and the clangorous cacophony of Lexington Avenue at rush hour.

Monk, who died on Wednesday in New York at the age of sixty-four, was one of the earliest pioneers of bebop, with its complicated chord substitutions and soaring melodic improvisations that lost most of the uninitiated just out of the starting gate. But his own music generally had a disarmingly childlike simplicity, with shadowy roots in the elemental stride style of such old-time pianists as James P. Johnson. ("Why do the rest of them always have to leave out the melody?" he once asked.) Indeed, after listeners had finally become attuned to the complex virtuosity of bop musicians like Bud Powell and Charlie Parker, Monk still sounded weird. The word went around that although he was an important composer, Monk was crude and clumsy as a pianist, and just couldn't play in the same league. There were those who referred to him, not always without malice, as Felonious Plunk.

Monk's music was nothing if not eccentric—as he himself was, with his collection of outrageous hats, and a habit of walking around his house rehanging pictures so they were off-center because, as he said, he could see no reason why they should be straight.

I vividly remember the impact of hearing him for the first time in the middle 1950s. His sound and conception were startling: cranky, lumbering in gait, moving in lurches, tics and spasms, yet with a nagging obsessiveness, somewhat like a drunk picking his way home. His crabbed chord progressions, jagged intervals, clotted dissonances and momentary detours into little cul-de-sacs where he would repeat a figure or filigree seemed impenetrably strange and exotic. Even when he played "'Round Midnight" or "Ruby, My Dear," his most effulgently lyrical compositions, Monk would shatter the romantic spell into which they were cast by most other musicians with an unexpected zigzag or 180-degree turn, or with one of his splayed, web-fingered chords, as sharp and brittle as breaking glass.

Yet there was a compelling, haunting poetry to his dark, glowering sonorities, and an irresistible humor to his music's unpredictable twists and irreverent, sometimes sarcastic paraphrases and asides. And once into Monk's strange musical world, one discovered an extraordinary self-consistency. His melodic inventions were almost always rare fulfillments of the definition of jazz improvisation as "instant composition"—at the very first hearing, a new reworking of "Epistrophy" or "Straight, No Chaser" would carry all the authority of a wholly new tune.

Side by side with Monk's muscular attack and bluntly chiseled declamations were phrases as delicate as spun glass. There was a rhyming symmetry to Monk's seemingly off-center phrasing, a momentum to his idiosyncratic rhythmic pulse that approached the infectious beat of rock 'n' roll. Monk would periodically test whether his group was swinging enough by rising from the piano to perform a curi-

ous shuffle around the stage. With an uncanny eloquence, not without parallels in Ellington and Basie, Monk knew when *not* to play—to "play the spaces." And, for all its inner logic, there was always at the core of Monk's music what Whitney Balliett once called "the sound of surprise."

An extended gig at the Five Spot in the late 1950s eventually brought Monk belated recognition, but success did little to change his ways. When his picture appeared on the cover of *Time* magazine in 1964, Monk was living with his wife and two children amid incredible clutter in the cramped apartment on San Juan Hill where he had lived with his parents since the early 1930s.

He was usually accompanied on the road by his wife, Nellie, who would bring along pots and fix the rice and beans. The absentminded Monk could be counted on to show up two hours late for a gig. He would run through a quick chorus, then let his combo take over, finally reappearing to play what usually turned out to be an unusually long set.

Monk's words were as pointed and even more spare than his music. ("I don't know where jazz is going," he once replied to a question in a rare seminar appearance in the 1960s. "For all I know, it's going straight to hell.") In one of the more successful interviews conducted with him, Monk told Grover Sales during his first appearance in San Francisco in 1959: "I say, play your own way. Don't play what the public wants you to play. Play what *you* want, and let the public pick up on what you doing, even if it *does* take them fifteen, twenty years." His only musical "theory," he added, had always been "I wanted to make it better."

Monk never swerved from these principles. Musicians from John Coltrane, who played with Monk briefly in the late 1950s, to a younger generation of avant-gardists have acknowledged the profound influence of one or another aspect of Monk's music, and the unyielding determination of his attitude.

Yet Monk, after a few sporadic gigs in the mid-1970s, withdrew more and more into a shadowy privacy and inactivity. It was rumored that he had serious health problems, physical or psychological. In one of his last published interviews, he said jazz was basically a form that belonged to the young, intimating he had done all he had set out to do.

What Monk did was to create his own universe, something only the greatest of artists manage to do. It was basically self-contained and inimitable, an artesian well off to one side of the mainstream currents of jazz. But it was also a musical expression that was authentically *American* (or black American): indifferent to the graces and technical niceties of European culture and permeated with a tough, steely musculature, yet charged with unexpected moments of tenderness, irony and elemental beauty ("Ugly Beauty," Monk named one of his tunes).

When and if the record is ever set straight on American music—when the guardians of official culture begin to acknowledge that Charlie Parker, Miles Davis and John Coltrane are at least as historically significant as Aaron Copland, Roger Sessions or Elliott Carter, and infinitely more vital—Monk will surely be acknowledged as one of the greatest contributions to twentieth-century music.

Music That Stirs Up a Holy Frenzy

AUGUST 30, 1982

The relationship between gospel singing and show business is a little like that between a man approaching mid-life crisis and a sexually precocious stepdaughter: close, complicated and uneasy.

Singers like Sam Cooke, Little Richard, Aretha Franklin and Ray Charles have passed through most of the shadings along the blurry spectrum that links gospel singing to blues-shouting, soul, rhythm and blues. But the bridge between church and club or concert stage seems to lead mostly one way.

Cooke was rebuffed by unforgiving purists when he tried to return to gospel after he had yielded to the seductions of commercial music and won meteoric popularity as a soul singer. Little Richard has been accepted back into the fold as a revivalist preacher, but only after renouncing his pop stardom and the style of life that went with it.

You or I may believe that all music—indeed, all kinds of art—is a form of invocation and that the spirit, when everything is working, is as likely to visit a seedy jazz club, or a museum, or even a glittery symphony hall filled with first-nighters in gowns and tuxedos, as it is a church.

But to disciples of gospel—although the ideal is to clap and shout yourself into a holy frenzy—the spirit is not prone to descend on places where people ingest the wrong chemicals, dress indecorously and otherwise carry on in unseemly ways. Love songs all come cloaked as hymns, and music is inextricably bound up with matters of sin and salvation.

The Noah's Ark Gospel Chateau in Richmond is a kind of halfway house in this gray area between show biz and the storefront church. You can get your gospel relatively pure without having to hear a sermon.

Chairs circle round tables distributed across the gently sloping floor of a former movie theater, its stippled ceiling lightly dusted with glitter. Framed by tall imitation candles that have the look of leftover Christmas decorations, a large mirror at the back of a stage is etched with lettering that says "Noah's Ark Nightclub." You pay a cover at the door.

But the drink menu lists only concoctions of fruit juices with names like Calvary Crush, Halleluiah Highball, Apostle Fizz and Jesus on the Rocks.

Fred Jackson, a portly man in a conservative suit, graying mutton chops and a demeanor of implaccable dignity, helps manage the club under sponsorship of a nearby Baptist church. He announces forthcoming events—the chateau presents gospel music almost every weekend—as almost any nightclub emcee might. But here and there, seemingly at random, he slips in an "Amen." And the audience—almost entirely black, attired as though for Sunday church—responds, "Yes, yes, brother."

Last Friday's program opened with a local quartet of women singers known as Oddessa Perkins and the Lathenettes. Visually, they are not likely to be confused with the Supremes or Chiffons. Their act made few concessions to Las Vegas–style production and values. Harmonies were ragged. Electric bass and guitar accompa-

niments were, at least at first, hopelessly out of tune. The singers asked the audience for its prayers.

But the second piece they did was carried by a lead singer with an electrifying contralto voice. It rang into every corner of the room. Its strength, richness and fervor sent shivers up and down your back. The Lathenettes did three or four more numbers. All came up short of this pinnacle of inspiration. Then, wholly without ceremony, they simply walked off stage.

The main event Friday was the Soul Stirrers of Chicago, a name that carries some weight in the annals of gospel music. R. H. Harris, lead singer with the Soul Stirrers in the 1940s, has been to gospel singing as Charlie Parker was to bebop. His protégé and replacement in the group, Sam Cooke, was one of the first to translate gospel into soul.

Paul Foster, who shared leads with both Harris and Cooke—the Soul Stirrers are said to have been the earliest gospel singers to expand from quartet to quintet format, with two voices exchanging leads—is now pastor of his own church in Vallejo, where the group had sung the night before. His son, George Foster, manages Noah's Ark.

Compared with the Lathenettes, the Soul Stirrers are slick and (even in their apparently rough edges) smooth. They were, at least initially, not stirring. In its present edition the group comprises four singers, two also accompanying on bass and guitar, plus a nonsinging lead guitarist and a drummer. The vocal harmonies carry on the trademark Soul Stir-

rer style: suave, polished, not notably adventurous. But the heavy dose of electric instrumentation—and mechanical, rock 'n' roll drumming—contributes a funk flavor that departs considerably from the airy a cappella sound of yore.

Eventually, fired by two lead singers alternating between gravelly hollers and a melodiousness as unctuous as machine oil, the Soul Stirrers managed to whip up a quotient of the kind of excitement the audience had come to take part in. As far as I was concerned, this was accomplished quite professionally, even somewhat routinely, the group pressing all the right buttons—lots of shouting and moving around through the audience—according to conventions that border on formula. The spirit had made its brief appearance earlier, during the opening set, and then it continued to kind of just hover around, on reconnaissance.

But the spirit moves in strange and mysterious ways. As a crescendo of soul-shouting built over an insistently rocking beat while the Soul Stirrers moved off stage toward a chartered bus waiting to deliver them to a Saturday gig in Southern California, a woman in the audience broke into a spasmodic dance, bucking, jerking and twitching like a beheaded snake, gyrating free from the arms of two women who were trying to contain her movements, eventually collapsing in a limp heap on the floor like a pile of laundry.

This is getting down.

If you're into salvation, Noah's Ark is certainly the place to be.

Scorching, Abstract Jazz

MARCH 11, 1976

Innovations in jazz during the past fifteen years have generally moved in two broad directions, corresponding roughly to the old distinction between Romanticism and Classicism.

The first is exemplified by musicians like John Coltrane, Albert Ayler, Cecil Taylor and McCoy Tyner—artists whose expression is like a force of nature, a tidal wave that engulfs and sweeps you off on its sheer momentum and power.

Anthony Braxton, who opened with his quartet Tuesday at Keystone Korner, represents another branch of jazz, emphasizing abstract forms that are more evidently man-made. They erect vast, airy, labyrinthean sound structures that resemble somewhat the *ficciones* of Jorge Luis Borges: intricate, yet fluid and open-ended enough to allow the mind, and spirit, freely to explore boundless spaces, avenues, corridors.

Although these structures contain some of the most scorching solos that you could ever hope to hear, they do not always reach out and grab you by the hand; you have to take the first few steps yourself. But the rewards are more than worth the effort, for in Braxton's music, as in all art of great strength and beauty, the twin currents of form and expression are united deep inside.

Unlike the concert that he presented at Zellerbach Auditorium last year, which comprised relatively short pieces using a variety of instrumentalists, each of Braxton's two sets Tuesday night consisted of a single, extended sequence of thematic statements and fantastic improvisatory adventures. Braxton drew on a bagful of reed instruments, most often alto saxophone, contrabass and standard clarinets, while Leo Smith performed on three trumpets of different ranges, Phillip Wilson erupted with explosions of subtly varying power on drums, and the local bassist, Chris Amberger, contributed to a pulsating foundation of drone notes and quivering colors.

The branch of jazz that Braxton carries forward has its roots in Ornette Coleman, Eric Dolphy, Lee Konitz, Lennie Tristano and, of course, behind them all, Charlie Parker (who, don't forget, once said he felt that he had exhausted the possibilities of the standard, thirty-two-bar form and professed a wish to study with the European avant-gardists Edgar Varèse and Stefan Wolpe). Like their music, Braxton's is primarily an art of line, rather than harmonic density—written themes with strong, angular profiles which serve as launching pads for improvisation.

It also encompasses innovations drawn from the twentieth-century "classical" tradition—Anton von Webern, John Cage, Karlheinz Stockhausen—not in the neither-fish-nor-fowl fashion that characterized the so-called Third Stream music of the early 1960s, however, but thoroughly absorbed and distilled.

And while you can hear Dolphy's vocal cries in the climaxes of Braxton's intense alto sax solos, his low, rumbling melodic lines on contrabass clarinet are more likely to suggest the unworldly

sounds of electronic music.

Braxton and his collaborators—all of them crucial—give color and texture to their lines by exploring an extraordinary palette of timbres and sonorities, Braxton and Smith employing the full ranges of several instruments, and by highly controlled dynamic shadings.

They then weave their lines together—unisons, solos, themes and counterthemes, all spun around spacious fields of silences—to create transparent structures which are not thickly piled tapestries of sound, but line drawings translated into great, openwork sculptures or skeletal architectures.

The two sets on Tuesday opened with concise, angular themes that resembled somewhat Coleman's melodic lines. The performances progressed through blocks of contrasting colors and moods—soft, lyrical passages wherein Braxton's alto or clarinet displayed his roots in the dry melodicism of Paul Desmond, heated excursions and exchanges with Smith that radiated a blinding white heat, Braxton building long, convoluted lines and Smith letting loose with barrages of terse, elliptical fragments and coruscating runs.

There were, unfortunately, probably less than one hundred people on hand to hear Braxton. For sure, this is not boogying music or easy listening. But whatever else you do, give it a hearing. Braxton is one of the greats.

Seider Ranked with the Very Best Jazz Musicians

MARCH 25, 1979

Like so many deaths in the jazz world, it was just a vital statistic that didn't get even a paragraph on the obit page: "Robert Michael Seider, 51,..."

Unless you were on the scene in North Beach during the late 1950s, the name is not likely to ring bells. So far as I know, Bob Seider never cut a record. Even at the height of the Beat era, he rarely held a regular gig. In recent years, his tenor saxophone had spent most of the time in South of Market hockshops, and Seider himself in and out of San Francisco General Hospital.

To those of us who regularly caught the Sunday sessions at the Coffee Gallery or after-hour jams at Jimbo's Bop City, however, Seider, at top form, ranked with the very best. Beyond that, he seemed to epitomize the life of the journeyman jazz musician in those days before CETA jobs and NEA grants, and to represent a way of life that the Beat era itself—below the superstar level of Allen Ginsberg et al.— was all about.

There was a bristling jazz underground in the city in those years, centering in North Beach but extending to after-hours clubs in the Fillmore and Tenderloin. There were always two or three bars with pianos where musicians could get an impromptu session (and an audience) together at almost any hour of the day or night. The scene included (off and on) a few legendary figures like pianist Joe Albany, Lord Buckley and Harry "The Hipster" Gibson who drifted West to look for work after their New York cabaret cards

had been lifted. There were a few other well-known musicians like Pony Poindexter and Brew Moore. Mostly, there were musicians like Seider, some of them immensely gifted but destined, for whatever reason, to cast their lives' works to the wind. Of them all, Seider, by consensus, was the reigning master.

Seider's idol was Lester Young. At his best, he sounded more like Lester Young than Pres himself had sounded for many years: lagging behind but insistently insinuating an infectious, rocking beat, alternately lyrical and singing, sometimes with astonishing tenderness, or tart and sardonic, unexpectedly punctuating a whispered entreaty with an abrasive bark or a quotation that dripped with innuendo.

Economy was Seider's forte; he once said his goal was to improvise thirty choruses playing only a single note. One night in 1957 or 1958 a group of us went with him to the Jazz Workshop on Broadway, where Seider took on Sonny Rollins in an impromptu cutting contest. The tune was "Lover Man," a Seider anthem, and by the time Seider had finished his first chorus, it was clear to everyone that Rollins had been carved. He had played all kinds of notes, fast, as was his custom. Seider had played very few, but each note had told a story.

Seider also emulated Lester Young's dress, mannerisms and the prototypical hipster style of life that contributed to both musicians' inexorable decline into inactivity and early deaths. I recall Seider's first appearance in North Beach some-

time in 1957, a slight, slouched figure, eccentrically dressed in an oversized, Pal Joey overcoat and porkpie hat; he spent several hours stalking back and forth with his horn outside the Co-Existence Bagel Shop, glowering through the window, before finally venturing in. Beneath the bluff, laconic, sometimes insulting manner, Seider was painfully shy.

He came from New Orleans via New York, another victim of the cabaret card dictatorship then exercised by the New York police. Seider was a striking, charismatic figure with fine, aquiline, vaguely Sephardic features and a kind of serpentine grace—underlined by the way his neck puffed out, cobralike, when he was playing. He spoke in a deep, honeyed drawl. His entrance into a club carrying a horn set an air of expectancy in motion. If the mood was not right, he might not play. He was not always on. But audiences then had more time and patience (cover and drinks were also cheaper), like baseball fans who show up each afternoon waiting for the Great Play or the no-hitter. At odd, unpredictable times, but with remarkable frequency, Seider would come through with jazz's version of the perfect game.

Eventually, Seider married a school teacher, and we were neighbors for a time in a cheap hotel above Ann's 440 Club on Broadway. Highly intelligent, surprisingly well-read, he liked to speak in ironic parables. He preferred to start the day with a mixture of port and gin, although port alone (or turpinhydrates cough syrup) would do. He had a certain Manichaean

fascination with the abstract idea of evil. He carried about a tattered copy of Georges Gurdjieff's *All and Everything,* and a Tarot deck with which he sometimes read fortunes. He identified himself with "The Fool" card.

At the end of the 1950s, when the North Beach scene broke up, Seider and his wife moved to New York. The story is that he worked as a high school math teacher and lived a "straight" life somewhere upstate. One day in the early 1970s, he showed up again in San Francisco by himself. Returning to North Beach, he played when and where he could, but times had changed and there was little interest in Seider's kind of music anymore. The red port gave way to white. Seider said his one remaining ambition was to be a Hell's Angel.

The audience for jazz has picked up in recent years, but it was too late to do Seider much good. Nor could he have fit into the more formal and highly regulated framework of the contemporary jazz world, where even "jam sessions" have sign-in sheets and time limits. Today's audiences tend to approach jazz as just one of the Good Things, each to its appropriate place and time. But to men like Seider, jazz meant a way of life; it depended on the existence of places to play, and people to hear, at virtually any hour of the day. For better or worse, that way of life has gone. It disappeared several years before Bob Seider himself passed from the scene.

A Devastating Evening of Jazz

MARCH 25, 1976

Like Muhammed Ali matched against Joe Louis, Bob Feller pitching to Ty Cobb, or Nureyev paired with Nijinsky, this week's double bill of Cecil Taylor and Archie Shepp at Keystone Korner is a near mythical event, at least for this part of the country.

Actually, Taylor is, without much doubt, the most astonishing musician of any kind now living; Shepp is merely one of the era's greatest tenor saxophonists. But the time when these things needed to be explained seems to have ended, for the club was crammed to overflowing at Tuesday's opening. And it was a devastating, earthshaking evening.

In fact, there were more extraordinary musicians on Keystone's stage than one finds in most jazz festivals, for both Shepp and Taylor are appearing with new quintets, each a fantastically together unit of superb solo and ensemble players, many of them appearing here for the first time.

Shepp opened, his big, biting tenor sounding a fragmentary theme from the dressing room, and continuing as he appeared on stage, a bearlike bulwark of a man who projects some of Charlie Parker's rocklike, implacable presence. Vibrant, keening, bending the notes slightly to either side of precise pitch so that the horn speaks as much as it sings, Shepp's tenor built terse, elliptical lines to a smashing climax. He laid out while trombonist Charles Greenlee blew a more low-burning, incandescent solo, then returned to develop a new peak of redoubled frenzy.

With Beaver Harris's thunderous drumrolls and cymbal explosions crashing all about him, Dave Burrell unleashing barrages of percussive clusters and lightning-quick, crystally articulated lines, his hands skittering up and down the keyboard like two enraged cats, and Cameron Brown's frenetically racing bass, it was an awesome, exhilarating, yet gut-level experience, as if one had entered the engine room housing the roaring, clattering mechanisms that turn the world around.

But that is only one of Shepp's sides. There followed a brilliant, a cappella solo that segued into a hard-swinging boppish riff, filled with inflections from rhythm and blues. And Shepp is one of the few musicians left who can inject a ballad like "Lush Life" with exquisite feeling and utter honesty, rather than merely using it as a pace-changing filler. In fact, he makes all the labels that are always tagged on different branches of jazz silly and meaningless. Shepp is a living history of the jazz saxophone. And then came Cecil. One does not go to a Cecil Taylor performance merely to hear music, but to experience a baptism—largely by fire and blinding light, but all the forces in the universe are brought into it by the time Cecil is through, which was a good hour and a half after he began.

Any additions to his piano court the superfluous, not to say outright intrusiveness, but this relatively large group— Jimmy Lyons, alto; David Wore, tenor; Larry Malek, trumpet; Marc Edwards, drums—works magnificently. They opened with a simple, poignantly ambiguous melodic figure. This figure underwent countless elaborations, permutations, even transubstantiations, but its rhythms and intervals permeated the dense, electrically energized textures, and bound together all that followed.

Wiry and tense as a coiled cobra,

wearing a cap and a light muslin suit, opened at its front like a judo outfit, Taylor virtually hurls himself on the keyboard, moving with the dynamic force of an acrobat or dancer, "comping"—if that word can still be used—with the percussive strength of a hundred Horace Silvers.

For Taylor is like a dervish, orchestrating all the powers of existence through his hands: dense, dissonant chords and clusters; lines, patterns and runs that rush forward in torrents and pile up on one another like foaming cascades. Horns slice in and out of this thickly piled tapestry—Wore, honking, screeching, launching shrill, wailing lines through his own bass warbles; Lyons, playing more lyrically; and Malek's trumpet, a radiant ember that periodically fans itself aflame. All are totally individual voices, but all feed off of Cecil's energy as he propels you veritably into the sound barrier—harrowing, excruciating, stomach-wrenching in its physicality and intensity, but also ecstatic, exultant. And then out the other side, into a realm where all the ordinary human emotions are present, but raised to another level of meaning and cosmic harmony.

And how does Cecil bring all this back down? His shirt by now wringing with sweat, he ebbed into a solo passage of such delicate lyricism that you could hear the solfège singing with which he accompanies his playing, and which gives his music a vocal as well as a kinetic quality.

And then it was ended, although I can hear it still and know it is going to be pulsating somewhere around me for years to come.

Jazz Artists Spend Their Careers Enacting Big-Little Dramas

DECEMBER 18, 1977

According to philosophers, music is as abstract as mathematics. Yet a great jazz artist can make it become a language, with or without words, as explicit as the blues, and as rich as the greatest literature.

Lester Young's solos used to "tell a little story"; Charlie Parker once said his art was about what he had for dinner (among other things). Beyond that, jazz maps—as all art does, but because of the nakedness with which it exposes the creative process in the very act, more graphically—the geography of a life: the year in, year out processes through which artists quite literally create themselves as they create their work—and the ways they burn out, sell out or simply give out. Coltrane's heroic questing, Bud Powell's tragic collapse, all of it is laid bare, sometimes painfully so, on the records they have left.

Somewhat as professional ball players, jazz musicians spend their careers publicly enacting both the big and little dramas—the triumphs, failures, luck, bad breaks and sheer struggle to get by from one day or year to another—in which all of us are cast members in the intimacy of our own lives. Because the art, the artists and our own identification with them are so intimately connected, the jazz listener, as the baseball follower, is likely also to be a "fan," taking a livelier interest in personalities than is sometimes thought seemly in other areas of art. And we are likely to feel it more personally when a member of the community of jazz artists and listeners dies.

No musician of recent years made more clear the human dimension—the "content"—of jazz than Rahsaan Roland Kirk. Rahsaan was known for his virtuosity, celebrated for his musicianship, but above all else, he was a master storyteller and one of the great tragic heroes of the existential paraphrase of life that great art is. He was, first of all, one of the most soulful tenor saxophonists this side of Ben Webster, one who could draw from his horn every nuance of poignancy or humor, suffering, anger or unbridled exuberance, and he could do the same playing flute, or three kinds of saxophone at once. When none of his instruments would suffice for the particular communication he had in mind, Rahsaan did not hesitate to turn to speech. He might spin an outrageous anecdote, improvise Lord Buckley–style riffs. Or, he might recite a moving line of poetry, or launch into a scorching tirade—laced with sardonic humor—against the onslaughts of commercialism in the music world and the falsities of American life.

In speech and in music, one of Rahsaan's principal messages was the power and beauty and redemptive spirituality of the entire tradition of jazz—or, as he preferred to call it, black classical music. Commentators were sometimes critical of Rahsaan's "eclecticism" and, indeed, he could switch at the drop of a grace note from an easy, lyrical swing rooted in Lester Young to furiously "outside" free-form, or Coltrane-inspired, cries. But Rahsaan always made these sounds come out of his own. And, in retrospect, it is apparent that

he was one of the pioneers of the kind of anthologizing of tradition and historic sources—of roots—that is one of the principal features of the 1970s "avant-garde" which is involved in both preserving tradition and carrying it another step forward.

Rahsaan was a sophisticated and erudite musician who had familiarized himself with every branch of jazz, and was knowledgeable in other areas of music as well. He was a major innovator on both tenor saxophone and flute, using a highly developed "circular breathing" technique to build long, continuous phrases to cyclonic climaxes. He was an early explorer of sounds derived from such then-unconventional "instruments" as gongs, sirens and whistles.

He was also a surrealist and a visionary. His musical ideas often first appeared to him in dreams, and some of his recordings were almost Frank Zappa–like in their conceptual formats. In fact, there was often something a little frightening about his performances, which seemed to take you into an entirely different world that existed strictly within his head. Sometimes, this "world" was an old movie, a Western or a corny love story with saccharine, romantic ballads; sometimes, distant memories of rice and beans and dogs barking in the night.

It was a world similar enough to our own to be recognizable, but it had its own dimensions and colors, and seemed to move faster, like a film at high speed; and all the familiar ingredients, the popular songs, were somehow transformed by contact with it. At such times, Rahsaan—deep in concentration, barely visible behind sunshades and instruments—seemed like some visitor from outer space; in fact, in one of his last LPs, "The Return of the 5,000 lb. Man," he cast himself as an emissary from the "Eulopians"—"his friends, the poets and artists"—whose music is "a duty free present to the traveller."

But then Rahsaan would let out an earthy chuckle, tell a corny joke, and your worlds would touch once more.

Rahsaan was almost blind from birth, and the lights went out altogether in his early childhood—years back—the result, it is said, of an unfortunate accident while his eyes were being treated. In November of 1975 he suffered a stroke that left his right side paralyzed.

"He poured all of his soul into a tenor saxophone," Rahsaan wrote in the lyrics he set to Charles Mingus's "Goodbye, Pork Pie Hat." The tribute to Lester Young seemed more and more to become Rahsaan's own theme as he defied the doctor's prognosis and began an extraordinary comeback. The sight of Rahsaan in his final appearance here—tired, frail, yet gaining strength as he gave himself up to his playing—is one I will not forget. As Todd Barkan said, "It was music that kept him alive." And it was the spirit that Rahsaan and his music represent that helps keep the rest of us going.

Deep Parallels between Art and Jazz

FEBRUARY 24, 1980

Oddly, no coherent investigation has ever been made, at least so far as I know, into the relationship between Modern art and jazz.

The influence of jazz on certain Modern artists—Piet Mondrian, Stuart Davis, many of the pioneer Abstract Expressionists—has been cited frequently enough, but, to my knowledge, no thorough study has ever been done on the more general relationship, the many deep historical and other parallels.

Jazz and the Modern movement were both born at about the same time, one in America, the other in Europe, both with profound roots in the mysterious cultures of Africa. The angular, sharply chiseled planes of African sculpture began to tear at the epidermis of traditional realism in Picasso's work shortly after 1906 (when Picasso is supposed to have been introduced to African carvings by Matisse). A decade later, the emphatic rhythms and jagged intervals of jazz began to enter the "serious music" of such composers as Igor Stravinsky and Darius Milhaud.

The principal impetus, at least at first, for painters and sculptors as well as musicians, was the raw, "primitive" energy and vitality that both jazz and African art represented to the European mentality—habitually oscillating between a rigid rationalism (not to mention a mushy bourgeois mercantilism) and the Romanticism of the Noble Savage that Henri Rousseau articulated in the eighteenth century.

For the Expressionists, the "primitive" artifacts of Africa, as well as of New Guinea and other Oceanic cultures, offered a model of art as *process*, still functionally integrated with both the spiritual and the everyday, practical lives of their societies. Their creations were charged with an intensity in which both spiritual and sexual energies were subsumed in an overriding expression of vigor and power that affirmed the preeminent authority of the lifeforce in general and fertility in particular. It directly touched—affected, moved—people's innermost lives.

Jazz, too, expressed and symbolized a raw, untamed energy and unverbalizable emotions. The word itself derived from a euphemism for sex. From another vantage point, think of the haunting scene in the 1929 Duke Ellington movie *Black and Tan Fantasy,* in which Freddie Washington dies surrounded by the almost primally plaintive lamenting of horns and singers. The blues are, perhaps, the deepest level of human speech, expressing about all that can be said of the fundamental dilemmas of existence. As a symbol of vitality, jazz also mingled with the myth of America itself—the frontier, the Indian, "The Natural Theater of Oklahoma," as Kafka fantasized it.

On the other hand, jazz has also been par excellence an expression of the twentieth-century city. Like urban America itself—a nation of *inventors* but indifferent handcraft—it emphasized the white-heat immediacy of new ideas and process rather than finesse and refinement. The Dutch writer John Kouwenhoven has observed that the New York skyline (which inspired so many painters in the 1920s and 1930s) "is jazz." Thelonious Monk used to spend hours standing on a corner near his midtown apartment listening to the kinds of street noises and rhythms which are abstracted in the hard-edged dissonance

and asymmetrical, but curiously rhyming motion of his music.

Abstract painting and sculpture in general during the early phases of Modernism aspired to the conditions of purity and concreteness (or absoluteness) that were commonly thought to be peculiar to music. Le Jazz Hot offered a model of bright, primary colors, clipped, staccato phrases and decisive rhythms.

It was this aspect of jazz that appealed to such painters as Mondrian, who, according to the Dutch art historian L. J. F. Wijsenbeek, regarded jazz as "the music of the future." The titles of Mondrian's late paintings—*Fox Trot A, Broadway Boogie-Woogie* and *Victory Boogie-Woogie*—reflect their musical inspiration. As James Johnson Sweeney described the latter, "The eye is led from one group of color notes to another at varying speeds. At the same time, contrasted with this endless change in the minor motives, we have a constant repetition of the right angle theme like a persistent bass chord sound through a sprinkling of running arpeggios and grace notes from the treble."

Louise Nevelson remembered going dancing with Mondrian in Harlem while he was living in New York in the 1940s. Jacobus Oud, the architect, recalled the way he used to dance in Paris in the previous decade: "Although he always followed the beat of the music, he seemed to interpolate a rhythm of his own. He was away in a dream, yet remained prim and precise and always kept exact time, although creating the impression of an artistic, indeed, almost an abstract, dancing figure. It could not have been much fun for the girl to drift across the dance floor in a kind of

trance in the midst of all the normal pleasure-seeking throng. He himself was aware of this, and later compensated the girl—most generously considering his slender means—for giving her time to him. 'Perhaps she was expecting something else,' he would say."

In thus bringing together the jungle and the modern city, jazz united the two principal strands—the Romantic atavism of the Expressionists and the Utopian futurism of the Neo-Plasticists and Constructivists—of early Modern art.

At the same time, jazz and modern painting and sculpture were closely anchored to an even deeper substratum which lies at the very foundation of the twentieth-century sensibility. That is the concept itself of an *underground*, at once social, cultural and psychological—the individual and collective subconscious—with its twin implications of subversion or revolution, toward the end of a new freedom. The subterranean energies were to be liberated for the reconstruction of a new life, or a New Order.

"I want to descend in the social scale," Lawrence Ferlinghetti riffed in his jazz-poem of the 1950s, "The Junkman's Obligatto." The Pierrots and harlequins that began to appear in Picasso's Rose Period paintings—and, as so much in Picasso, later found an echo in Igor Stravinsky—were salvaged from the same refuse heap of humanity from which Toulouse-Lautrec had reclaimed his dancing girls and prostitutes (and Velázquez his dwarfs and retardates). As *entertainers*, they were outcasts of a special, uniquely equivocal kind who, like the court jesters of the past— casting wisdom in the form of jokes—simul-

taneously served (and fascinated) society and made a mockery of many of its values.

The jazz musician eventually became the principal symbolic figure of this sinister cultural underworld. Like the jesters, troubadours, jongleurs and other improvisers of old, he created an art that was as indifferent to *permanence* and monumentality—indeed, to its status as "art"—as it was to other conventional formal rules. The essence of what he did could not be learned in school; he, himself, could not duplicate it. Eliminating the traditional distinction between "creation" and "performance," the jazz musician used the most unprepossessing of "found objects"—popular music, formulized blues structures. Directly before one's eyes, and ears, they were transformed into art, or they remained simple entertainment, according to his improvisational gifts—or might be "entertainment" early in the evening, and "art" later on.

The spontaneity and immediacy of improvisation offered the possibility of "art" that was artless, that was perpetually both self-destroying—gone with the wind— and self-renewing, that was freed from the constraints of materialism. Jazz had no Absolutes—an accident could be incorporated and developed; there was always a chance to start afresh. Yet each attempt at a daring embroidering or substitution was absolutely decisive, a risk that could not be retracted or reworked. The goals and methods of jazz found their counterparts in the improvisations of artists and sculptures—the early found-object constructions of Picasso, and the "unfinished" look of some of his early paintings, the improvisations of Wassily Kandinsky, the "ran-

dom" pieces of Jean Arp, the early Dada events in which the artist became a performer. The sketches of old masters were revived and reevaluated, often regarded more highly as direct expositions of *ideas* than their more "finished" paintings, or "products."

The "descent" on the "social scale" of humanity was accompanied by a journey into the junk piles of official culture, by the reclamation of despised, rejected and discarded objects. Since the Renaissance, European art had maintained much of its vitality through infusions by successive generations of forms and themes from life that had previously been deemed too "real" (or too mad), too "unfinished" and "raw," beneath the dignity of art. This drive gained immense momentum with the development of collage—perhaps Picasso's, and Stravinsky's, most momentous achievements (what would movies, and the entire way of seeing that they have fostered, be like without the techniques of enforced juxtaposition—montage—that collage helped to foster?).

As Cubism had opened up forms that were previously closed, and spread out all of their different aspects on a flat surface, collage brought together the whole of time and space—of consciousness—on a single plane. It obliterated hierarchies— in collage there was no essential difference between an engraving of the Venus de Milo, a photograph of the Great Wall of China and a postage stamp or bus transfer.

Ultimately, the "descent" was fundamentally Jungian and Existentialist, a kind of voyage of discovery through the demimonde of the psyche. Herman Hesse, in *Steppenwolf,* made a jazz musician—the

tenor saxophonist Pablo—the symbolic guide who leads the novel's protagonist on an epic journey through the underworld of his own consciousness until the conventional dualities of Western culture—between inside and outside, consciousness and matter, the vernacular and "high art"—disappear in Mozart's laughter. To Sartre, in *Nausea,* "the Negro singer," with her tinny, jukebox rendition of "Some of These Days," represented the force of undifferentiated raw experience—the Absolute value of the specific and concrete—that might free his protagonist (symbolic of European man) from the shackles of historicism, enabling him to begin to create his own life. Such insights, in turn, opened the door for the illuminations of Oriental thought, particularly of Zen, with its emphasis on particularity and on process.

The existential and improvisational aspects of jazz (reinforcing the influence of Surrealist automatic writing) profoundly affected many of the first-generation Abstract Expressionist painters, particularly the action painters—Pollock, Kline, de Kooning—who used to hang around the Cedar Bar. Jazz itself was changing dramatically in the 1940s, giving birth to the more complex virtuosity of bebop and its emphasis on the individual soloist. The best action painters employed controlled accident and incorporated inspired chance within a definite, if not always readily decipherable, structure, much as a bop musician improvised with great freedom around a sometimes almost subliminal framework of chord changes. Risk and open-endedness were part of the *statement* of their paintings.

Pollock's dense, soaring, Baroque linear improvisations sometimes seemed a mirror of the long, convoluted, furiously slaloming melodic lines that Charlie Parker improvised on alto saxophone; Kline's abstractions could be likened to the spare, staccato phrases of Miles Davis. The paintings of Clyfford Still, with their rawness, dissonance and jagged angularity—the stark, unyielding walls that startlingly (and, thus, sometimes almost humorously) open to totally unexpected glimpses of worlds of exhilarating, limitless freedom—seemed analogous to the piano music of Thelonious Monk, the most profoundly original of American jazz musicians, as Still was of American abstract painters. (The humor is especially true of Still's tiny pastels, which he never exhibits.)

Jazz was a staple at the California School of Fine Arts in the late 1940s, when Still was teaching here. Its Studio 13 Jazz Band, which played at parties and dances, specialized in the revivalist Dixieland that had its center in San Francisco in the 1940s. The band included the school's director, Douglas MacAgy, on drums, David Park on piano, and Elmer Bischoff, playing trumpet. Such painters as Hassel Smith, Deborah Remington, Jay DeFeo and James Kelly were influenced by jazz, bebop as well as traditional; Smith frequently alluded to jazz or jazz musicians in his titles.

Jazz—in still another new form known as hard bop or funk—was central to poetry as well as painting and sculpture during the Beat era of the 1950s. Poetry readings, like action painting, served to reduce the distinction between "creative arts" and "performing arts." Poets, paint-

ers and musicians would sometimes gather, getting high and looking at strange lights, to toss words and phrases back and forth, the way a jazz soloist trades four-bar measures with the drummer. A sequence of intermediate stages might end in such bizarre mutations as *Shopping Hour* (from Schopenhauer) and *Bottom Jelly* from Botticelli (both titles of paintings by Wally Hedrick).

In Los Angeles, Peter Voulkos studied jazz guitar and improvised unprecedented abstract forms in clay. In New York, Larry Rivers, a onetime tenor saxophonist, carried to a further extreme (albeit, much less successfully) the emphasis on improvisational process that had been stressed by de Kooning.

American artists began to mine and improvise new relationships around the bottomless treasure trove of their own vernacular imagery, as European artists had done during the early years of Dada and Surrealism. Wallace Berman, who in his youth had collaborated on writing blues tunes with Jimmy Witherspoon, created his own version of Pablo's "Magic Theater" with common images drawn from newspapers and magazines, arranged without special order or rank, whose juxtapositions and connections suggested mysterious correspondences within the inner reaches of one's consciousness. Bruce Conner and George Herms reclaimed lost objects from the rubbish heaps and debris of urban renewal and assembled them into creations where relationships conferred upon them a new, metaphorical meaning, even as the objects remained specific and concrete. These early Funk artists epitomized the equation of art with impermanence, not an object to be crafted, nor merely a concept, but an action, a poetic *event*, to be communicated as intensely as possible and then left, while the artist moved on.

Specialization set into art as it did almost everything else at the beginning of the 1960s; painting was supposed to grow from painting, sculpture from sculpture. The relationships between the visual arts and jazz (or most other areas of life) in the past two decades have lacked the intimacy that existed in the 1950s; dealers and collectors have showed how materialism always manages to reassert its claims. Parallels, however, if not necessarily influences, continue to exist. The high-energy jazz of John Coltrane and Cecil Taylor has a counterpart in the kinetic speed and vibrant cacophonies of certain color abstraction, and also in the dense layering of space in some more recent painting and sculpture. The emphasis on raw materials and process of post-Conceptual artists is echoed in the performances of Anthony Braxton, the Art Ensemble of Chicago and their followers. The eclecticism and revivalism that characterized most painting and sculpture in the 1970s were paralleled in jazz by fusion and by the anthologizing of such musical encyclopedists as Rahsaan Roland Kirk and Jaki Byard.

Meanwhile, of course, rock, in its various forms or "waves," has also risen to affect and form parallels to the work of painters, sculptors and performance artists. But that's another story.

Afterword

LAWRENCE FERLINGHETTI

Tom Albright Himself

It seems a long time now since Tom Albright went over the hill and into the
trees, but he's still being missed around here. Where are you, Tom, when
we need you more than ever with your sardonic critique of all that is shallow
and *arriviste*... San Francisco painters particularly still miss Tom Albright.
He knew the line between the coasts of abstract and figurative expressionism,
and he knew the difference wasn't provincial. Other art critics might travel
constantly to give their reportage a national or international aura, but Tom
did it all at home. And he's still missed in North Beach, San Francisco,
his haunt of haunts, for the *San Francisco Chronicle* used him to cover not
only art but other cultural and historical North Beach events that no one else
at the *Chron* could cover as an insider. He was the painters' insider. He was
their interior monologue.

Index